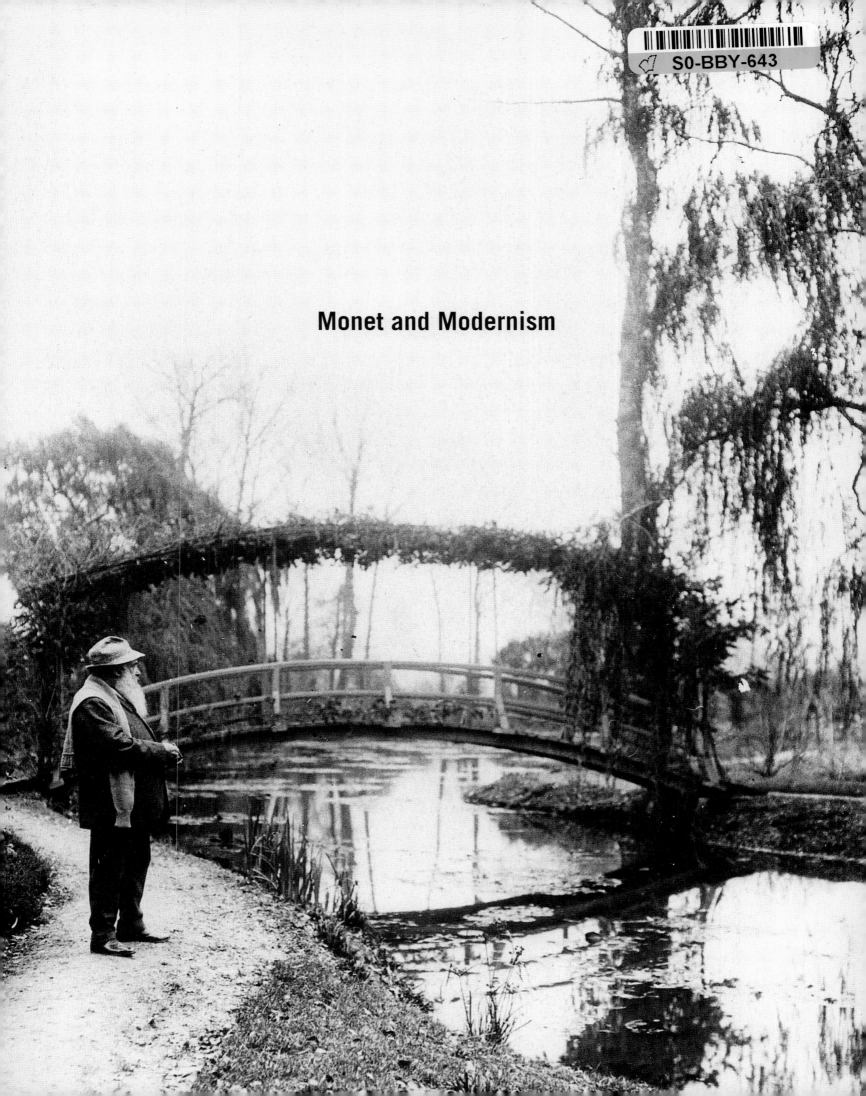

Monet and Modernism

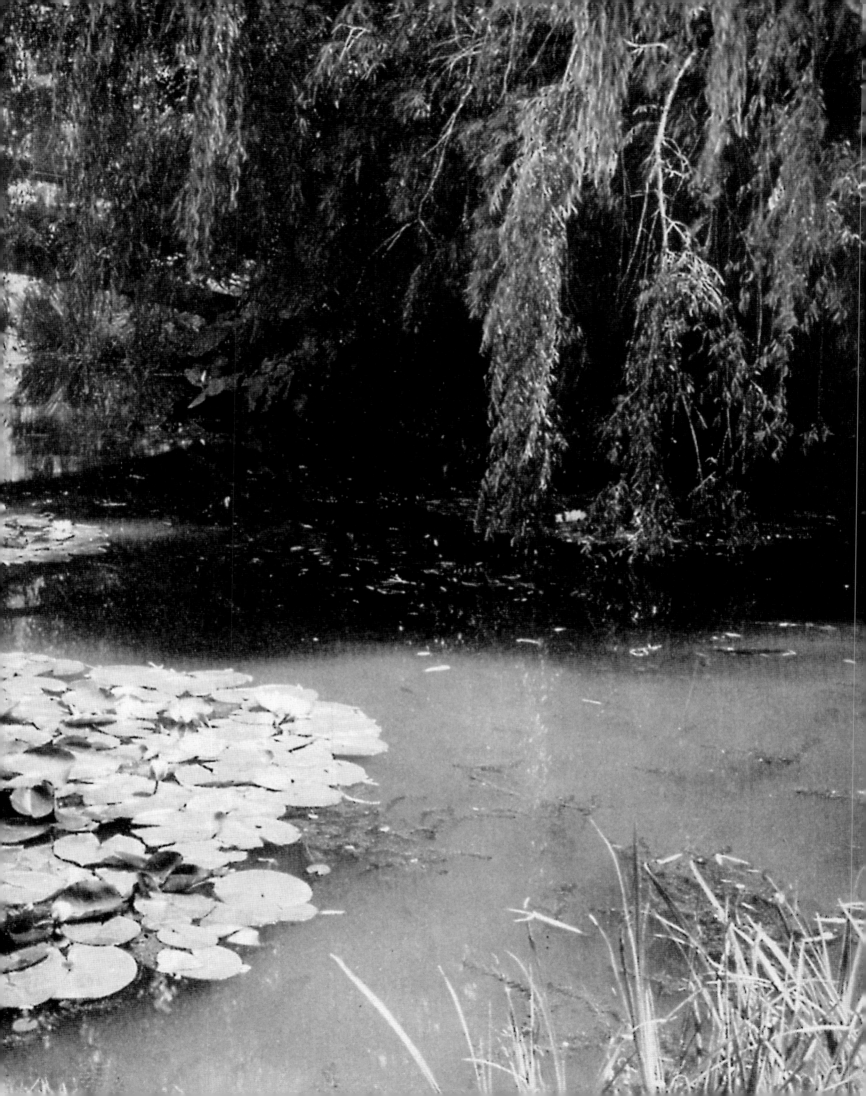

Monet and Modernism

Edited by
Karin Sagner-Düchting

With contributions by
Gottfried Boehm, Hajo Düchting, Ann Gibson,
Claudia Posca, Karin Sagner-Düchting

Kunsthalle der Hypo-Kulturstiftung

Prestel Munich · London · New York

Hajo Düchting

Artists' Biographies

Foreword

In 1874, Manet painted his famous picture of Monet seated in a boat the latter had turned into a floating studio. (The picture was acquired in 1913 by the Neue Pinakothek in Munich, with funds from the Tschudi donation.) The boat is seen on the Seine near Argenteuil, with Monet at work on a landscape and his wife Camille seated at the entrance to the cabin. This studio boat was where the artist produced many now well-known works, including views of the railway and Seine bridges at Argenteuil, his own house and garden in the same place, the poppy field at Argenteuil (Musée d'Orsay, Paris) or the famous *Impression, Sunrise* (Musée Marmottan, Paris). For Monet, water in its many aspects —and especially the Seine—was a favorite subject matter. This is borne out time and again by the famous series of the 1880s and 1890s, likewise painted from the floating studio and represented in this exhibition by the *Ile aux Orties* and *Les Glaçons*. Monet painted this great river "all his life, at every hour of the day, every season of the year, from Paris to the sea." The Giverny area, where Monet finally settled in a pink-washed house with a large garden in 1883 and lived until his death in 1926, is likewise riddled with water channels. From there he traveled to Rouen, to make 26 paintings of the cathedral facade; to London, which appealed to him most in the mist; and to the sea. Best of all, he transformed the garden in Giverny into a rustling sea of flowers, creating an artificial pond in which his beloved waterlilies bloomed. In his late work, these became more and more the central subject matter of his paintings. Ultimately, the waterlilies are the starting point for this exhibition as well, because it was they that have fascinated and enduringly influenced painters of all nations down to the present day.

After Monet's death in 1926, art critics wrote off the late oeuvre as 'formless' and therefore passé. His work was not reappraised until the 1950s, and new impulses came from across the Atlantic. Young American artists in Paris on scholarships discovered Monet's waterlilies at the Orangerie. American Abstract Expressionism is deeply indebted to their reaction. This exhibition endeavors to show how, by presenting works of important artists of the movement. It also examines Monet's influence on French artists and German representatives of Art Informel. This is the first major exhibition of Monet's works in Munich. There have been many great exhibitions on Monet, most recently in London and Vienna, but none of them have looked at him closely in the context of his overwhelming influence on later generations of artists. Karin Sagner-Düchting, the curator of this exhibition, has studied and researched the phenomenon for years. The Kunsthalle of the Hypo Kulturstiftung has been fortunate in acquiring her expertise in order to make the present ambitious project reality.

The next port of call for the exhibition is the Fondation Beyeler in Riehen, Basel, which is another stroke of good fortune. As a partner in the venture, the Fondation was

not only a potential lender of the most important paintings by Monet and other artists but, thanks to its worldwide reputation and vigorous assistance in the task of locating and obtaining loaned works, made it possible to put on such an outstanding exhibition in the first place. Our profound thanks are due first of all to Mr. Ernst Beyeler for his personal commitment and unflagging enthusiasm for the project. We likewise owe thanks to all our colleagues at the Fondation, especially Verena Formanek.

With four major exhibitions running simultaneously with works by Monet, it was very difficulty to get major loans for this exhibition. Many of Monet's paintings are extra-ordinarily fragile, and understandably many of our requests were turned down or strict conditions were imposed regarding transport to the Kunsthalle. We are therefore all the more grateful to museums and private collectors who were willing to support us. Special mention must be made here of Jean-Marie Garnier, director of the Musée Marmottan, who made an extensive range of works available to us. At the same time, as is evident from the next page, we are immensely indebted to colleagues in museums at home and abroad and to many private collectors, among whom the name of Eve Scharf is particularly prominent as a source of loans.

Our gratitude goes also to Daniel Wildenstein in Paris and his colleague Gerard Stora in New York for their great commitment to our exhibition project. We have them to thank for many important loans.

We should also like to thank the following, whether for loans, making archives available or scholarly studies: Christian Bührle (Zurich), Philippe Piguet (Monet's great-grandson), Yseult Riopelle, Dr. Peter Nathan (Zurich), the auction houses Christie's and Sotheby's as well as all authors of the catalogue, Professor Ann Gibson, Dr. Claudia Posca and Dr. Hajo Düchting.

My thanks finally go to publishers Prestel Verlag, who took charge of editing, printing and distributing the catalogue in their usual expert manner.

Johann Georg Prinz von Hohenzollern

Lenders to the Exhibition

Special thanks goes to the following Museums, private collections and artists,
as well as all lenders who wish to remain anonymous.

American Contemporary Art Gallery

Acquavella Contemporary Art

Bayerische Staatsgemäldesammlungen Munich, Neue Pinakothek

Beck & Eggeling International Fine Art, Düsseldorf – New York

Frédéric Benrath

Fondation Beyeler, Riehen/Basel

Stiftung Sammlung E.G. Bührle, Zurich

Denver Art Museum, Denver

Douglas and Beverly Feurring

Gimpel Fils

Folkwang Museum, Essen

FRAC (Fonds régional d'art Contemporain, Provence-Alpes-Côte d'Azur), Marseille

Herzog Franz von Bayern

Bernard Frize

Galerie nächst St. Stephan, Vienna

Galerie Mark Müller, Zurich

Galerie Alice Pauli, Lausanne

Galerie Proarta, Zurich

Galerie Werner, Cologne

Raimund Girke

K.O. Götz

Gotthard Graubner

Ellsworth Kelly

Byron Kim

Helmut Klewan, Munich

Kunstsammlungen zu Weimar, Weimar

Sammlung H. Lebrun

Museum Ludwig, Cologne

Joseph Marioni

Marlborough International Fine Art Est.

Philippe Meyer

Metropolitan Museum of Art, New York

Robert Miller Gallery, New York
Moderna Museet, Stockholm
Musée Marmottan-Monet, Paris
Museum of Art, New Orleans
Dr. Peter Nathan, Zurich
National Gallery of Art, Washington
The Philadelphia Museum of Art, Philadelphia
The Estate of Richard Pousette-Dart, New York
Max Protetch Gallery, New York
Milton Resnick
Michael Rosenfeld Gallery, New York
Scharf Collection
Stafford Collection
Staatsgalerie moderner Kunst, Munich
Stedelijk Museum, Amsterdam
Virginia Museum of Fine Arts, Richmond
Jerry Zeniuk

We would especially like to thank Ann Gibson, whose curatorial advice
contributed to the successful outcome of this exhibition.

For their support we would further like to thank

Gisèle Barreau
Michael Blackwood Production, New York
Sam Francis Foundation, Santa Monica, California
Gerhard und Margarete Hoehme-Stiftung, Neuss
The Estate of Hans Hofmann, New York
Shirley Jaffe
Willem de Kooning Revocable Trust, New York
Fondation Maeght
Zuka Mitelberg
Musée Monet, Giverny
Musée de l'Orangerie, Paris
Pierre Schneider
Dirk Snauwaert
Oliver Wick

The paintings exhibited are depicted as full-page illustrations.

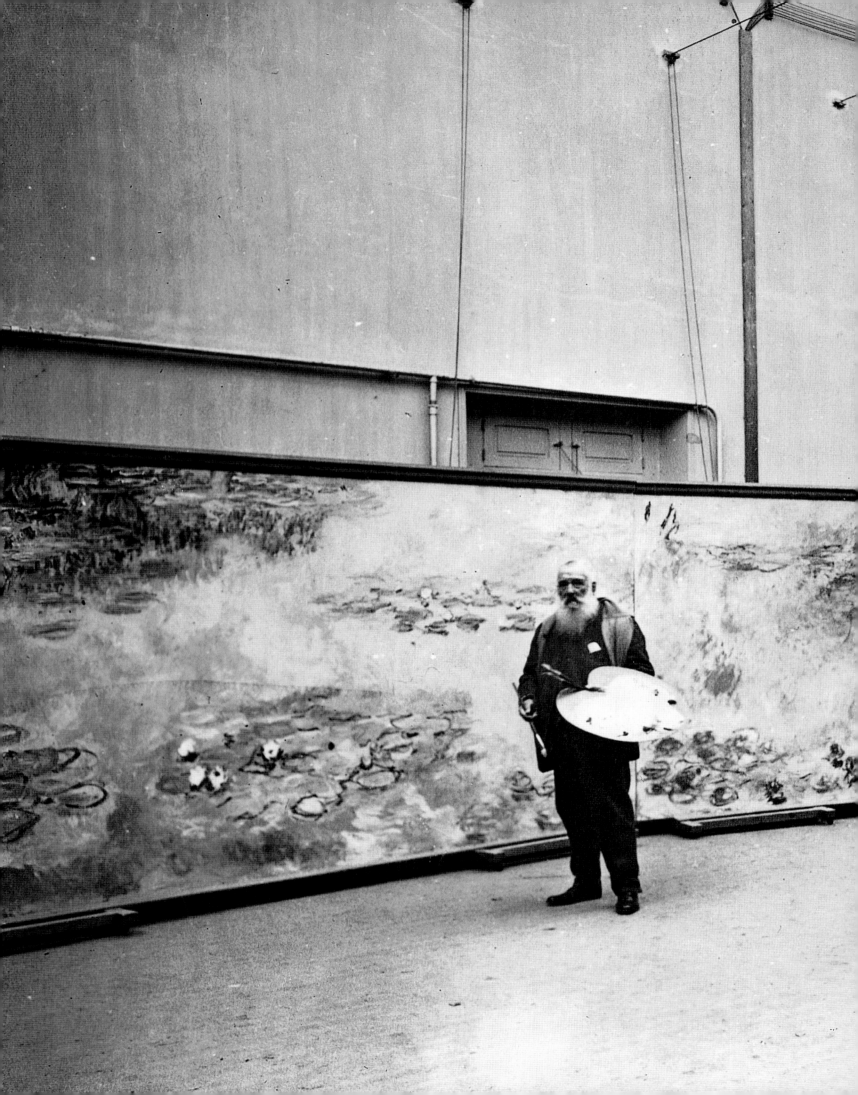

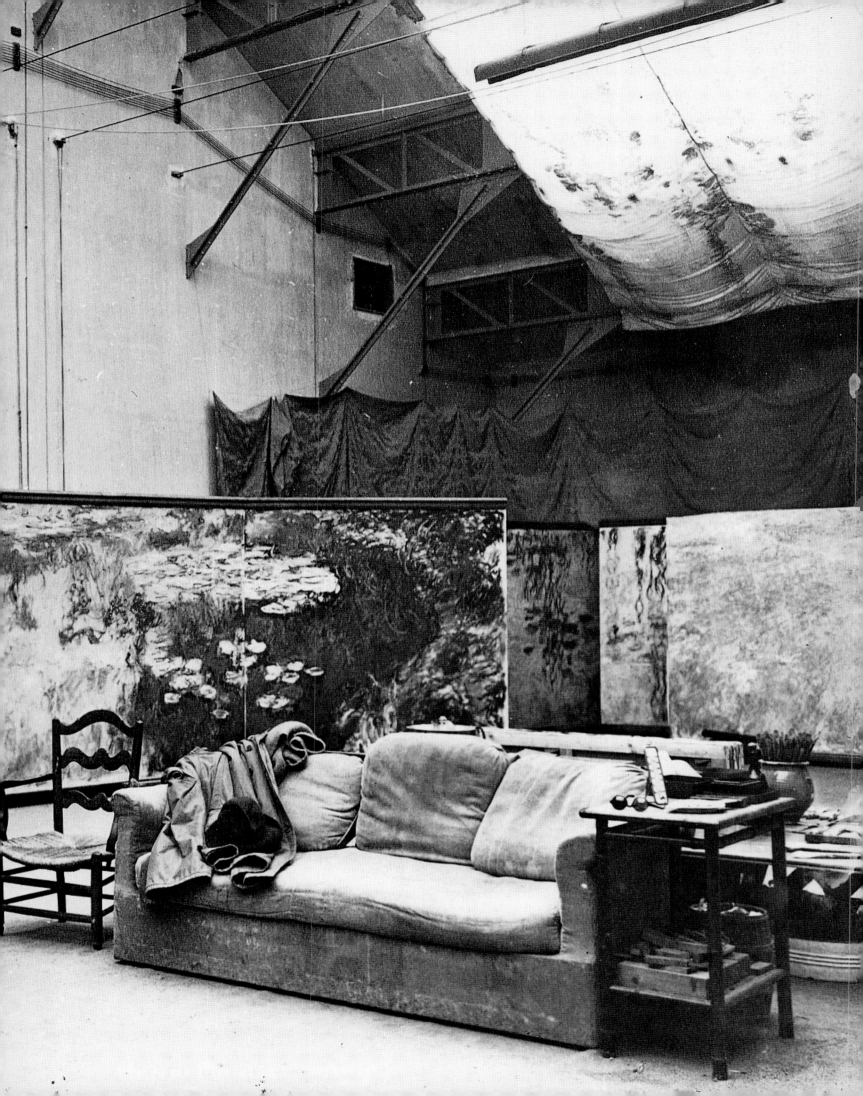

Monet and Modernism

Karin Sagner-Düchting

Monet's Late Work from the Vantage Point of Modernism

Claude Monet, Le Pont japonais, 1918–1924
The Japanese Bridge
Oil on canvas, 89 × 100 cm.
Paris, Musée Marmottan-Monet. Detail

Monet's late work has long held an outstanding place in art history, being admired by critics, collectors and connoisseurs alike. We need only recall the countless publications on Monet that have appeared since the middle of the 1980s and the unflagging enthusiasm shown by audiences of the many Monet exhibitions held in the past two decades.[1] It is truly hard to imagine that his late work was once neglected, even forgotten, and had to be "rediscovered."

What was the source of this low estimation and when, where and why were the artist's late paintings rediscovered in the course of the spectacular Monet revival that took place in the 1950s? Wherein lies the aesthetic potential that has since made the modernity of these paintings so obvious, both to artists and audiences, down to the present day?[2]

An attempt to answer these questions in an exhibition seemed overdue and necessary.[3] We soon realized that the meaning of Monet's painting for later generations of artists—based on new modes of perception and an altered understanding of reality—could be traced only in terms of certain focuses, because any attempt at a complete, encyclopedic review would be condemned to failure from the start. The works chosen range from selected examples of Abstract Expressionism and Color Field painting, Tachisme and L'Art Informel, down to individual representatives of contemporary art.

Monet's late work, covering the years from about 1890 to 1926, found its culmination in his installation at the Paris Orangerie, a *Grande Décoration* of monumental wall paintings with motifs from his waterlily garden at Giverny. A gift of the artist to the French nation,[4] the installation was officially opened to the public as the "Musée Monet" on May 17, 1927. Yet already at the inauguration, complaints were raised about lack of interest in the paintings.[5] Nor did the following years bring much improvement. A case in point was the Monet retrospective held at the Orangerie in 1931, which included few —and not highly regarded—late paintings.[6] In subsequent years several exhibitions were mounted at the Orangerie, despite the fact that this was expressly prohibited in the contract with the artist.[7] In 1935, for instance, there was a show of Flemish carpets, which were simply hung over Monet's canvases. The low regard in which his late work was held was also reflected in the contemporaneous art-historical literature. The critiques were suffused by an interpretational conflict between supposed objective and subjective criteria in works of art. This conflict ultimately determined the entire evaluation of

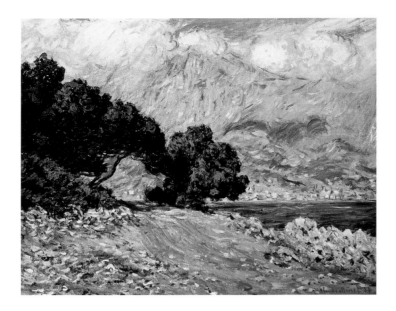

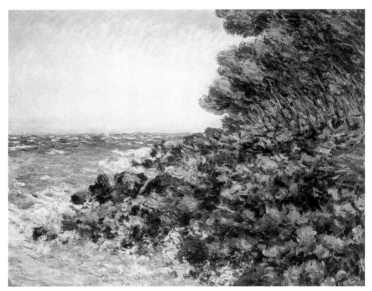

Impressionism[8] and, in a more subtle form, it has continued to influence interpretation to this day.

We can distinguish two basic approaches that mutually conditioned and occasionally overlapped each other. When Monet's style was viewed as the result of direct observation and precise recording of sense perceptions of nature, critics saw this empirical relationship to nature as either successfully established or faulty. In this interpretation, the aesthetic process, the brushwork, coloration and subject matter were viewed in analogy to scientific methods and set in direct relation to nature. The discrete brushstrokes and agitated, dissolved picture surface supposedly reflected visual experiences of the environment. More, Monet's painting was thought to represent scientific evidence of the physical data of nature.[9] In his late work with its increasing dissolution of form, on the other hand, this empirical reference seemed lacking, and so it was criticized as consisting of mere color sensations.[10] The late work ran counter to the idea of Impressionism as being an optically precise representation of nature.

This fundamental distinction between an important early Impressionist phase (from about 1870 to 1880) and a declining late phase remained in effect, with few exceptions, until the 1980s.[11] In this context, criticism focussed on the artist's supposedly anti-naturalistic, anti-positivistic attitude, perhaps historically determined by non-conformism and a rejection of faith in progress. This was first formulated in the 1880s and 1890s, the period of Monet's late work: "Aesthetics has turned full circle. The nature of the artist should no longer be that of a tool of reality, producing its likeness, but just the reverse—reality now once again became the material with which the artist proclaims his nature, in clear and effective symbols."[12]

In the course of this development, and against the backdrop of a revival of the decorative arts,[13] decorative values, formal means, and a subjective transformation of reality took on increasing significance. The goal was a new painting which required not only new techniques and definitions—including a liberation of painting from the frame—but new content as well. Art that was considered naturalistic and positivistic was rejected as constricting, since scientific methods supposedly led to an over-generalization of

Claude Monet, Menton vu du Cap Martin, 1884
View of Menton from Cape Martin
Oil on canvas, 68 × 84 cm.
Boston, Museum of Fine Arts

Claude Monet, Le Cap Martin, 1884
Cape Martin
Oil on canvas, 65 × 81 cm.
Tournai, Musée des Beaux-Arts

Claude Monet and Pierre Bonnard

Claude Monet, Xavier Roussel and Edouard
Vuillard, June 30, 1926

sense perceptions. Furthermore, in view of a reality that appeared ever more threatening, it seemed only logical to expand or overcome reality through imagination and vision.[14] In this sense, the Symbolists[15] and contemporaneous critics viewed the Monet of the period from about 1880 to the turn of the century as a pioneer in the liberation of the artist's personality.

Members of the Fauves and Nabis openly expressed their admiration of Monet. Indeed, the contrast-rich, luminous colors of many of the Bordighera and Vétheuil canvases (ill. p. 20 top) anticipate the Fauves, bring to mind Henri Matisse,[16] André Derain[17] and Maurice de Vlaminck.[18] Lovis Corinth, Max Liebermann, Max Slevogt, Augusto Giacometti and others also appreciated Monet, though they tended to concentrate on the earlier Impressionist phase.

This immediate influence ended with Pierre Bonnard, a great admirer of Monet who continued to develop his methods and wrote, shortly before his death in 1947, that he, Bonnard, was the last Impressionist. Bonnard[19] had visited Monet in Giverny several times (ill. p. 20 bottom),[20] and knew his exhibitions, which since 1890 had been prime events for everyone interested in painting. The Nabis Edouard Vuillard and Xavier Roussel also visited Giverny as admirers (on June 30, 1926; ill. left). Monet, familiar with the latest developments in painting, knew and appreciated their works,[21] whereas he rejected Cubism as being quite incomprehensible.[22]

In Monet's late work, the point of departure is no longer the motif or nature alone, but essentially the sensations felt by the artist in the face of the motif. This resulted in an increasing significance of color as an abstract quality, and an increasing autonomy of artistic means. From the 1920s to the present day, Monet's position has been basically understood as lying somewhere between naturalism and abstraction. This apparent contradiction made the late work seem paradoxical (in the negative sense), despite the fact that the very modernity of the paintings was revealed by the creative potentials for a new synthesis inherent in this paradox.

Monet's painting from the turn of the century to 1926 could no longer be related to any current avant-garde approach, and was rejected as being anachronistic salon art. In view of Cubist and non-objective painting, Monet's concern with subjective sensations, his recurrence to nature and his dispensing with solid pictorial structure were viewed as an irrelevant retreat into some private earthly paradise. Although the dissolution of static form in the late works found a positive echo among the Futurists, including Boccioni and Soffici, the Cubists largely rejected these works.[23] This judgement was reached especially by comparison to Paul Cézanne, to whose works the avant-gardes of the period oriented themselves and who was soon declared the Father of Modernism. Compared with Cézanne's, Monet's compositions appeared amorphous and unreflected. The Cubists, with their conceptual approach to subject matter and attempt to objectify the painting process, therefore declared Monet's work to represent a decorative use of painting in space (the Orangerie), and to lack composition and "wholeness."[24] Yet apart from these widespread criticisms, a few young avant-garde artists of the period did recognize the significance of the late works for modernism quite early on. Most of them, including Kandinsky and Malevich, were not French.

In 1896, Kandinsky saw a Monet *Haystack* that far transcended naturalism in terms of color, form and line.[25] For him, it marked the inception of autonomous painting, the

beginning of abstraction. Without knowing the painting's title, he was unable to recognize the subject: "I vaguely sensed that the object was missing from this picture. And I remarked with astonishment and confusion that the picture not only gripped me but engraved itself indelibly in my memory, and continually and quite unexpectedly hovered in front of my eyes, down to the finest detail."[26] Malevich was able to view, from 1904, Monet paintings in private collections in Moscow.[27] These inspired him to do two small Neo-Impressionist landscape studies, and in his writings he discussed them extensively, placing special emphasis on the autonomous painterly value of the *Cathedrals*.[28]

Although Monet's late, highly abstracted works could be seen as paralleling developments in abstract art from 1914 onwards, the following generation rejected him. In the 1930s and 1940s, apparently possessing no further significance for modernism, the late work fell into oblivion,[29] and any further involvement with it was generally based on the evaluative criteria outlined above. This was not markedly altered by individual publications in the 1920s that might have contributed to a re-evaluation.[30] In this regard, André Masson's 1952 article "Monet le fondateur"[31] represented a pioneering achievement in the evaluation of the late Monet. Masson was in fact the first artist in France to actively champion these works.

For Chagall, a corresponding involvement with Monet came in 1947. "Monet interested me," he wrote. "I discovered him after the war on the liner that brought me back from America. There, on the ocean, I returned to the question, Where do the sources of color lie? And I said, Monet. Today, Monet is the Michelangelo of our epoch for me …"[32] (ill. above).

Chagall by the waterlily pond in Giverny, July 3, 1963

Camille Bryen, Patron-Monet, 1972
Oil on canvas, 195 × 114 cm. Paris, Centre Pompidou, Musée National d'Art Moderne

However, the truly far-reaching rediscovery of the late work, which made Monet a pioneer of modernism, took place after World War II, under the impression of emergent American gestural painting and in connection with a new antirationalism that now began to suffuse avant-garde art. A revived interest in Monet's late work was due largely to abstract painting in the 1950s, and that not only in America (ill. p. 23). In contrast to artists, the critics who now began to notice Monet[33] initially

Newspaper article: "Old Master's Modern Heirs," in: *Life,* December 2, 1957

described him as a naturalist,[34] a category that soon made the prevailing conception of Impressionism appear too restrictive. For many of the over 300 American artists who, encouraged by the triumphs of homegrown art, went on the pilgrimage to Paris in the 1950s and occasionally stayed,[35] the immediate experience of Monet became a catalyst. Ellsworth Kelly and Sam Francis were cases in point.[36] Most of these artists came on scholarships, and studied at the Académie des Beaux-Arts or the private academies Julian and de la Grande Chaumière. They included Kenneth Noland, Jules Olitski, George Sugarman and Richard Stankiewicz. After 1957, their numbers began to dwindle.

The Paris shows of these young Americans[37] contributed to a broader acceptance of their new, gestural abstraction: "The American revolution led to the downfall of everything that was directly or indirectly associated with geometric forms."[38] In this sense, the growing, mutual sensibility for a new type of painting took place almost simultaneously in Europe and the United States—and one of its premises was the newly revived Monet reception. Key figures in conveying the European painting tradition to America, apart from Hans Hofmann,[39] (ill. p. 211), were those European artists who had emigrated there before or during World War II.[40]

International recognition of Monet's late work was furthered by the first great exhibitions in the 1950s. The 1949 exhibition at Kunsthalle Basel paved the way.[41] This was the first comprehensive showing of the often misunderstood and harshly criticized late work, focusing largely on the *Waterlily* series. Since Monet's death in 1926, these

OLD MASTER'S MODERN HEIRS

The scorned work of Monet's later years inspires a present generation of painters

canvases had not left the Giverny studio, which, according to Ellsworth Kelly's recollections of his visit in 1952 (see p. 214), was in a desolate state. For countless other artists (such as Sam Francis, who had been in Paris since 1950),[42] it was the retrospectives of the *Waterlilies* held in 1956 and 1957 at Galerie Katja Granoff that inspired a visit to the Orangerie. Subsequently, in a reaction to geometric formalism,[43] proponents of L'Art Informel, Tachisme,[44] and Nuagisme[45] (see ill. p. 22 bottom) vied to claim the *Waterlilies* as their own. The Orangerie became a place of pilgrimage. Seen in this light, then, the rediscovery of Monet was materially facilitated by the emergence of new directions in painting.

The interest of American artists in Monet's late work might have been due in part to the mediation of André Masson, who was in the U. S. from 1941 to 1945.[46] "It cannot be excluded that the arrival of the Surrealists in America represented the stimulus," Masson recalled. "Influences often become effective in an indirect way. If, as people have often told and written me, I had a certain influence on the young American painting, then it is because, without being an Impressionist, I have employed color in a similar way to the Impressionists. [My] paintings … exude an enormous fascination with color, with the paint blotch, which cannot have escaped either Pollock or de Kooning … And the young American painters of the period … have understood that form no longer

has the same power as previously, and that in our period color is more suited to expressing our deep sensations."[47] Masson himself did not become involved with Monet until after his break with the Surrealists in 1931,[48] but he was instrumental in defining and propagating the modernity of the *Waterlilies* in the 1950s.[49] For Masson, Monet's spontaneous translation of perceptions and sensations represented a very personal brand of painting in which the brushstroke, the gesture, attained to unprecedented freedom. This aspect of Monet's work made him a major forerunner of L'Art Informel[50] and, in Masson's eyes, his late work marked the inception of gestural painting, indeed of modern painting per se. Although Masson viewed Monet's blurring of contours as a lack of drawing—which was to overstate the case—he still detected the presence of composition, since the light and color that articulated the paint masses and lent them coherence constituted a new type of composition. This was linked with a new understanding of the picture plane, in which the paint application no longer recurred to a tectonically articulated surface; a mathematically defined picture plane could no longer function as support for a potential color arrangement. Monet's paintings were certainly composed, but the basis of composition had

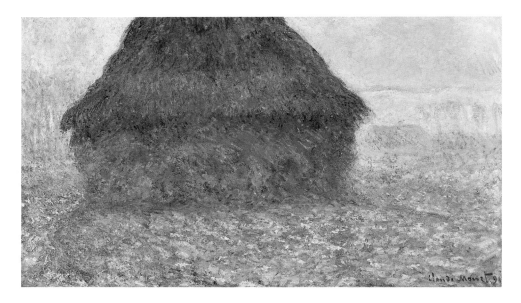

shifted away from linear structure and toward color accents, which became the fundamental centers of the compositional scaffolding. In addition, the free brushstrokes with their visible texture made the surface tangible as a vibrating and dynamic one. Masson recognized that Monet's search for a new, dynamic pictorial unity in which the brushstroke was materially involved was one aspect that determined the modernity of the late paintings.

This new pictorial unity was that of light and color, which supplanted "the destruction of form out of sheer negation."[51] Monet no longer focussed on isolated objects or things, but on their relationship illuminated by light. In other words, his point of departure was no longer an imitation of nature but a perception of color arrangements in nature. Instead of depicting what distinguished one object from another, he depicted what they shared, and painted things as being made visible, indeed generated by light. The dissolution of form that determined the later works implied a merger of elements that had its roots in the idea of one fundamental unity.

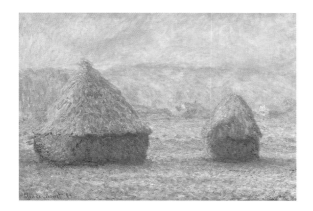

"Whereas you search philosophically for the world in itself ...," Monet told Clemenceau,[52] "my efforts are directed purely and simply at a maximum of appearance, closely linked with unknown realities. When you find yourself on the level of corresponding appearances, you cannot be far from reality, or at least from what we are capable of perceiving. I have done nothing but observe what the universe showed me, in order to bear witness to it with my brush ... Your error consists in wishing to reduce reality to your own measure (to known realities), while with a growing knowledge about things, your self-recognition should actually have increased."

Masson saw an essentially altered view of nature and reality in Monet's work, since its increased emphasis on color already ran counter to the derivation of imagery from mimesis. Monet's attempt to achieve a luminous unity reflected a change in attitude towards nature. Nature, eluding any purely rational attempt at fixation, was viewed as mutable, continually changing through time. Monet's contribution to modernism lay in dissolving solidly constructed, static form and replacing it by a different art form, legitimate in its own right. The traditional distinction between the finished and unfinished work lost its validity, and this contributed materially to the appearance of incompleteness, openness, and the lack of fixed spatial limits in these paintings. The new, painterly understanding of space manifested in Monet's late work was based on a rejection of illusionistic space as defined by the laws of perspective, and on a turn to large formats in the *Waterlily* series—in other words, on a liberation of the traditional easel painting from its spatial constrictions. A direct link can be detected here with the painting of Jackson Pollock (ill. pp. 123, 265), Barnett Newman (ill. pp. 110, 253) and Mark Rothko (ill. pp. 125, 287). Due to their openness, Monet's late paintings defined a new relationship between viewer and work. In this relationship, which was to play a crucial role in modernism, the viewer relinquished his distance from the picture to virtually enter its "movements," and actively contributed to recreating, completing the image. A related pictorial form was the serial imagery Monet pursued from the 1890s onwards, making him a pioneer in what was to become a significant aspect of twentieth-century art.

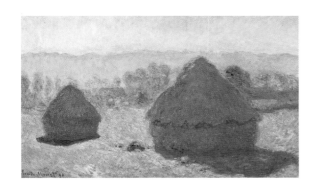

Beginning with the *Meules (Haystacks),* 1890–91 (ill. pp. 24/25, 154), several significant series emerged: the *Peupliers (Poplars),* 1891 (ill. pp. 27, 117), the *Cathédrale de Rouen (Rouen Cathedral),* 1892–93 (ill. pp. 36–39), *Les Débâcles (Ice Floes),* 1893 (ill. pp. 41–45), *Les Falaises (Coastal Paintings),* 1896/97 (ill. pp. 46/47, 49–51), the London series, 1899–1904 (ill. pp. 60–63), the Venice series, 1908–12 and, ranging from 1897 to 1926, the series of *Nymphéas (Waterlilies)* (ill. pp. 66, 72–103). Monet described the point of departure of his series as follows: "It was ... about this time when, in order to expand my field of vision, I [undertook] excursions of several weeks to Normandy, Brittany and elsewhere. One day, when I happened to be in Vernon, I found the silhouette of the church so remarkable that I absolutely had to paint it. It was the beginning of summer, still somewhat raw. After cool morning mists the sun suddenly broke through, whose rays, warm as they were, were only gradually able to disperse the veils of fog that hung over all the projections of the building and in the course of time completely concealed the golden shimmering stone in mist. This observation was the point of departure for my series of cathedrals. I told myself that it would not be uninteresting to study one and the same motif at different times of day, and capture the light effects

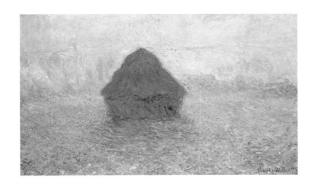

that so subtly altered the appearance and coloration of the building hour by hour. For the moment I did not succumb to this idea, but it continued to germinate in my mind. It was not until much later, ten or twelve years after I had landed in Giverny after a stay of about ten years in Vétheuil, and saw the iridescent autumn colors over which still lay morning fog penetrated by the first sunrays, that I began my series of haystacks, in the spirit of the same observations. After that, at an interval of five or six years, followed the cathedrals. In this way one discovers new things without intending to, and that is much more valuable. Prefabricated systems are the vice of painting and painters. Nature, if you subordinate yourself entirely to her, is the most sagacious guide."[53]

Working in series was predicated on a conscious decision to represent only a single motif or closely related motifs, and to employ a limited number of vantage points and formats. Even in the minimally varied composition types, the individual pictures in the series are interlinked by specific color relationships. Each work shares colors and effects, and thus a certain tonality, with the rest.[54] The holistic conception of the series always took first priority for Monet, who set the pictures next to each other in his studio in order to perfect the interaction among them.

In a subtle way, even reflections on water represented a repetition of the same motif in form and color. Monet turned to this theme very early on.[55] In the context of empirical observation of nature, logical, serial work offered the opportunity to represent characteristic, sequential temporality, and at the same time was bound up with a stronger focus on the painterly means involved. Interestingly, Monet's serial language was closely allied to the concurrent search in other arts, poetry[56] and music,[57] for a new language in which space and time became crucial factors. The serial principle was predicated on an altered perception of time, because when viewing a series, one has the sense that different moments in time (morning, noon, evening, etc.) merge into a simultaneous continuum, which—thanks to a negation of linear consecutiveness and a space-related presentation—makes time graspable in terms of space. This simultaneous condensation can be experienced only through the act of perception, a creative reliving of moments in time recorded in our own memory. Thus the series, as an aesthetic form, reveals more about the nature of perception than about the things perceived.

Capable of continuation at any point, and thus open-ended, the series conveys the appearance of a perpetual now (momentaneousness), and nevertheless manages to capture perpetuity in change. In this sense, the series evokes the endlessness of a pictorial substance, and by dint of its open structure, represents a fundamental innovation as regards a new painterly conception of space, a space that is open and no longer spatially or temporally limited. When viewing these serial works of art, we automatically sense the presence of multiple layers of meaning. Each individual painting in the series possesses equal intrinsic value and yet is part of a greater whole, the series. This immediately diminishes the meaning of the traditional idea of the individual masterpiece, and introduces a radically new aesthetic conception relevant to modernism: an emphasis on pictorial process, sequentiality and progression, continuity and creative production, challenging the viewer to virtually complete the open structural design presented to his eye.

Key aspects of the serial imagery introduced by Monet and central to modernism found a wide echo in twentieth-century art.[58] Still, Monet's modernity does not rest solely on the pioneering achievement of his logical, serial development of a motif. It is based,

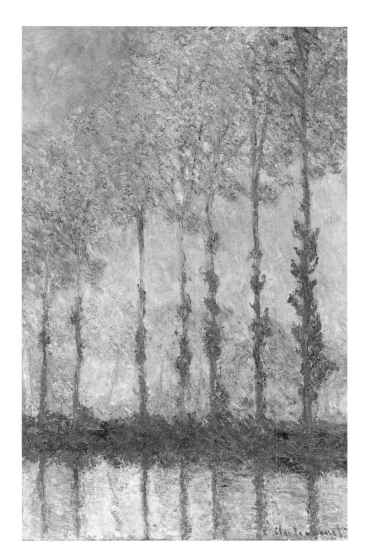

**Claude Monet, Les Peupliers, effet blanc
et jaune**, 1891 Poplars, White and Yellow
Effect. Oil on canvas, 100 × 65 cm.
Philadelphia, Philadelphia Museum of Art,
Bequest of Anne Thomson in memory of
her father, Frank Thomson, and her mother,
Mary Elizabeth Clarke Thomson

in a more complex way, on the radically altered perception and trans-
lation of nature that was announced in the series from 1890 onwards,
but that culminated in the series of paintings of his garden at Giverny. In
this series, which was conceived as a permanently installed architectural
decoration,[59] aspects of the interior decorations so popular around the
turn of the century were linked with vegetative symbolism, in which
the external world was projected into an interior space and functioned
as a symbol of nature as opposed to a technological environment. The
decorative wall painting or mural was conceived as liberating the con-
ventional easel painting from its frame,[60] and opening new dimensions
for painting, both literally and figuratively. Crucial to this attempt,
apart from a rejection of naturalism, were the aesthetic qualities of
form and color, which, in correspondence to nature, were intended to
trigger subjective sensations in the viewer's mind.

Interestingly, Monet's original plan for the installation of his
Waterlily decoration was closely linked with the idea of the panorama,
which enjoyed great popularity in the nineteenth century.[61] In an artful
way, Monet's decoration, originally planned for a rotunda, was similarly
meant to convey the illusion of actually being out of doors, in a real
garden with waterlily ponds (cf. the arrangement of paintings in his
studio, pp. 64/65). This illusion of a continuous, open space in
which the garden space both figuratively and literally became an in-
terior space, could be created only by exploding the conventional
picture format, or in other words, by completely dispensing with rigid,
one-point perspective. Thanks to this lack of perspective as a space-
defining device, the viewer no longer has any precisely defined vantage
point. The space expands in his mind, things apparently near grow
distant, and the traditional viewer-to-picture distance is undermined.[62]
The concomitant ambivalence, multivalent meaning and opening of space were already
key aspects of the serial method, and yet these can also be immediately seen in the
artist's pictoral translation of landscape space, pointing to Monet's radically altered
perception of nature.[63]

For the Orangerie installation, Monet had to abandon his original idea of creating
a panorama of the waterlily garden, and instead attempted a combination or synthesis of
various views. The resulting landscape room, freed of all topographical precision, could be
much more strongly experienced as an interior space in which subject and object, viewer
and nature, merged. In this sense, the fundamental motif of the Grande Décoration, the
garden and ponds at Giverny, went through a conceptual replanning from the very start.
For instance, Monet had one of his six gardeners arrange individual Waterlily blossoms
and leaves into a predetermined composition. The artificial garden became a palette for
Monet, a means of aesthetically appropriating nature.

Monet repeatedly spoke of his effort to merge with nature, and, in a unity of
sensation and memory, to achieve a holistic conception and translation of reality into
art.[64] His effort, he said, was to represent the various phenemona of reality in their
close interweave with unknown realities. Monet understood reality as being caught up

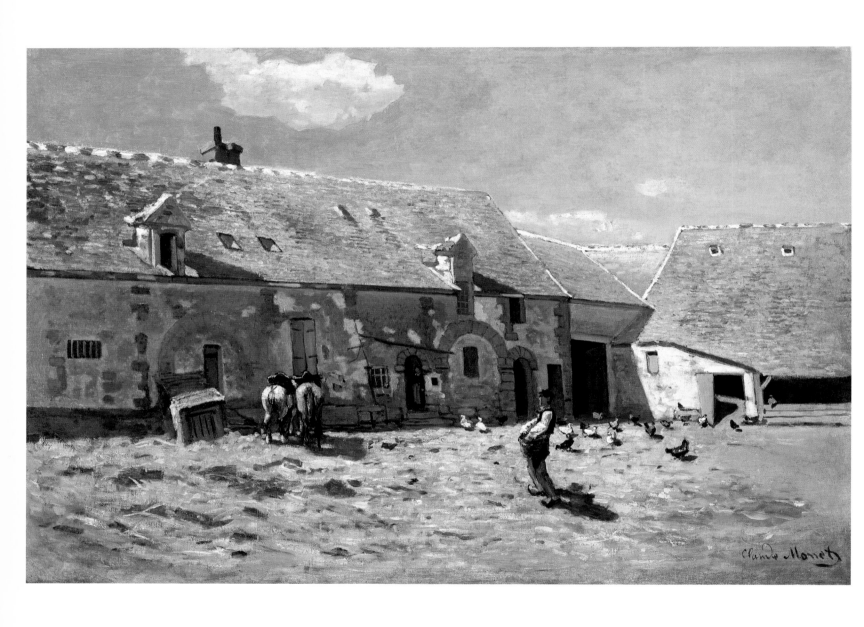

Claude Monet, Cour de ferme à Chailly, 1856 Farmyard in Chailly

Oil on canvas, 54 × 80 cm. Private collection

in continuous change, and saw the artist's task as visualizing and pictorially translating this dynamic, pantheistic unity of all things. This philosophy intrinsically implied a rejection of any static, rationally explicable world view, and hence of mimetic representation. Accordingly, the artist could dispense with the laws of perspective, because they fixed and constricted his viewpoint. What was needed was a new kind of seeing, a dynamic vision and perception that included doubt as to whether reality was ultimately knowable at all. The artist, said, Monet, must liberate himself of all preconceived knowledge:

"The truth is simpler; my only virtue consists in subordination to instinct: because I rediscovered the hidden powers of intuition and gave them priority, I was able to identify with Creation and merge with it.... The interpreters of my painting think that, in connection with reality, I have achieved the highest degree of abstraction and imagination. I would prefer it if they recognized in this the abandonment of my self."[65]

A subjective experience of landscape opens the artist's mind for an experience of the universe. The artist is not only an interpreter of natural appearances, but recognizes their truth. In order to truly see nature anew and not merely register it, habitual perception must be made more difficult, by means, say, of creating analogies to visible phenenoma, merely suggesting rather than sharply delineating objects, emphasizing ambiguity and openness, employing serial methods, and including the viewer in art. By formulating a new beginning in painting, art will be liberated from conventions and strict rules to become an incarnation of the creative process, a process in which the paint material itself takes on a catalyzing function. This insight, and the concomitant awareness of a crisis in artistic forms of expression, is one of the central aspects of modern art. It resulted in a conceptual and formal revolution, at the onset of which stood Monet's late work.

The impact of this work on twentieth-century art was manifold, and affected some artists directly, others indirectly. The present exhibition purposely concentrates on artists from the United States, France and Germany. With the inclusion of German representatives of L'Art Informel we enter untrod territory, since the history of the reception of Monet in Germany at that period has yet to be written. The establishment of links between the selected works and Monet, by means of a prospectus of current positions in the three countries, is intended to illustrate the modernity of Monet's late work, although it makes no claim to completeness.[66]

Just as Monet's late work was long neglected, lyrically abstract, non-geometric, gestural painting dropped from our field of vision without really having been accorded the place it justly earned. This may serve to illustrate the necessity of continually revising the history of art, and, for viewers of our exhibition, it might provide an opportunity for one or another "rediscovery."

... I experienced two events that left a mark on my entire life and at the time shook me to the core. They were the French exhibition in Moscow—primarily the *Haystack* by Claude Monet. At the first fleeting glance I saw a picture. That it was a haystack I learnt from the catalogue. I couldn't see it. I found this non-recognition embarrassing. I also found that the painter had no right to paint so unclearly. I sensed vaguely that the object was missing from this picture. And noticed with astonishment and confusion that the picture not only grabbed me but also impressed itself indelibly in my memory and quite unexpectedly remained clear in my mind's eye down to the last detail. That was unclear to me, and I was not able to draw any simple conclusion from this experience. But what was completely clear to me was the unsuspected power of the palette, hitherto hidden from me, that surpassed my wildest dreams.

Wassily Kandinsky, *Die gesammelten Schriften* (Collected Works), vol.1, ed. by Hans K. Roethel and Yelena Hahl-Koch, Bern, p. 32.

Wassily Kandinsky, Improvisation, 1910
Oil on cardboard, 56 x 71 cm. Private collection

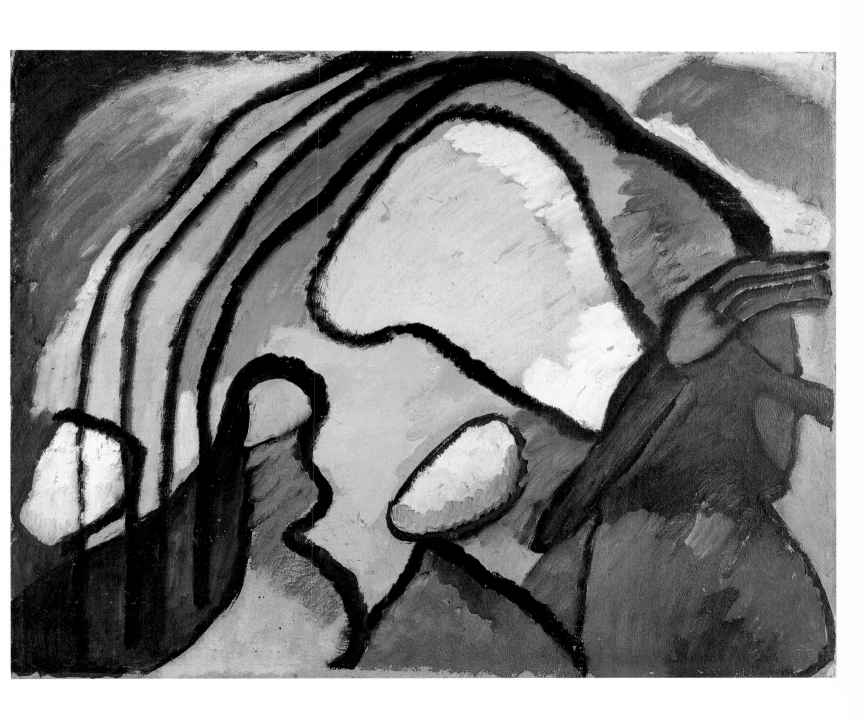

1 For a list of the most important Monet exhibitions since the mid–1980s, see the bibliography. ■ 2 The first fundamental discussion of the subject is found in the present author's *Claude Monet: Nymphéas. Eine Annäherung* (PhD diss., Munich, 1983), Hildesheim, 1985. ■ 3 Initial approaches were made, for instance, in the exhibition *Monet in the 20th Century*, Museum of Fine Arts, Boston, 1998, and Royal Academy of Arts, London, 1999. This was followed by the exhibition *Monets Vermächtnis. Serie—Ordnung und Obsession,* Kunsthalle, Hamburg, 2001. ■ In art criticism, the theme had been treated in America since the 1950s, especially by Clement Greenberg, William Rubin and Irving Sandler, and in France by Jean-Dominique Rey. See note 33 below. ■ 4 The donation had been planned since 1918. ■ 5 See Jean Martet, *Clemenceau peint par lui-même,* Paris, 1930, pp. 89–90; and Georges Clemenceau, *Claude Monet par Clemenceau,* Paris, 1965, pp. 133–34 ■ 6 See *Claude Monet, Exposition Rétrospective* (exh. cat.), Musée de l'Orangerie, Paris, 1931 (introduction by Paul Jamot). ■ 7 Monet attached various stipulations to his donation, including a provision that his design of the space was not to be altered. To letters of protest from Michel Monet and the journalist Thadée Natanson, the French ministry reacted by extending the exhibition. Due to lack of interest, moving the paintings to the Musée d'art moderne or the Ministry of Finance was even considered. See Jean Pierre Hoschedé, *Monet, Ce ma connu,* Geneva, 1960, pp. 19–20. ■ 8 See Richard Schiff, *Impressionist Criticism* (PhD diss.), Yale University, 1983; and Steven Z. Levine, *Monet and His Critics,* New York and London, 1976. ■ 9 In this regard, Monet was a positivistic painter in the strictest sense. Of the major contemporaneous critics, mention should be made of Gustave Geffroy (*Claude Monet, sa vie, son temps, son oeuvre,* Paris, 1922, 1980, pp. 125, 418) and Georges Clemenceau. See Jean Martet, *Georges Clemenceau,* Paris, 1931, p. 136; and Clemenceau, *Claude Monet, Cinquante ans d'amitié,* Paris, 1926 (1965). ■ 10 Monet's late work was interpreted as the result of an unreflected sensualism and, divorced entirely from the historical context, was declared to be Monet's greatest artistic error by authors such as Lionello Venturi (*Impressionists and Symbolists,* New York, 1950, 1973, p. 62 ff.). ■ 11 See Denis Rouart and Jean-Dominique Rey, *Monet, Nymphéas ou les miroirs du temps,* Paris, 1972. ■ 12 See Hermann Bahr, "Zur Überwindung des Naturalismus" (1891), in: *Theoretische Schriften 1887–1904,* Stuttgart, 1986, p. 86. ■ 13 On this topic, see Karin Sagner-Düchting, *Claude Monet: Nymphéas. Eine Annäherung,* Hildesheim, 1983, p. 10. ■ 14 See Charles Baudelaire, *Curiosités esthétiques,* Paris, 1962, p. 321. Written from 1845 as reviews of the Salon exhibitions and first collected in Baudelaire, *Oeuvres complètes,* vol. 2, Paris, 1868. ■ 15 Compare esp. Gustave Moreau. ■ 16 Matisse's admiration for Monet is recorded, among other places, in a letter written by his fellow-student Henri Evenepoel to their teacher Gustave Moreau on February 2, 1897. See Francis E. Hyslop, *Henri Evenepoel à Paris, Lettres choisies, 1892–1899,* Brussels, 1971, p. 135. See also London series (note 11), p. 58/59. ■ 17 See London series (note 13), p. 59. ■ 18 Vlaminck admired and loved Monet. See Maurice Vlaminck, *Portraits avant décès,* Paris, undated (1943), p. 66. ■ 19 Bonnard illustrated an edition of a book by Octave Mirbeau, *La 628-E8,* which was much admired by Monet. ■ 20 Monet in Giverny had become a legend, and he complained about the invasion of countless painters, including Americans, that set in about 1890. See the detailed discussion in William H. Gerdts, *Monet's Giverny, An Impressionist Colony,* New York, London and Paris, 1993. ■ 21 Louis Vauxcelles, "Chez les peintres, Un après-midi chez Claude Monet," *L'art et les artistes,* December 1905, p. 88. ■ 22 See Jacques Salomon, "Chez Monet avec Vuillard et Roussel," *L'Oeil,* May 1971, p. 24. ■ 23 Although, according to Masson, this did not hold for the brushwork: "Later the Cubists attempted to reestablish the terrorism of form, whereby they simultaneously retained the Impressionist brushstroke in their analytic pictures of 1911–1913. This has yet to be sufficiently appreciated. Picasso once told Kahnweiler that Braque and he had been fascinated by the vibrations of the brush in Monet. They admired him not only for his color but for the freedom of his brushstroke." Interview with André Masson, 1975 (recorded by Alice Rewald), in: André Masson, *Gesammelte Schriften,* vol. 1, Munich, 1990, p. 277. ■ 24 See Albert Gleizes and Jean Metzinger, *Du cubisme,* Paris, 1912, pp. 8, 17–18. ■ 25 The work in question was *Meule au soleil,* 1891 (Catalogue raisonné no. 1288; now Kunsthaus Zurich), which was included in the 1896–97 exhibition of French art in Moscow and St. Petersburg. ■ 26 See Wassily Kandinsky, "Rückblicke" (1913), in: *Die Gesammelten Schriften,* vol. I, *Autobiographische Schriften* (ed. by Hans K. Roethel and Jelena Hahl-Koch), Bern, 1980, p. 32. ■ 27 Including works from the collections of Sergei Shtshukin (*Vétheuil,* 1901; *Le Parlement, Les Mouettes,* 1900–01; *Le Bassin aux Nymphéas,* 1899; *La Cathédrale de Rouen,* 1892; *Le Portail,* 1893 (Catalogue raisonné nos. 1635, 1613, 1513, 1326, 1350; now Pushkin Museum, Moscow) and Ivan Morosov (*Waterloo Bridge, Effet de Brouillard,* 1899–1901; Catalogue raisonné no. 1580). See Otto Grautoff, "Die Sammlung Schtschukin in Moskau," *Kunst und Künstler,* December 1918; I. Tougenhold, "Oeuvres françaises de la collection Stoukine," *Apollo,* 1914, p. 43. ■ 28 See Victor Fedjuschin (ed.), *Kasimir Malewitsch, Die neuen Systeme in der Kunst, Statik und Bewegung,* 1919, Zurich,

1988. ■ 29 The publications of these years were limited to documentary writings based on established evaluative criteria. ■ 30 Gustave Geffroy, *Claude Monet, sa vie, son temps, son oeuvre,* Paris, 1922 (1924); Georges Clemenceau, *Cinquante ans d'amitié,* Paris, 1926 (1965). ■ 31 André Masson, "Monet le fondateur," *Verve,* vol. 7, no. 27–28, 1952. Repr. in Masson, *Gesammelte Schriften,* vol. 2 (ed. by Barbara Seitz, transl. from French by Reinhard Tiffert), Munich, 2002. ■ 32 See "Marc Chagall im Gespräch mit Pierre Schneider," in: Pierre Schneider, *Les dialogues du Louvre,* Paris (1967), 1972, p. 42. ■ 33 Of the extensive American literature devoted to the subject in the 1950s to 1970s, special mention should be made of Clement Greenberg's "The Late Monet" (1957), *Art and Culture,* Boston, 1961 (1965). See also the same author's "American Type Painting," *Partisan Review,* no. 22, 1955, p. 190; Louis Finkelstein, "New Look: Abstract Impressionism," *Art News,* October 1956, pp. 42, 53; William Rubin, "Jackson Pollock and the Modern Tradition, I-III," *Artforum,* 1967; William Seitz, "The Relevance of Impressionism," *Art News,* no. 67, January 1969, pp. 28–34, 56–59. ■ 34 See Seitz, ibid., p. 34, and Greenberg, "Art in Culture," op. cit., p. 42. ■ 35 See Michel Seuphor, "Paris," *Art Digest,* March 1, 1958, p. 9. Also, *Américains à Paris: The 50s* (exh. cat.), Fine Arts Gallery, California State University, Northridge, 1979. ■ 36 Francis, with Norman Bluhm, Shirley Jaffe, Jean Paul Riopelle, and from 1956, Joan Mitchell, was a member of a group that met in an obscure *café-tabac* on Rue du Dragon. In addition to poetry, their discussions often revolved around the painting of Matisse and Monet. In cafés like La Coupole and La Flore, American artists and writers, and European artists such as Nicolas de Stael and Georges Mathieu, gathered around Georges Duthuit. Duthuit became an advocate of lyrical, gestural tendencies, which, to set them off from the prevailing cool geometrical abstraction, he dubbed *"abstrait chaud,"* or hot abstraction. See Duthuit, "L'image en souffrance," *Mercure de France,* 1961. ■ 37 Including the group exhibition "Regards sur la peinture Américaine," Galerie de France, Paris, 1952. ■ 38 See Jean Alvard, "The American Potentiality," *Cimaise,* November–December 1956, p. 44. ■ 39 Hans Hofmann was in New York from 1932, and in 1933 opened the Hofmann School of Fine Arts there. His students included Jackson Pollock, Lee Krasner, Mark Rothko, Robert Motherwell and Milton Resnick. ■ 40 Including Marcel Duchamp, Fernand Léger, Piet Mondrian, Max Ernst, Max Beckmann, André Breton and André Masson. ■ 41 On this topic, see Christian Geelhaar, "Claude Monet in Basel: 1949 und 1986," *Nymphéas, Impression-Vision* (exh. cat.), Kunstmuseum Basel, 1986, pp. 9–13; and Oliver Wick, *Nichts und doch etwas, Monet und Rothko, Farbe und Raum,* (diss.), Basel, 1988, p. 8 ff. ■ 42 In the course of this reception, the *Waterlilies* in the Orangerie were cleaned. Many museums, including the Museum of Modern Art, New York, acquired these and other late works by Monet. For a detailed discussion, see Michael Leja, "The Rediscovery of Monet and the Abstract Painting of the New York School," *Monet in the 20th Century* (exh. cat.), Museum of Fine Arts, Boston, and Royal Academy of Arts, London, pp. 98–108. ■ 43 Emphasis on the subjective painterly gesture, autonomous coloration, "open" form, spontaneous surface treatment (e.g., grattage, scratching or incising the surface with sharp tools), and an interest in the subconscious mind inspired by Surrealist *écriture automatique,* were among the pictorial means of L'Art Informel. ■ 44 In this context mention should be made of Camille Bryen, one of the founders of Tachisme. Bryen was lastingly influenced by Monet's *Waterlilies,* which he saw as early as 1946 at an exhibition of the group Témoinage in Paris. See Bryen's *Hommages à Monet* (e.g., *Patron Monet,* 1972, Centre Georges Pompidou, Paris). Revealing material is provided by the film "Les impressionistes, Claude Monet le miroir de la transparence," Antenne 2, 1974–75; and the articles by René Barotte, "Monet est-il le père de la jeune peinture abstraite," *Paris-Presse,* June 30, 1959; Denys Chevalier, "Hommages à Monet," *Aujourd'hui,* no. 23, September 1959, p. 35; and Guy Weelen, "Monet aujourd'hui," *La quinzaine littéraire,* March 16, 1973. ■ 45 A group of French painters who showed together from 1953 to 1966. Their style was neither geometric nor gestural, and expanded L'Art Informel by means of transparency and spatial depth, as well as by opening the closed surface of the painting to evoke the atmosphere of the four elements and the rhythms of the cosmos. All of its representatives, including Frédéric Benrath, recurred to Monet's *Waterlilies.* See *Le Nuagisme* (exh. cat.), Musée des Beaux-Arts, Lyon, 1973; Jean-Jacques Leveque, "L'héritage de Monet," *Revue Galerie des Arts,* 1962; Jean Grenier, "Le Nuagisme," *Revue Chefs-d'oeuvre de l'Art,* 1965; Gérald Gassiot-Talabot, "Les Nuagistes," *Opus International,* no. 28, November 1971. ■ 46 The much-needed investigation on this topic has yet to be undertaken. ■ 47 André Masson on Claude Monet, "Interview with André Masson," 1975 (recorded by Alice Rewald), in: Masson, *Gesammelte Schriften I,* Munich, 1990, p. 284. A scholarly study of this history of effects remains to be done. ■ 48 In 1942 Masson emphasized a view from the series *Falaises à Pourville* in a Baltimore collection and works in the Metropolitan Museum, New York. In 1950 he singled out the *Waterlilies* in the Teriade Collection, Paris. ■ 49 Jean-Dominique Rey dedicated his book *Monet, Nymphéas ou les miroirs du temps* (Paris, 1972) to Masson as being the rediscoverer of the *Waterlilies.* Despite all due reservations,

the book remains crucial for the history of the reception of the late Monet. See also Dieter Rahn, *André Masson, Raumdarstellung und Zeitbezug in der Malerei* (PhD diss., 1978), Munich, 1982. ■ 50 L'Art Informel strived for complete independence from the object (subject-matter) and a dissolution of defined form, whereby form became equivalent to movement or action. As in Surrealism, psychic automatism and spontaneous creative expression held first priority. For many German representatives of L'Art Informel, such as Karl Otto Götz, Gerhard Hoehme, Bernhard Schultze, Winfred Gaul, Sonderborg, Otto Greis and Heinz Kreutz, the great source of inspiration was Paris, where they lived for considerable periods. Their contacts with France remained close, as in the case of Frédéric Benrath. ■ 51 See André Masson, *Vagabond du surréalisme,* tape transcripts (ed. by Gilbert Brownstone), Paris, 1975, p. 131. ■ 52 See Claude Monet, in: Georges Clemenceau, *Les Nymphéas,* Paris, 1926, pp. 145–46. ■ 53 See François Thiébault, "Autour de Claude Monet, anecdotes et souvenirs," *Le Temps,* January 8, 1927. ■ 54 In which it differs considerably from the traditional emblematic, symbolic and naturalistic depictions of the times of day, months and seasons. ■ 55 The paintings of *Gare Saint Lazare* (Saint Lazare Station), 1876–77, might be considered further precursors of Monet's series, although unlike these, they were not reworked in the studio to bring their color schemes in line with an overall conception. ■ 56 In their rhythmical enumeration and the motif of repetition in symbolistic literature, they are comparable to the visual series as a sequence of several related images. Proust accordingly described this potential literary method in analogy to Monet in 1908–10. See Proust, *Contre Sainte-Beuve,* Paris, pp. 262–63. ■ 57 See Rudolf Frisius, "Serielle Musik," in: Ludwig Finscher (ed.), *Die Musik in Geschichte und Gegenwart,* vol. 8, Kassel et al., 1998, pp. 1328–54; Paul Griffiths, "Serialism," in: Stanley Sadie and John Tyrrell (eds.), *The New Grove Dictionary of Music and Musicians,* vol. 23, London, 2001, pp. 116–23. In the 1950s and '60s, Monet's *Waterlilies* inspired innovative compositions, such as Marcel Dupré's "Les Nymphéas for Organ," op. 54 (1959), and Peter Pindar Stearns' "Six Paintings of Monet for Orchestra" (1963). Dupré's eight impressions exhibit a remarkable affinity to the Orangerie *Waterlilies,* and will be performed during the present exhibition.
■ 58 Further reading on the subject: Martin Krahe, *Serie und System* (PhD diss.), Essen, 1999; Ines Lindner (ed.), *Sehbewegungen. Über die Folgen der Entprivilegierung des Einzelbildes in der zeitgenössischen Kunst,* Berlin, 1993; Gilles Deleuze, *Differenz und Wiederholung,* Munich, 1992; *Monet in the '90s, The Series Paintings* (exh. cat.), Museum of Fine Arts, Boston, 1990; Katharina Sykora, *Das Phänomen des Seriellen in der Kunst, Aspekte einer künstlerischen Methode von Monet bis zur amerikanischen Pop Art,* Würzburg, 1983; Grace Seiberling, *Monet's Series* (diss.), Yale University, 1976; John Coplans, *Serial Imagery,* Los Angeles, 1968. Each of these publications contains an extensive bibliography. ■ 59 The decoration of an interior with large-format paintings, usually with floral motifs, was a familiar task for Monet from 1876. He received several commissions of the type, e.g. from Pierre Hoschedé in 1876, and from Durand-Ruel in 1882–85. ■ 60 See Maurice Denis, *Du symbolisme au classicisme, Théories (1890–1910),* Paris, 1964, p. 33. ■ 61 See Stephan Oettermann, *Das Panorama, Die Geschichte eines Massenmedium,* Frankfurt am Main, 1980. The panorama, usually devoted to an historical or landscape theme and located in a special rotunda as a continuous 360-degree representation, lost its meaning as an illusionistic image around 1900 with the rise of photography and film. ■ 62 Multiple perspectives or decentralization of the image were also fundamental means of the Support-Surface group, whose representative Louis Cane paid homage to Monet's *Waterlilies* in his polyptych *Nymphéas,* 1993, Oil on stretchers, 260 × 2220 cm. ■ 63 On this topic, see Stephen Z. Levine, "Monet, Lumière and Cinematic Time," *The Journal of Aesthetics and Art Criticism,* summer 1978, vol. 36/4, pp. 441–47. Levine relates Monet's radically altered perception to the space-time conception of film, which concurrently developed from the diorama (a three-dimensional variant of the panorama). ■ 64 See note 50 above. ■ 65 Claude Monet in conversation with Roger Marx, in Marx, "Les Nymphéas de M. Claude Monet," *Gazette des Beaux-Arts,* June 1909. In this regard, Monet's Orangerie intrigued numerous writers, especially in Surrealist circles. André Breton and Tristan Tzara were frequent guests of a nephew of Monet's. ■ 66 We decided not to stage direct confrontations with serial imagery, as this is the theme of the nearly concurrent exhibition at the Hamburger Kunsthalle: *Monets Vermächtnis. Serie—Ordnung und Obsession,* September 28, 2001 to January 6, 2002.

La Cathédrale de Rouen—Rouen Cathedral

The paintings in this series, which represent one of the peaks of Monet's production, were painted in 1892 and 1893, though several works show the later date of 1894. The catalogue of his complete works lists a total of thirty partial views of the cathedral.[1] Two depict part of the Alban tower (*Tour d'Albane*) and the old houses, now destroyed, adjacent to the church. In the other twenty-eight, Monet concentrates on the facade of the cathedral as seen from different vantage-points, with the format varying correspondingly in height and width.

From February to April 1892 Monet stayed in Rouen to make the first preliminary studies.[2] At first he rented a room in an empty flat at Place de la Cathédrale 31, opposite the cathedral. Works such as *Le portail vu de face, harmonie brune* document his almost frontal view of the facade as provided by the window of this room (ill. p. 39 left).

The pictures of the next period, up to the end of April 1892,[3] were made in a room on the first floor of a fashion designer's boutique at Place de la Cathédrale 23. They can be identified by the bit of sky that shows on the left between a small tower and the central part of the facade.

In mid-February of the following year Monet returned to Rouen. He intended to complete works begun the previous year and start on new motifs. His points of departure were not only the familiar view from Place de la Cathédrale 31 but also a newly chosen vantage-point farther right of the main portal in Rue Grand Point 81, which included more of the portal and the Alban tower.

The changing weather conditions and times of day referred to in the titles suggest that this series was conceived as a cycle. Monet, however, was not in the least concerned with scientific exactitude in depicting a recognizable sequence of times of the day. Rather, what mattered was "to represent what I feel,"[4] which was the sensation he had facing the motif and its interpretation in color. Hence the final subtle harmonization of the colors with each other of the individual works was not completed on site but proceeded up to 1895 in the studio. Thus the paintings of the cathedral are both studies from the model and studio works. A preliminary study of the cathedral now in the Musée Marmottan in Paris documents the unfinished state of these pictures when they arrived at the studio in Giverny. It shows that the impasto and the grainy vibrating layer of paint of the completed works were the result of later reworking in the studio. On the basis of an individualized harmonious palette for each painting, Monet used few hues, a maximum of five, and toned down strong complementary color contrasts, such as yellow and bluish violet, with a unifying white. The loose structure of color interwoven like a net emphasizes the 'vibration' of the paint surface.

Serial unity and harmonious color characterize the twenty paintings that were first shown to the public in 1895 at the Durand-Ruel Gallery. The exhibition was an overwhelming success. The paintings had high prices of up to 15,000 francs, yet were quickly sold nonetheless and, as Monet actually regretted, "dispersed in all directions." The press called the exhibition a cultural event of the first order; among fellow artists it was the subject of both debate and high praise.[5] Interpreting the Gothic facade in a partial and extremely close-up view and dispensing with distance to define the space between the painter and the subject were seen as both strange and revolutionary. As Camille Pisarro wrote on 26 March 1895 to his son Lucien: "I would be sorry if you did not come here before the closing of the Monet exhibition. His *Cathédrales* will soon be scattered in all directions, though they should just be seen as a whole ... I am completely overwhelmed by this extraordinary mastery. Cézanne, whom I met at Durand's yesterday, fully agrees with me that this is the work of an original, very self-confident artist, who studies the elusive nuances of nature in a way I have never seen realized by any other artist."[6]

The Gothic cathedral was regarded by many of Monet's contemporaries as popular architecture and the symbol of liberty. Monet was republican and anticlerical; a religious approach to the subject was far from his intention in the cathedral series. How unusual and independent Monet's interpretation of this motif is can be seen by comparisons with works by contemporaries and Romantic painters. Monet's work lacks any kind of narrative element, pleasing composition and allegorical transformation whatsoever. He shows a detail of the facade, not an ideal view, constantly wresting new pictorial effects from the model through minimal variations in vantage-point. "The twenty lighting conditions are cleverly chosen; twenty paintings have an order and a sequence, completing each other in a consummate development ... Ordered according to their functional content, they would reveal the complete equality of art and phenomena ... At a single look around we would then be

Facade of Rouen Cathedral, photo ca. 1900

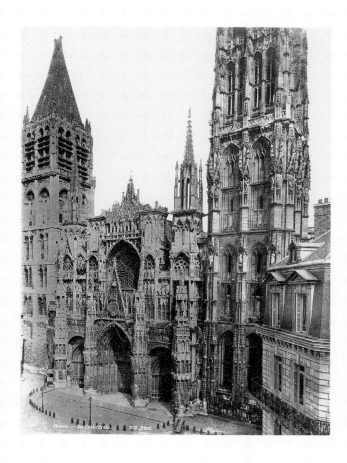

"No one had ever seen actual painting, the movement and the infinite growth of colored spots, and Monet, when he painted the cathedral, had the depiction of light and shadow on the walls of the cathedral in mind. But that is not true, in fact Monet concentrated entirely on developing a kind of painting the way it spreads on the walls of a cathedral. His main objective was not light and shadow but painting in light and shadow ... It was not about the cathedral but about painting ... And hence we must look at its painterly aspect and not ... at the cathedral ..."[8]

astonished to perceive something tremendous... they would make a sudden, indelible impression, not of 20, but of 100, of 1000, of billions of states of the cathedral in the eternal circling of the sun."[7]

Thus, instead of a detailed, architecturally precise depiction, colored light predominates as the formative element. It seems to transform the stone of the cathedral into 'animated matter.' The light makes the forms recede or advance or blend into each other. The subject of the picture is described in the process of metamorphosis. Monet deliberately chose the pale light heralding spring. He valued the subtle, refracted, veiling light of the early morning hours and the winter. It stimulates the imagination, lends the motif a mysterious charm and makes the colors glimmer delicately. Unlike the light at high noon, the soft evening and morning light shining at an angle makes the forms more pronounced.

Kasimir Malevich recognized the importance of this series for modern painting early on:

1 Daniel Wildenstein, *Monet: Biographie et catalogue raisonné*, vol. 3, Paris 1979 (rev. ed: *Monet: Catalogue raisonné—Werkverzeichnis*, Cologne 1996), nos. 1317–29, 1345–61. ■ 2 Drawings of the facade of Rouen cathedral are in the Musée Marmottan, Paris. Monet knew Rouen well. It was the home of his older brother, a successful businessman whom he visited often and who secured buyers and exhibitions for him in town. ■ 3 D. Wildenstein, *Monet: Biographie et catalogue raisonné*, vol. 3, Paris 1979, nos. 1321–29. ■ 4 Claude Monet in a letter dated 28 March 1893 to Gustave Geffroy: D. Wildenstein, *Monet: Biographie et catalogue raisonné*, vol. 3, Paris 1979, p. 272. ■ 5 Contemporary painters' admiration for the cathedrals was extraordinarily great. After Monet's death this series, along with all of his late work, was temporarily forgotten. Only with the 're-discovery' of Monet in the 1950s was the art world's interest in this series revived, as documented by, among others, the silkscreen series *Rouen Cathedral (Seen at Three Ddifferent Times of Day)*, 1969, by the Pop artist Roy Lichtenstein. ■ 6 John Rewald (ed.), *Camille Pissarro, Briefe an seinen Sohn Lucien*, Erlenbach-Zurich 1953, p. 316. ■ 7 Georges Clemenceau, *Claude Monet, Betrachtungen und Erinnerungen eines Freundes*, afterword by Gottfried Boehm, Frankfurt a. M. 1989, pp. 87–90. ■ 8 Kasimir Malevich, *Über die Neuen Systeme in der Kunst*, Zurich 1988, p. 20.

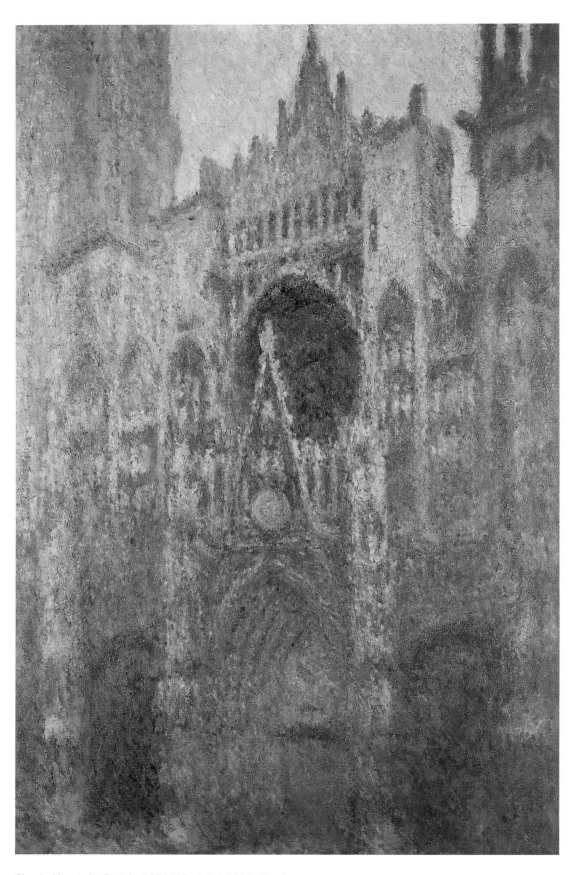

Claude Monet, Le Portail, 1892/93, dated 1894 The Doorway
Oil on canvas, 100 × 65 cm. Weimar, Kunstsammlungen, Schlossmuseum

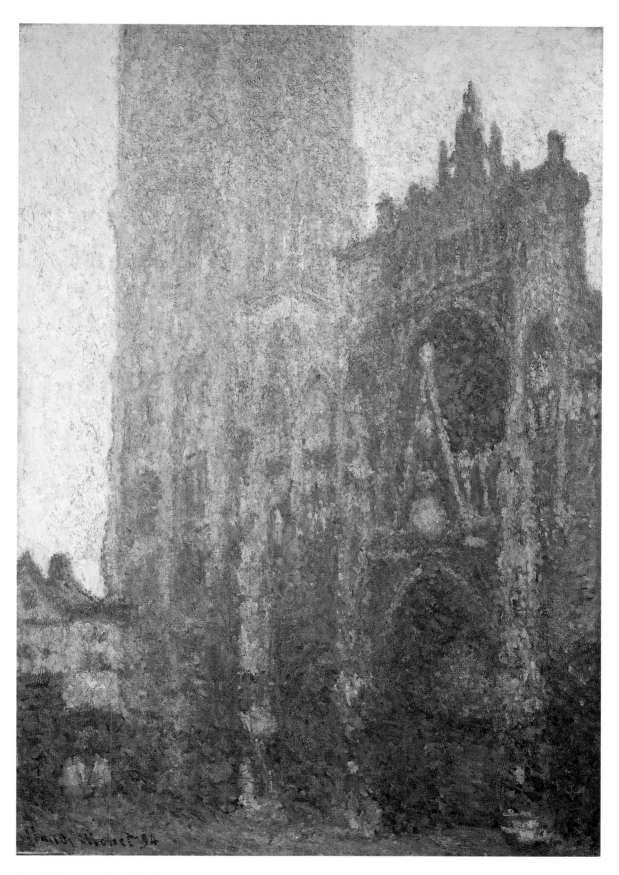

Claude Monet, Le Portail (effet du matin), 1894 The Doorway (Morning Effect)

Oil on canvas, 107 × 74 cm. Riehen/Basel, Fondation Beyeler

Claude Monet, Le Portail et la tour d'Albane (plein soleil), 1894

The Doorway and Alban Tower (Full Sunlight)

Oil on canvas, 107 × 73 cm. Paris, Musée d'Orsay

Claude Monet, Le Portail (temps gris), 1894 The Doorway (Overcast Weather)

Oil on canvas, 100 × 65 cm. Paris, Musée d'Orsay

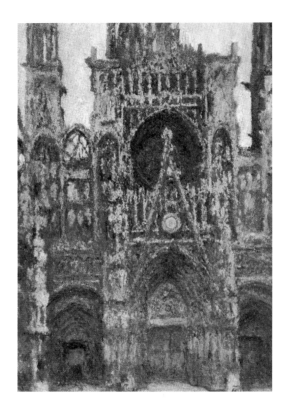 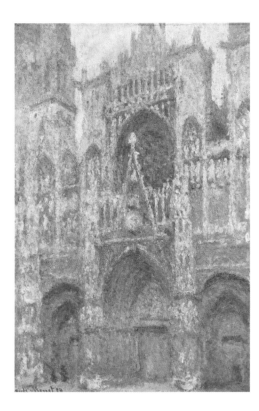

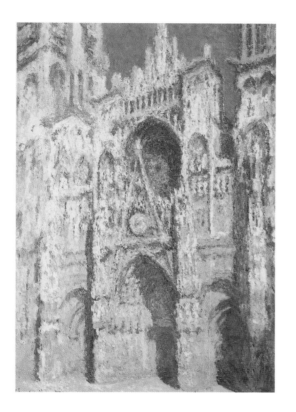 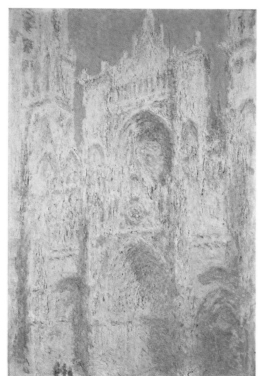 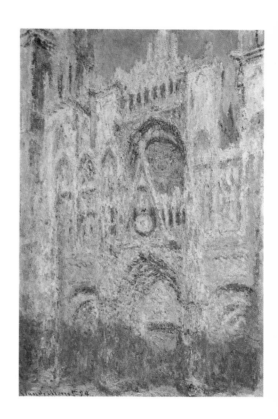

Claude Monet, Le Portail vu de face, harmonie brune, 1894

The Doorway from in Front, Brown Harmony

Oil on canvas, 107 × 73 cm. Paris, Musée d'Orsay

Claude Monet, Le Portail (soleil), 1894 The Doorway (Sun)

Oil on canvas, 100 × 65 cm. Washington, D.C., National Gallery of Art,

Chester Dale Collection

Claude Monet, Cathédrale de Rouen, 1893 Rouen Cathedral

Oil on canvas, 100 × 65 cm. Belgrade, Narodni Muzej

Les Glaçons—The Ice Drift

Monet had turned to the immediate surroundings of Giverny for the first time in the summer of 1883 when he painted the views of Port-Villez, whose rural structure fascinated him. Water and meadow landscapes in this area were among his favorite motifs, whereby the river motifs of the 1890s were painted from his boat studio.

"The Seine! I have been painting it all my life, at every time of day, at every time of the year, from Paris to the sea … Argenteuil, Poissy, Rueil, Vétheuil, Giverny, Rouen, le Havre … Manet used to laugh about it and say: 'Tell Monet he should leave something for the others!' … I never get tired of it. It is always new to me … I have spent burning hot summers there, damaged my eyes from the reflections. In winter, too, when it shows its unfriendly side … For instance in the winter of 1889 [date uncertain, author's note], when I painted on the ice in January. The Seine was frozen over. I set myself up on the river; I struggled to secure my easel and my folding chair. From time to time someone brought me a hot-water bottle. It was not for my feet—I was not cold—but for my numb fingers that were threatening to drop the paintbrush. The landscape was wonderful!"[1]

In late December 1892 and January 1893 there was a harsh cold spell in Giverny with heavy snows so that the Seine, adrift with ice floes for several days, finally froze over completely in mid-January. This inspired Monet to paint winter landscapes, which he was especially fond of (ill. pp. 42–45): "The landscape is much more beautiful in winter than in summer; particularly the trees and flowers are much prettier in overcast weather because sunlight bleaches the colors."[2]

In the twelve-part series[3] of paintings of the ice drift (Glaçons) he picked up the motif of the break-up of the ice that had already fascinated him in 1879/80, shortly after the death of his first wife Camille.[4] At that time it expressed profound melancholy, reflecting the cold and forlorn atmosphere of despair. Picking up familiar compositional schemes, the Glaçons of 1893 are elegiac and calm with unusual colors and frosty atmospheric effects, the choice and treatment of the motifs corresponding to the painter's feelings. "The motif is secondary for me; what I would like to depict is what happens between me and the motif."[5]

The paintings were made in January 1893, before Monet returned to the cathedral series. Surprised by the thaw, the artist complained about how difficult it was to produce something really good after a long pause: "…I have been struggling to paint out of doors the whole time lately, but the thaw came too soon for me. After not having worked for a long time, I only produced bad things that I had to destroy, and it was only towards the end that I found myself again."[6]

Three views from this series were exhibited for the first time at the Durand-Ruel Gallery in 1895. The paintings were in great demand and unusually expensive. Hence the painting of the Ice Drift at Bennecourt fetched over 12,000 francs at the Henri Vever art auction on 1–2 February at the Georges Petit Gallery in 1897.

The vantage-point Monet chose for the Glaçons was on the bank of the Seine near Bennecourt close to Giverny (see map), with a view of the row of hills on the left side of the river and the little island in the Seine, Ilot de Forée (between Grande-Ile and Ile de la Flotte). In Matin brumeux, débacle (ill. p. 43) this island is in the center of the picture and the Bennecourt shoreline can be made out on the lower right. The very reduced palette ranging from bluish gray, brownish blue to white in combination with the lack of concrete figurative representation contributes to an overall flattening of the picture plane. The group of trees on the island appears only as a colored mass. Its reflections shift the surface of the water and hence the 'ground' on which the 'figures' of the ice floes drift weightlessly—suggested with a few brushstrokes—into the unknown. The reflections also virtually expand the space, for the difference between the reflections of the space above the water and the depth of the water itself is no longer clear. The traditional figure-ground relationship is thus eliminated.

The spatial reference, i.e. the landscape, is merely suggested by the diagonal right riverbank. In several frontal and symmetrical views of the river in this series Monet even leaves it out entirely (ill. p. 45). For these, Monet changed his vantage-point to show Ilot de Forée on the left side of the picture, with Ile de la Motte, which has now disappeared, in front of it. Les glaçons, écluse de Port-Villez (ill. p. 44), for instance, was painted upriver towards Port-Villez, with the weir of the former artificial pond of Port-Villez and the rising steam of a passing train on the Le Havre-Paris line on the right.

Les glaçons, écluse de Port-Villez presents a frontal view of the opposite bank. Featuring an unusually expressive and very

Claude Monet, La Débâcle, 1879/80 Ice Thawing
Oil on canvas, 72.5 × 99.5 cm. Private collection

Map of Giverny and surroundings

loose brushstroke and subdivided into planes, this picture is a highlight of the series. The upper half is divided diagonally into two almost monochrome color fields that suggest the bright sky and the dark row of hills along the far side of the river. By contrast, on the clay-hued surface of the water in the lower half of the picture, the ice floes are in dull white, blue and ice green with broad hard-edged lines. In the rest of the works in this series, the color scheme of clay-like hues and the lack of strong contrasts connects the different parts of the picture more closely. This alternating between expressive, broad brushstrokes and small strokes with soft nuances, in combination with explosive or meditative colors, can be observed throughout Monet's entire oeuvre.

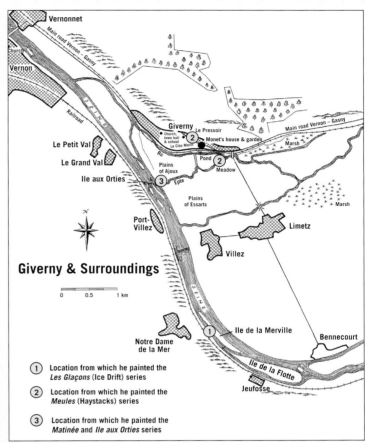

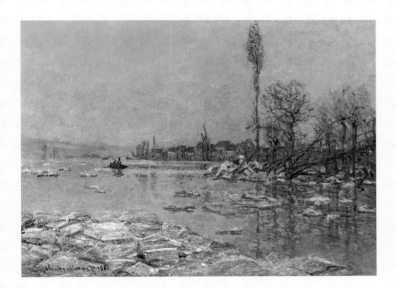

The floating chunks of ice with the reflections that expand the space suggest a vague depth of the water. The interplay of 'figure' and 'ground,' of flat monochrome and rhythmical planes, of reflections and space as well as the brushstroke that, for the most part, departs from figurative representation foreshadow the paintings of the *Grande Décoration*. Thus the extraordinary importance of this series is in its proximity to the later paintings of waterlilies. It can be seen as their conceptual precursor.

1 Claude Monet in April 1924 in conversation with Marc Elder: Marc Elder, *A Giverny, chez Claude Monet*, Paris 1924, p. 35. ■ 2 Claude Monet in conversation with Paul Hellu: Paulette Howard Johnston, *L'œil* (March 1969) p. 31. ■ 3 Daniel Wildenstein, *Monet: Biographie et catalogue raisonné*, vol. 3, Paris 1979, nos. 1333–44. ■ 4 D. Wildenstein, *Monet: Biographie et catalogue raisonné*, vol. 1, Paris 1974: nos. 560–574. ■ 5 Claude Monet in *Dagbladet* (4 April 1895): Jacques P. Hoschedé, *Claude Monet, ce mal connu*, Geneva 1960, vol. 2, pp. 109–110. ■ 6 Cf. letter by Claude Monet to Paul Durand-Ruel dated 24.01.1893: D. Wildenstein, *Monet, Biographie et catalogue raisonné*, vol. 3, Paris 1979, p. 269.

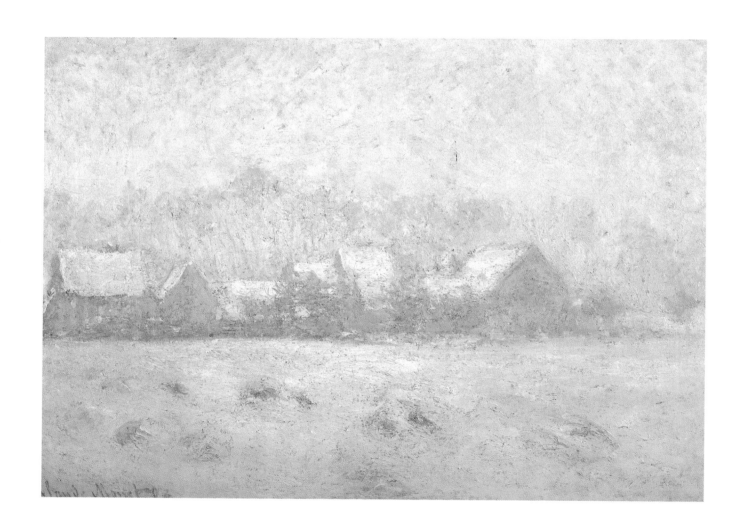

Claude Monet, Effet de neige à Giverny, 1893 Effect of Snow at Giverny

Oil on canvas, 65 × 92 cm. New Orleans, Museum of Art, Stafford Collection

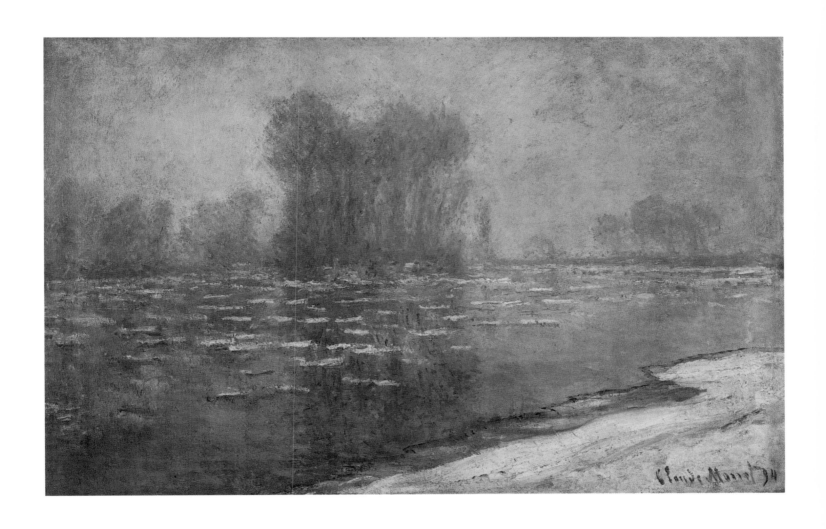

Claude Monet, Matin brumeux, débâcle, 1893, dated 1894 Ice Thawing on a Misty Morning

Oil on canvas, 65 × 100 cm. Philadelphia, Philadelphia Museum of Art, Bequest of Mrs. Frank Graham Thomson

Claude Monet, Les Glaçons, écluse de Port-Villez, 1893

Ice Floes, Port-Villez Lock

Oil on canvas, 73 × 92 cm. Private collection

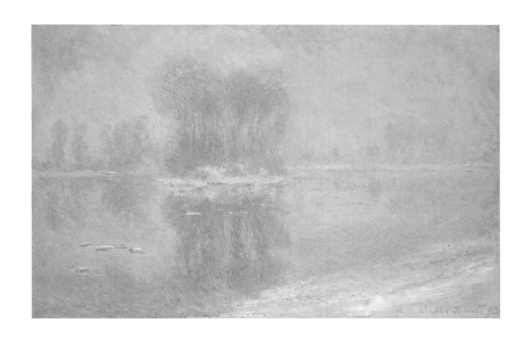

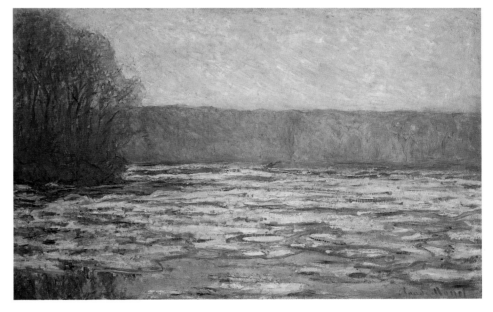

Claude Monet, Les Glaçons, 1893 Ice Floes

Oil on canvas, 65 × 100 cm. New York, Metropolitan Museum of Art,

H.O. Havemeyer Collection, Bequest of Mrs. H.O. Havemeyer, 1929

Claude Monet, Débâcle de la Seine près de Bennecourt, 1893

Ice Thawing on the Seine near Bennecourt

Oil on canvas, 65 × 100 cm. Liverpool, Walker Art Gallery,

Board of Trustees of the National Museums and Galleries on Merseyside

Les Falaises—Coastal Paintings

Claude Monet, La Manneporte, 1883 Manneporte (Etretat)
Oil on canvas, 65 × 81 cm. New York, Metropolitan Museum of Art,
Bequest of William Church Osborne

Monet loved Normandy, which he always described very affection-
ately in his letters and comments. The landscape of Normandy
is characterized by its mild maritime climate. The juicy verdure
under the broad sky, often sparkling blue, the luminosity in the
air—even under an overcast sky—the fertile hinterland with its
hills, and the beaches, bays and jagged rocks have fascinated
artists time and again. The Impressionists also appreciated the
coastal landscape of the Seine-Maritime. Especially its northern
coastline with its striking white rock formations, often steeply rising
by a hundred meters, was a favorite picturesque motif in the
19th century. The coast at Etretat in particular, with its famous
rock gate and awesome drama of natural forces, attracted innumer-
able painters, including Gustave Courbet, Eugène Delacroix and
Camille Corot.

From his early period on, Monet worked repeatedly on the
coast of Normandy. In the 1880s he produced over 150 views
of this area; among the most famous are those of *Etretat* dating
from 1883–86.

Monet first focused on the motifs in Pourville-Varengeville
in 1882. He stayed in Pourville again in 1896, from mid-February
to early April, and during the same months in the following year.[1]
The series consisting of almost fifty pictures can be subdivided
into three different groups of motifs according to the changing
sights along the coast: the *Falaises de Pourville*, the *Pointe du Petit
Ailly* with the *Cabane des Douaniers* (customs officers' cabin),
and the *Falaise de Dieppe*.[2] Given the exhibition title of *Série des
Falaises*, twenty-four of these views were first presented in 1898
at the Georges Petit Gallery in Paris.[3] For his work on the bluffs
of Varengeville Monet chose a vantage-point from a bathing box
on the beach. Instead of letting himself in for battling with the
elements on the coast even in stormy weather, as in the 1880s,
he now sought—often complaining about the variable weather
conditions—more sheltered locations.

This may explain his preference for the view east of Pourville
in the direction of Dieppe in the *Falaise de Dieppe* group (ill. p. 49).
The location was easy to reach from the road. In early February
1897 the further development of this motif seemed endangered
at first, for the "place where I had started so many works in the
direction of the cliff and in the direction of Dieppe is closed to the
public."[4] It was now reserved for the recreation of Dieppe's high
society, the painter complained to Alice Hoschedé.

The crag of Petit Ailly with the little customs officers' hut,
where the Falaises de Varengeville divide, provides the third
category in the series: *Sur la Falaise, au Petit Ailly* and *Cabane des
Douaniers*,[5] which had already inspired several pictures in 1882.

By returning to earlier locations, Monet makes memory and
artistic vision into basic factors in the creative process. "I had
… got the idea of making a synthesis for each of the successive
categories of motifs I had applied myself to, whereby I would use
one picture, sometimes two, to sum up my earlier impressions
and feelings. I have done without it. I would have had to travel a
lot and for a long time to see all the stations of my life as a painter
again one after another and to re-examine the feelings of the past.
I told myself that a series of overall impressions, captured during
the hours when my way of seeing was most likely to be precise,
would not be without interest. I waited until the idea took shape,
until the order and composition of the motifs had gradually im-
printed themselves on my brain."[6]

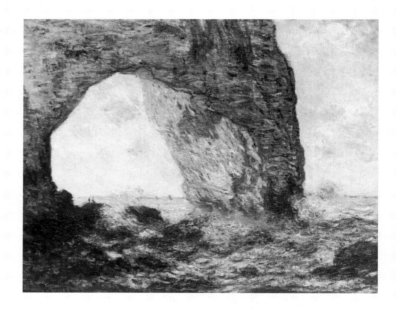

While the existing natural forms remain the same in the in-
dividual pictures, their appearance changes with the time of day,
light, and atmospheric conditions. Similar to the way memory takes
things separate in time and assembles them into a new entity,
Monet conceived each of these series, with its separate pictures,

The Stacks at Port-Coton, postcard ca. 1900

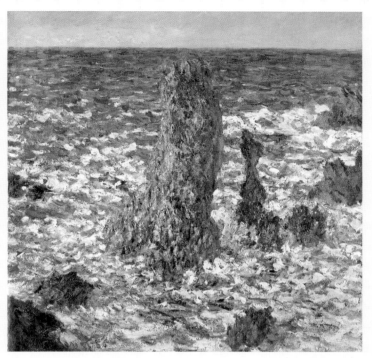

as a whole. For him this was the only way to convey a more comprehensive idea of each landscape.

With a certain affinity to Marcel Proust's novel *Remembrance of Things Past*, the actual subject of the work of art is not an event proceeding in linear fashion but the multifarious simultaneousness of layers of time. This is how both Monet and Proust address the transformation of perception with time.

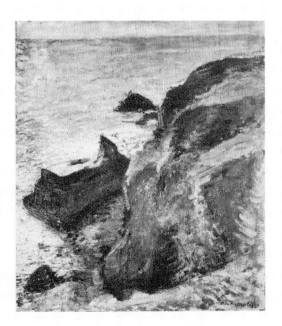

Henri Matisse, Marine, Belle-Ile, 1897
Oil on canvas, 65 × 53.9 cm.
Paris, Private Collection

While the *Série des Falaises* is one of the less known series of the 1890s, its radical pictorial approach ranks it among the most unique and personal of Monet's works of this period. He distances himself uncompromisingly from an approach to landscape that is interested in topographical exactitude or anecdotal detail. The landscape setting serves Monet as a pretext for pictorial reflection. Color, format, relative sizes and locations that recall and are inspired by immediate impressions outdoors determine how the painting is completed in the studio.

The Pourville-Varengeville paintings of 1882 (*Promenade sur la Falaise, Pourville*, 1882) had been separate works painted in the sense of anecdotal and formal criteria. They were neither summed up under a collective title nor exhibited as a group. The paintings of 1896/97, on the other hand, in which the element of motif was radically reduced, can only be understood when seen together serially as a synthesis. The calligraphic brushstroke effective in the paintings of 1882 had been bound to figurative representation and was hence eliminated, the color contrasts were toned down with the addition of a lot of white, and the palette reduced. These monochrome landscapes are built up only of color planes of alternating values. The unusual, even disorienting,

Coast near Pourville, photo ca. 1900

angle of vision in the *Falaises de Dieppe*, the interaction between open planes and closed ones bound by perspective, between infinite space and space limited by perspective—this is what occupied Monet intensely in the 1880s. He preferred geometrical structures diagonal to the picture plane which usually divide the canvas up

clearly. Thus the curved forms of the cliff in *Falaises de Dieppe* (ill. p. 49) divide the picture into a closed part with land and an open part with water, sky and clouds. The plain and elemental features of the coastal landscape of Normandy[7] appear shrouded in fantastic, unrealistic hues of pink, orange, violet and blue. They display an affinity to the transcendence, mysticism and spirituality in contemporary painting of the 1890s.

Monet's impressive landscapes of the bluffs in Normandy and their unusual approach have inspired many young painters to try something similar. One of them was Henri Matisse in 1895–1896 (ill. p. 47).[8]

1 Pourville was a small unassuming village four kilometers east of the fashionable resort of Dieppe, "un petit village de rien," (a little nothing village), as Monet wrote on February 14, 1882 to Alice Hoschedé. See Daniel Wildenstein, *Monet: Biographie et catalogue raisonné*, vol. 3, Paris 1979, p. 241. ■ 2 D. Wildenstein, *Monet: Biographie et catalogue raisonné*, vol. 3, Paris 1979, nos. 1421–34 and 1441–71. ■ 3 Georges Petit Gallery, Paris, from June 1 to July 10 (?) 1898. ■ 4 Claude Monet in a letter to Alice Hoschedé, dated Pourville, February 6, 1897: D. Wildenstein, *Monet: Biographie et catalogue raisonné*, vol. 3, Paris 1979, p. 293. ■ 5 D. Wildenstein, *Monet: Biographie et catalogue raisonné*, vol. 3, Paris 1979, nos. 1448–58. ■ 6 Claude Monet in conversation with François Thébault-Sisson, 'Les Nymphéas de Claude Monet à l'Orangerie,' *Revue de l'art ancien et moderne*

(June 1927) p. 48. ■ 7 Formally related to Japanese woodcuts and their symbolical synthesis of condensed form, significant choice of detail and the decorative element. Monet owned a substantial collection of Japanese colored woodcuts (a total of 230 prints). The proximity of their motifs to works by Monet is sometimes astounding. See also Gérald van der Kemp (ed.), *La Collection d'estampes japonais de Claude Monet à Giverny*, Neuchâtel 1983, and *Monet & Japan*, exh. cat. National Gallery of Australia, Canberra 2001. ■ 8 "J'ai travaillé à Belle-Ile, à la côte sauvage, celle de Monet." (I worked at Belle-Ile, on the rocky coast, that of Monet."): Henri Matisse, *Ecrits et propos sur l'art*, ed. Dominique Fourcade, Paris 1972, p. 115.

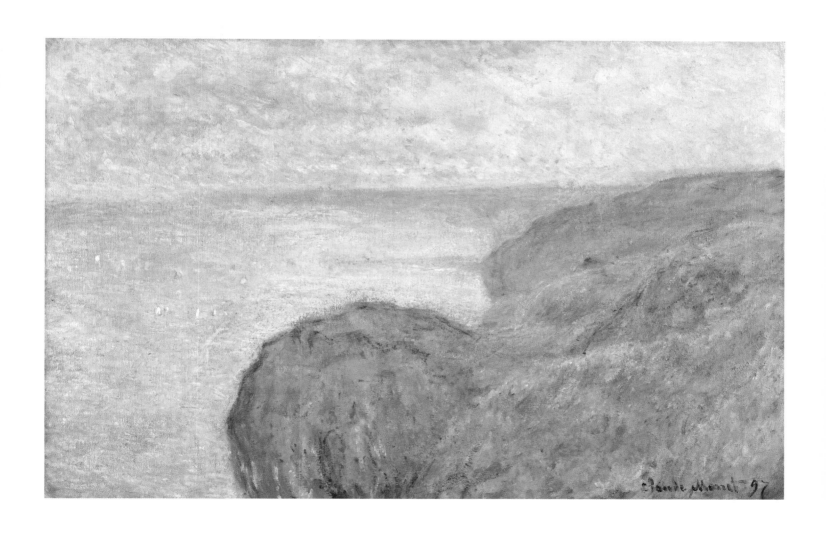

Claude Monet, Sur la Falaise Dieppe, ciel nuageux, 1896/97

On the Cliffs near Dieppe, Cloudy Sky

Oil on canvas, 65 × 100 cm. Private collection

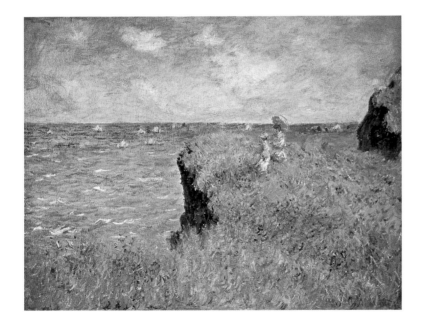

Claude Monet, Promenade sur la Falaise, Pourville, 1882

Walking on the Cliffs, Pourville

Oil on canvas, 65 × 81 cm. Chicago, Art Institute of Chicago

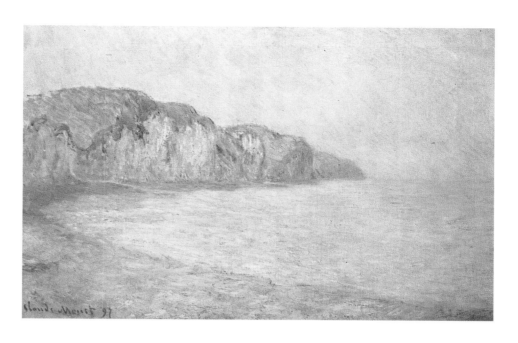

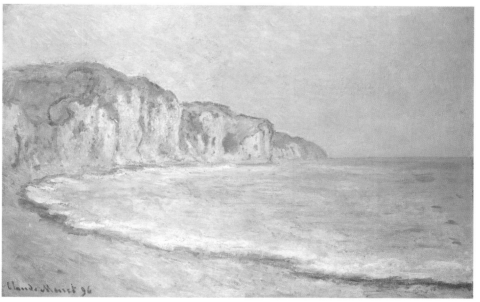

Claude Monet, Falaise de Pourville, le matin, 1897 Pourville Cliffs, Morning
Oil on canvas, 65 × 100 cm. Montreal, Musée des Beaux Arts de Montreal

Claude Monet, Falaise à Pourville, 1895/96 Cliffs at Pourville
Oil on canvas, 65 × 100 cm. Private collection

Ile aux Orties, Giverny

The *Ile aux Orties* series of 1897 comprises six works.[1] In motif it belongs to the *Matinée sur la Seine* (Morning on the Seine) series[2] that Monet began on the island of Ile aux Orties. Direct precursors as to the motif are paintings of *La Seine à Giverny* of 1885[3] and *Les Iles à Port-Villez* of 1890 (*La Seine près de Giverny*, 1885).[4] Monet established the titles for the Ile aux Orties paintings in 1898 for the exhibition at the Georges Petit Gallery. On display were fourteen views of the *Matinée sur la Seine* series and three views of *Ile aux Orties*, including *Près de Vernon, Ile aux Orties*.

Monet painted these pictures in his boat on a branch of the Seine, working in the early morning and in complete silence. When Maurice Guillemot visited Giverny in August 1897 he accompanied the artist to his boat studio,[5] which was anchored where the Epte flows into the Seine at Ile aux Orties.[6] He was able to watch the artist at work: "At daybreak in August, three-thirty in the morning: his body padded with a white woollen cardigan, his feet in heavy leather boots with thick waterproof soles, his head covered with a picturesque brown felt hat ... he opens the gate, goes down the stairs, follows the path down the middle of his garden, where the flowers are waking up and stretching towards the rising sun, crosses the road, passes through the level-crossing gate over the railway tracks of Gisors, goes around the pond covered with waterlilies, steps over the brook babbling between the willows, enters the meadows draped in morning mist and reaches the river.

He has started fourteen paintings at the same time, like a series of studies, of one and the same motif, each given a different appearance depending on the different atmospheric conditions, such as sunshine, clouds, or the time of day. It is a place where the Epte joins the Seine among small islands shaded by large trees. Under the foliage the arms of the river form solitary and peaceful lakes and the water reflects the leaves. Claude Monet has been at work there since last summer—his winters are taken up by another series, the *Falaises à Pourville*, near Dieppe."[7]

The river is the most important feature in these paintings: it takes up half of each picture. In the small *Ile aux Orties* series the painter leaves the left bank behind and provides a frontal view of the island opposite. Shifting the perspective this way makes the foreground loose its reference to landscape and space. This

effect is emphasized by the subtle distinctions in the (overall) hue that suggests cool morning mist, supplants local color and creates an almost complete flattening of the picture space. A horizontal line becomes a mirror axis of symmetrical plant forms and suggests reflections—depending on the changes in brushwork and the changes in luminosity. This is both real and projected vegetation. In these works the serial concept of picture-making appears in two senses: the mirror image itself is already a pair of pictures in the context of the idea of a series. The mirror image thus acquires a pictorial function pertaining to the subject-matter.

In the *Matinées* the trees are masses that spread cloud-like into the sky and frame the broad expanse of water with their

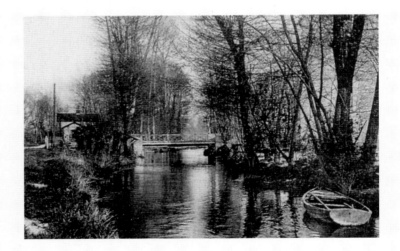

reflections. The visible horizon, the transition from the water to the vegetation and the sky, dissolves in the texture of colors evenly covering the whole surface of the picture. Delicate and luminous pink, yellow and blue tints alternating with dark and cool blue and green, suggest morning freshness and the softly shining light that blends everything together. Beyond time, quiet and calm, these *Mornings on the Seine* have a poetic way of evoking atmosphere, whereby the concrete figurative element is relegated completely to the background. As though by undergoing metamorphosis, the figure is divested of familiar and identifiable features. In a symbolist sense it is merely suggested, not clearly defined. By analogy to the sensations under the surface of pure

Claude Monet, La Seine près de Giverny, 1885 The Seine near Giverny
Oil on canvas, 65 × 92 cm. Providence, Rhode Island, Museum of Art,
Rhode Island School of Design

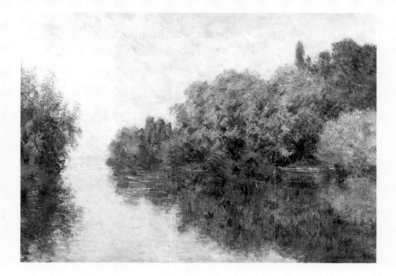

appearances, this figure can make the essence of things under-
standable and enhance the perception of the visible world. Directly
influenced by Monet, Marcel Proust makes this pure kind of seeing,
beyond any conceptual fixation, come to life in his fictional char-
acter of a painter, Elstir.[8] For Monet—as for Elstir—the landscape
becomes something on which to project personal feelings; nature
becomes a metaphor. The lyrical atmosphere of these works is
reminiscent of the waterscapes of the *Grande Décoration*, for which
Monet was preparing his preliminary studies at almost the same
time.

1 Cf. Daniel Wildenstein, *Monet: Biographie et catalogue raisonné*, vol. 3, Paris 1979, nos. 1489–94. Most of the paintings in this series are almost square in format. They are dated 1897 although they were started in 1896. ■ 2 Ibid., nos. 1472–88 (17 views in all). ■ 3 Ibid., nos. 1006–08 (3 views on all). ■ 4 Ibid., nos. 1262–65 (4 views in all). The small islands on the Seine (such as Ile au Sable) no longer exist; they were off Port-Villez, near Ile aux Orties, where Monet's boats were anchored. ■ 5 Monet had this boat built by the small shipyard of his painter friend Gustave Caillebotte. Inspired by the house-boat of his teacher Charles Daubigny, Monet had started early to look for suitable motifs along the Seine and its arms from a floating studio. Edouard Manet documented this boat studio in 1874 in his painting of *Monet Painting on the Seine* (Bayerische Staatsgemälde-sammlungen, Munich). ■ 6 Monet had a shed built here on the bank of the Seine to house his boats and his easels and canvases. See the letter by Claude Monet to Paul Durand-Ruel dated 05.06.1883: D. Wildenstein, *Monet: Biographie et catalogue raisonné*,

vol. 2, Paris 1979, p. 229. From his earliest works Monet was partial to the working method of studying motifs along the Seine from a boat. ■ 7 Maurice Guillemot, 'Claude Monet,' *La Revue illustrée* (15 March 1898), n.p. ■ 8 Marcel Proust, who studied Monet's painting closely, described three characters who are artists in his seven-part novel, *A la recherche du temps perdu*, 1913–27. One is the painter Elstir, who tried to liberate himself from conceptualism when he was looking at the natural landscape, i.e. he did not want to depict things to correspond to our knowledge, but to create them anew through a sub-jective transformation. Proust defines Elstir's painting as a synthesis of sensations nour-ished by both recollection and precise observation. By overlapping, i.e. blending objects in the painting, as in reflections, Elstir expands the figurative subject metaphorically. Proust saw this objective met in the same way in Monet's painting. See Marcel Proust, 'Les Elouissements,' *Figaro* (15 June 1907) and J. Cocking, 'Proust and Painting,' Ulrich Finke (ed.), *French 19th-Century Painting and Literature*, Manchester 1972, pp. 305 ff.

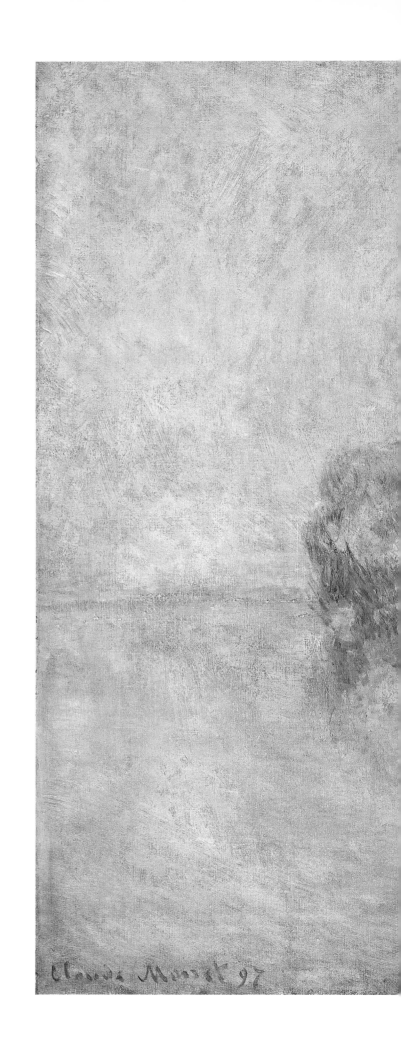

Claude Monet, Ile aux Orties, 1897 Nettles Island
Oil on canvas, 73 × 92 cm. New York, Metropolitan Museum of Art,
Gift of Mr. and Mrs. Charles S. McVeigh, 1960

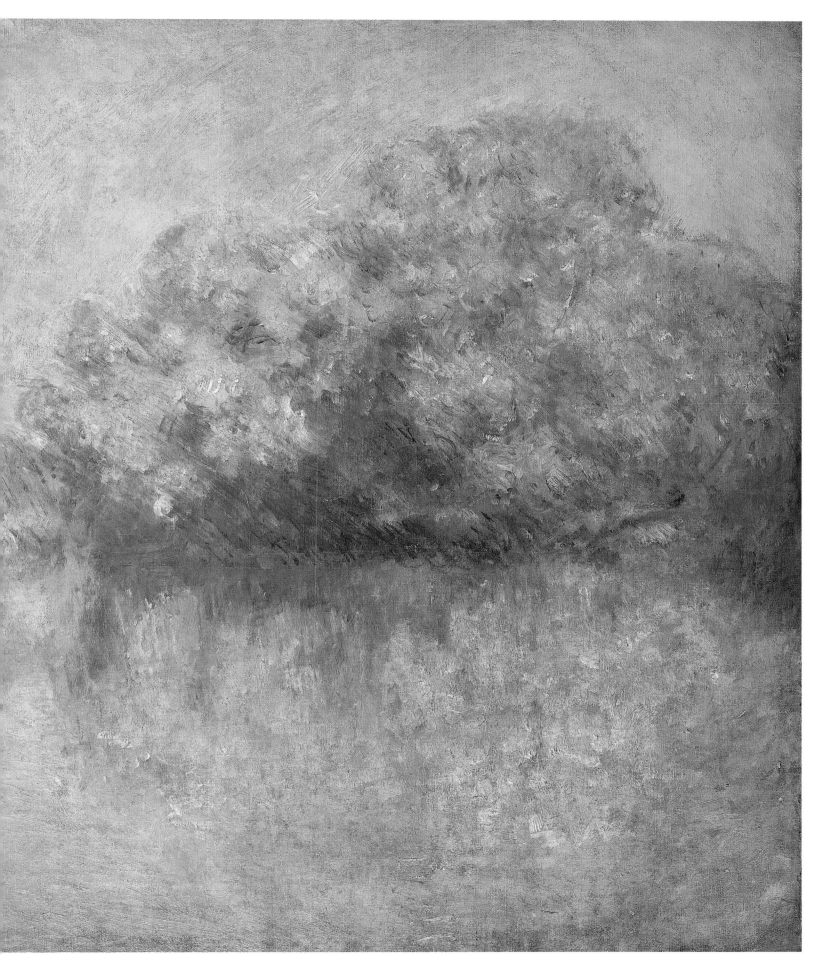

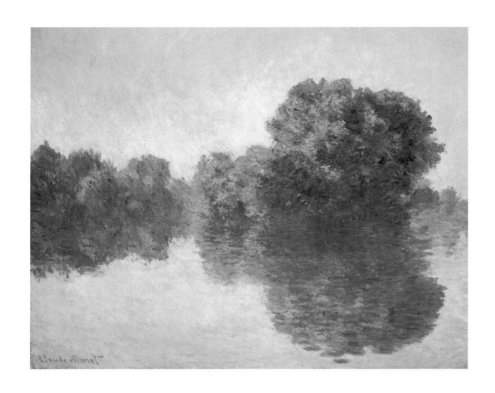

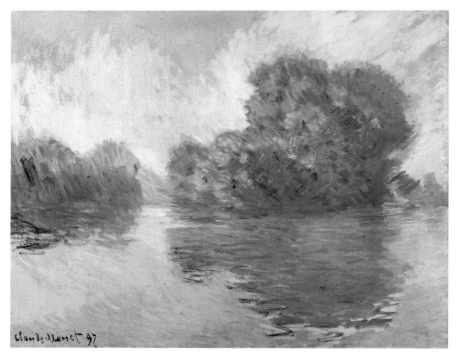

Claude Monet, La Seine près de Giverny, 1897 The Seine near Giverny
Oil on canvas, 81 × 100 cm. Washington, D.C., National Gallery of Art,
Chester Dale Collection

Claude Monet, Les Îles à Port-Villez, 1897 The Islands at Port-Villez
Oil on canvas, 81 × 100 cm. New York, Brooklyn Museum of Art,
Bequest of Mrs. Grace Underwood Barton

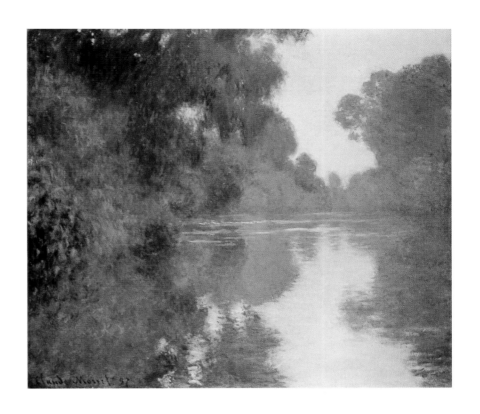

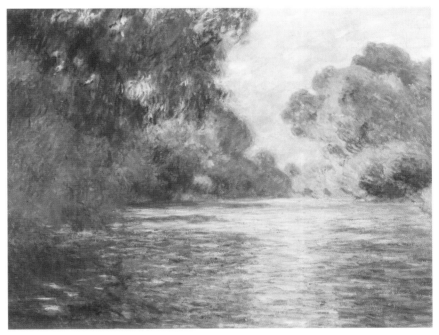

Claude Monet, Bras de Seine près de Giverny, 1897 Branch of the Seine at Giverny
Oil on canvas, 81 × 92 cm. Boston, Museum of Fine Arts, Donated by Mrs. Walter Scott Fitz

Claude Monet, Bras de Seine près de Giverny, 1897 Branch of the Seine at Giverny
Oil on canvas, 75 × 92.5 cm. Paris, Musée d'Orsay

The London Paintings

Claude Monet, La Tamise et le Parlement, 1871 The Thames and Houses of Parliament. Oil on canvas, 47 × 73 cm. London, National Gallery

Monet's approximately one hundred paintings of London, painted in 1899–1901, can be grouped into four subject categories:[1] *Charing Cross Bridge*, 1899–1904, *Waterloo Bridge*, 1899–1901, *Le Parlement* (*The Houses of Parliament*), 1900–1901, and *Leicester Square*, 1900–1901. This is the largest series in Monet's oeuvre. Thirty-seven of these cityscapes were exhibited in 1904 as *Série de vues de la Tamise à Londres* in the Durand-Ruel Gallery in Paris.[2] The paintings were subsequently dated from 1900 to 1904, thus documenting the long and difficult period of their completion in the artist's studio in Giverny. As

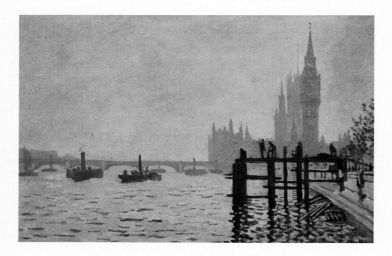

late as March 1903 Monet was still putting Durand-Ruel off: "I cannot send you a single painting of the London series as it is absolutely necessary for the work I am doing to have them all in front of me and, to be honest, not a single one is completed yet."[3]

During the Franco-Prussian War Monet stayed in London until the end of May 1871. This was the beginning of his lifelong intimate relationship with the city and of his acquaintance with the Parisian art dealer Paul Durand-Ruel, who had opened a branch of his gallery in London. In 1887 Monet was in London as the guest of the artist James McNeill Whistler. Other visits followed in 1888, 1891 and 1898, though no pictures have been preserved from these trips.[4]

His plan to paint a series of views of London dates at the latest from 1891.[5] Its concrete realization, however, was not until 1899, when Monet rented a room in the Savoy Hotel from September to November 1899. He returned there, to continue the works he had begun, from February to April 1900 and again from January to April 1901. From the fifth storey of this hotel on the Thames he painted the views of Charing Cross and Waterloo Bridge. The series of views of the Houses of Parliament were painted from a room in St. Thomas Hospital and the unusual nocturnal scenes of Leicester Square from the Green Room of a club in St. Martin Street (see map below).

It is astonishing that the artist would pick up urban motifs again after over 20 years. He may have been sounding out the subject-matter for further development. However, as the travel required became increasingly difficult for Monet, after the Venice series of 1908–1912 this genre was no longer relevant.

On his first London visit in 1899 Monet concentrated mainly on Charing Cross Bridge, an iron railway bridge with clear, massive, vertical and horizontal forms. It stands out distinctly from the clouds of smoke from the trains, the partially visible trees on Victoria Embankment in the right foreground, the Victoria Tower and the rectangular outline of Big Ben as well as the riverbank opposite the Houses of Parliament. The picture's horizontal subdivisions suggest depth, which is underscored by the diagonal arrangement of the boats.

In the views of Waterloo Bridge, the painter's gaze moves down-river across the stone bridge with its sweeping, rhythmical pilaster arches to the right bank opposite with its factory chimney stacks and towers. Foggy scenes alternate with sunlit ones (ill. pp. 60–63), while he preferred to paint the Houses of Parliament

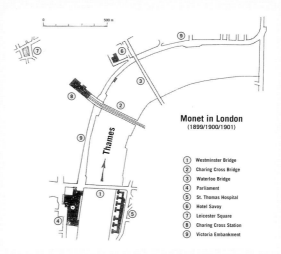

Monet in London
(1899/1900/1901)

1. Westminster Bridge
2. Charing Cross Bridge
3. Waterloo Bridge
4. Parliament
5. St. Thomas Hospital
6. Hotel Savoy
7. Leicester Square
8. Charing Cross Station
9. Victoria Embankment

André Derain, Londres: Le Pont de Hungerford à Charing Cross,
1905/06 Hungerford Bridge, Charing Cross, London.
Oil on canvas, 81 × 100 cm. Private collection

in the late afternoon, against the light or in the setting sun. The rapidly changing weather and light conditions sometimes drove him near desperation.

The exhibition catalogue of 1904 provides explanatory titles such as "Twilight," "Sunset," "Fog in the Morning," "Cloudy Weather," "Sunshine in Fog," etc., that do not permit definite identifications but make Monet's aim clear. He wanted to capture the changing appearance of the bridges and the Neo-Gothic Houses of Parliament in constantly changing lighting conditions. They make the subject of the picture appear to dissolve and lend it a mysterious, magical aura.[6]

Monet did not go to London to paint the city's bridges or buildings but to paint the fog: "I like London a lot, but only in winter. In summer it is beautiful in the parks but that cannot take the place of the winter with the fog, for without the fog London would not be a beautiful city. It is the fog that gives it a grandiose breadth. Its regular and massive blocks look grand through this mysterious cloak."[7]

This brings William Turner's paintings to mind, which Monet had studied thoroughly back in 1870. Monet admired them very much, but turned away from them in his late work for he found them lacking in the structural element of color.[8] "I used to admire Turner very much, nowadays I like him less ... he did not structure (draw) color enough and he used too much of it; I have studied it carefully."[9] Turner's pictures were familiar to Monet from his visits to the National Gallery,[10] though he probably did not know his thematically related *The Burning of the Houses of Lords and Commons, 16th October, 1834,* 1835. He was able, however, to study his *The Sun of Venice,* 1840. In 1908 and 1909 in Venice he created similar works: color symphonies, in which water and earth, air and fire are elemental qualities.

How important this influence actually was is explained by the advice Camille Pissarro gave Henri Matisse in 1897, when he suggested that latter go to London in order to study closely—as he and Monet had done—the works of William Turner. Matisse was keeping to an impressionist style in 1897, "doing Impressionism now and only thinking via Claude Monet."[11]

The response to Monet's London paintings exhibited in 1904 was overwhelming, the press enthusiastic and the sale prices correspondingly high. After this show the art dealer Ambroise Vollard sent the Fauve painter André Derain[12] to London to imitate Monet.

Derain took his advice, as documented in 1905 and 1906 by paintings of the Houses of Parliament and Waterloo Bridge. These were "series of paintings that I made for Mr Vollard, who had sent me to London at the time, wanting pictures that were inspired by the atmosphere of London. He sent me in the hopes that I would continue in the mode of expression (pictorial effect) that Monet had developed so astoundingly and that had such a strong influence in Paris in the years to follow."[13]

1 Daniel Wildenstein, *Monet: Biographie et catalogue raisonné*, vol. 4, Paris 1985, nos. 1521–1617; *Charing Cross Bridge*, nos. 1521–54 (34 views); *Waterloo Bridge*, nos. 1555–95 (41 views); *Le Parlement*, nos. 1596–1614 (19 views); and *Leicester Square*, nos. 1615–17 (3 views). ■ 2 Durand-Ruel Gallery, Paris, 9 May–4 June 1904. ■ 3 Claude Monet to Paul Durand-Ruel, 23 March 1903: D. Wildenstein, *Monet: Biographie et catalogue raisonné*, vol. 4, Paris 1985, p. 363. On particular difficulties resulting from his serial working method on the London paintings, see Claude Monet in conversation with the Duc de Trévise, 'Le Pélerinage de Giverny,' *Revue de l'art ancien et moderne* (February 1927) p. 126. ■ 4 Monet went mainly to visit friends and his son Michel, who was learning English in London, and to see exhibitions. ■ 5 Camille Pissarro's letter to his son Lucien of 9 December 1891: "Monet has been in London since yesterday. He will probably be working there. His London series is being eagerly awaited." John Rewald (ed.), *Camille Pissarro, Briefe an seinen Sohn Lucien*, Erlenbach/ Zurich 1953, p. 225. ■ 6 Cf. the review of the exhibition by the writer Octave Mirbeau, who was a close friend of Monet's: Pierre Michel and Jean-François Nivet (eds.), *Octave Mirbeau, Correspondance avec Claude Monet*, Paris 1990, pp. 258–262. ■ 7 Claude Monet in conversation with René Gimpel on 1 February 1919: René Gimpel, *Journal d'un collectionneur, marchand de tableaux*, Paris 1963, p. 156. ■ 8 Claude Monet in conversation with René Gimpel in July 1926: René Gimpel, 'At Giverny with Claude Monet,' *Art in America* 15 (June 1927) p. 174. ■ 9 Claude Monet in conversation with René Gimpel on 28 November 1918: René Gimpel, *Journal d'un collectionneur, marchand de tableaux*, Paris 1963, p. 88. ■ 10 Exhibited at the National Gallery was, among others, Turner's famous *Rain, Steam, and Speed—The Great Western Railroad*, 1844, which Monet expressly mentioned to Theodore Butler in 1892. Cf. John Gage, *Turner: Rain, Steam and Speed*, New York 1972, p. 72. ■ 11 Letter by Henri Evenepoel to Gustave Moreau dated 2 February 1897: Francis E. Hyslop, *Henri Evenepoel à Paris, Lettres choisies, 1892–1899*, Brussels 1971, p. 135. ■ 12 Cf. André Derain, *Barges on the Thames*, 1905/06. ■ 13 André Derain in his letter of 15 May 1953 to the President of the Royal Academy: Ronald Alley, *Tate Gallery Catalogues: The Foreign Paintings, Drawings and Sculpture*, London 1959, pp. 64–65.*paintings, drawings and sculpture*, London 1959, p. 64–65.

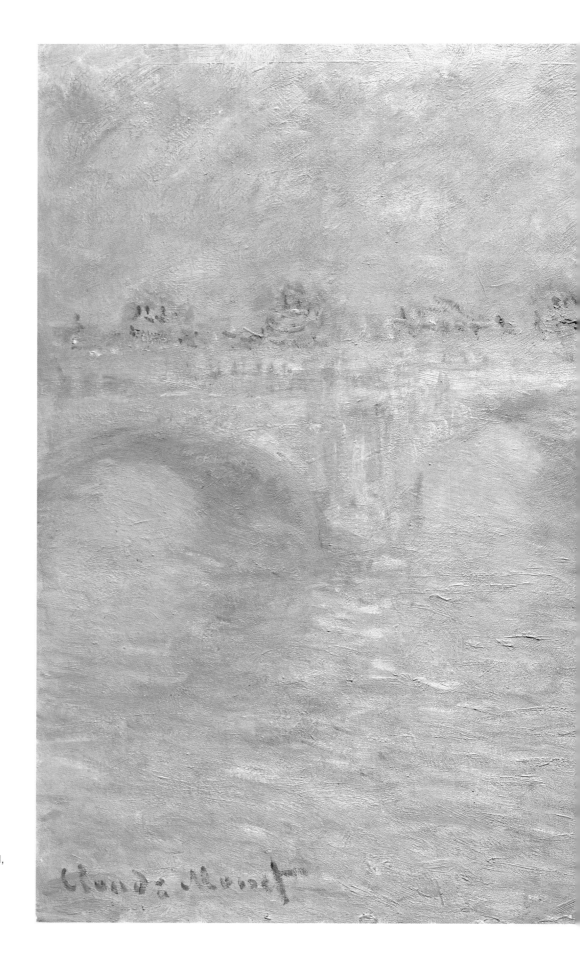

Claude Monet, Waterloo Bridge, effet de soleil,
1899–1901 Waterloo Bridge in the Sun
Oil on canvas, 65 × 100 cm.
Zurich, Stiftung Sammlung E.G. Bührle

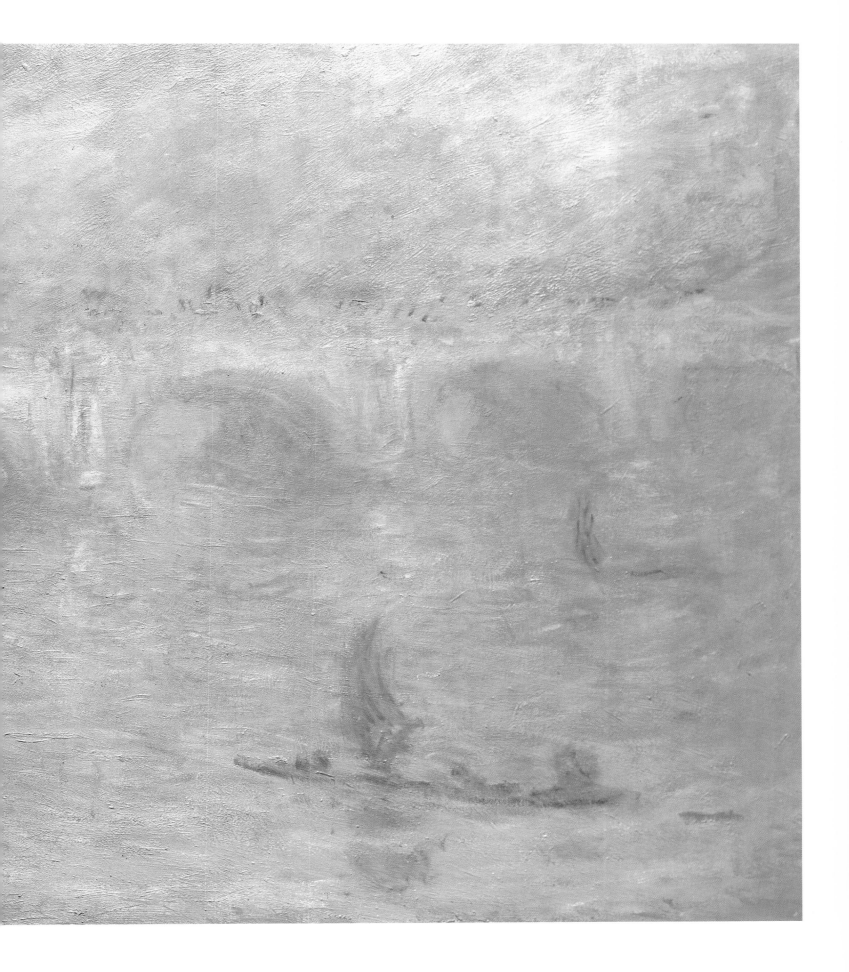

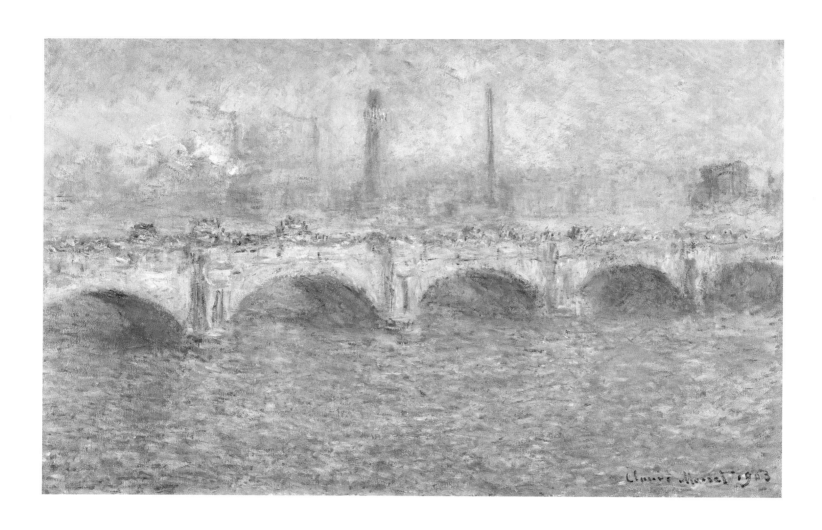

Claude Monet, Waterloo Bridge, effet de soleil, 1899–1901, dated 1903

Waterloo Bridge in the Sun

Oil on canvas, 65 × 100 cm. Private collection

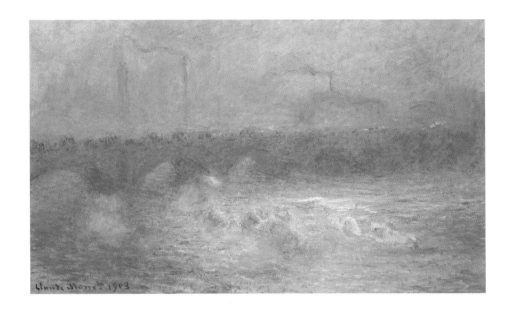

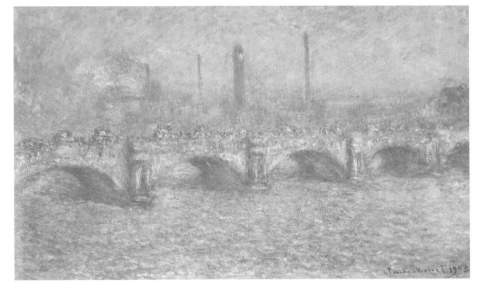

Claude Monet, Waterloo Bridge, effet de soleil avec fumées, 1899–1901, dated 1903
Waterloo Bridge, Sun and Smoke Effect
Oil on canvas, 65 × 100 cm.
Baltimore, Baltimore Museum of Art,
The Helen and Abram Eisenberg Collection

Claude Monet, Waterloo Bridge, soleil voilé, 1903
Waterloo Bridge in Hazy Sunlight
Oil on canvas, 65 × 100 cm.
Rochester, Memorial Art Gallery of the
University of Rochester, Gift of the estate
of Emily and James Sibley Watson

Claude Monet, Waterloo Bridge, effet de soleil, 1899–1901, dated 1903
Waterloo Bridge in the Sun
Oil on canvas, 65 × 100 cm.
Chicago, Art Institute of Chicago,
Mr. and Mrs. Martin A. Ryerson Collection

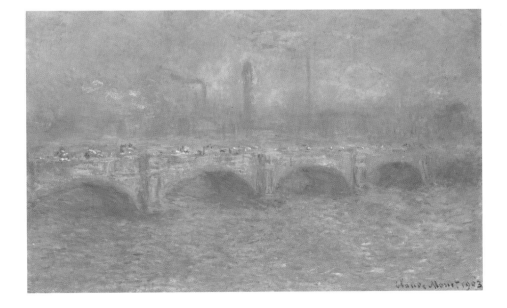

The Waterlilies in Giverny and the *Grande Décoration*

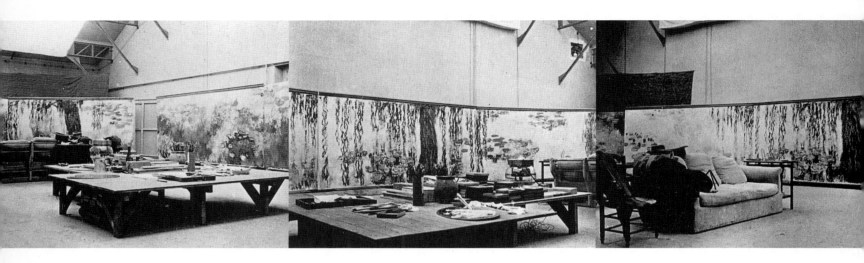

Giverny represents a new period of Monet's life, during which the 'Monet legend' takes its course and his success as an artist finally also brings with it a certain financial security. The landscape around Giverny and the small farming village itself, only sixty kilometers north of Paris and easily accessible even in those days by fast train from Vernon, filled Monet with enthusiasm. Here, in the water and meadow landscapes nearby, he found his favorite motifs again: "I am enraptured! To me Giverny is a wonderful area."[1] (ill. p. 67)

Monet's move to Giverny in April 1883, buying the house[2] in 1890 and, in February 1893, enlarging the existing garden by purchasing a property opposite the house but separated from it by railway tracks[3] were the preconditions for his paintings of the water garden that became the main theme of his last thirty years of production and the peak of his creative achievement. The approximately 300 paintings[4] that have been preserved are closely related in content and form to the *Grande Décoration*, the installation of the waterlily paintings in the Orangerie in Paris

Giverny and surroundings

Map of house and garden at Giverny

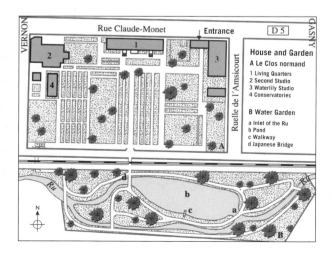

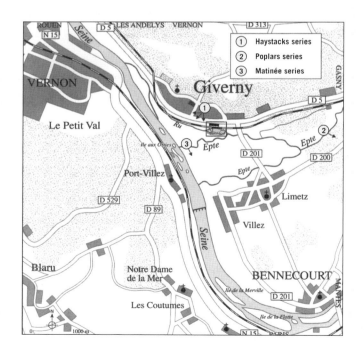

The Waterlily paintings in Monet's studio, November 11, 1917

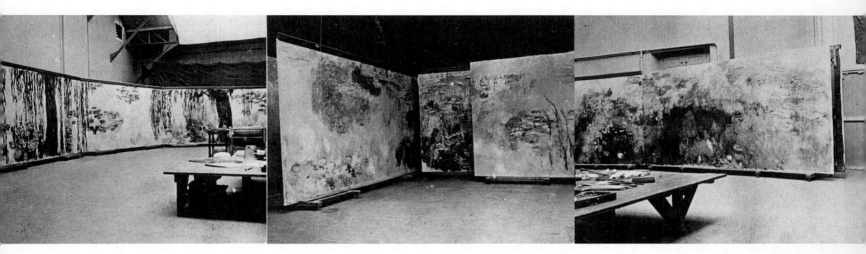

that was made accessible—at the artist's request—to the general public in 1927.

In the years to follow, the new piece of land acquired in 1893, with its existing pond and the little Ru brook running through it, was subject to major changes that were fundamental for Monet's work on the *Grande Décoration*. It seems astonishing that this water garden of relatively modest proportions[5] was the model for the monumental decoration of the Orangerie. The garden itself had been turned into a work of art by the artist's hard work at designing it. While his creative vision had already found expression in the purposeful design of the landscape according to the principles of the palette, the landscape motif was now turned into a picture. Thus, for instance, Monet, who was an enthusiastic gardener and did most of the gardening himself until 1892, had one of his six gardeners arrange the individual blossoms and positions of the leaves of the waterlilies in a compositional and color sequence determined by himself.[6] "It took me a long time to understand my waterlilies … I planted them for pleasure, looked after them without thinking of painting them … A landscape does not catch hold of you immediately … And then I suddenly discovered the magic of my pond. I reached for my palette … I have scarcely had another motif since."[7]

The lily pond is thus the manifestation in reality of an aesthetic appropriation of nature. It is also an ideal image of nature in the sense of the unity of natural landscape and subject. To Monet the experience of landscape, or of the waterlily garden, should correspond to the direct sensual experience of painting. The individual painting evolves from a mixture of contemplation of nature and deeper reflection on the materials and means of painting. With nature as the point of departure, it links the outer world and the inner world, being the subjective concept of reality. Thus Monet insists: "One is not an artist if one does not already have one's picture in one's head before executing it, if one is not

Claude Monet, Une Allée du jardin de Monet, Giverny, 1902
An Avenue in Monet's Garden, Giverny. Oil on canvas, 89 × 92 cm.
Vienna, Österreichische Galerie Belvedere

Claude Monet, Nymphéas, effet du soir, 1897/98 Waterlilies, Evening Effect

Oil on canvas, 73 × 100 cm. Paris, Musée Marmottan-Monet

sure of one's craft and one's composition ... The techniques change ... Art remains the same: it is both original and sensitive representation of nature."[8]

Monet's attempt to approximate the motif, i. e. the water garden, to painting is reflected in both the subtly changing series of motifs and the continual redesigning of this garden.

In the first design, weirs were built in the east and west between 1893 and 1901 for the waterlilies to be planted and the water warmed. Monet had a Japanese-style arched wooden bridge added in 1893 along a theoretical continuation of the axis of the garden path that led to the house (ill. pp. 72/73, 80–85).

Because of its astonishing similarity to Japanese gardens, Monet's waterlily garden was also called 'Jardin japonais' (Japanese garden) by his contemporaries. The bridge was a motif providing form in the *Bassin aux nymphéas* series of 1895,[9] 1899[10] and 1900.[11]

The first view of the lily pond with the Japanese bridge, *Bassin aux nymphéas, hiver* (Lily pond in Winter) of 1895 anticipates Monet's project for a waterlily decoration intended for a particular space, which he first mentions in 1897.[12] The paintings of waterlilies dating from 1897,[13] showing only the surface of the water with the leaves and flowers and the grasses swaying at the bottom of the pond are directly related to it (ill. above). These paintings, placed side by side and to a height of about one meter, were

meant to suggest a water landscape in a round room, which was not specified in more detail but presumably private.[14] Monet evidently did not follow up on this plan. Hence the studies landed in the art cellar and it was not until 1914, when they were 're-discovered' by the artist, that they would provide inspiration for the *Grande Décoration*.

Bassins aux nymphéas, 1899–1900

Twelve paintings of the bridge followed in the summer of 1899 and six more in 1900, differing from the earlier ones in the broader visual angle that includes the shoreline on the left. Twelve of these were displayed in 1900 with the title of *Bassins aux nymphéas* at the Durand-Ruel Gallery.[15]

In comparison to the open paintings of 1897, with the motif reduced and the space 'empty,' these works feature the lush vegetation of the lily pond with the geometrical structure of the bridge providing symmetry and linear perspective. This interplay of 'fullness' and 'emptiness' is characteristic of the whole series. The space crowded with plants, without a horizon and without a sky, and the correspondingly heavy impasto of the paint, inundates the entire picture plane and thus underscores the suggestion of being immersed in nature.

"... beauty is attained precisely by evoking nature in its entirety. You can imagine the whole garden in these simple presentations of water and grasses. You sense dark life at the bottom of the pond; the lavish growth of the roots, the confusion of the stems, of which the extravagant bouquets on the surface are merely the unfolding ..."[16] (ill. pp. 72/73).

In 1901 the garden was further expanded, the pond enlarged and the Ru diverted, by permission of the municipality. The Japanese bridge was given an additional arch over the top. Later, covered with wisteria, it became the subject of the bridge paintings of 1918–1924.[17] These late works, however, are strongly differentiated from the earlier ones by their expressive coloring and technique.

Paysages d'eau, 1903–08

From 1903 to 1908 Monet returned to painting the waterlilies on the surface of the water. While the shore is included in the

Claude Monet, Vue du village de Giverny, 1886 Looking Towards Giverny

Oil on canvas, 65 × 81 cm. New Orleans, Museum of Art, Stafford Collection

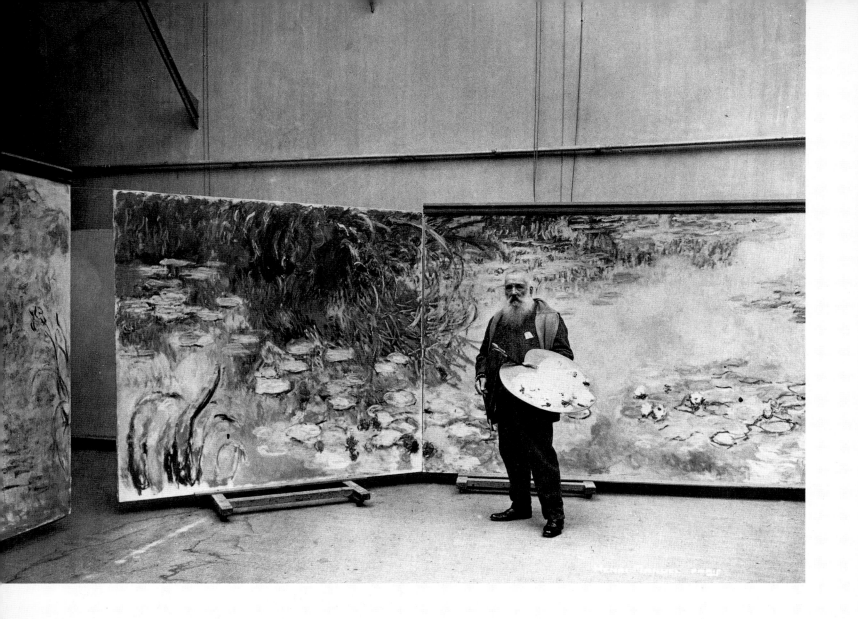

upper fifth of the picture in most of the paintings of 1903–04[18] (ill. p. 75), it disappears entirely between 1904 and 1908 (ill. pp. 76/77).[19] The focus is now on the surface of the pond with its reflections and on the waterlilies. This subject-matter increasingly dominates his artwork: "These water landscapes and reflections have become an obsession. It exceeds the strength of an old man, and yet I strive to depict what I feel."[20] In this series Monet concentrated on the study of nature in changing lighting conditions, on optical phenomena. He intensified the procedure by restricting himself purposely to a small detail of the landscape, i.e. limiting the pictorial repertoire dramatically, and by refusing to include the shoreline, which had defined the landscape space in the first paintings of this series. In the paintings from 1904 on the shore is kept only as a reflection. The reflections of the sky and the surrounding landscape, the surface of the water and the plants in the depth of the pond, the reflected and the real landscape are combined into a new, virtual, even simultaneously expanded, landscape space that refers far beyond

reality and that is complex, ambivalent and indefinable. The perception of concrete figure-ground relationships and systems of spatial relationships begins to falter.

These landscapes are no longer composed in the academic and classical sense. They cannot be reduced to an ordered perspective with a foreground, middle ground and background. The fact that the viewer can have the illusion of depth in the water nevertheless derives from the rhythmical, diagonal arrangement and the proportions of the waterlilies as they diminish into the distance. The *Paysages d'eau* also document Monet's extensive formal exploration of the interaction of forms, colors, light and shadow, which is also expressed in the changing formats with almost square, wide, tall or even round (tondo-shaped) series, and which Monet would be refining constantly in the years to come.

Durand-Ruel mounted an exhibition with these paintings in 1909.[21] Entitled *Nymphéas, séries de paysages d'eau*, it showed 48 works dating from 1903–08 in a coherent series,[22] subdivided into six smaller thematic groups. The importance of the series as

Claude Monet in his waterlily studio, ca. 1920

a principle of aesthetic autonomy for Monet is documented by his precise instructions for the presentation of this one. Critical response to the exhibition was euphoric[23] and greatly lamented the fact that the series was to be dispersed soon: "I cannot think without regret of the imminent splitting up of these enchanting works, which form a complete whole, which complement each other mutually and will be united only once and for a short time to convey the total impression and sensation of the poetry they emanate."[24]

"Art such as yours is the glory of a nation and of an era. When I am depressed about the mediocrity of today's literature and today's music, all I have to do is look at your painting, where works such as your 'Waterlilies' bloom, for me to become reconciled with our artistic era and to feel that it is equal to the greatest there ever were."[25]

The *Grande Décoration*, 1914–26

Several strokes of fate in rapid succession, including the flooding of the waterlily garden in 1910, the death of Alice Hoschedé in 1911 and Monet's eye disease,[26] from which he suffered from 1912 on, led to a lengthy interruption of his work until 1914.

In April of that year Monet—inspired by the 're-discovered' waterlily paintings of 1897 (ill. p. 66)—revived the idea of an installation in a room, a *Grande Décoration*, with pictures of the water garden.[27] He began putting it into practice as early as the autumn of 1914: "I am following up on my idea of a large-scale decoration ... It concerns the project I had a long time ago: water, waterlilies, plants, but covering a very large area ..."[28] He proceeded from both large-scale studies made in the water garden straight from the motif and from existing pictures, groups of motifs, which he then assembled in the studio into other compositions.

Also included in the decoration project were many motifs from the edges of the pond, such as weeping willows (*Saules pleureurs*) (ill. pp. 86/87), iris agapanthus (ill. pp. 78/79), wisteria (ill. p. 88), and the gateway with the rose trellis (ill. pp. 92/93). The paintings of wisteria, for instance, were intended for a frieze above the doors in the installation. One immediate consequence of this plan was the radical enlargement of the formats to a height

of two meters. In order to cope with what were now monumental formats without having to do without *plein air* painting entirely, Monet worked on the canvases of the decoration in his studio in the winter and on large studies of the lily pond and the vegetation of the shore from nature during the warmer seasons. These studies from nature were not intended for public view and thus Monet only sold one of them. They are usually two meters high, some are square, and they feature a reduced palette with strong contrasts and a very free gestural brushstroke (ill. pp. 94/95). When Monet was working on the large decorative canvases he was able to fall back on these studies and use them as 'model books.'

Besides the large studies from nature Monet also painted smaller formats picking up motifs from the lily pond and the garden in 1917–1920. These are distinguished by a very dense surface, an explosive, turbulent brushstroke and an unusually expressive colorfulness. These very diffuse expressive works were enthusiastically 'discovered' in the 1950s by the protagonists of Abstract Expressionism. If Monet did not further develop the artistic approach heralded here—because of his acute eye disease in the 1920s—this does not in the least diminish its outstanding importance in Monet's oeuvre.

The large-scale compositions that were to be assembled from two, three or four paintings called for the construction of a studio in 1914–16 with an area of 276 square meters to hold several canvases at once. Photographs taken in late 1915 to early 1916 show Monet in this studio in front of large-sized paintings, each two meters high and 4.25 meters wide, grouped side-by-side on easels. A triptych with weeping willows can be identified. (ill. pp. 68/69). In 1918 Monet offered his friend, the French statesman Georges Clemenceau[29]—on the occasion of the victorious end of World War I—several of the completed

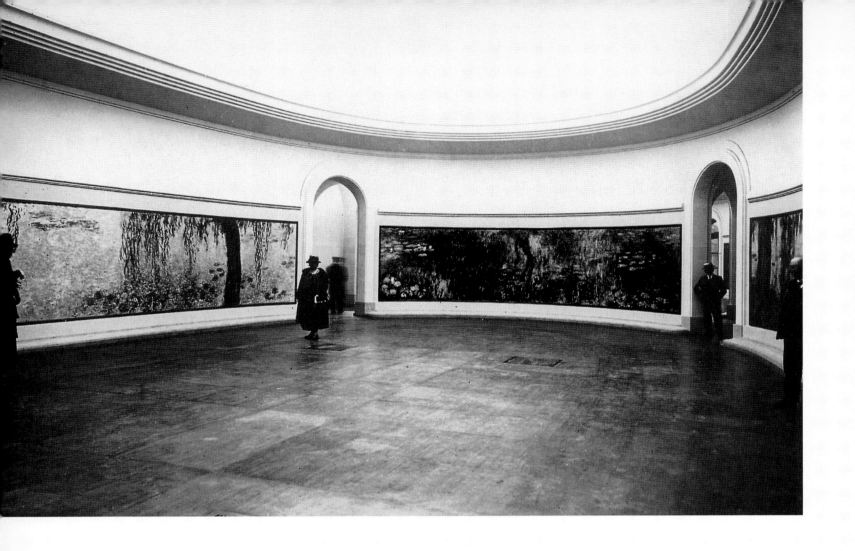

decorative paintings as a gift to the French nation. Clemenceau probably persuaded the artist to make a substantially larger gift. The idea became reality starting in 1920. Twelve canvases with motifs of the water garden (iris, agapanthus, willows, and reflections of clouds on triptychs and diptychs) were to be housed in a rotunda with a glass roof—according to plans by Monet—in Hotel Biron, today's Musée Rodin in Paris. This plan was given up in the spring of 1921. In the summer of that year Monet worked on a new concept for the Orangerie in Paris, where the elliptical shape of the two rooms meant he was faced with completely new spatial conditions, which also called for doubling the number of paintings. In November 1921 the decision to house the series in the Orangerie was definite. The realization was problematic throughout: the serious worsening of his eye disease forced Monet to undergo an operation on his right eye in January 1923, which led to a temporary change in his perception of color. Euphoric painting fits alternated with phases of profound self-doubt, against which Clemenceau had to battle repeatedly:

"First you wanted to complete the unfinished parts. That was not absolutely necessary but understandable. Then you had the absurd idea of improving upon the others ... You produced

new canvases, most of which were masterpieces and still are, if you have not ruined them in the meantime. Then you wanted to create super-masterpieces ... upon your request a contract between yourself and France was signed which set down the commitments of the state. You asked for the postponement of your own, which was granted through my intervention. I myself was of good faith and would not like you to make me look like a flatterer, who has done a disservice to art and to France in order to give in to the whims of a friend. You must come to an artistic and honourable conclusion for there are obligations you have undertaken, no 'ifs, ands or buts.'"[30] In fits of discouragement, Monet destroyed what are probably hundreds of pictures of water-lilies, sometimes chopping them up with a knife,[31] though some fragments have been preserved (ill. p. 96).

In July 1925 Monet's vision improved and with great enthusiasm he painted outdoors once again. In early 1926 the decoration of the Orangerie was almost completed. Improvements that Monet was still contemplating were no longer carried out; the artist died on 5 December of that year. After his death Michel Monet presented eight wall-paintings consisting of 22 canvases to the Orangerie as a gift. From then on the first room contained

View of the Orangerie, ca. 1927

Soleil couchant, *Les Nuages*, *Le Matin* and *Les Reflets verts*, and the second room *Reflets d'arbres*, *Le Matin avec saules pleureurs*, *Le Matin avec saules pleureurs* and *Les deux saules*. They were glued directly onto the concave walls as per Monet's instructions and opened to the public as Musée Claude Monet on 17 May 1927.

According to Monet's original idea the installation of the *Grande Décoration* was to depict a panorama[32] of the lily pond in Giverny, fostering in the viewer the illusion of being in a real and infinite natural landscape without a horizon and without a shore-line. While associations of this kind certainly arise in the Orangerie and contemporary visitors did feel "like in an aquarium,"[33] the final installation in the Orangerie differs considerably from the empirical illusionism of 19th-century panoramas. The paintings in the Orangerie are a synthesis of the perception and sensation of nature in the sense of a comprehensive creative vision. The indoor presentation of these wall-paintings that actually surround the viewer physically requires his active participation and foreshadows the fusion of reality and art, of indoor and outdoor space, and the idea of the environment in modern art.

1 Claude Monet in a letter to André Duret: Daniel Wildenstein, *Monet: Biographie et catalogue raisonné*, vol. 2, Paris 1979, p. 229. ■ 2 The house provided enough room for what was by now a family of ten: Alice Hoschedé with her six children and Monet with his two sons, Jean and Michel. The ground floor and first floor had four rooms each. The barn to the west became Monet's first studio. The property was in the part of town called Le Pressoir (the winepress). It also included a garden surrounded by a fieldstone wall (clos Normand). ■ 3 After Monet's death in 1926 the garden and the house went to his son Michel, who died without issue in 1966. The property gradually deteriorated. It was not until the re-awakening of interest in Monet that it was restored at great expense and turned into the Musée Monet, opened to the public in 1980. Today it is a pilgrimage site for countless Monet admirers. ■ 4 Monet had also destroyed dozens of paintings. ■ 5 The water garden has an area of only about 1200 square meters. ■ 6 Cf. the re-collections of Monet's stepson: Jean-Pierre Hoschedé, *Claude Monet, ce mal connu*, Geneva 1960, vol. 2, pp. 49–50. ■ 7 Claude Monet in conversation with Marc Elder: Marc Elder, *A Giverny chez Claude Monet*, Paris 1924, p. 13. ■ 8 Claude Monet in conversation with Marcel Pays: *Exelsior* (26.01.1921); reprinted: Gustave Geffroy, *Monet, sa vie, son oeuvre*, Paris 1924, p. 250. ■ 9 Cf. D. Wildenstein, *Monet: Biographie et catalogue raisonné*, vol. 3, Paris 1979, nos. 1392, 1419, 1419b (3 views). ■ 10 Cf. D. Wildenstein, *Monet: Biographie et catalogue raisonné*, vol. 4, Paris 1985, nos. 1509–20 (12 views). ■ 11 Cf. D. Wildenstein, *Monet: Biographie et catalogue raisonné*, vol. 4, Paris 1985, nos. 1628–33 (6 views). ■ 12 Maurice Guillemot, 'Claude Monet,' *La Revue illustrée* (15 March 1898) n. p. Guillemot visited Monet in Giverny in August 1897, when he already saw studies for this project in the studio. ■ 13 Cf. D. Wildenstein, *Monet: Biographie et catalogue raisonné*, vol. 4, Paris 1985, nos. 1501–08. ■ 14 See note 5 and Arsène Alexandre, 'Un paysagiste d'aujourd'hui,' *Comoedia* (8 May 1909) p. 3. ■ 15 *Quelques oeuvres récentes de Claude Monet*, November 22–December 15,1900, Durand-Ruel Gallery, Paris. ■ 16 Cf. Emile Verhaeren, 'Art Moderne,' *Mercure de France* (February 7, 1901) p. 545. ■ 17 Cf. D. Wildenstein, *Monet: Biographie et catalogue raisonné*, vol. 4, Paris 1985, nos. 1911–33 (22 views).

■ 18 Cf. D. Wildenstein, *Monet: Biographie et catalogue raisonné*, vol. 4, Paris 1985, nos. 1655–58, 1662–67 (10 views). ■ 19 Cf. D. Wildenstein, *Monet: Biographie et catalogue raisonné*, vol. 4, Paris 1985, nos. 1671–91, 1694–1735 (42 views). ■ 20 Claude Monet in a letter to Gustave Geffroy dated August 11, 1908: Gustave Geffroy, *Monet, sa vie, son oeuvre*, Paris 1924, p. 238. ■ 21 From 6 May to 5 June at the Durand-Ruel Gallery, rue Laffite: 1903 series (1 view), 1904 series (5 views), 1905 series (7 views), 1906 series (5 views), 1907 series (21 views), 1908 series (9 views). ■ 22 The plan for a waterlily decoration comprising 12–15 canvases in a round room, or rotunda (dining room), existed as early as 1909. See the thorough study by Robert Gordon and Charles Stuckey, 'Blossoms and Blunders: Monet and the State,' *Art in America* 67 (January–February 1979). ■ 23 See particularly the review by Roger Marx, *Gazette des Beaux-Arts* 1 (June 1909) pp. 523–531, which includes fundamental comments by Monet on his painting procedure. ■ 24 Louis de Fourcaud, 'Les Nymphéas de Claude Monet,' *Le Gaulois* (May 22, 1909) p. 1. ■ 25 Romain Rolland in a letter to Claude Monet dated June 14, 1909: Gustave Geffroy, *Monet, sa vie, son oeuvre*, Paris 1924, p. 245. ■ 26 The diagnosis of cataracts on both eyes called for an operation that Monet avoided at first by having conventional treatment. ■ 27 Claude Monet in a letter to Gustave Geffroy dated April 30, 1914: D. Wildenstein, *Monet: Biographie et catalogue raisonné*, vol. 4, Paris 1985, p. 390. ■ 28 Claude Monet in a letter to A. R. Koechlin dated January 15, 1915: D. Wildenstein, *Monet: Biographie et catalogue raisonné*, vol. 4, Paris 1985, p. 392. ■ 29 Cf. Georges Clemenceau, *Claude Monet: Betrachtungen und Erinnerungen eines Freundes*, Frankfurt a. M. 1989. ■ 30 Cf. Georges Suarez, *La Vie orguilleuse de Clemenceau*, Paris 1930, pp. 625–627. ■ 31 'Monet's Fits of Anger,' *New York Times* (June 12, 1927). ■ 32 Around 1900, a panorama was a 360° picture (of an historical scene or landscape) arranged on the inside of cylindrical surface round the viewer as the center in a custom-built rotunda. It could be viewed from a raised vantage-point in the middle of the room. ■ 33 Cf. André Dezzarrois, 'Les Nymphéas de Claude Monet à l'Orangerie des Tuileries,' *Illustration* (21 March 1927) p. 548.

Pont-Japonais (Bassin aux nymphéas) 1899–1900

Claude Monet, Le Bassin aux nymphéas, 1899 The Waterlily Pond
Oil on canvas, 89 × 92 cm. London, National Gallery

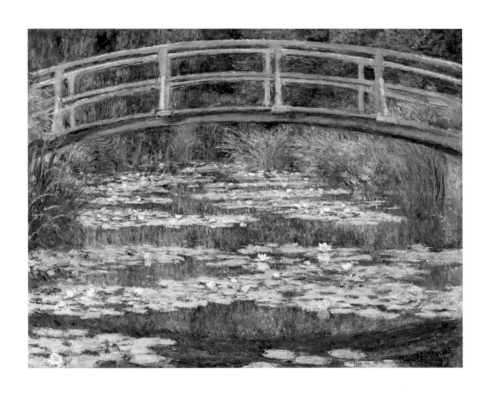

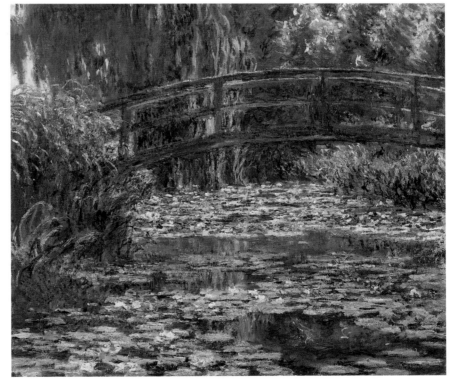

Claude Monet, Bassin aux nymphéas, 1899
The Waterlily Pond
Oil on canvas, 81 × 100 cm.
Washington, D.C., National Gallery of Art,
Gift of Victoria Nebeker Coberly, in memory
of her son John W. Mudd, and Walter H. and
Leonore Annenberg

**Claude Monet, Le Pont sur le bassin
aux nymphéas, Giverny**, 1900
The Bridge over the Waterlily Pond at Giverny
Oil on canvas, 89 × 100 cm.
Chicago, Art Institute of Chicago,
Mr. and Mrs. Lewis Larned Coburn
Memorial Collection

Claude Monet, Nymphéas, 1904 Waterlilies
Oil on canvas, 89 × 92 cm. Denver, Denver Art Museum, Helen Dill Fund

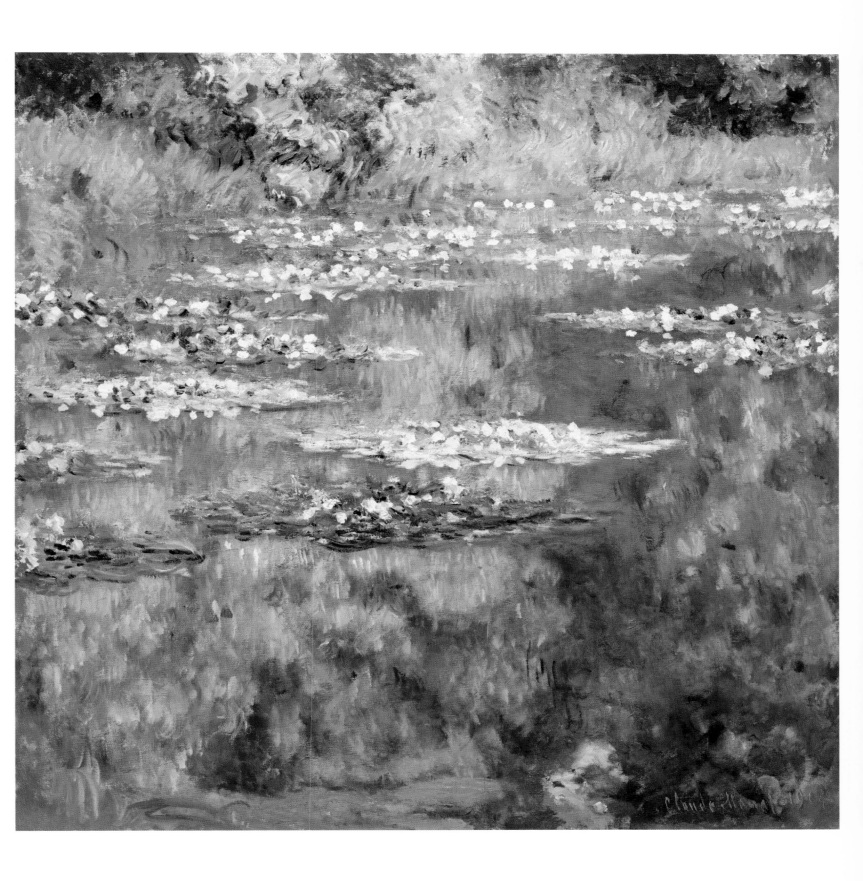

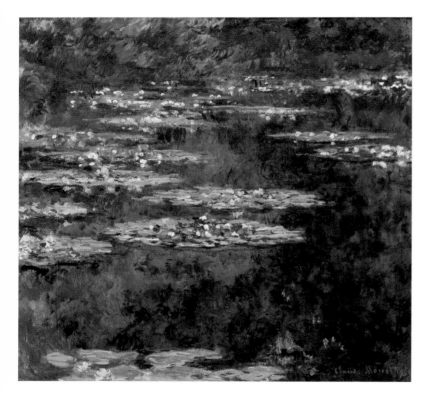 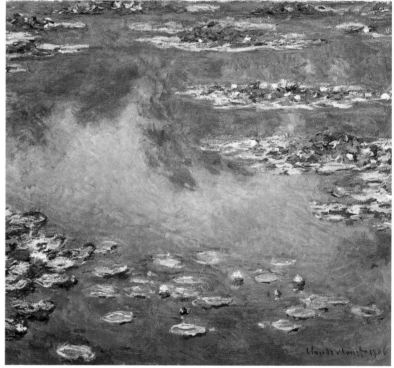

Claude Monet, Nymphéas, 1904 Waterlilies
Oil on canvas, 93 x 87 cm. Musée Malraux, Le Havre

Claude Monet, Nymphéas, 1906 Waterlilies
Oil on canvas, 90 × 93 cm. Chicago, Art Institute of Chicago,
Mr. and Mrs. Martin A. Ryerson Collection

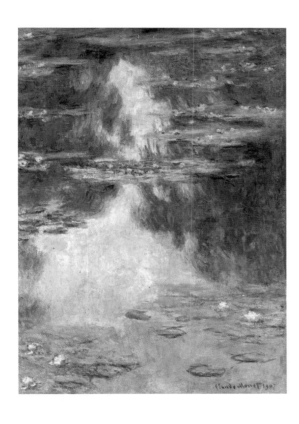 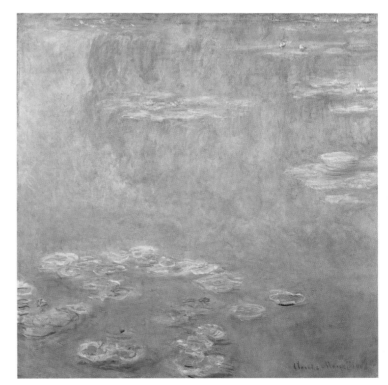

Claude Monet, Nymphéas, 1907 Waterlilies

Oil on canvas, 100.5 × 71 cm. Jerusalem, The Israel Museum

Claude Monet, Nymphéas, 1908 Waterlilies

Oil on canvas, 92 × 90 cm. Worcester, Worcester Art Museum, Museum purchase

Grande Décoration Iris 1914–1917

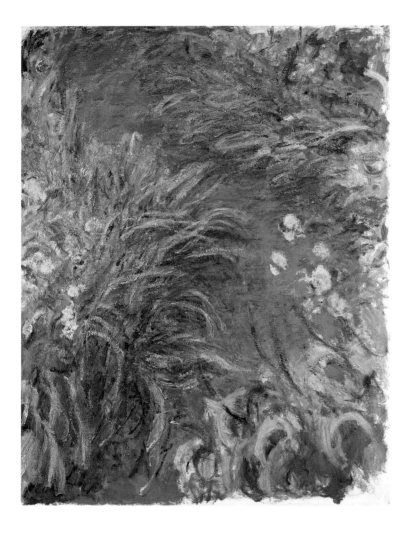

Claude Monet, Le Chemin dans les iris, 1914–1917
The Path through the Irises
Oil on canvas, 200 × 150 cm. London, National Gallery

Claude Monet, Iris, 1914–1917
Oil on canvas, 200 × 150 cm.
Richmond, Virginia Museum of Fine Arts,
Adolph D. and Wilkins C. Williams Fund

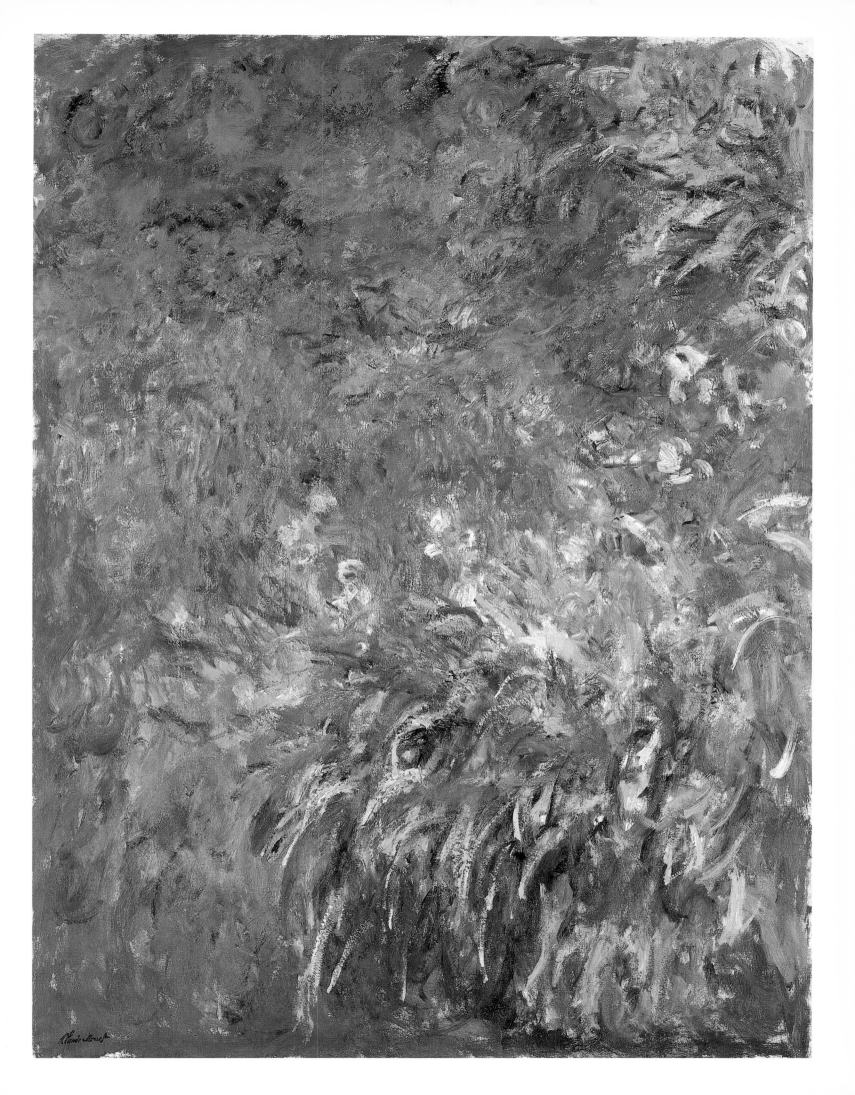

Grande Décoration Le Pont japonais 1918–1924

Claude Monet, Le Pont japonais, 1918–1924
The Japanese Bridge
Oil on canvas, 89 × 100 cm
Paris, Musée Marmottan-Monet

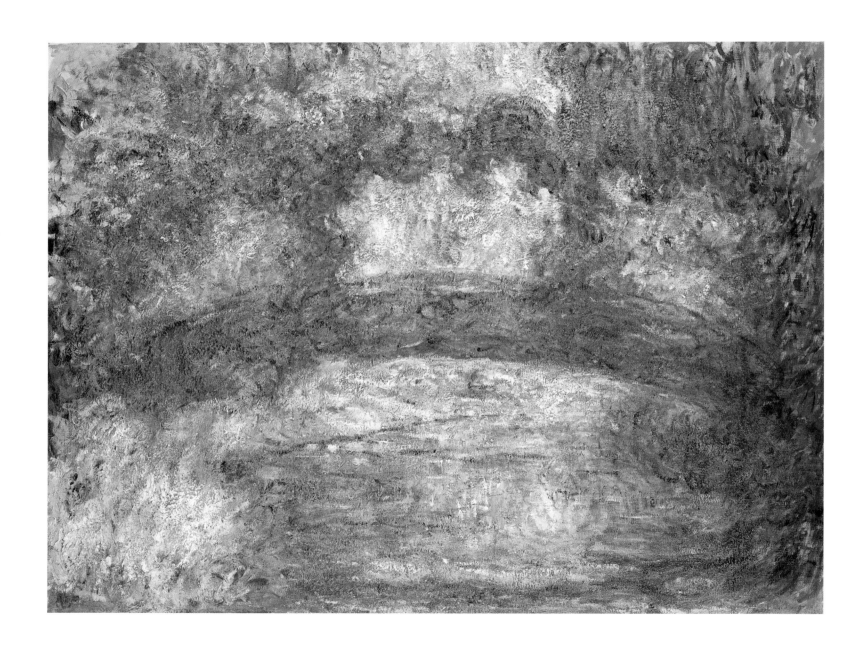

Claude Monet, Le Pont japonais, 1918–1924 The Japanese Bridge
Oil on canvas, 89.5 × 116.3 cm. Private collection

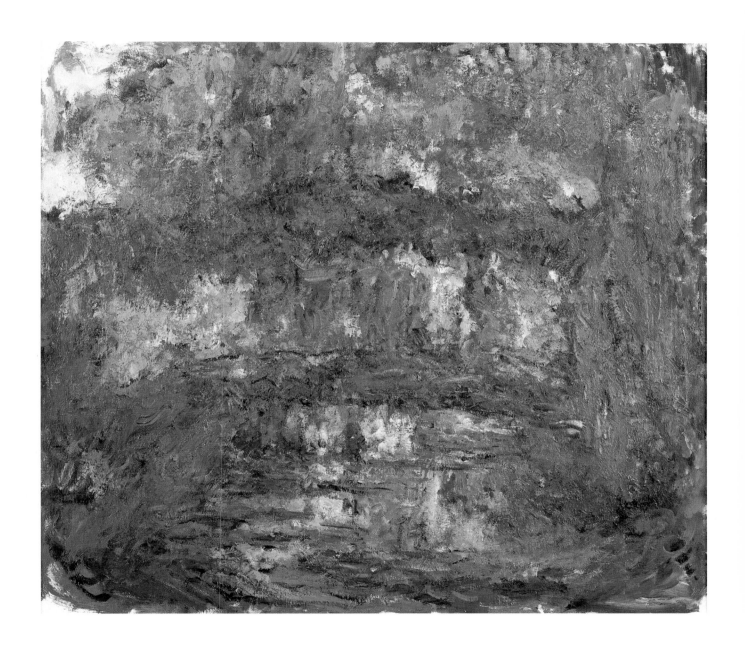

Claude Monet, Le Pont japonais, 1918–1924 The Japanese Bridge

Oil on canvas, 89 × 100 cm. Paris, Musée Marmottan-Monet

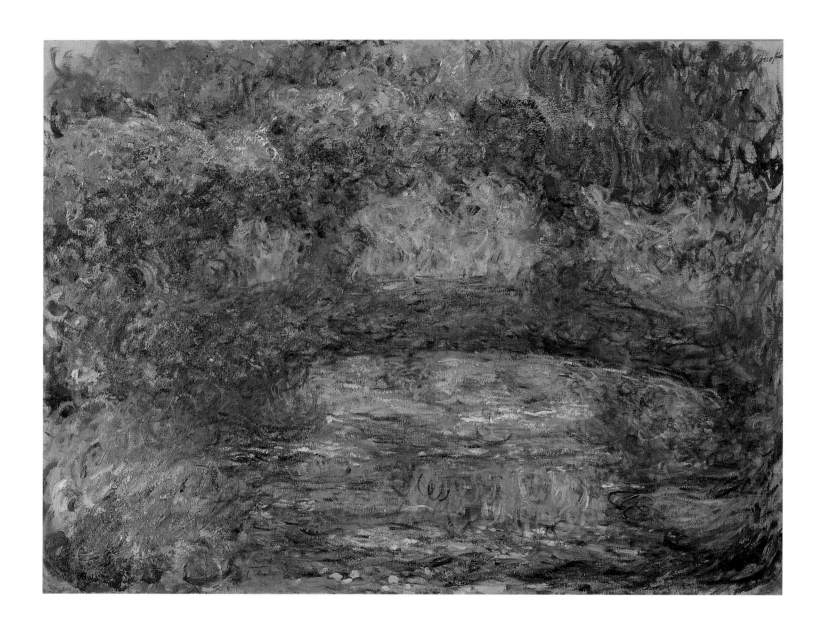

Claude Monet, Le Pont japonais, 1918–1924 The Japanese Bridge
Oil on canvas, 89 × 115 cm. Riehen / Basel, Fondation Beyeler

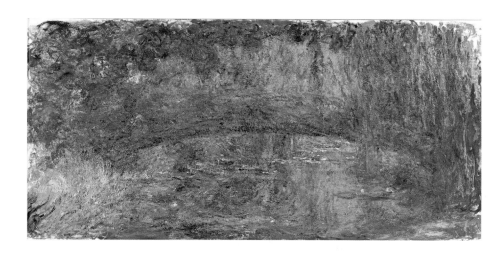

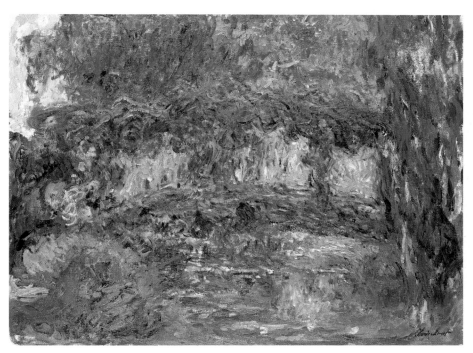

Claude Monet, Le Pont japonais, 1918
The Japanese Bridge
Oil on canvas, 100 × 200 cm.
Paris, Musée Marmottan-Monet

Claude Monet, Le Pont japonais, 1918–1924
The Japanese Bridge
Oil on canvas, 89 × 116 cm.
Minneapolis, Minneapolis Institute of Arts,
Bequest of Putnam Dana McMillan

**Claude Monet, La Passerelle sur
le bassin aux nymphéas**, 1919
The Footbridge over the Waterlily Pond
Oil on canvas, 65 × 107.5 cm.
Basel, Öffentliche Kunstsammlung Basel,
Kunstmuseum

Grande Décoration Saule pleureur 1918–1922

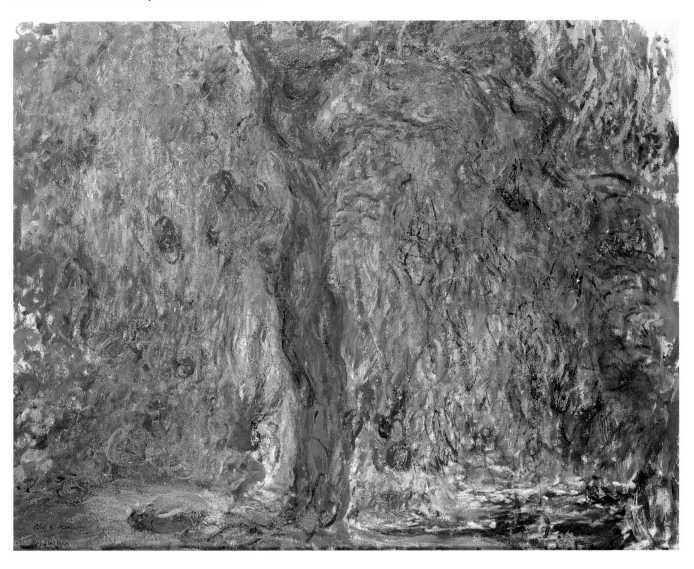

Claude Monet, Saule pleureur, 1918/19 Weeping Willow

Oil on canvas, 100 × 110 cm. Paris, Musée Marmottan-Monet

Claude Monet, Saule pleureur, 1918/19 Weeping Willow

Oil on canvas, 100 × 120 cm. Private collection

Claude Monet, Saule pleureur, 1920–1922 Weeping Willow

Oil on canvas, 110 × 100 cm. Private collection

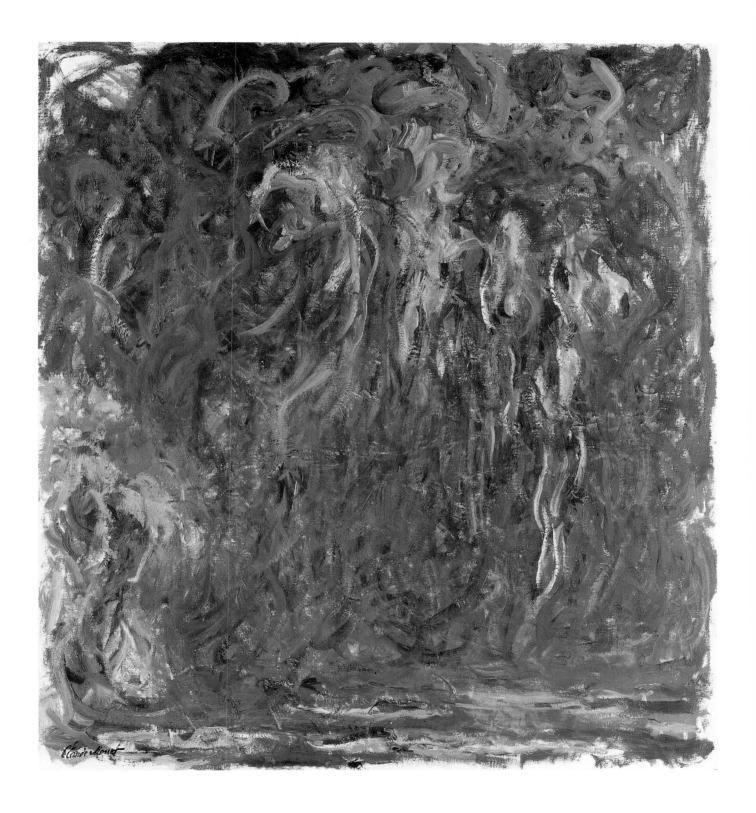

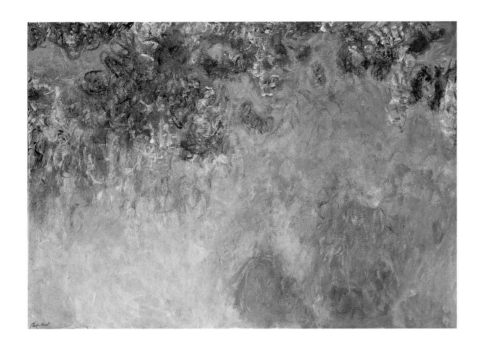

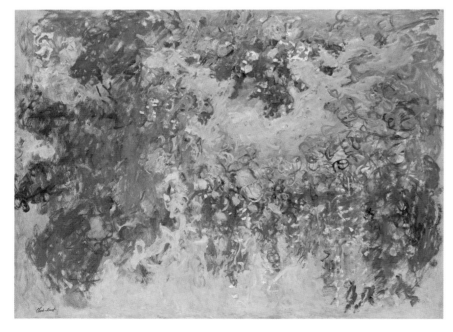

Claude Monet, Glycines, 1919/20 Wisteria
Oil on canvas, 150 × 200 cm. Private collection

Claude Monet, Glycines, 1919/20 Wisteria
Oil on canvas, 150 × 200 cm. The Hague, Haags Gemeentemuseum

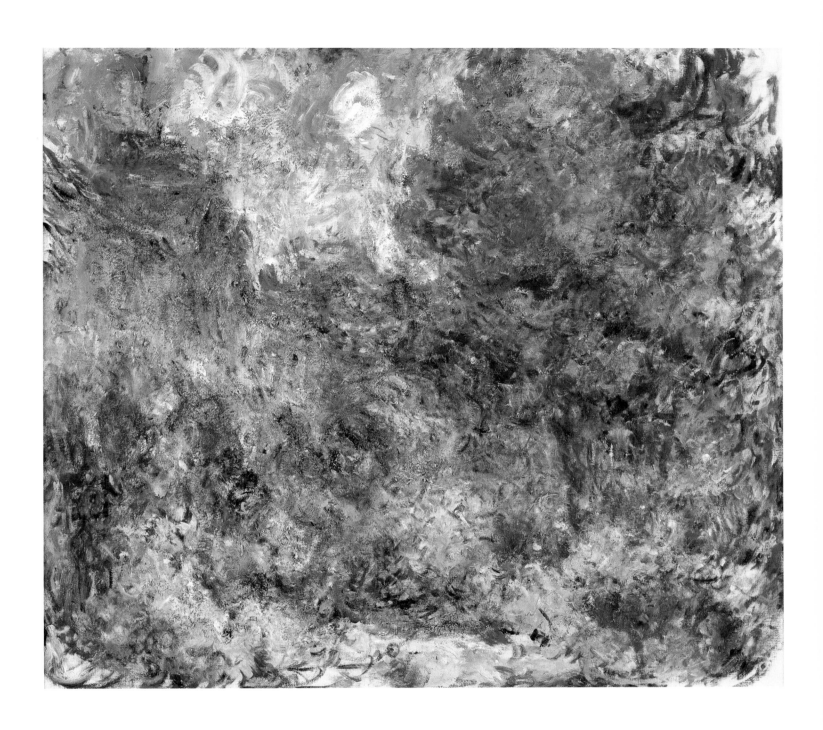

Claude Monet, La Maison vue du jardin aux roses, 1922–1924

The House Seen from the Rose Garden

Oil on canvas, 89 × 100 cm. Paris, Musée Marmottan-Monet

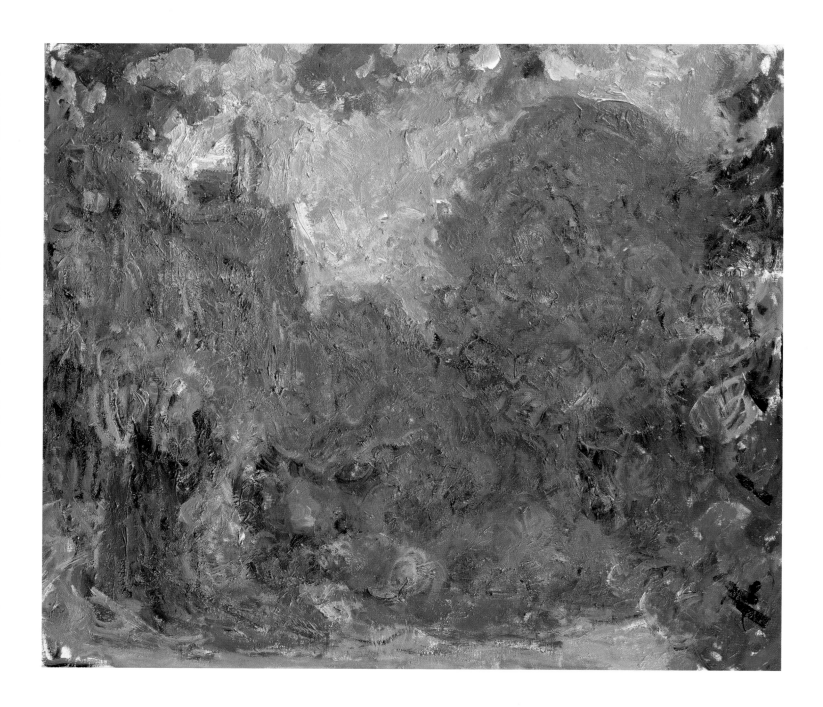

Claude Monet, La Maison vue du jardin aux roses, 1922–1924

The House Seen from the Rose Garden

Oil on canvas, 81 × 92 cm. Paris, Musée Marmottan-Monet

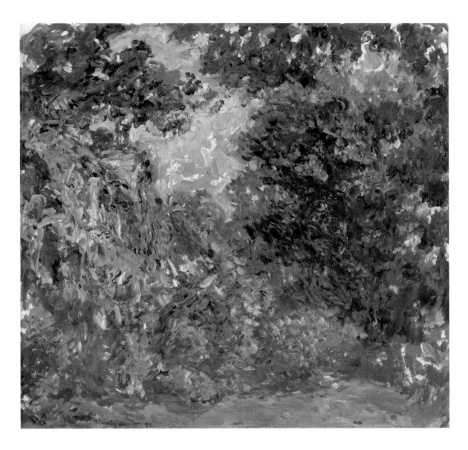

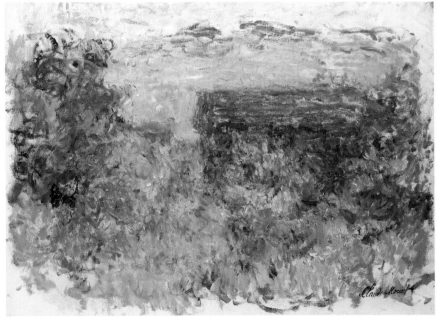

Claude Monet, La Maison de l'artiste vue du jardin aux roses, 1922–1924

The Artist's House Seen from the Rose Garden. Oil on canvas, 89 × 92 cm.

Paris, Musée Marmottan-Monet

Claude Monet, La Maison à travers les roses, 1925/26

The House Seen Across the Roses. Oil on canvas, 62 × 80 cm. Private collection

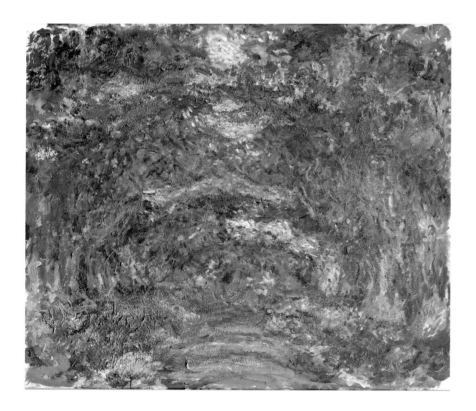

Grande Décoration L'Allée de rosiers 1920–1922

Claude Monet, L'Allée de rosiers, Giverny, 1920–1922 The Rose Walk at Giverny

Oil on canvas, 89 × 100 cm. Paris, Musée Marmottan-Monet

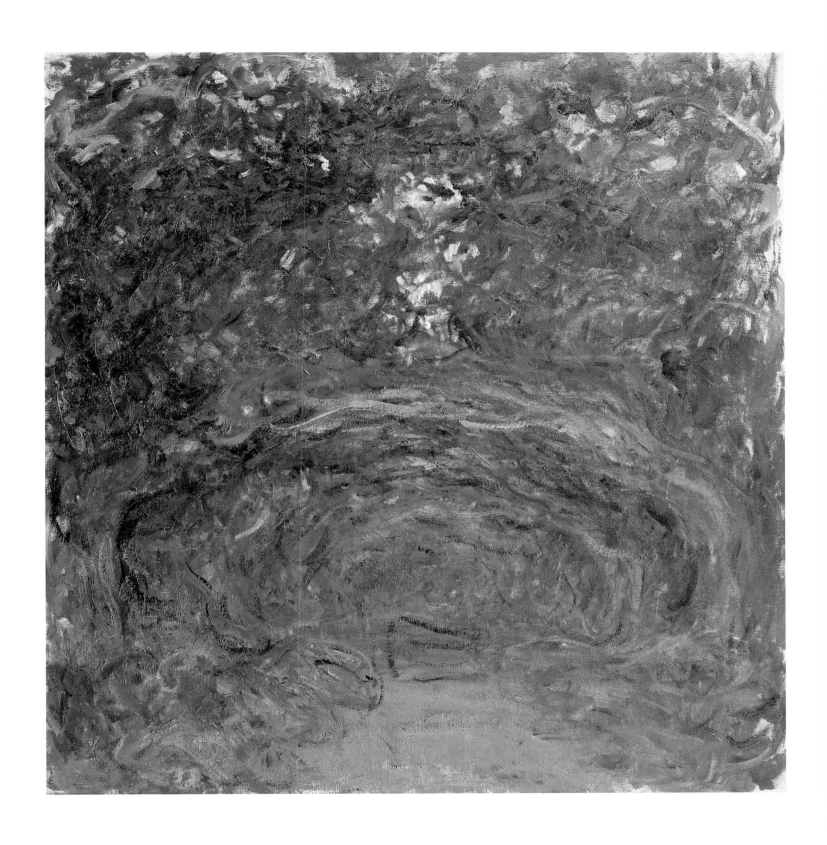

Claude Monet, L'Allée de rosiers, 1920–1922 The Rose Walk

Oil on canvas, 92 × 89 cm. Paris, Musée Marmottan-Monet

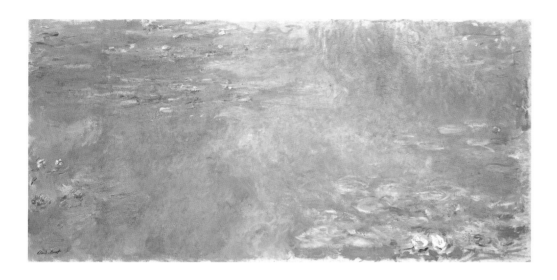

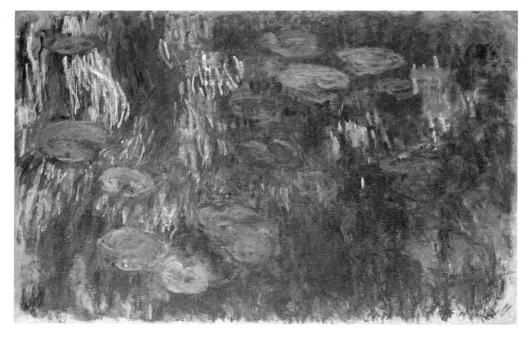

Claude Monet, Le Bassin aux nymphéas, 1917–1919 The Waterlily Pond
Oil on canvas, 100 × 200 cm. Private collection

Claude Monet, Nymphéas, reflets de saule, 1917–1919 Waterlilies and Reflections of a Willow
Oil on canvas, 130 × 200 cm. New York, Metropolitan Museum of Art, Gift of Louise Reinhardt Smith, 1983

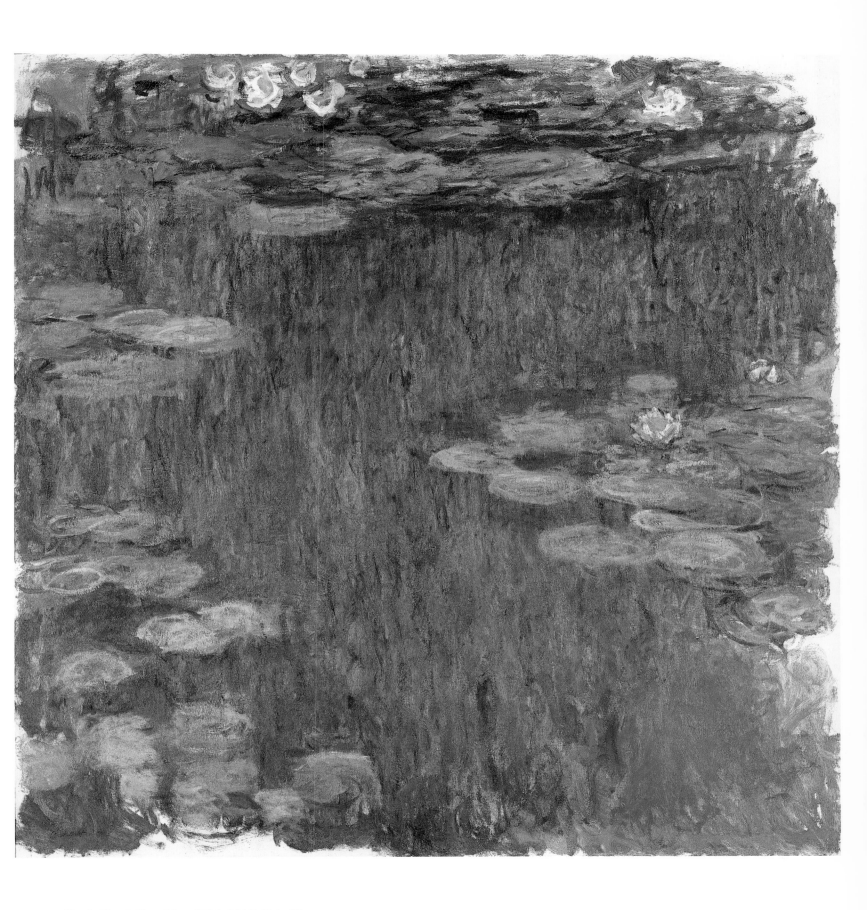

Claude Monet, Nymphéas, 1914–1917 Waterlilies

Oil on canvas, 200 × 200 cm. Private collection

Grande Décoration Nymphéas 1914–1925

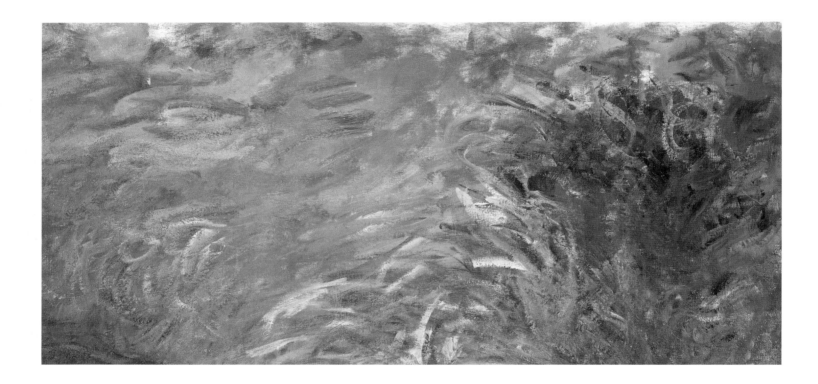

Claude Monet, Herbes aquatiques, 1925 Water plants

Oil on canvas, 56 × 109 cm. Private collection

Section of a larger, destroyed painting

Claude Monet, Nymphéas, 1918–1921 Waterlilies
Oil on canvas, 140 × 185 cm. Munich, Bayerische Staatsgemäldesammlungen, Neue Pinakothek

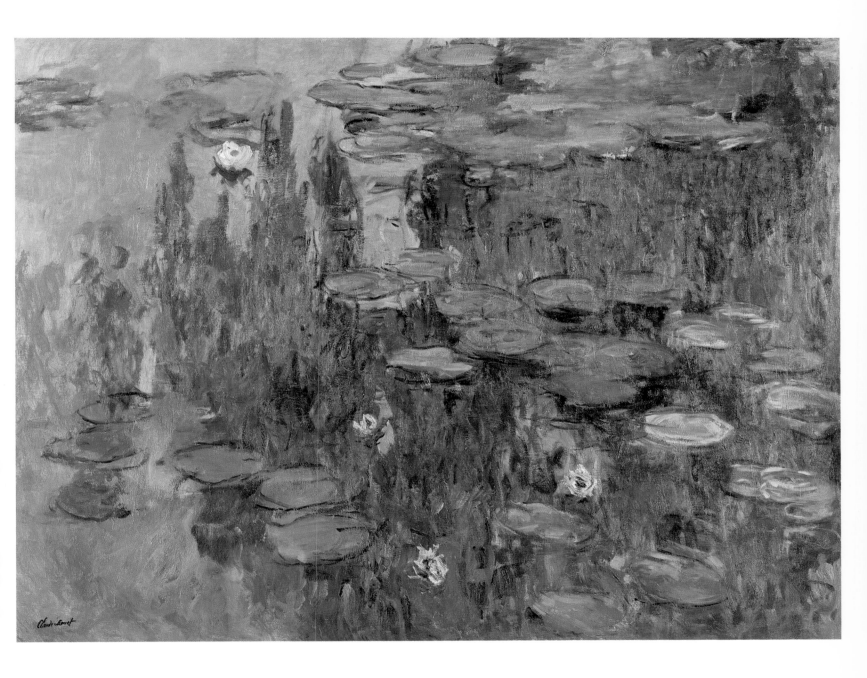

Grande Décoration Nymphéas 1914–1925

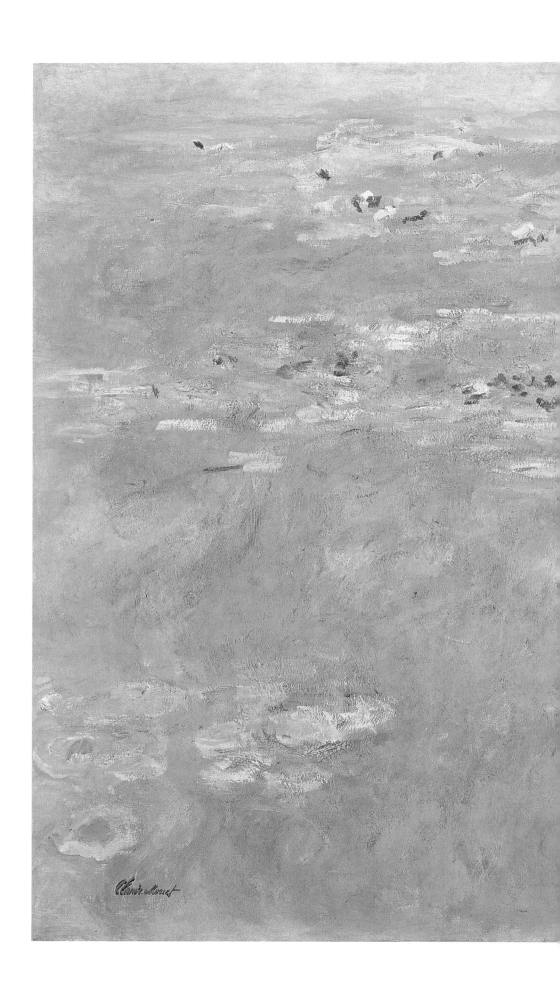

Claude Monet, Le Bassin aux nymphéas,
1917–1919 The Waterlily Pond
Oil on canvas, 130 × 200 cm.
Essen, Museum Folkwang

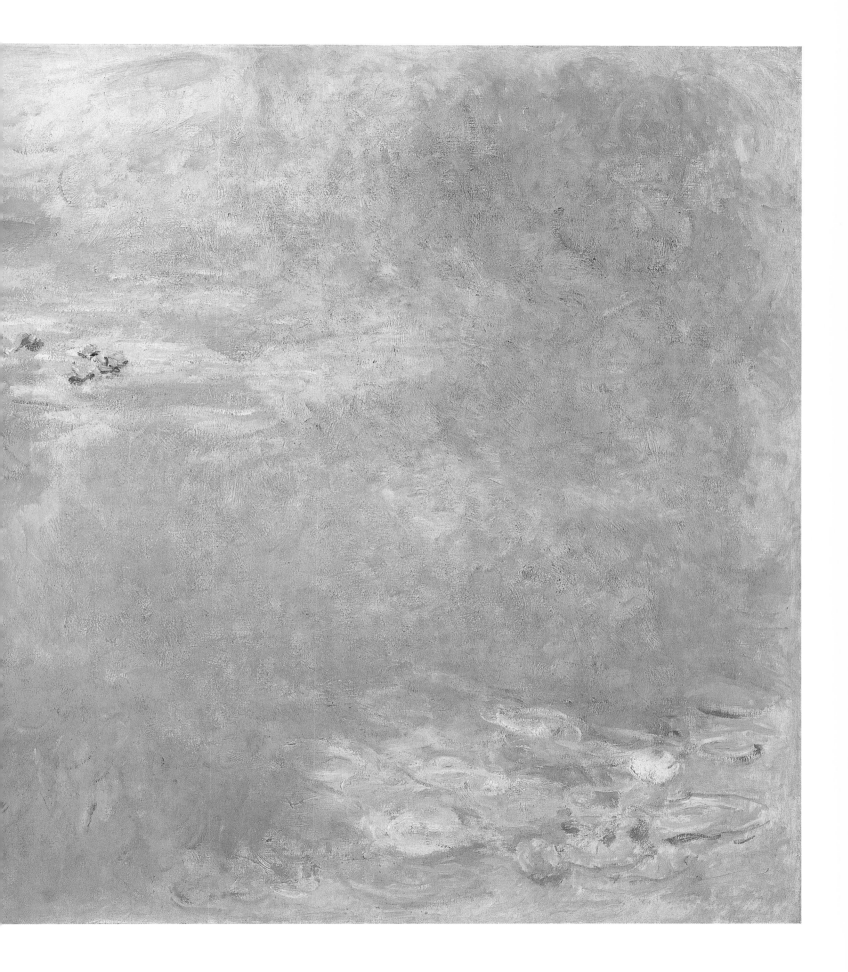

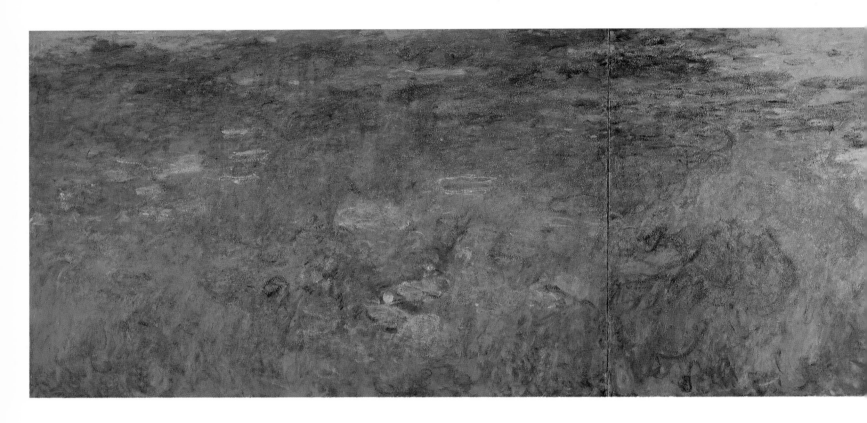

Claude Monet, Le Bassin aux nymphéas, 1917–1919 The Waterlily Pond

Oil on canvas (Triptych), each panel 200 × 300 cm. Riehen / Basel, Fondation Beyeler

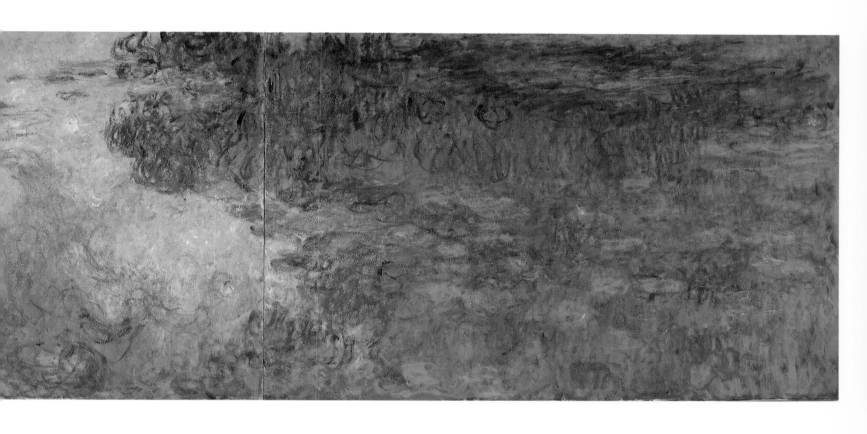

Claude Monet, Nymphéas, 1916–1919 Waterlilies
Oil on canvas, 200 × 180 cm. Private collection

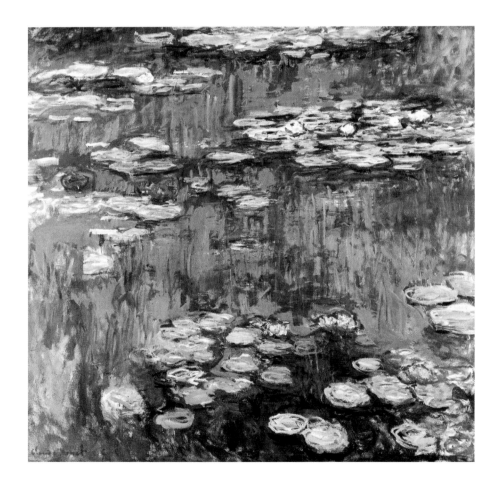

Claude Monet, Nymphéas, 1916 Waterlilies
Oil on canvas, 200 × 200 cm. Tokyo, National Museum of Western Art

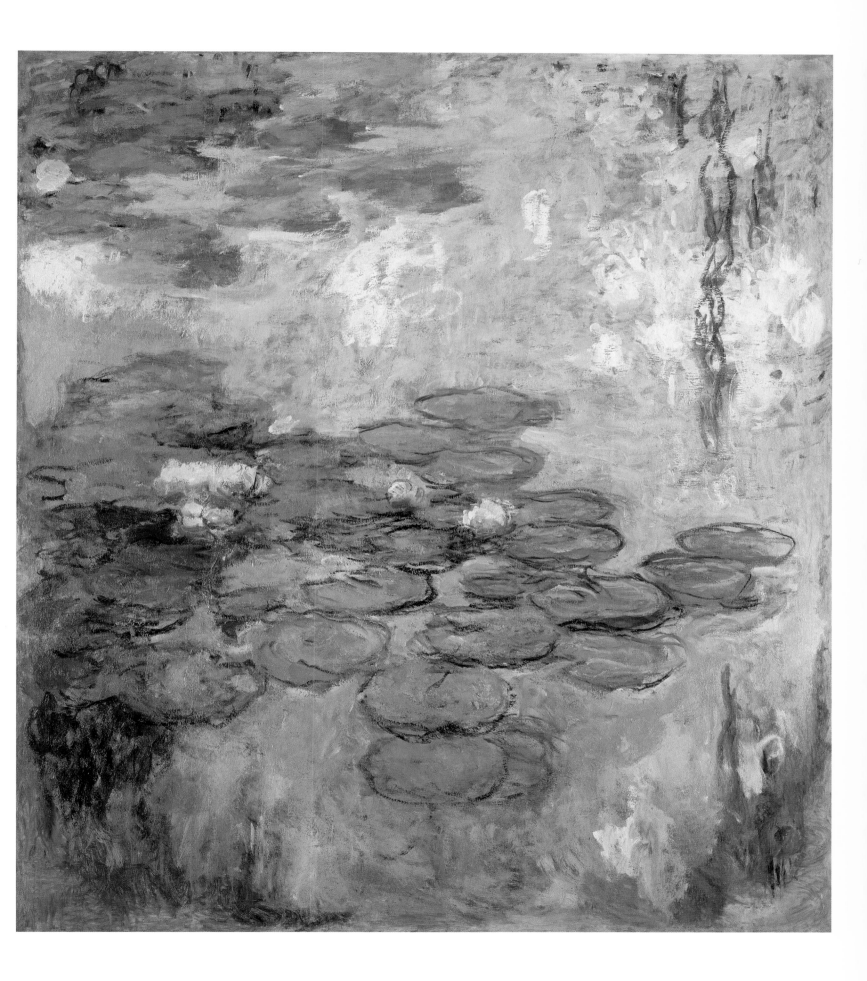

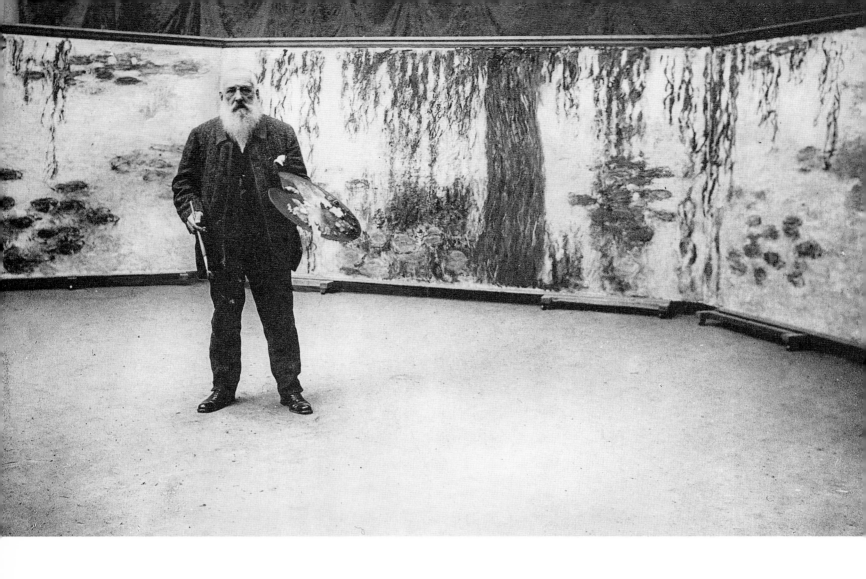

Claude Monet—Chronology

1840	Born in Paris
ca. 1856	Draws his first caricatures
1858	Meets the landscape painter Eugène Boudin
1860	Studies at the Académie Suisse in Paris, an independent art school where he meets Camille Pissarro
1861	Military service in Algeria; is discharged due to typhoid
1862	Studies at the independent studio of Charles Gleyre, where he makes friends with Auguste Renoir, Alfred Sisley and Frédéric Bazille; meets the Dutch landscape painter Johan Barthold Jongkind in Le Havre
1865	*Luncheon on the Grass*, the first *plein air* painting with figures
1869	Paints on the beach island of La Grenouillère with Renoir; chiaroscuro painting bound to local color dissolves into atmospheric spots of color
1870/71	Exile in London, where he admires the works of William Turner and John Constable
1871–78	Settles in Argenteuil; culmination of Impressionism
1874	First Impressionist Exhibition at the studio of the photographer Nadar
1875	Second Impressionist Exhibition; meets the art patron Ernest Hoschedé
1878–81	Lives in Vétheuil
1879	Fourth Impressionist Exhibition
1881	Successful sales through Durand-Ruel
1883	Solo exhibition at the Galerie Durand-Ruel; moves to Giverny

Claude Monet in his Waterlily studio, ca. 1920

Claude Monet in Vétheuil, ca. 1880

1890/91	*Meules* (Haystacks) series
1891	*Peupliers* (Poplars) series
1892–95	*Cathédrale de Rouen* (Rouen Cathedral) series
1896–97	*Matinée sur la Seine* (Mornings on the Seine) series
1899	*Le Pont japonais* (Japanese Bridge) series
1897–	*Nymphéas* (Waterlilies) series
1911	Solo exhibition at the Durand-Ruel Gallery in New York
1914–	Plans a large decoration with *Waterlilies* series
1921	Retrospective at the Galerie Bernheim-Jeune
1926	Dies of lung sclerosis
1927	May 17: opening of the *Grande Décoration* of the *Waterlilies* in the Orangerie in Paris

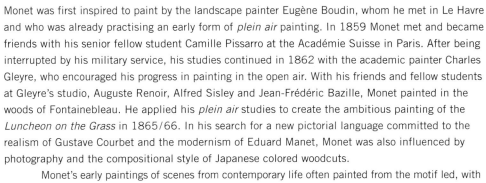

Monet was first inspired to paint by the landscape painter Eugène Boudin, whom he met in Le Havre and who was already practising an early form of *plein air* painting. In 1859 Monet met and became friends with his senior fellow student Camille Pissarro at the Académie Suisse in Paris. After being interrupted by his military service, his studies continued in 1862 with the academic painter Charles Gleyre, who encouraged his progress in painting in the open air. With his friends and fellow students at Gleyre's studio, Auguste Renoir, Alfred Sisley and Jean-Frédéric Bazille, Monet painted in the woods of Fontainebleau. He applied his *plein air* studies to create the ambitious painting of the *Luncheon on the Grass* in 1865/66. In his search for a new pictorial language committed to the realism of Gustave Courbet and the modernism of Eduard Manet, Monet was also influenced by photography and the compositional style of Japanese colored woodcuts.

Monet's early paintings of scenes from contemporary life often painted from the motif led, with his paintings of the beach island of La Grenouillère in 1869, to Impressionism. For the first time an artist had made the play of colored light on moving water show atmospheric changes, visual

Claude Monet in Giverny, ca. 1888/89

Claude Monet in his flower garden, ca. 1923

phenomena and movement by means of small, sketchy brushstrokes and lively high-contrast colors. The title of his harbour scene *Impression, Sunrise* shown at the First Impressionist Exhibition lent this new kind of painting its—originally intended as mocking—name: Impressionism.

After his exile first in London and then in Holland during the Franco-Prussian War of 1870–71, Monet lived in Argenteuil from 1872 to 1878. There he painted the works that mark the height of

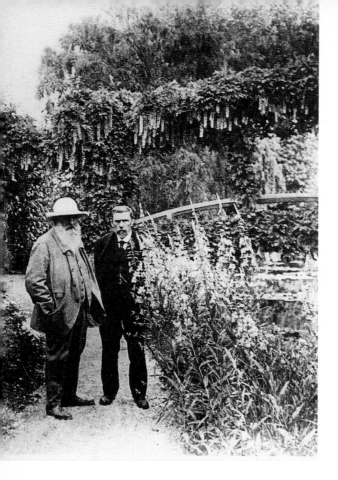

Impressionism: depictions of bridges, boats, scenes of family life in the house and garden, and views of town and country. They rank as classics in their wealth of color, luminosity and composition, and they influenced the other Impressionists. From 1878 to 1881 Monet lived in Vétheuil, another town on the Seine, where, after the death of his wife Camille in 1879, he painted deserted landscapes with a gloomy atmosphere (*Ice Drift* series).

In his attempts at capturing the constantly changing appearance of reality in an adequate pictorial form, Monet went increasingly beyond Impressionism and topographic accuracy from the 1880s on. He now painted unusual motifs: cliffs, rocks and bays that were difficult to access, views in severe cold weather, storms, rain or brilliant sunlight with novel visual angles. While painting the large series of his late period (poplars, haystacks, Rouen Cathedral), after he moved to Giverny in 1883, Monet found the way to a new pictorial language that was extremely important for the development of modern art. Featuring innovative views focusing only on a detail, reflections, symmetries, and heavy impasto in the paint, this new language culminated in the *Waterlilies* series painted by Monet in his famous Japanese garden in Giverny. Going beyond objectively perceptible reality, these paintings break with traditional pictorial concepts. Their intentional openness and ambiguity, their gigantic formats, their lack of frames corresponding to the opening into space, their abstract and expressive painting technique, and their generally autonomous pictorial means anticipated decisive developments in 20th-century painting. As the *Waterlilies* were outside contemporary art trends, they were long forgotten and not re-discovered until the 1950s, mainly by abstract painters in Europe (*Art Informel*) and the USA (Abstract Expressionism).

Claude Monet and Gustave Geffroy, ca. 1920

Claude Monet in his studio, ca. 1913

Lit.: *Monet's Years at Giverny: Beyond Impressionism*, exh. cat., Metropolitan Museum, New York 1978; *Hommage à Claude Monet*, exh. cat., Grand Palais, Paris 1980; Robert Gordon and Andrew Forge, *Monet*, New York 1983; Gottfried Boehm (ed.), *Claude Monet: Nymphéas, Impression, Vision*, exh. cat., Kunstmuseum, Basel 1986; Paul Hayes Tucker, *Monet in the 90s: The Series Paintings*, exh. cat., Museum of Fine Arts, Boston, New Haven and London 1989; Karin Sagner-Düchting, *Claude Monet: Ein Fest für die Augen*, Cologne 1990; Charles F. Stuckey, *Claude Monet 1840–1926*, Chicago 1995; Daniel Wildenstein, *Claude Monet: Biographie et catalogue raisonné*, vols 1–5, Paris 1974–1991; Karin Sagner-Düchting, *Monet in Giverny*, Munich 1994; Paul Hayes Tucker, *Monet in the 20th Century*, exh. cat., Museum of Fine Arts Boston/Royal Academy London 1998/99.

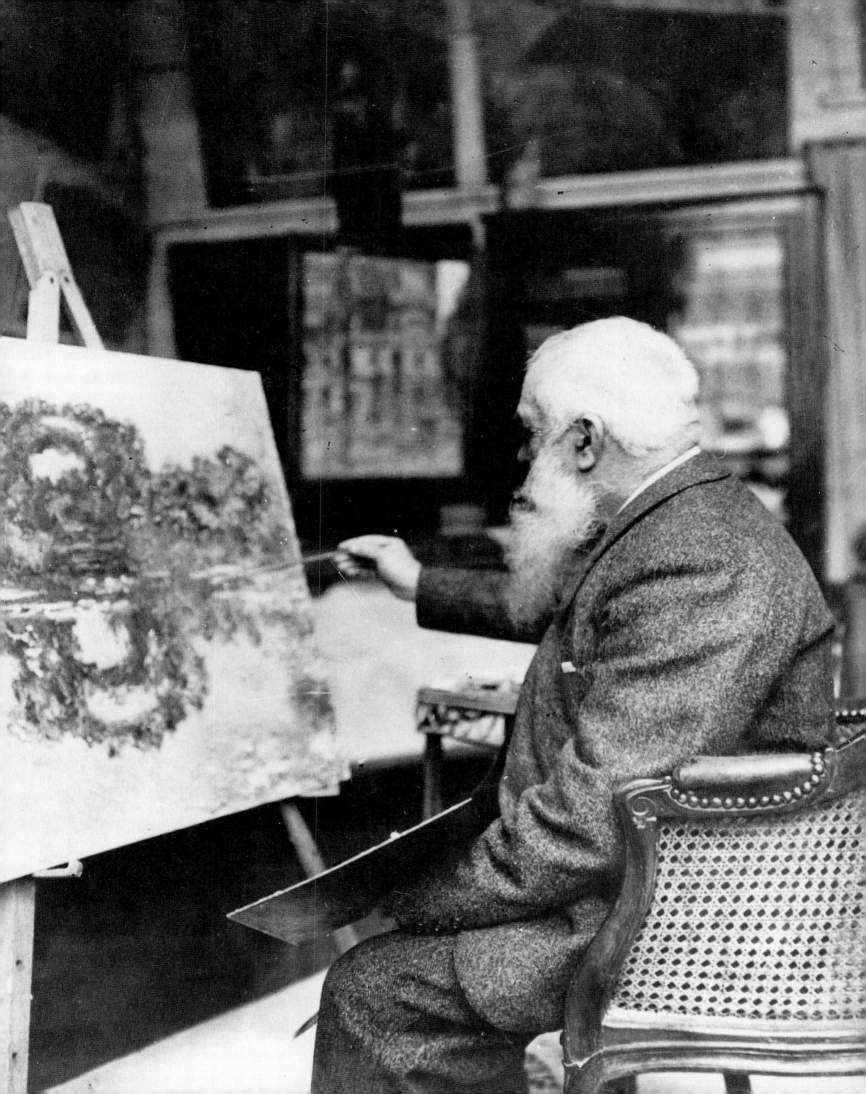

Monet and Modernism

Ann Gibson

Things in the World: Color in the Work of U.S. Painters During and After the Monet Revival

As the 21st century begins, some of the most recent art in this publication suggests two divergent understandings of French Impressionist Claude Monet's explorations of color at the end of his career. Already present among artists' divergent responses to Monet's renewed popularity at mid-century, at the century's end they seem again to be converging, as they did for Monet. One understanding, signaled in Joseph Marioni's *Yellow Painting*, 2001 (ill. p. 239), sees Monet's structuring of pigment and light in the *Nymphéas* independent of the delineation of objects and events in everyday life as a key development in the history of painting. The other, evident in Byron Kim's *Grunion Run,* 2001 (ill. p. 223), forges a fluid rapport between painting as an act of perception that connects viewers to 'things in the world' while also acknowledging that abstract paintings independent of this function are now things in that world, too. The difference is that artists engaged in the first direction have seen their art as the production of an independent visual phenomenon. In the second, the artist's priority is to represent, enact, or cause a connection between viewers' perceptions and things in the world. Of course, overlapping territory exists. Around mid-century and in the decades that followed, intense interest among artists in the issues at stake in this distinction precipitated a renewed interest in the Monet's late paintings.

A significant proportion of the painting in this exhibition represents the spectrum of concerns that Louis Finkelstein linked in 1956 to Monet's Nymphéas in "New Look: Abstract-Impressionism," one of a suite of articles by various critics that initially defined the Monet revival in the United States. Finkelstein saw artists such as Philip Guston, Joan Mitchell, and others[1] as inheritors of Monet's mantle in a generation whose styles had matured in the fifties, responding to the development of Abstract Expressionism in the forties. Of the Abstract Expressionists (many of whom were still producing at the time of his article) he noted that Hans Hofmann, Jackson Pollock, Willem de Kooning, and Mark Rothko, particularly important to the Abstract Impressionists of the fifties, evoked light and air in the same ways Monet had. Finkelstein indentified the color-based work he defined as "Abstract Impressionism" as "visual," (i.e., producing "a specifically optical experience,") opposed to the color of painting limited by "*a-priori*" structural systems (i.e., those oriented in Cézanne, Cubism, Constructivism) or by the "anti-theoretical ... symbolism of inner experience" (i.e. Abstract Expressionism). By contrast, the "Abstract Impressionists," as Finkelstein described them, derived their approach from painters like Matisse and the Fauves, Bonnard, and Monet. These painters, argued Finkelstein, had used heightened

Barnett Newman, Day Before One, 1951
Oil on cotton, 335 × 127.5 cm.
Basel, Öffentliche Kunstsammlung Basel,
Kunstmuseum, Gift of Schweizerische
Nationalversicherungsgesellschaft

color, among other means, to create a surface that integrated inner experience with sense experience. "For the artist," argued Finkelstein, "perception always challenges concept."[2] This was quite different, he cautioned, from the painting of Mondrian and Albers, whose relationships arose only from the conjunction of the lines, shapes, and colors, making it "irrelevant to construe these elements as referring to experience in the real world."[3]

By "optical experience" Finkelstein meant a visualism infused by both subjective and descriptive impulses—in some ways like Byron Kim's—and opposed to the geometric structuralism of Cézanne and the Cubists that many saw as the basis of modernist painting. "When Cézanne said of Monet that he was 'only an eye, but my God what an eye,' he was, besides defining a part of his own position, expressing a kind of artistic authority," wrote Finkelstein.[4] The well-established and hierarchical distinction between Cézanne's structure and Monet's amorphousness that Finkelstein wished to overturn was defused and refocused however—on an aspect of color closer to that supported by Marioni's *Yellow Painting*—by two articles that sandwiched Finkelstein's. Both by Clement Greenberg, a critic who had announced his concern with the optical in the forties, they presented an opticality less context-bound than Finkelstein's.[5]

Clement Greenberg, who would in the next decade become the dean of a newly-established opticality in American painting, published in 1955 an article entitled "American-Type Painting." His suggestion there that a structure of color instead of form could be the basis of important painting was especially important for the color-field wing of the group of artists that was beginning to be called American Abstract Expressionism. Although he praised Pollock as well as Rothko and Newman, he seemed most impressed by Still's painting in particular for employing a structure of color as opposed to three or even two-dimensional form. Still accomplished this, wrote Greenberg, through downplaying shape and value contract between areas [i.e. drawing and depth], thereby increasing the integrity of the painting's flatness.[6] Remarking that his somewhat belated critical acknowledgment of Still's importance coincided with the fact that "recently, some of the late Monets began to assume a unity and power they had never had before," Greenberg claimed that "as the Cubists resumed Cézanne, Still has resumed Monet...."[7] The general appeal of the style was, however, a problem for Greenberg. Seeing Turner as the first painter to break with the European tradition of value-painting, a break whose appeal to the general public Monet seemed to have inherited, Greenberg struggled to reconcile the coincidence of certain aspects of the color and style of the new tradition of close values with popular taste. Noting near the end of the article that the effect produced by Newman's, Rothko's and Still's use of large expanses of unbroken color that suppressed value contrasts may regrettably also be experienced by spectators as decorative, symbolic of landscape, or environmental, Greenberg concluded a somewhat conflicted apotheosis of their work with a plea that "American-type" painting be evaluated with the best of ambitious contemporary European painting.[8]

Two years later he raised the bar in "The Later Monet," claiming that what was at stake in the switch from Cézanne to Monet as the father of Modern art was not the move from the structural and symbolic to the optical, but from a structure based on the old analogues of three-dimensional form, dark and light, to a new structure based—like the radical Abstract Expressionists he had discussed in "American-Type Painting"—on huge canvases whose painted textures breathe color from the body of the canvas. Monet, he wrote, confirmed and deepened Impressionism's most revolutionary insight: "that values

—the contrasts and gradations of dark and light—were indispensable neither to the representation of Nature nor to the integrity of pictorial art." Where Cézanne and the Cubists evaded illusionism by exaggerating their value contrasts until they rose to the top like decoration, Monet suppressed value contrasts and ended up on the surface as well. What Greenberg thought the avant-garde initially missed in Monet's late paintings was that the lack of light and dark contrast in their twilight glimmer was not a lack of structure, but signaled instead a momentous exchange from the traditional pictorial armament of form to one of chromatic structure. He saw this new basis in color as "symphonic," moored in time solicited from large expanses of lateral space, not depth, and built on contrasts of hue and intensity, not dark and light.[9]

The differences between recent paintings by Marioni (a 'Radical Painter' whose work emerged in the 1970s) and Kim (emerging after Post-Modernism in the 1990s) with which this essay begins articulate concerns at the heart of the Monet revival. Like others whose work appeared at earlier points in the wake of that "vogue"—such as Milton Resnick, Ellsworth Kelly, and Jules Olitsky—Marioni's and Kim's work presents potentials for color in painting that critics and scholars will discuss. A similar situation existed between artists at the fore in the mid-fifties and the writers of entries in the "suite" of articles about the Monet revival.[10] They describe the issues that intensified around the function of color in Monet's late painting, issues that continue to strike fire in the work of contemporary artists, even in some who did not see themselves as particularly interested in Monet. This essay will discuss the uses of color that emerged as central to the Monet revival in the United States. In order to establish the situation from which we discern them, it is helpful to look briefly at the forms those practices have taken in the two paintings by Kim and Marioni mentioned above.

The title of Kim's *Grunion Run*, one of a series entitled *The Sky is Blue*, is a reference to a group of fish who have silver streaks running along their sides, and who swim at nearly full moon in schools to spawn off the California coast (where Kim used to live). Suggested by a friend after the painting was completed, it gives a most specific reference to this fairly generalized image that consists of a sharply delineated line across the canvas that becomes somewhat atmospheric in the center.[11] A slightly modulated cold blue is brushed above the line and a deeper azure is spread thick and smooth below. The painting's material presence is like sixties modernism in its spare composition and use of paint as physical stuff, but perhaps even more like certain paintings by Gerhard Richter. Like Richter's *Abstract Painting No. 525 "Prague"* (ill. p. 277) which represents abstraction but which is itself an individual, particular abstract painting, *Grunion Run* is conceptual in the way its title makes a specific event out of an otherwise generalized image.[12] Kim connects his interest in Richter's work with Monet: "I saw [Richter's] *Atlas* and realized he wasn't lyric—everyone who follows him is ironic and he's not. To me now he's the - *only* painter. I think there's part of him that does follow Monet: the part about *seeing*."[13] Like Monet, Kim neither gives up the referential function of the image, nor abandons painting as a record of perception, here seen as a continuing interest in sky and water, but pursues an image that exists "somewhere in between my mind and my eyes."[14]

On the other hand, for Joseph Marioni, the achievement of Monet in his late paintings is his frequent use of color's optical potential to occupy actual space, as opposed to its more usual role either as the provider of emphasis and illusion in drawn arrangements

of representational objects—or as a conceptual link between the perception of color in paintings and the way it operates in conditions or objects in the world. Marioni, whose work emerged two decades earlier than Kim's and became allied in the mid-eighties with "Radical Painting," understands that Monet was not, in his era, able to completely abandon representation completely (as was the case with Picasso and Braque as well). But Marioni intends to do precisely this. His purpose in *Yellow Painting* is to produce a volume of certain color, in this case, a yellow that is nuanced by glazes and translucent coats of greens, pinks, and various grays and yellows as they are rolled, brushed, or permitted to drip down the canvas.[15] Traces of the painter's manipulation and the paint's response as it is pushed or coaxed into place are not obscured, because for Marioni it is important to the presentation that a) the viewer understand the painting as a consciously proffered volume of color, not a found surface, a mechanically reproducible product or a happy accident, and that b) the viewer understand that color they see as *real*, a primary phenomenon, not a representation of color seen elsewhere. *Yellow Painting* is an intentional object whose effect on the viewer Marioni does not predict, but courts by providing an unusually rich, skillfully structured sensual experience of colored substances (various pigments in acrylic binders) as they articulate the light they reflect. The different articulations of light (colors) that viewers see is subtle, but within a narrow band of intensity and tone, and quite diverse. It differs noticeably in changing kinds and amounts of light. While viewers' are challenged to make visual discriminations about their actual perception, their emotional and intellectual *responses* to the kind of attention the painting prompts may vary widely, a part of their reaction the painter has no desire to direct or control. What he does hope his audience understands is that a person made the object that is giving them the opportunity for this experience, that their perceptual recognition of the material itself is a part of the painting's content, and that the colors they see are actually there.

Losing Monet and Finding Him Again: An Inversion of Signs

Monet's intention overall has never been easy to understand, because its apparent simplicity as he stated it was belied by his paintings' effects. He claimed, if often coyly, that he merely wished to provide an accurate record of the action of light as it illuminated objects in the world: "Perhaps my originality boils down to being a hypersensitive receptor, and the expediency of a shorthand by means of which I project on a canvas, as if on a screen, impressions registered on my retina," he observed to a journalist in 1909.[16] But viewers' responses to his work differed to such an extend that the paintings have come to be regarded as more than mere recordings. Was Monet just an eye—or as his analogy suggests, a recording device with a paintbrush? Or was his obsessive persistence in transcribing the increasingly acute distinctions of his "impressions" of light's effects on such everyday objects as trees, rivers, and meadows actually what enabled him to produce not only what some saw as pantheistic hymns to nature herself and emblems of the endurance of the French nation after World War I, but also as some of the earliest material abstractions in the history of art?[17]

The Nymphéas, especially, raised such questions. As he had in the series of the grainstacks and the facades of Rouen cathedral, Monet painted the surfaces of the waterlily gardens he had constructed and planted at Giverny from different angles, at different

times of day and evening, and during different seasons of the year. But for a number of reasons, Monet's involvement with the multiple subjects that the lily ponds comprised lasted longer than his other series, stretching through decades that became effectively interwoven with events in his own personal life, that of his family, and that of the nation.[18] The apparent subject of the Nymphéas—water, plants, and reflected sky—is at once common and cosmic, a situation in which neither iconographic nor even symbolic or visionary interpretations could assume a satisfying finality.[19] In addition, even the breadth of the reaches of these associations, whose poles seem as if they might encompass the universe, tend to dissolve on close viewing into expanses of iridescent color that later painters, such as some of those in this exhibition, chose to use as a springboard to the perceptual, psychological, and material adventures of 20th-century art.

At the time of World War I, as Clement Greenberg remarked in 1957, "Monet seemed to have nothing to tell ambitious young artists except how to persist in blunders of conception and taste."[20] By its end in 1918, critical opinion preferred the articulations of physical form that structured the paintings of Cézanne, Renior, Degas, and the later Van Gogh, Gauguin, and Seurat, to what came to be seen as the "amorphousness" of Impressionist artists such as the later Monet. Indeed, in a televised interview Marcel Duchamp intimated that when Monet painted *Chapel at Blanville* in 1902 Impressionism was still considered an avant-garde style; but that by 1904 it was outdated.[21]

By mid-century, however, there were signs of a revision of this judgment in the acquisition of later Monets by "a collector of very modern art in Pittsburgh" and André Masson's extremely positive remarks about Monet's paintings in 1952, including a memorable remark that the Orangerie was the "Sistine Chapel of Impressionism" began to be widely quoted.[22] By the time Greenberg alluded in 1957 to his own earlier repudiation in 1945 of the later painting of Monet for its dependence on "the texture of color as adequate form in painting," he was one of the last to weigh in with a positive opinion that Monet was Cézanne's equal.[23]

One of the first institutions to review Monet's later work after the war was the Basel Kunsthalle in 1949, which included in an exhibition of Impressionism some of the water garden paintings left at Giverny.[24] In 1952–53, the Kunsthaus in Zurich, the Galerie Wildenstein in Paris, and the Gemeentemuseum, The Hague together produced a Monet exhibition; in 1954 in an exhibition of Impressionist paintings, the Brooklyn Museum showed three late Monets; and in April and May of 1945 Wildenstein & Co. in New York showed 83 Monets.[25] Most influentially for artists in the United States, Alfred Barr, the Museum of Modern Art's director of Museum Collections, bought a large waterlily painting in the spring of 1955. Critical articles in trade and scholarly journals in the two years after this date suggest that it was the acquisition of this painting, more than any other single factor, that sparked the Monet revival in New York.[26] In 1957 a Monet exhibition was held in St. Louis and Minneapolis, and in 1960, the grand finale of the Monet Revival, an exhibition curated by William Seitz, was held at MoMA, traveling to the Los Angeles County Museum of Art.

The pathos of Monet's decades of struggle against loneliness, war, blindness and death to produce the *Nymphéas* ran contrary to the years of rational balance of the *juste milieu* that followed World War I. However, as Romy Golan succinctly pointed out, after World War II "an inversion of signs took place." Through the lens of an Abstract Expressionism

exported to France, most notably in Paul Facchetti's exhibition of Pollock in Paris in 1952, the waterlily paintings began to be seen not as dead relics of a past era, but as the epic landscape of a great soul's existential struggle.[27] The very impermanence of the effects projected by these murals, which were then visibly damaged in the war, emphasized their vulnerability, as opposed to the effect of solidity projected by art produced before and during the war that was more obviously in service to political regimes.[28] In a recollection quoted by Golan, Facchetti wrote that not only the Pollock show but the response of American painters in Paris spurred a reevaluation of Monet's *Grandes Decorations*:

"For us [the French] it [the discovery of Abstract Expressionism] was an extraordinary adventure: we discovered a painting triumphant with the freedom of color and rhythm. There was a great impulse given by Pollock. The American painters, on the other hand, those who came to Paris after the war with their famous G. I. bills, they were impressed by European culture, and they all rushed like flies to one place: the Orangerie, to look at the *Nymphéas* by Monet, those colored rhythms with no beginning or end."[29]

One of the first American critics to publicly rethink Monet's significance did so even before MoMA's purchase. Robert Rosenblum in October 1954 reviewed the "Varieties of Impressionism," on view at the Brooklyn Museum under a subtitle that would set the tone for the critical revision of Monet already underway among collectors and curators: "In the Context of Contemporary Styles the 19th Century Masters Reveal New Values." Although he also mentioned Cézanne, Gauguin, Bonnard, Degas, and others, Rosenblum found the Monets above all surprising because of their unexpected analogies with recent painting. Three late Monets especially, including the *Church of Vernon* of 1894 and the *Ducal Palace* of 1908, he wrote, made him think "inevitably" of Rothko, Pollock, and Guston. By making work whose coherence was accomplished with color, not line, Rosenblum observed, they challenged traditional, "i. e., *cubist*" (the emphasis is Rosenblum's) conventions of formal structure.[30]

By the time critics had had time to see the *Nymphéas* purchased by the Museum of Modern Art, upwardly revised opinions of Monet seem to have become nearly unanimous among the most highly respected supporters of Abstract Expressionism, although not all of them connected the reason for their new appreciation to Abstract Expressionism. Leo Steinberg noted in February 1956 that along with the reflections in the river of the long, straight tree trunks in *Four Trees* (1891) (ill. p. 117), the comparable doubles of reality in the shadows of the *Haystacks* at the Metropolitan and the clouds reflected in the lower part of MoMA's new waterlily garden painting enabled him to see that "the hierarchy of things more or less real is not determined by degrees of tangibility; that all those things are real which fully form the contents of experience." Although he reported that in these paintings "the whole world is cut loose from anthropomorphic or conceptual points of reference" Steinberg did not here draw connections between contemporary abstraction and Monet.[31]

But in October of 1956, Thomas Hess read Clement Greenberg's essay on "The Later Monet" for the upcoming *Art News Annual* and saw a remarkable exhibition, "Les *Nymphéas* series de Paysages d'eau by Claude Monet," at Knoedler's. The exhibition contained 14 paintings, and, as the announcement indicates, exhibited work by lenders such as Mr. and Mrs. Bareiss, Mr. Edgar Kauffman, Jr., Mr. and Mrs. Loeb, and Mr. and Mrs. David Rockefeller. The largest portion of the announcement card was occupied by

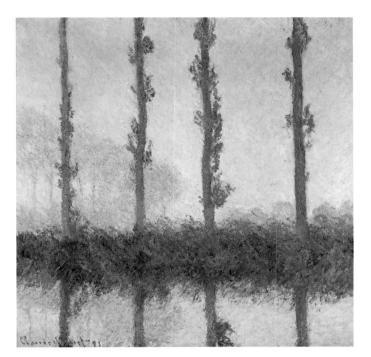

an extended quotation from the English translation of Georges Clemenceau's *Claude Monet, The Waterlilies*, worth reprinting here for the similarity of its description of the French painter's procedure and the surfaces of his paintings to the romantic conception of current Abstract Expressionism:

"The Waterlily panels will show him to us lost in his reach after realizations of the impossible. From his quivering hand shoot rockets of transparent luminosity, which cause the thick paint to burst into flame. Genius is no less present in the attack of his brushes upon the canvas than in the churnings of his many-colored palette, on which Monet will gather with a single stroke, resolutely, the drops of luminous dew which he will return as alms to the elements which have not troubled to keep them. Close to the eye, the canvas appears to be a bacchanalia of incongruous colors, which, from the proper distance, become ordered, aligned, associated for a delicate construction of interpretative forms in the precision and steadiness of the realm of light."[32]

With this fresh in his mind, Hess wrote that although formalist criticism a quarter of a century earlier attacked Monet "as a vaporizer of form," painting such as that by Pollock, Rothko, Still, Barnett Newman, Ad Reinhardt and Tobey, and writing by Masson and Barnett Newman, had changed the situation. Monet's establishment of the surface of the painting as the location of meaning made him modern, thought Hess; but because he was not "a modern of today" he maintained contact also with the external realities of the sky, plants, the surface of the water, and the pond below its transparent surface.[33] It is clear from this comment and his list (with the possible exception of Masson, see below) that for Hess, "a modern of today" would not paint even as mimetically as Monet. It also suggests that Hess' thinking about what connects the "moderns" to Monet follows Monet's *treatment* of light and color, but does not pursue his connection, even metaphorically, with nature in the form of water, sky, and plant life. Such a break, like the passage from Clemenceau used by Knoedler, posits a visual framework for judging painting in which color and texture might constitute as effective a structure for painting as line and form. This is what was at stake in considering a switch to Monet from Cézanne as the father of Modernism. But in neither of these camps, as Hess' comment about Monet's not being a "modern of today" implies, was there room for either metaphoric or metonymic reference to things in the world. In the broadest of terms, then, the operational basis for the switch that the Monet Revival sealed was from an earlier emphasis on tensions between flat and three-dimensionally shaded form (or between depicted line and the actual line of the edge of the painting), to the tensions in forms produced by the difference between value and intensity among hues. This was the division that Greenberg, Hess and others effected when they suggested that Monet's use of color (that is, not only Cézanne's emphasis on the cube, the cone and the cylinder) could form the armature of painting. But the effects of this division, with its potential to separate (and elevate) artists whose interests were structured through color from those structured with form, multiplied in many directions after the split was initiated in the mid-1950s, and by the century's end had not only become more emphatic and focused in the work of some (Marioni), but had also circled

Claude Monet, Les quatre arbres, 1891
Four trees. Oil on canvas, 82 × 81.5 cm.
New York, Metropolitan Museum of Art,
H. O. Havemeyer Collection, Bequest of
Mrs. H. O. Havemeyer, 1929

back to re-embrace the metaphoric and metonymic referents above and below the surface of the *Nymphéas* that Hess dismissed (Kim). This exhibition includes work in both of these areas by artists whose thinking and/or careers have been substantially affected by the understanding of color's potential for structural primacy that informed the re-evaluation of Monet in the 1950s.

Drawn to the puzzle of Monet's simultaneous homage to what many saw as the - incompatible realities of abstraction in painting and the natural world, a month later Hilton Kramer also commented on the new Monet at MoMA and those in the Knoedler exhibition. Debating Fry's devaluation of Monet in favor of Cézanne and citing Wilhelm Worringer's sociological and developmental separation of naturalism and abstraction, Kramer wrote, "What makes Monet's achievement so baffling is that he arrived ultimately at a style whose components we are used to regarding as separate, incompatible entities, as deriving from opposite cultural impulses." Pushing the point, Kramer observed that although "in this generation" most spoke of the waterlily paintings "as if they had *no* naturalistic basis at all," to Monet, "this Naturalistic interest was scarcely negligible."[34]

Museums, curators, collectors, and critics were surprisingly quick to change their evaluations of the late paintings of Monet. As Golan and Leja have noted, they were prompted by American painting itself, especially certain work of some Abstract Expressionists. Looking back through late 20th-century considerations of color to the most heralded initiators of the Monet revival—Jackson Pollock, Clyfford Still, Willem de Kooning, Barnett Newman, and Mark Rothko—it is useful to consider also the role of artists whose work received less attention at that time, and whose uses of color occurred along a spectrum that stretches from color alone to color as a conduit from the eyes to the mind: Hans Hofmann, Beauford Delaney, Mark Tobey, Milton Resnick, Sam Francis, Ellsworth Kelly, Joan Mitchell, and Richard Pousette-Dart. It was not primarily, however, a matter of the painters' spoken or written appreciations of Monet's late work or even of impressionism in general that effected the scholarly, institutional, and economic reevaluations of Monet. Rather, lessons taken by those who had learned to read in color, texture, and paint application a language and even a subject sufficient for painting began to see Monet as the beginning.

Early Appreciation

Hans Hofmann, who taught a number of American painters, including Carl Holty and Louise Nevelson in Munich and Lee Krasner, Milton Resnick and Clement Greenberg in New York, is one of those who prepared the ground for a re-evaluation of Monet. Although Hofmann was known more as a translator of Fauvism and Cubism than of Monet, the deep and personal derivation of his knowledge of modern painting enabled him to encompass and pass on the lessons of Monet's color, particularly its independence from the modeling of form, a lesson that would have been reinforced by more than a passing knowledge of Kandinsky. Hofmann first saw impressionist painting in Munich in 1898, surely earlier than nearly any other participant in the Monet revival in the United States. By 1903 he could count Picasso, Braque, Matisse and Delaunay as his colleagues in Paris. Teaching in Berkeley and Los Angeles in 1930 and 1931, and in New York by 1932, Hofmann developed a complex and flexible method of relating color to form that he was able to

convey to his students, as well as to practice in his own painting. He continued to teach until 1958, the year he painted *The Pond*, whose title as well as its brilliant hues recall Monet. He then retired and embarked upon the most active period of production in his career. *The Conjurer* (1959) (ill. p. 211) is a product of his new-found freedom.

One of those who most effectively inserted into the "New American Painting" its tendency to incorporate tendencies of style and feeling previously thought to be incompatible, Hofmann (unlike Monet) emphasized the importance of emotion and memory to painting. Nevertheless, Hofmann believed passionately that painting is "forming with color."[35] Greenberg's preference for painting in which color was permitted to operate at full or close to full intensity was probably established and surely confirmed by Hofmann's concern for what the painter called "the intrinsic life of color". Greenberg would later write that Hofmann's discovery was that "color can galvanize the most inertly decorative pattern into a pictorial entity." By refusing any obligation to three-dimensional form, he was able to show how color could subsume it. In doing so, observed Greenberg, "he has linked up, over Delaunay's and over Matisse's head, with Monet's last phase."[36] According to Hofmann, any shade or tint "emanates a very characteristic light," but "tonal painting," [adding black to make a color recede or white to make it come forward from colors toned in deeper values] in which "color is degraded to a mere black-and-white function" prevents the creation of this light, an idea basic later to Greenberg's rationale in "American-Type Painting".[37] Unlike Monet, Hofmann did use black, as *Conjurer* demonstrates, but not for "tonal" shading. Instead, like Manet, he used it as a color. But of the *social* suggestion of the title of *Conjurer*, and of the large, black, anthropomorphic shape at its center (reproduced in color in his Hofmann catalogue of 1963, where he described Hofmann's esthetic principles in pages of sensitive detail), neither Greenberg of Seitz say a word.

Non-recognition is the significant obverse of the understanding of "blackness" in the work of another painter, Beauford Delaney, in the same years that *Conjurer* was painted. Whereas Hofmann's modernist use of color receives considerable attention, and justifiably so, Delaney's use of color has not been seriously analyzed.[38] Hofmann started in Europe and moved to the United States; but Beauford Delaney sailed in the opposite direction. He arrived in Paris in 1953, the year Monet's paintings in the Orangerie, having been damaged in World War II, were re-opened to the public. David Leeming, the artist's biographer, said the artist mentioned Monet frequently, and spoke about his (Delaney's) visit to the Orangerie.[39]

Although Delaney's apprehension of Monet was most apparent in his abstract work done in Paris, such as *Untitled,* 1960 (ill. p. 184), and *Untitled*, 1963 (ill. p. 185), Delaney, like Hofmann, was exposed early in his artistic life to Monet.[40] In Boston, Massachusetts from 1923 to 1929 he took classes at the Copley Society, the South Boston School of Art and the Lowell Institute, taking advantage also of Boston's rich offerings in literature, music and the arts. He became adept at classical portraiture, and haunted his "favorite place in Boston," the Isabella Stewart Gardner Museum. He enjoyed the Impressionists, admiring Monet particularly.

When an exhibition of his paintings was held on the occasion of his death in 1926 in the studio of the also recently deceased John Singer Sargent, Delaney attended. He was extremely impressed by Monet's concerted effort to portray the effects of light on color and form at different times of day. Leeming, one of the few who has explored Delaney's

papers, comments that the waterlily paintings he saw there gave him a language with which to develop the more emotional and visionary apparatus of his New York street scenes of the early 1930s and his still more abstract paintings of the later years.[41] Some of his paintings, such as *Burning Bush* (1941) (ill. p. 133), done in New York, demonstrate the appreciation of Monet as well as Van Gogh Delaney had developed in Boston. Some of his earlier cityscapes, as well as some portraits and abstractions could be described in the terms Thomas Hess had used to evoke Monet's late paintings of his garden in the Knoedler show in 1956—"high-keyed and acrid,"—such as the *Le Pont japonais* (ill. pp. 80–85) canvases or other paintings from the Marmottan such as *L'Allee de rosiers*, or *La Maison de l'artiste* (ill. pp. 90–93) in this show. "The effect is electric," wrote Hess. "Monet stimulated his annual dexterity to its highest excitement, igniting bushes into flames.... The hot colors are intense.... They are African landscapes—burnt, sandy, red and green." Hess associated this last comment with Monet's age, saying that perhaps all old men's interior landscapes are Africa.[42] Monet's age and infirmities had made it hard for people to see his paintings even before his death; Hess's remark, an effort to make aging into a special and particular place, not just a disintegrative stage, suggests his awareness of the continuing nature of the problem, one that Delaney and Hofmann would have shared with Monet.

Hess was less aware, however, that Africa, like age and color, is often poeticized into something else, like the "primitive," which had already been metamorphosed in both Paris and New York between the World Wars into a healing balm for modernity's wounds. When people looked at Delaney's work, they were more apt to see Africa than age, especially if they were aware of the artist's African heritage. Noting *not* that the figures were flattened so that color might operate at its fullest (as Seitz had in discussing even a painting like Hofmann's C*onjurer* whose title and large black anthropomorphic central form connoted Africa more than anything in most of Delaney's paintings), the critic Jean Guichard-Meili wrote that portraits in an exhibition in 1964 "tended toward a primitivistic form," but more astutely observed that "background, clothing, hands, faces are the pretext for autonomous harmonies." Moreover, he sensitively wrote of a group of abstractions that quite probably contained *Untitled* 1963 that "Only a methodological and extended exercise of vision will permit their being sensed and savored amid and beneath the network of color tones, differentiated among themselves, the subtle play of this pink and that blue (of the same value), the movements of internal convection, the vibrations of underlying design."[43]

If Hofmann and Delaney flew under the radar screen of most of the critics discussing the influence of Monet on modern art during the Monet revival of the fifties, André Masson did not. Nevertheless, he was not considered to be one of the revival's major figures, perhaps because his own personal "Monet revival" began—and ended—some time earlier, when, before returning from the U.S. to France at the end of World War II, he visited the Metropolitan Museum and found Monet's *Cliffs at Entretat* particularly engaging.[44] But later, in the early fifties, it was Masson's published remarks of high regard for Monet, as Greenberg and others suggested, not his paintings, that added fuel to the fervor for the French painter. But if Masson's main effect on the Monet revival of the mid-fifties was due only to his written enthusiasm for Monet's "acceptance ... of the flight of time, of the ephemeral,..." it was not because he was not, like Monet, painting the effect of this acceptance in terms of things in the visible world. In fact, 'things' like pomegranates, flowers and fish had become quite apparent in a fairly literal way in his paintings between

1950 and 1952. Masson failed to become a major figure in the revival at least in part because he actually chose to *withdraw* from the kind of painting that most clearly showed his enthusiasm for Monet, referring to them as a temporary regression. Perhaps he had become aware that the newborn naturalism of his interpretation was out of place in a New York art world in which abstraction was rapidly becoming the signature of the avant-garde. In any case, by 1954, the artist was writing to Alfred Barr, whose acquisition of one of the *Nymphéas* for MoMA's collection in 1955, remember, was to be the galvanizing event of the Monet revival, that he had put the mimetic elements of his recent work behind him. The "'return' to sensation that I attempted these last years," the artist told the curator, had been superseded by an evolution of his work toward "a renewal of the imaginary and of vision." Characterizing by 1970 the impressionism he had earlier adopted in order to suppress drawing and form to evoke the sensation of a fleeting moment as a "trap," Masson recalled in 1972 of that time, "the line, banished, is once again favored."[45]

It was not until 1955, eight years after he had returned to France from the United States, that he began paintings such as *Le Printemps s'avance*, 1957 (ill. p. 243) and *Migration d'automne*, 1960, that effectively demonstrate a comprehension more like that of his contemporaries in New York of Monet's achievement. Like Pollock's paintings, they can be read as abstract works referring only to themselves as objects. But at the same time, with the help of their titles, they are streams of pollen floating in a dark stream or the cosmos in the night sky in *Printemps*, or petals, leaves, or even large groups of people in movement, seen from overhead, as in *Migration.* Masson may have seen his "Impressionist" period as a necessary retreat to sensation—or felt it necessary to characterize it as such to Barr—but these two kinds of "vision"—both his pomegranates and his "petals" of paint —hover in viewers' consciousness in the way Monet's bright lilies appear simultaneously as flowers and as squiggles and smears of paint on a dark surface.

Well before Masson wrote about Monet's ability to paint the fleeting moment, abstract painters in the U.S. and Europe were developing a kind of painting that set the stage for Monet's reevaluation. Mark Tobey, for instance, who spoke highly of Monet, was more deeply influenced by elements of Asian art and culture than by the Impressionist.[46] Tobey saw the empirical observation that cubism demanded as too controlling, separating "the knower and known, seer and seen," he said, quoting Ananda Coomaraswami.[47] According to William Seitz, Tobey's preeminence in a reevaluation of Monet occasioned by Abstract Expressionism and Tachisme lay in Tobey's early initiation of the allover, nonfocal composition in 1936, a mode that became a major characteristic of Abstract Expressionism only a decade later when it was taken up by Pollock, Bradley Walker Tomlin and Ad Reinhardt.[48] Tobey's interest in allover composition (which continued for the rest of his life, as is evident in *Unknown Journey,* 1966, and *Oncoming White,* 1972 (ill. p. 297), owes as much to his enjoyment of the textures of sea-shells, tree-bark, and ceramic pieces as to the example of Monet.[49]

Seeing Monet through Abstract Expressionism

It is very unlikely that Jackson Pollock had even seen one of Monet's waterlily paintings in person before he painted *Lavender Mist* in 1950 a painting that has been discussed in terms of its similarity to the *Nymphéas*, although there is a better chance that he may

have found aspects of Masson's work instructive.[50] (Pollock probably did see drypoints such as Masson's 1941 *Rape* in Stanley William Hayter's New York Studio, where both Masson and Pollock worked, as well as paintings such as Masson's *Meditation on an Oak Leaf* (1942) and *Pasiphaë* (1943), which shares significant iconography as well as elements of style with Pollock's *Pasiphaë* of the same year.[51])

A series of articles published in 1967 by William Rubin still informs aspects of current comprehension of Monet's continuing significance for modern painting and it codified Pollock's position in the Monet revival. But it also aligned the connection between Monet and Pollock with the opticalization of color occurring in the wake of color field painting and in opposition to the social and real-world associations of color attending the ascendancy of Pop art. In the second article of this series Rubin observed that Pollock's painting was similar not only to that of Monet but to other Impressionists in its disengagement of color and brushwork from their customary duties of contouring and describing objects, and in the approximate evenness of density of color and texture. But "the large, late Monets," he claimed, "constitute the sole genuine precedent in the modern tradition for the wall-sized pictures pioneered by Pollock, Rothko, Newman and Still, beginning in 1950."[52] Note that Rubin used the word 'precedent,' not 'influence.' Like Pollock, he wrote, "the late Monet digests nature but recasts it poetically." Quoting painter Robert Goodnough, Rubin wrote that faced with paintings such as Pollock's *Lavender Mist, One* (ill. p. 123), and *Autumn Rhythm,* as with Monet, "one is aware of color rather than colors."[53] Monet alone advanced a new solution. In the Orangerie series he retained Impressionism's alloverness but with a much bigger brushstroke. It worked because it abandoned the earlier structure of hue juxtaposition for a dominant tonal color with a variation of values from dark to light.

According to Rubin, the late Monets announced a new conception of scale, as even the largest Matisses, Picassos, and Mattas, which had figurative and/or illusionistic aspects, did not. Like Monet, Pollock's Rothko's, Newman's and Still's wall-sized picture of 1950 likewise abjured figuration and illusion for large scale, "although they were arrived at independently. In fact," remarked Rubin, "the revival of the late Monet which began in the late forties [coinciding with paintings in this exhibition by Pollock such as *Alchemy* (1949) and *Untitled* (1949) (ill. p. 265)] represented—as I have observed—a convergence of tastes in which the big Pollocks unquestionably played a role." What was different about the scale of the Americans' paintings, Rubin explained, was that while Monet had retained a scale related to nature, the Americans' pictures had an *absolute* scale, one that owed more to Mondrian than to Monet. But unlike most architectural murals, wrote Rubin, the achievement of these paintings is their maintenance of the intimacy of easel painting at the size of the mural, but without the social implications of its esthetic subordination to the collectivity of architecture.[54]

If Pollock's "affinities" in 1950 with the Monet revival of the mid-1950s was determined only after the fact and enlarged and certified a decade later, detailed discussions of the relation to Monet of other major figures in the color field wing of Abstract Expressionism—the artists elevated in Greenberg's 1955 "American-Type Painting" to the pinnacle of achievement (i.e., Newman, Rothko, and Still)—were developed even later. When Rubin wrote about Abstract Expressionism's integration of intimacy and architectural scale, he might well have been responding to ideas such as those expressed by Rothko in 1951:

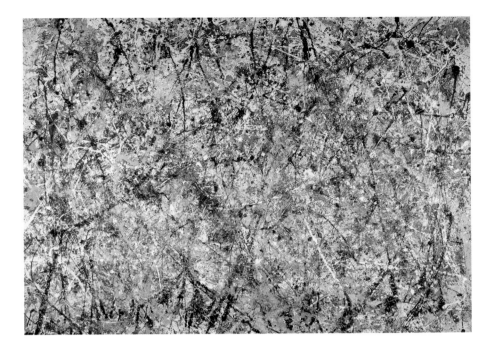

"I paint very large pictures. I realize that historically the function of painting large pictures is something very grandiose and pompous. The reason I paint them, however—I think it applies to other painters I know—is precisely because I want to be very intimate and human. To paint a small picture is to place yourself outside your experience, to look upon an experience as a stereopticon view or with a reducing glass. However you paint the larger picture, you are in it. It isn't something you command."[55]

In 1987, in the Tate Gallery's Rothko retrospective, Robert Rosenblum noted that, like Monet's series paintings, Rothko's chromatic variations on his chosen structure [as may be observed in Greens and Blue on Blue, 1956, and Saffron, 1957, in this exhibition] offer the widest variations, "from the blazing intensities of sunlit reds and oranges with their blue-violet reflections to the near-invisibility of pallid hues concealed in the fog of dawn." And like Monet, he created complete visual environments to extend the immersion in a subjective world prompted by a total immersion in the phenomena of colored light. To this end, Rosenblum noted, Rothko would group his paintings in series of shrine/sanctuaries when possible, as Monet did with his paintings in the Orangerie. Both artists created sanctuaries from the outside world for themselves and their paintings, noted Rosenblum: Monet at Giverny and in the Orangerie, and Rothko in various commissions, starting with a series intended for the Four Seasons in 1958, continuing with a room in which Duncan Phillips installed three of Rothko's paintings alone at the Phillips Collection in 1960, adding a fourth in 1964, and ending with the installation in 1971 of a series of commissioned paintings installed after the artist's death in Dominique and John de Menil's interdenominational Houston Chapel (ill. p. 125). For Rosenblum, both installations hover "between a shrine of art and a shrine of the sprit, an avowal by a great painter to devote the whole of his being to the religion of art ..."[56] More recently Jeffrey Weiss has placed Rothko's mural work in the tradition of commemorative architecture beginning in the French Enlightenment with Etienne-Louis Boullé, tracing Rothko's representation of space in architecture from his early city pictures to the abstract pictorial space he created in his paintings after 1950, and culminating in his architectural commissions. Though a number of writers note Rothko's appreciation of Greek temples and Michelangelo's Medici Library at the cloister of San Lorenzo, links to Monet and the *Nymphéas* at the Orangerie seem to have been made by critics alone, not Rothko himself. Weiss mentions that Rothko believed that his murals were not "just" decorative but established an environment that redefines and expressively alters the existing space.[57] Weiss is correct in his use of the adjective I have apostrophized to characterize Rothko's attitude toward the decorative, which had been seriously devalued since the turn of the century. It is worth noting that Monet himself described his late paintings as the Grandes Decorations, a positive characterization at that time and place.

Jackson Pollock, Number 1, 1950 (Lavender Mist). Oil, enamel- and aluminum-paint on canvas, 221 × 299.7 cm. Washington, D.C., National Gallery of Art, Ailsa Mellon Bruce Fund

Clyfford Still would never have described his paintings as decorative either, though, even more than Monet and Rothko, he became convinced that his paintings must be seen ensemble. Rothko's goal for his paintings was to attain for them sympathetic observers. That is what the artist believed would bring them to life[58]. Still's, on the other hand, was to have his paintings say to observers, "Here am I; this is my presence, my feeling, myself. Here I stand implacable, proud, alive, naked, unafraid...."[59] Both artists believed strongly that their colors did not refer to or symbolize things in the world. Rothko said in 1952 that "My new areas of colors are things," and "These new shapes say ... what the symbols said," emphasizing at the same time that his colors were not substitutes for the figures he had banished from his painting.[60] Still went further, saying that he "consciously endeavored in his paintings to disembarrass color from all conventional, familiar associations and responses ..."[61] But in comparison to Rothko, whose stained, scrubbed and thinly brushed handling of hue and luminosity produced what one critic called "color-light," Still's use of contrasting patches of paint containing high and low amounts of linseed oil in thickly painted areas in the same painting produced what Michael Auping characterized as "a moody drama unparalled in post-war painting." Rothko's characterization of Still's material means as "of the earth," Auping remarked, was probably based on the reflective and absorbent, but hardly translucent character of his surfaces.[62]

Monet was increasingly reluctant to release his paintings, claiming at one point that he needed to have the finished ones around to compare them "to the ones I am going to make."[63] Still was even more reluctant to release his painting than Monet and Rothko. Already in 1949 he was writing to his dealer, Betty Parsons, that "These works are a series of acts best comprehended in groups or as a continuity. Except as a created revelation, a new experience, they are without value. It is my desire that they be kept in groups as much as possible and remain so ..."[64] His desire to keep his works together was so strong that towards the end of his career he seldom permitted a painting to be sold, though he did donate three carefully chosen groups to museums on the condition that none ever be sold or loaned.[65]

In 1961 Greenberg called Still an "admirer of Monet," though Still clearly resented the implication that he might be "influenced" by anyone, as the following statement, written in 1959, demonstrates.[66] "Self-appointed spokesmen and self-styled intellectuals with the list of immaturity for leadership invoked all the gods of Apology and hung them around our necks with compulsive and sadistic fervor. Hegel, Kierkegaard, Cézanne, Freud, Picasso, Kandinsky, Plato, Marx, Aquinas, Spengler, Croce, Monet—the list grows monotonous," he remarked.[67] As Seymour H. Knox observed of Still, "He felt very strongly that artists should not have to explain their work in terms of the past, but at the right moment he was not above admitting to the few artists he found interesting. In his many summer visits to Buffalo over the years, I can only remember him mentioning Turner and Ryder, and only briefly."[68]

Nevertheless, Still's mention in 1959 of Monet, who with Picasso is the only artist in the above list other than Cézanne (upon whom Still wrote his master's thesis), could not be a random choice. Perhaps Still resented his actual attraction to the work of these acknowledged masters (and there are some similarities between aspects of theclose values and the heavily applied and worked surfaces of Monet's *Nymphéas* and Still's canvases). But surely, given his desire to be understood outside nearly all art historical or indeed,

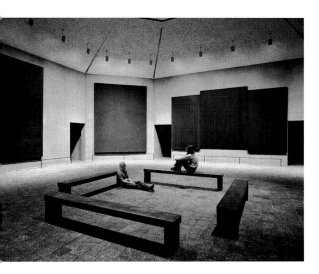

Mark Rothko, The Rothko Chapel, Houston

any intellectual or historical contexts, he resented being cast, as he was during the Monet revival, among those carrying Monet's banner into art history.

Richard Pousette-Dart's part in the Monet revival was not a major one, perhaps because he did not paint the canvases that most reminded scholars of Monet until after the revival had peaked. In the late 1950s, Pousette-Dart was re-evaluating Impressionism, perhaps as a result of the events of the Monet revival. Robert Hobbs has suggested that he may have found that the atomized color of Impressionism was well suited to an art that related to nature, one that, as Pousette-Dart stated in 1958, "simply through me as a mystical part of nature and the universe."[69] "He loved Monet's work," recalled his widow, Evelyn Pousette-Dart. "In Paris, in the summer of 1960, he went to the round room [the Orangerie]—in fact, it was the first place he went," she recalled, noting that they used to go together to the Modern frequently to see the Monet there.[70] Remarking that *In the Garden*, 1960, seemed to mediate between the real space of physiological perception and an inner realm, Robert Hobbs observed that this painting comes closest in its "thick coruscations" to Monet's work of the 1880s and in its abstraction to his Waterlily paintings. Less thickly painted with even more "atomized" touches of the brush, *Hieroglyph White Garden*, 1971 (ill. p. 269) shares with *In the Garden* that painting's sense of ephemerality and Pousette-Dart's desire to manifest emotion and spirit "in paint, light and color rather than imitating the appearances of the external world."[71]

The only one of this company to comment on Monet's importance publicly, and on more than one occasion, was Barnett Newman. Newman had been impressed by the Impressionist paintings he had seen at the Kelekian gallery in the 1920s,[72] and in the mid-forties, inspired by ideals quite different from Still's, wrote in an essay that "modern painting begins with the impressionists precisely because for the first time in history, a group of artists repudiated the role of the great personal message with its attendant doctrine of the immaculate conception and decided to devote themselves exclusively to solving a technical problem in painting—color." Crediting "Pissarro, Monet, Seurat et al." with the creation of "a new color aesthetic," Newman proclaimed that "No matter what we may think today of the impressionists as artists, they solved the problem of color for all those painting since."[73] Newman's correspondence with officials at the Museum of Modern Art on the topic of Monet's significance for modern art was more than a little tongue-in-cheek, but it is clear that he saw the MoMA's recent acquisition of Monet's *Four Trees*, 1891 (ill. p. 117) as a glitch in the smooth functioning of the formalist machinery of the Museum's "partisan role of misleading art scholarship," one that might, he suggested, lead to the abandonment of the "the myth of post-impressionism invented by the English critic Roger Fry." Did such a development, Newman asked, mean that MoMA would stop asserting "Cézanne as the father of modern art, Marcel Duchamp as his self-appointed heir, and the Bauhaus screwdriver designers ... to fight for a new concept of art?"[74]

If Newman admired the Impressionists, it may have been because they confirmed what Yve-Alain Bois adroitly called his "sense that the context entirely determines one's perception."[75] Yet despite his desire for a more inclusive version of modernity than the one he understood the Museum of Modern Art to sponsor, his support for Monet's inclusion in MoMA's collection was conflicted. He rejected Impressionism's involvement with "beauty," preferring "sublimity," which he may well have found in Monet's later painting, especially the *Nymphéas*, and he complained that Monet "was always spotlighting theatrically except

in his late work."[76] His ambivalence is well illustrated in his account to Harold Rosenberg of his experience as a guest lecturer in a graduate seminar of Meyer Schapiro at Columbia:

"Schapiro drew four rectangles on the blackboard, outlined an object in one, filled the second with dots, the third with interlocked forms, and the fourth with disassociated elements. He understood that this was a topology of modern art history: Realism, Impressionism, Cubism, Surrealism. And when Schapiro asked him where he fitted in, he went to the blackboard, erased the dots, and drew his "zip" down the edge.

When asked about this, Newman shakes his head and says: "I remember; I had to think fast; so I wiped out Impressionism!"[77]

With this gesture, Newman replaced Impressionism's "dots" with his "zip." The shift he made was structural—the replacement of one way of using color with another. His principal concern was how the color, whether it was blue, as in *Day Before One* (1951) (ill. p. 110) or orange, as in *Tertia* (1964) (ill. p. 253), could be made to perform as a perceptive event for the viewer. "Meaning is the viewer's business," he had told Pierre Schneider in 1969, "but the incentive which makes him want to mean—that is the picture's prerogative."[78] One wonders if, as far as color is concerned, Newman like Marioni, felt that the ways painters present their color has everything to do with the way viewers *perceive* it, but that what that means to each viewer is not under the painter's control.[79]

Looking and Not Looking at Monet: Abstract Impressionism and Not

As Michael Leja pointed out, *Life* magazine (one of America's most popular pictorial journal of news and contemporary culture in the fifties) was explaining Abstract Expressionism to the American public by 1959 in the same terms that two years *earlier* it had presented Hyde Solomon, Sam Francis, and Jean-Paul Riopelle to them as "Monet's Heirs."[80] Identifying in 1956 precedents for the Abstract Impressionist boom among painters whose work in the last ten years delivered "a strong sense of space and spatial activity," Louis Finkelstein mentioned Willem de Kooning, among others, saying that he preferred the "so-called abstract paintings" like *Attic, Excavation* (ill. right) and *Asheville* to the more obviously figurative *Women*, of which de Kooning's *Rosy Fingered Dawn at Louse Point* (ill. p. 231) is later and even more gesturally explosive example.[81] Although Finkelstein did include Rothko among his precedents, it is notable that every one of the fifteen 'Abstract-Impressionist' paintings pictured with his article, (such as Joan Mitchell's, whose later paintings *La Grande Vallée, IV*, 1983 [ill. p. 247], *La Grande Vallée*, 1983, and *Chord X*, 1987 [ill. p. 249] are in this exhibition), like the most of the "precedents" he cited, were more gestural than color field.[82] It follows that not all those allied in some way with Monet's painting were "Abstract Impressionists." The work of Ellsworth Kelly, in this exhibition, for instance, was too flat and too hard-edged to be thought of as "Abstract Impressionist," though he admitted in a backhand way (discussed below) that Monet was important to him. Nor did all "Abstract Impressionists" admire Monet.

"I am not the follower of Monet," proclaimed Milton Resnick in 1962, after a spate of reviews that said of his work such things as "there's no use pretending these very big abstract paintings don't look like Late Monets."[83] Another described some of the paintings as having "the famous Monet look," referring to the ethical force of those with "adventitious floral foci," such as *F. L. W.,* 1960 (ill. p. 272) in this exhibition, as

"frayed" and "dissipated," whereas works such as *Swan,* with more restrained color (such as *Letter,* 1960, [ill. p. 273], was able to pilot its image "into less tropical but more bracing waters."[84] More recently, Resnick has said of his relation with Monet, "My earliest influence was Cézanne. Years later, in the early 1960s, I saw the Waterlilies at MoMA. I was surprised at how much closer I had come to Monet."[85]

Like Philip Guston, another chronological contemporary of artists whom Finkelstein saw as "authoritative precedents" to Abstract Impressionism, Resnick's slow rise to prominence in the New York art world (after serving in World War II he lived for two years in Paris, and had his first one person exhibition in New York only in 1955) placed him among the more youthful painters whose approaches had developed in the ambiance of an already-existing style increasingly referred to as "Abstract Expressionism."[86] Explaining his desire to escape from the polarities of Abstract Expressionism's binary oppositions as they were reflected in his work before 1959, such as *Low Gate*, 1957 (ill. p. 129), Resnick recalled of his move away from such violent, muscular compositions that "I once saw only black and white, right and wrong, but something painful happened. The further apart, the more collision. I try to put them back into one in my painting." As Nancy Ellison remarked, by New York School standards, the more tentative and fragile paintings of the late fifties and early sixties [such as *F. L. W.*] were judged as "floral and dissipated" instead of being understood as equally intense but fragmented by a strangely stored intensity.[87]

Joan Mitchell, whose brushier work was closer to most people's idea of impressionism, went even further than Resnick in distancing herself from Monet, not only disclaiming any association with the painter of the *Nymphéas* at the Orangerie, but disavowing the very element of his work on which his revived popularity was based.[88] "He was not a good colorist," said Mitchell, referring to Monet. Seeing him as a painter of immediate sensation,

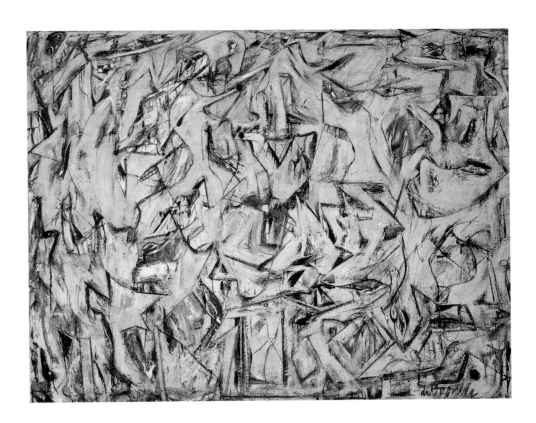

Willem de Kooning, Excavation, 1950
Oil and enamel on canvas, 203.5 × 254.5 cm.
Chicago, The Art Institute of Chicago

not of feelings and sensations, Mitchell claimed, "he isn't my favorite painter ... I never much liked Monet."[89] Although Facchetti (who showed Americans such as Pollock, and eventually Delaney, in his gallery) emphasized the role of Abstract Expressionism in preparing the way for a reevaluation of Monet, Gaston Bachelard saw the revival beginning in Paris first—at least three or four years before it began in New York, and coincident with the reopening of the Musée de l'Orangerie. Monet's home was not open, but it was possible for visitors to wander through the gardens at Giverny, and, unbelievably, to go through the contents of Monet's deserted studio. Mitchell and Guston were the first artists from America to do so after the war, in 1948, and their bright, light colors helped to associate their work with Monet in the U.S. during the early 1950s.[90]

In Paris from the spring of 1948 until the end of 1949, Mitchell's work developed from realism to painting "expressionist landscapes or boats on the beach, or something like that, which I still do."[91] Like other artists who found themselves having to paint in the shadow of a number of older painters who were becoming legends, she returned to nature, and particularly landscape, as a subject.[92] But for Mitchell, who returned to France part-time in 1959 before finally buying a house in the country, nature was a subject, but a subject as emotion, "realized in paint as it was objectified in nature, as Hess said of de Kooning."[93] Emphasizing that her color was nonreferential to nature, Mitchell said, " ... I carry my landscape around with me."[94] But despite her demurrers, as Michael Plante has noted, her prismatic palette so close to Monet's, her move to France for good, and her move around 1970 to multi-panel compositions like his only intensified the opinion that she was a *demi-française*, and one especially close to Monet at that.[95]

Ellsworth Kelly, like Beauford Delaney, was familiar with Monet's work from his study at the Boston Museum School. Monet's *Haystacks* and the *Rouen Cathedral* series, which pushed figure and ground up to meet on the picture plane, may have influenced early paintings such as *La Combe I* and *II* in 1950 (ill. above), whose patterns were taken from changes Kelly traced in the shadow of a trussed-iron railing on the steps at the Villa La Combe during the afternoon of a summer day.[96] Like Guston and Mitchell, Kelly arrived in Paris in 1948, and like them he visited Giverny, but not until he had been in Paris for several years, in 1942.[97] As the artist later recalled, "In 1952 I began to wonder what

Elsworth Kelly, La Combe I, 1950
Oil on wood, 96.5 × 161.3 cm. Private collection

Elsworth Kelly, La Combe II, 1950/51
Oil on wood, 99.1 × 118.1 cm. Private collection

Milton Resnick, Low Gate, 1957
Oil on canvas, 193 × 174 cm.
New York, Whitney Museum of Art,
Gift of Mr. And Mrs. Guy A. Weill

happened to Monet in his late years. So I wrote to his stepson in Giverny and was invited to visit." Kelly continued:

"There must have been at least a dozen huge paintings, each on two easels. There were birds flying around. The paintings had been abandoned, really. And one of the things I remember most was one painting, a huge one, that was all white, very heavily painted. There was some orange and some pink, maybe, and some pale green. And in the middle of it was a big, jagged cut. The stepson said that Monet had slashed it himself. And then we went into a second studio and there must have been a hundred paintings there of medium size that were just jammed together. When we went back to Paris we talked to dealers about the paintings, everyone said that Monet was color-blind at the end of this life and that these paintings were worthless. But we kept talking about them, and eventually the Museum of Art purchased one of them."[98]

Asked if Monet was an inspiration for him, Kelly admitted, "The day after I visited Giverny I painted a green picture, a monochrome, *Tableau Vert* (ill. p. 217). I had already done paintings with six different color panels, but now I wondered if I could do a painting with only one color. So that is my Monet influence."[99]

Kelly's admission of Monet's influence is too quick, too easy, or, perhaps better, too simple, to take at face value. It helps to read it in the context of another memory, one about the significance that the "already-made" came to have for him in 1949. That was the year that Kelly began making abstractions directly from life (as Monet said he did for his paintings.) His first was of the large windows at the Museum of Modern Art in Paris. "From then on," he said, "painting as I had known it was finished for me. Everywhere I looked, everything I saw became something to be made, and it had to be made exactly as it was, with nothing added. It was a new freedom: there was no longer the need to compose. The subject was there already made...."[100]

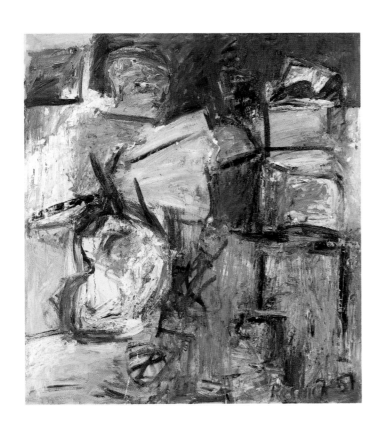

The "already-made" finds an echo in the "ready-made," with which it is not identical. As Yve-Alain Bois pointed out, although motifs are already-made, paintings are simply *made*. Most of Kelly's paintings and objects after this are not "ready-mades," but indexical—that is, citing Charles Saunders Peirce, Bois notes that they have a "dynamic connection" with their referent, like footprints in sand or, more to the point for Kelly, photographs or shadows.[101] There *is* a ready-made aspect to certain of Kelly's works, such as the 25 squares of store-bought dyed cotton, stretched onto wooden panels that comprise *Red Yellow Blue White,* 1952. But the pictorial nominalism these squares present —a sort of "panorama of the index," as Rosalind Krauss has called the color chart function of Duchamp's *T'um* (1918)—is not the aspect of Kelly's color that brings him close to Monet.[102]

That aspect of Kelly's work lies in the way his color, like what Linda Nochlin calls the "opened-out, edgy, sometimes metamorphic geometry" that he takes directly from things in the world, is "usually a little bit 'off,' painstakingly mixed by the artist, deviating from the simplified verities of the primaries," more like Gauguin's color than Mondrian's.[103] Just as Monet looked so carefully at colors that he found it necessary to start a new painting when the light changed with the

time of day, so Kelly indexes his colors to what he sees "already-made" in things in the world. But Kelly goes further than Monet, who even in his most abstract moments late in life never abandoned a detectable connection with things. Kelly always does. It is not that his objects—such as his shaped canvases—are not colors remembered or parts of forms seen, as opposed to invented ones, but he differs from Monet in not connecting the colors and forms to their referents—for us. Thus, in Kelly, though the particularity of both color and form is due to their indexicality, that is, they come right from something in the world besides Kelly's mind, they must stand or fall on their effect. Both color and form must "work" independently of recognizable subject matter, resisting the mistaken idea, as Nochlin has noted, that meaning must coincide with recognizable iconography.[104]

While Kelly may well have given considerable thought to Monet's role in his own use of color as a structural element in painting and to the influence their large size may have had on his, the "Monet influence" that he so easily admitted was surely also his choice of Monet's *Nymphéas* as a phenomenon "already made." The brushiness of *Tableau Vert,* as a rare exception to Kelly's unpainterly surfaces, signals his understanding of the importance of texture as integral to Monet's color; but at the same time this very homage is the exception that proves the rule. In transposing Monet's waterlily picture into his own Green Picture, Kelly gratefully retained (though not without significant alteration), signs of a maker other than himself.

Many viewers outside the United States became acquainted with Abstract Expressionism through the paintings of the Californian Sam Francis.[105] Exposed after World War II to the painting of Clyfford Still and Mark Rothko, major figures in the development of San Francisco Bay Area Abstract Expressionism, Francis moved from there directly to Paris in 1950.[106] In Paris he immersed himself in the tradition of color in French painting, and in particular the color and light in Claude Monet, Paul Cézanne, Henri Matisse, and Paul Bonnard. It is ironic that the painter whose work represented the vitality of the New York School of post-war American art to so many worldwide actually did not feel at home in New York, and that the painter whom James Johnson Sweeney thought to be "the most sensitive and sensuous painter of his generation" was often misread as too "decorative" or "emotionally thin" in the gritty environs of the New York School.[107] Most accounts of Francis put his first acquaintance with Monet's *Nymphéas* in 1953, on the occasion of his trip to the Orangerie.[108] But as Agee notes, it is unlikely that Francis, who had a master's degree in Art History from University of California at Berkeley by 1950, was unaware of Monet's waterlily paintings. This makes more sense of his statement, made soon after he arrived in Paris, that "I make Monet pure," that is, that in Francis' curtains of leaf-like forms there is no reference to any particular biomorphic entity, such as lily pads, or any specific place, such as the pond in Giverny. *For Fred*, 1949 (ill. p. 131), for instance, shows simultaneously Francis' understanding of Mark Rothko's glowing squares and Monet's kidney-shaped lily pads, and perhaps his memories of microscopic and x-ray images, the legacy of Francis' early medical ambitions and a protracted recovery from injuries and infections incurred in World War II.[109]

Beginning in 1952 with a black series, Francis initiated a little-known group of high chroma monochrome canvasses in the primary colors and green; they were worked in the pod-like forms that would become an early hallmark of his work.[110] During this time he made a visit to the newly-opened Orangerie. The first state of Basel's *Deep Orange and*

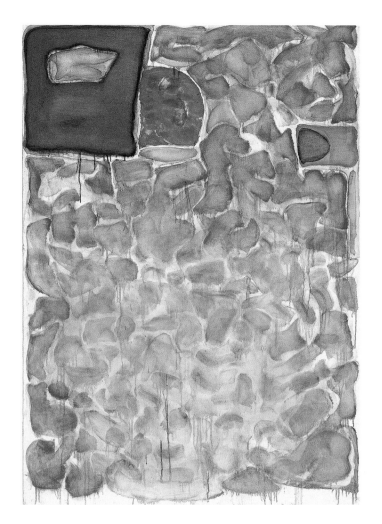

Black of 1953 was "an open and foglike field" of orange that Peter Selz described as "reminiscent of Monet's mural cycles in the Orangerie." But Francis applied a black frame of the same forms that eventually nearly covered them, floating between the hot orange mist, so to speak, and the viewer.[111] Monet is a precedent as well for Francis' large *Basel Mural* (ill. p. 148), similar in style and color to *Untitled*, 1958 (ill. p. 188), in this exhibition, and to the *Untitled Mural*, 1959, in the Chase Manhattan Bank. The three-panel *Basel Mural*, took three years to complete—not as long as the Orangerie *Nymphéas*, but it has recalled them to at least one contemporary, as the "most significant decorative scheme undertaken in 20th-century painting since the late work of Monet."[112] Francis' achievement has been to develop a practice that comes out of American color field and gestural painting such as Pollock's, but at the same time participates in the French tradition of prismatic color.

While it is not surprising that an article on 'Abstract Impressionism' in 1956 would not mention the anti-gestural Ellsworth Kelly, it is strange looking back from the 21st century, to find Mitchell and Philip Guston (the latter artist being the most frequently mentioned in the article) but not Sam Francis or Jean-Paul Riopelle, who, though from Canada, had been showing at Pierre Matisse in the United States since 1954. All of them, after all, were involved in the Monet Revival, if hardly to the same degree, or for the same reasons.[113] Although not a citizen of the U.S. like Francis, Riopelle went to Paris after World War II, and his perceived relation to Monet, in part the result of his connection with American expatriate painters, throws light on one of the ways Monet was understood. Born in the same year as Francis—1923—he also went to Paris directly from his home city, Montreal. Riopelle probably saw Francis' painting for the first time in 1950 at the Salon de Mai in Paris; he recalls thinking at the time that one day they might meet. They did: Riopelle organized Sam Francis' first exhibition at the Galerie Du Dragon, a meeting-place for the Surrealists after World War II. An exhibition of his work is also organized at the Studio Paul Facchetti by Michel Tapié. By 1951, Riopelle was showing there with him in a group show that included Rothko, Pollock, Mathieu, and Tobey.[114]

All of these were eventually considered to be in one way or another as inheritors of elements of the later Monet, and so was Riopelle. Titles of paintings such as *Robe of Stars*, 1952 (ill. p. 283), which enable an obviously material application of paint to evoke a cosmic topic recalls the *Nymphéas*, where sky and weather are chronicled in the appearance of plants and water represented by ridged and scumbled paint that is still, when viewed close up, very much still itself. This is perhaps what led Pierre Schneider to write of him in 1981 as one in whose work "the landscape of painting opens out on the painting of landscape" in which nature becomes in icon (*Hommage à Robert le Diabolique*, 1953, ill. pp. 280/281).[115]

The Canadian painter's expression of admiration for the last work by Monet was so great, and late Monet was, by 1959, so often a reference in discussions of "the most recent,

Sam Francis, For Fred, 1949
Oil on canvas, 150 × 102 cm.
Tokyo, Idemitsu Museum

up-to-date painting," that Werner Schmalenbach wrote in a catalogue of his work in 1959 that Riopelle's work was actually beginning, as was that of others who admired Monet, to be spoken of as "abstract impressionism." "This does not so much imply that the Impressionists are perceived as the first *tachists*," wrote Schmalenbach, "as that the artistic eruptions of painters such as Riopelle are taking place in the context of nature.... When we look at certain works by this artist, it is hard to resist saying that there is an unmistakable impression of forest, while others conjure up long-buried memories of fields and meadows."[116]

Riopelle's perceived relation to nature in works that were themselves extremely abstract was increased by his association with "abstract expressionism." Monet had long been considered a painter of nature. But when William Seitz, who had written one of the earlier and more scholarly treatments of Monet's relation to current abstraction in 1956, curated in 1960 a landmark exhibition of Monet's late paintings that included photographs of the sites from which they were drawn and the observations that "As a nature poet, Monet's psychic state was more determined by the weather than by any other influence," Monet was indeed turned into something of a weather bureau.[117]

Reductive characterization of Monet as simply a retinal recorder of nature made admissions of admiration for his work of the French painter somewhat dangerous, especially in the United States. The debates that ensued around his work regarding the role of color as a conduit between external reality and interior comprehension, however, continued to influence contemporary practice.

Opticality, Color Field, Radical Painting, and the Fall of Some Myths

The differences among these painters, all of whom were deeply concerned with color, does more than illustrate that there were many ways of understanding the problems Monet's use of color in the *Nymphéas* had broached, although this is certainly true. They also point to a productive conflict around the interpretation of a key criterion of value for Modernist painting and sculpture: "opticality." For Clement Greenberg and his younger colleagues such as Michael Fried and William Rubin, it became an exclusively visual and pictorial way of distinguishing the perception of depth from that of color alone, one in which it was desirable that images on the picture plane assume a disembodied flatness unsuitable for the presentation of material things or even ideas.[118] In April of 1948 Greenberg claimed that neither Cézanne, Van Gogh, Gauguin, Matisse nor the Fauves had so radically violated the traditional laws of composition as had Pissarro and Monet. By flattening the picture and keeping any form from dominating the composition, these two had much earlier arrived at the "allover" composition—dangerously close in its decorative potential to wallpaper—practiced in the U.S. by artists such as Jackson Pollock, Mark Tobey, and Janet Sobel, among others.[119] Less than a year later, in January 1949, he wrote in "The Role of Nature in Modern Painting" that French painting between Courbet and Cézanne [i.e., including Monet], while departing from illusionism, was determined to give as accurate an account of nature *in context* (his italics) as possible. This meant that "the limitations imposed by the flat surface, the canvas' shape, and the nature of the pigments... had to be accommodated to those of nature."[120] By the time Greenberg revised this essay in 1961 for publication in *Art and Culture,* his claim that representations of nature or even

Janet Sobel, Milky Way, 1945
Enamel on canvas, 114 × 75.9 cm.
New York, The Museum of Modern Art

Beauford Delanay, The Burning Bush, 1941
Enamel on canvas, 114 × 75.9 cm. Newark, N.J.,
The Newark Museum

perception of nature must accommodate what is specific to painting had become more straightforward: "the essence of art," he wrote, "conforms to exclusively two-dimensional, optical, and altogether untactile definitions of experience."[121] One notes in his remarks on Louis and Noland that Greenberg now prefers his color to be as textureless as possible, which was not the case in his discussion of Monet's Waterlily paintings in 1957. Indeed, for Greenberg in the early sixties the only texture that did not interfere with color was that of the canvas itself; by being "soaked in paint rather than merely covered by it," the canvas becomes "paint itself, color in itself."[122] In the version of his "Modernist Painting" published in 1965, Greenberg's continuing call for opticality had defined an arena in which a disembodied, "optical" painting with little or no texture by artists such as Morris Louis (ill. pp. 234/235) Kenneth Noland (ill. pp. 134, 256/257), and Jules Olitsky (ill. pp. 260/261) was prominent.[123] As William Rubin noted, Noland and Louis shared with early Ellsworth Kelly the use of a "quantitative dosage of color within the framework of simple geometrical devices." And unlike Kelly, Rubin continued, Noland and Louis continued to use multiple color chords.[124] But even more unlike Kelly, who continued to draw his forms from a repertoire of specific things in the world, Louis and Noland's "disembodied" images were influentially seen as self-consciously nonreferential, not only by Greenberg, but also by other enthusiasts of opticality, such as Michael Fried and Kenworth Moffett.

The restrictions opticality imposed were similar in some ways to those that have dogged Monet's reputation in regard to his being concerned only with retinal imaging. Critics in both the popular press and more specialized journals have seen Louis and Noland (as Monet was criticized), in effect, as "only an eye": In New York Kay Larson observed, "Like Kenneth Noland and friends, he [Louis] stripped his art of psychic truth. Unlike them, he did such a thorough job of it that only the retinal remains."[125] Joseph Masheck observed that Noland's horizontal stripe paintings [some of which are longer and narrower than Brunswick (ill. pp. 256/257), such as the remarkable seven-foot long High Rest, 1969] are wide enough for the viewer to become dimensionally lost. If used as a continuum in a circular room, they would run the risk of looking like wainscoting, he suggested, but "the lack of patternistic redundancy might sustain the decorative continuum, as it did for Monet."[126]

It is symptomatic of the response of many to the painting of Noland, Louis, Frank Stella, and even some of Jules Olitsky's, that it returns to matters of form (i.e., "patternistic redundancy"). Michael Fried, for instance, in his introductory essay in Three American Painters, said that he would begin "with the observation that the structural aspect of Noland's paintings, especially since the first chevrons of 1962, may be discussed with a kind of precision and logical rigor that his use of color resists."[127] In Olitsky as well— consider his Compelled (1965) (ill. pp. 260/261), for instance—it may be observed that vertical divisions at the edges relate the adventures of color to the (linear) limits of the canvas. From the standpoint of pure or radical color, these verticals, subtle as they are, nevertheless bring both life and shape into play like crutches for a color structure that might not be able to stand on its own. As Rosalind Krauss observed, these "interior frames,"

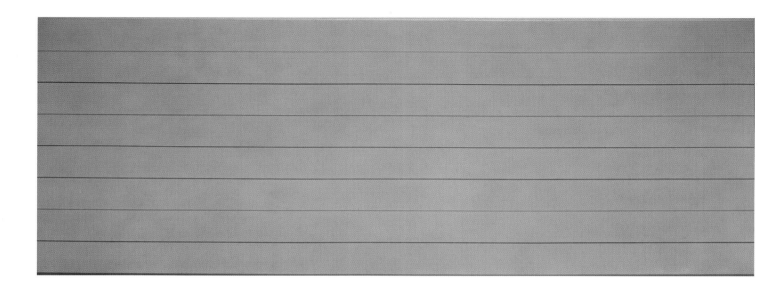

leaning at an angle to the exterior edge, suggest a form that is oblique to the literal surface of the canvas, an example of his "antagonism" to local color.[128]

In an atmosphere influenced by observations such as these, Olitsky's paintings were presented, however enthusiastically, in terms that called to mind color's historical reputation as a signifier of superficiality (Kermit Champa, using the artist's own words in 1967 entitled an article about Olitsky at the Corcoran "Olitsky: Nothing but Color."[129] A vogue for color, not so dissimilar from the Monet revival of the fifties, had begun. Marcia Tucker at the Whitney Museum of American art curated a survey of artists in whose work she judged color to play the decisive role.[130] By 1973 Olitsky having a retrospective at the Whitney Museum of American Art while Kelly was having one at MoMA. Both artists were seen as avatars of color, but as Harold Rosenberg remarked, they represented the opposed poles of Color Abstraction. Olitsky was affirmed by Kenworth Moffett (who directed the Olitski exhibition), Walter Darby Bannard, Barbara Rose and Thomas Hess, reported Rosenberg, because they saw Olitsky as the necessary link between the allover picture and color structure. Citing Moffet's opinion that Olitsky put Pollock's overall composition at the service of color, Rosenberg suggested that since it was Rothko, not Pollock, who most effectively detached color from the surface on which it had been applied, it was Rothko, not Pollock, with which Olitsky's paintings should be affiliated.[131] It is an interestingly arguable observation; but more to the point here is Robert Hughes' observation about the difference between Olitsky and Monet, one that supported the proponents of use of color in the other exhibition in town, Ellsworth Kelly's:

"Critics often credit Olitsky's pictures with the meditative expansion, the hypnotic and floating silence of Monet's last and greatest cycle of canvases: the enormous lily pond "decorations" from Giverny. But this is Monet without the water or the lily pads—without, in other words, the sense of a reality constantly in transubstantiation."[132]

Kelly, like Hughes, kept his abstraction referential, since his abstractions are derived from nature, reported Rosenberg. Thus they are related to pop art as well, in that they are born as much out of the "art phenomena of daily life" as Warhol's *Brillo Boxes*. Says Rosenberg, "It is Kelly, rather than Olitski, who represents something new in the art of the seventies; that is, the readiness of non-Expressionist abstract art to get along without

the support of metaphysics (Kandinsky, Newman), or the 'logic of history' (Mondrian, the Constructivists)."[133]

But in the wake of this debate over the proper relation of color in painting to things in the world, a revision in Impressionist scholarship was brewing. This should perhaps be the topic of another exhibition, but it is important to note that by the late eighties, the Monet who had become "nothing but an eye" to many even before his death, and who was metamorphosed by Abstract Expressionism into an avatar of spontaneity and shortly after into a conduit between the perception of external reality and internal realization (Abstract Impressionism), was exchanged for a Monet who was the father of modernist color structure. In this reincarnation, Monet became the craftsman of amazingly painstaking surfaces that proffered the appearance of precise records, quickly transcribed, but were actually the result of many layers of carefully calibrated paint applications.

The revision was actually a resurrection of an originally more nuanced characterization of Impressionist intentions in the remarks of critics such as Jules Castagnary. He had noted in 1874, for instance, that the Impressionists did not simply render the landscape, but their impressions of it. Richard Shiff began his essay entitled "The End of Impressionism" in 1978 with this observation. He followed the issues Castagnary's remark raised through their philosophic, psychological, and technical dimensions in the 19th and 20th centuries. Does nature exist independently of our perception of it? Does everyone see it the same way? Do painters differ in the way they paint even the same thing because they see it differently, or because even though they see the same thing they formulate it differently?[134] Working through the literature of the nineteenth and twentieth centuries as it has been trained on Impressionist goals and techniques, Shiff concluded that impressionists, including Monet and his critics, understood their work to be personal and subjective. In an era when even positivist physiologists such as Émile Littrè and Hippolyte Taine insisted that one's "impressions" were subject to personal emotion, distinctions

Bridget Riley, Rêve, 1999
Oil on canvas, 228 × 238 cm.
London, Courtesy Karsten Schubert

Odili Donald Odita, Frequencies, 1999
Acrylic on canvas, 91 × 122 cm.
New York, Courtesy Florence Lynch Gallery

between subject and object were breaking down. As a result, "reality became equated with consciousness, and ... the primordial act of consciousness was the perceiving of the impression; the impression was neither subject nor object, but [became] both the source of their identities and the product of their interaction."[135]

This understanding as a part of Impressionist practice and theory had been subsumed by the Symbolists as part of their reaction against Impressionism, however, and brought forward into the 20th century as a new insight—associated with the work of Niels Bohr, for instance.[136] Especially important for the late turnaround in Monet scholarship, in Shiff's view, is the observation in the section of this article entitled "The Loss of the Subject/Object Distinction in the Theory of Knowledge and its Persistence in the Theory of Art," that fundamental to Impressionism is Zola's acceptance of the *possibility* (Shiff's emphasis) of using a studied yet unconventional technique to render the immediacy of impressions. "It is necessary to fix this minute on the canvas for all time by a technique (facture) well studied," wrote Zola.[137]

A year after Shiff's article appeared, Robert Herbert applied his arguments and others specifically to Monet in an article entitled "Method and Meaning in Monet" published in the widely-circulated trade journal *Art in America*.[138] Reviewing the disapprobation Monet's color-based structure had occasioned, Herbert argued that not only had Monet's use of color been attacked as lacking in form, but so were his spontaneous brushstrokes (the "rockets of transparent luminosity" cited above that Clemenceau described as they shot from Monet's "quivering hand,") which gave rise in the 20th century to the perception that such impulsivity must be accompanied by a random choice of subject matter. Herbert would put that myth to rest, following on the heels of Timothy J. Clark's *The Painting of Modern Life* in 1985, with his own book, *Impressionism, Art, Leisure, and Parisian Society* in 1988.[139] But his article in 1979, which meshed the arguments of Shiff and others in a close reading of Monet's surfaces, demonstrated that they revealed the long and conscious process of the painter's "calculated and intentional effort."[140]

Taking care not to posit that Monet was *never* spontaneous, Herbert described the *Rouen Cathedrals* as the culmination of the artist's procedure of building up his textures in stages, and then strategically scumbling, overpainting and glazing them. But he proceeded to discuss Monet's use in Boston's *Waterlilies I* (1905) of a technique Herbert called "corrugation," in which the artist brushed quickly at right angles to the protruding threads over a canvas whose weft threads are thicker than its warp. Those threads became covered in pigment, but the valleys remained bare. Monet let it dry, then repeated the process, seldom in areas that exceed six or seven inches. The process grows more effective as each time a thicker layer is caught by what is now a protruding set of ribs. Close observation by Herbert and curators revealed that Monet worked into the last two or three before they were dry, pushing them over the valleys. This provided a textured matrix for his surface colors, which might then be thin or thick, filling the valleys or not, and providing an opportunity, when the next coats were dry, for further tipping the ridges with other colors or glazing them and the valleys. The technique, which for viewers translates into a perception of wavering or twinkling surfaces and barely-perceptible highs and lows, is an apt rendition of the surface of clear water, among other phenomena. Monet had used it for many other purposes, Herbert observed, perhaps earliest in the view of Argenteuil of 1972 now in the National Gallery in Washington, D.C.[141]

Richard Pousette-Dart, In the Garden, 1999
Oil on canvas, 192.8 × 142.5 cm.
New York, The Estate of Richard Pousette-Dart

Noting that Monet sometimes worked up to sixty times on the same picture, Herbert quite directly stated: "The myth of Monet's apparently mindless spontaneity is a creature of 20th-century formalism, parallel to the defense of abstract painting which has wanted to deny significance to 19th-century artistic consciousness (pre-modern art was said to be merely imitation) and to subject matter."[142] Going into the eighties then, one might observe that attentive viewers and alert readers had at their disposal what could be called deconstructive readings of Monet and other Impressionists. Artists in particular were becoming more and more aware that Monet's painting was the product of a consciousness deeply committed to its own material and emotional resources and aware that viewers, to one degree or another, had resources as well.

One might have thought that the basis of this debate regarding Monet, which has now lasted more than a century, might have been exhausted. It clearly was not, but it has been continuously reformulated.[143] This exhibition, with its inclusion of the painting of Joseph Marioni, the paintings and installation of Byron Kim, and the installation of Olafur Eliasson[144] suggests the substantial directions these reformulations have taken. In the late seventies, as Shiff's and Herbert's views were being formulated, a group of painters in New York that included Joseph Marioni, who shared overlapping but by no means identical or even reconcilable ideas about material and process in the vicinity of color, began to meet on a regular basis.[145] Those meetings, with the midwifery of Thomas Krens, the Williams College Art Gallery and Williams College students, eventuated in 1984 in an exhibition and catalogue entitled *Radical Painting*, whose major essay was written by Lily Wei. Noting that the adjective "radical" in the title of the exhibition "refers to the radices [roots, or most basic aspects] of painting: paint and color applied to a suface," Wei wrote that the theme of all of the paintings in the exhibition was "the elaboration of structure based on the optic and haptic qualities of paint and color," an affirmation that paint and color are themselves primary material, primary sensation, complete in themselves. She pointed out that the painters in the exhibition (some of whom, such as Raimund Girke (ill. p. 199) and Günter Umberg, were not based in New York) were American and European—as are the artists in this exhibition. But they did all agree that they did not use traditional references, that they preferred isolated color, and that they were creating "an art of experience."[146] Already in that catalogue, Marioni is quoted as saying that painting and picturing are different activities; that painting should be experienced as "active sensation—not as transfer of information."[147] The emphasis then for Marioni, as it is now, was on the exchange between the viewer and an object that has been constructed to deliver certain color experiences.[148] This goal has not changed, but the methods of constructing the color experience have developed in the direction of subtlety and complexity. As he says in the statement for this exhibition (see p. 238), for him, Monet was the first painter in the 20th century to structure color in painting with this goal in mind.

As artists have considered the relation of color to perception, those aspects of color that made Monet's late waterlily paintings seem too amorphous, too subjective to count as serious painting, have begun to appear as the hallmark of all perception, just at a time when "perception" (shepherded, perhaps, by a prolonged consideration of the work of Maurice Merleau-Ponty by many in the art world) has become the watchword of that meeting of the inner self with things in the world by which each seems to exist for the other. What constituted *Radical Painting* in 1984 has expanded, spilling over into territory previously occupied by shape, and even three-dimensional form. Now *Radical Abstract Painting* is the subtitle of *Pleasures of Sight and States of Being,* an exhibition curated by Roald Nasgaard at the Florida State University Museum of Fine Arts this year (2001). It includes not only painting, but sculpture and bas-relief. Nasgaard begins his essay with two extended epitaphs, one by Bridget Riley and one by Joseph Marioni. Both are about perception. Riley's "Pleasures of Sight" take her by surprise, she writes, and can't be repeated because they depend on a perfect balance of mind and nature, "momentarily turning the commonplace into the ravishing."[149] Marioni's "States of Being" identify the "perceptual identity of a painting" with the sustained experience of having arrived at a place where "nothing is taking place but the place itself."[150] While Riley's visual pleasure is fleeting and unpredictable—and not necessarily about painting—Marioni's is an accord that may be established with a painting to which one might return more or less at will. But both are in accord with Barnett Newman's idea, cited above, that meaning is produced by viewers, but paintings inspire them to make meaning in certain ways.

Visually, the closest painting in *Pleasures of Sight and States of Being* to Riley's *Rêve* (ill. p. 135 left) was Odili Donald Odita's *Frequencies* (ill. p. 135 right). Odita's modernist tastes were honed on a diet of Noland and Louis after graduation from college, but he left painting in 1993 to photograph and construct manifestations of power in visual juxtapositions. Only in 1999 did he return to abstract painting, applying to it the same principles of juxtaposition he had found in things in the world. His destabilizing abstractions, with what Nasgaard sees as their "multiple horizon lines" change their meanings with their context.[151] In another exhibition in 2001, "Here and Now," Odita exhibits with Olivier Mosset, one of the painters in Krens' *Radical Painting* in 1984, and Byron Kim, in this exhibition. Of all the painters here, Kim may be as close to Monet as one can get today. When he painted *Grunion Run* (ill. p. 223) and *White Painting # 5 (After Melvin)* (ill. p. 221), Kim said, "I was thinking through real-world visual phenomena about painting *and vice versa....* All of those [*The Sky is Blue* series] were done *thinking* about looking, not actually looking at the sky or the water."[152] In her essay for *Here and Now* Lily Wei wrote, "What you see is ... not simple." It is "acculturated, politicized, contextualized, psychologized. Vision does not exist in a vacuum." All that is seen, she observes of artists such as Kim, "is already subject to speculation, to the particular cognitive and emotive susceptibilities of the one who sees."[153]

So in the present essay, much as Rosenblum noted that Monet's paintings revealed new meanings "In the Context of Contemporary Styles," similar to the way that Bois noted Newman's "sense that the context entirely determines one's perception," and to the way Greenberg saw French painting from Courbet to Cézanne as trying to take as accurate an account of "nature *in context*" as possible, investigations of color have led artists from Monet to Marioni and Byron Kim to an increasing awareness—and imaginative

and productive employment—of the contextual instability that has been seen as color's weakness. What was once color's bane has become its blessing and its lesson, not only to form, but to perception itself.

My thanks to Jennifer Barrett and Isabelle Lachat, graduate students at the University of Delaware, and to Carla Kingery, an undergraduate at the University of Delaware, who assisted with the research for this essay with enthusiasm and imagination.

1 Among others, Finkelstein included as 'Abstract Impressionists' Pat Adams, Rosemary Beck, Nell Blaine, Charles Cajori, Gretna Campbell, Robert De Niro, Robert Goodnough, John Grillo, Jan Müller, Wolf Kahn, Ray Parker Wallace Reiss, Hyde Solomon, and Miriam Schapiro. "New Look: Abstract-Impressionism," *Art News* 55: 1 (March 1956): 36–39, 66–68. ■ 2 Louis Finkelstein, "New Look: Abstract-Impressionism," 38. ■ 3 Ibid., 38. ■ 4 Ibid., 37. ■ 5 Greenberg mentioned optical mixing of paint by juxtaposition on the canvas in reviews of exhibitions of Impressionism and Monet respectively in *The Nation* on October 21, 1944 and May 5, 1945, and in a review of Willem de Kooning extended his thinking to the "optical imagination," in *The Nation* on October on April 24, 1948. Although Finkelstein and Greenberg agreed on the importance of opticality in advanced painting, they disagreed about what opticality was. See Michael Leja, "The Monet Revival and New York School Abstraction" in *Monet in the Twentieth Century*, ed. Paul Tucker (London, Boston and New Haven: Royal Academy of Arts, Museum of Fine Arts and Yale University Press, 1988), 105–106. ■ 6 Clement Greenberg, "American-Type Painting" [*Partisan Review* (Spring 1955)], reprinted in John O'Brian in *Clement Greenberg the Collected Essays*, vol. 3, ed. John O'Brian (Chicago: the University of Chicago Press, 1993), 233. A number of Still's paintings from the later forties and the first half of the fifties are notable for their close values. ■ 7 Clement Greenberg, "American-Type Painting" [*Partisan Review* (Spring 1955)], reprinted in John O'Brian in *Clement Greenberg the Collected Essays*, vol. 3, ed. John O'Brian (Chicago: the University of Chicago Press, 1993), 228. ■ 8 The relation between Clement Greenberg's struggle against the commercial values that his father's garment business represented to him and his aesthetic judgments has been usefully discussed by Florence Rubenfeld in Ch. 16, "Imperial Clem" in *Clement Greenberg A Life* (New York: Scribner, 1997). The anti-commercial attitude Greenberg displayed in his writing is interestingly opposed to the influence his positive and negative judgments had in the art market. Michael Leja has explored the relation of criticism to the rise and fall of the Monet revival in relation to New York School abstraction, evaluating the roles played by the economic and professional activities of curators, collectors and dealers in the light of the ascendancy of New York School painters such as Jackson Pollock as well as the newer critical recognition of painters such as Philip Guston, Joan Mitchell, Sam Francis, Nell Blaine, and Jean-Paul Riopelle (Michael Leja, "The Monet Revival and New York School Abstraction," 104 ff.). The development of an art history that deeply investigates and integrates economic and material conditions into the analysis of aesthetic judgments in the establishment of visual culture will be a valuable contribution to the humanities. ■ 9 Clement Greenberg, "The Later Monet," *Art News Annual* 26 (1957) 132–148, 194–196, reprinted in *Clement Greenberg the Collected Essays*, vol. 4, ed. John O'Brian (Chicago: the University of Chicago Press, 1993), 8–10. ■ 10 While denying that the Monet revival was a conspiracy of tastemakers, Michael Leja, rightly notes that it was overdetermined, and could well be called a "vogue." Michael Leja, "The Monet Revival," 108. These other writers include: Robert Rosenblum, "Varieties of Impressionism," *Arts* 29: 1 (October 1, 1954): 7; Leo Steinberg, "Month in Review," *Arts*, 30: 5 (February 1956): 46–48; Thomas B. Hess, "Monet: Tithonus at Giverny," *Art News* 55: 6 (October 1956): 42, 53; Hilton Kramer, "Month in Review," *Arts* 31: 2 (November 1956): 52–55; William Seitz, "Monet and Abstract Painting," *College Art Journal* 26: 1

(Fall 1956): 34–46; John Richardson, "Monet," *The Studio* 154 (October 1957): 97–103, 128; and Clement Greenberg, "The Later Monet." ■ 11 Telephone conversations with Josie Browne and Byron Kim, June and July 2001. ■ 12 Andrea Miller-Keller has noted that Kim's work is consistently conceptual; as a college student he had the opportunity in 1983 to view the Sol LeWitt collection at the Wadsworth Atheneum in Hartford Connecticut; work there by artists such as Daniel Buren, Hans Haacke, Eleanor Antin, Hanne Darboven, Richard Long, and others "opened a world of possibilities" for the young artist. "Byron Kim/MATRIX 125," October 2–November 20, 1994, pamphlet of the Wadsworth Atheneum, Hartford Connecticut. ■ 13 Author's telephone conversation with Byron Kim, May 18, 2001. ■ 14 Ibid. ■ 15 Joseph Marioni, conversation with the author, 26 July, 2001. ■ 16 Monet to Roger Marx, in "M. Claude Monet's 'waterlilies'" in the *Gazette des Beaux-Arts* (June 1901), tl. Catherine J. Richards, reprinted in *Monet, a Retrospective*, ed. Charles F. Stuckey (New York: Hugh Lauter Levin Associates, Inc., 1985), 266–67. ■ 17 For the Waterlilies as hymns to nature and to France, see Paul Tucker, Ch. 7, "Monet and his Giverny Gardens: 1900–1926," in his *Claude Monet, Life and Art*, (New Haven: Yale University Press, 1985), and "The Revolution in the Garden: Monet in the Twentieth Century," in Paul Tucker, ed., *Monet in the Twentieth Century*, 14–85. ■ 18 See, for instance, Paul Tucker "Revolution in the Garden," for Monet and the Dreyfus Affair and its aftermath for Monet (20–26), and 200–213 in Tucker, *Claude Monet*, for Monet's personal losses and World War I in the middle years of the series. ■ 19 As Paul Tucker has noted in his recent essay "The Revolution in the Garden: Monet in the Twentieth Century," in *Monet in the Twentieth Century*: 41–45. ■ 20 Clement Greenberg, "The Later Monet" [*Art News Annual* 26, 1957], reprinted in *Clement Greenberg the Collected Essays*, vol. 4, ed. John O'Brian (Chicago: the University of Chicago Press, 1993), 3. ■ 21 Seitz, "Monet and Abstract Painting," 34, n. 2. ■ 22 Greenberg, "The Later Monet," 5, 7. André Masson, "Monet le fondateur," *Verve* 7, nos. 27–28 (1952): 68; See Michael Leja for early collectors: "The Monet Revival and New York School Abstraction," 100 and 291, n. 9. ■ 23 Greenberg's earlier remarks on Monet's late painting were published in "Review of an Exhibition of Claude Monet" in *The Nation* in May 1945, reprinted in *Clement Greenberg the Collected Essays*, vol. 2, ed. John O'Brian (Chicago: University of Chicago Press, 1986), 20–23. ■ 24 For Basel Kunsthalle, see Leja, "The Monet Revival," 100; for Wildenstein, see William C. Seitz, *Claude Monet Seasons and Moments* (New York: The Museum of Modern Art, 1960), 58. ■ 25 William C. Seitz, *Claude Monet Seasons and Moments* (New York: The Museum of Modern Art, 1960), 58; for Brooklyn see Robert Rosenblum, "Varieties of Impressionism," 7. ■ 26 Katia Granoff, an art dealer in Paris, played a crucial part in making available in exhibition and for purchase the late Monets stored at Giverny since Monet's death. For more on this see Leja, "The Monet Revival," 100. As Leja points out here and elsewhere in this essay, there were many factors contributing to the explosion of enthusiasm about Monet's late paintings, not the least of which was the purchase of these heretofore unavailable paintings by American collectors and their donation of them to American museums. ■ 27 Romy Golan, "Oceanic Sensations: Monet's *Grandes Decorations* and Mural Painting in France from 1927 to 1952," in Tucker, *Monet in the Twentieth Century*, 95–96. ■ 28 Before World War I, however, Monet's art was seen as an icon of French nationalism, evidently with the assent of the artist.

See Paul Tucker on the grainstacks, the poplars and the Rouen Cathedral series in *Claude Monet Life and Work*, 139–155. ■ 29 Golan, "Oceanic Sensations," 96; Paul Facchetti in "Jeanne et Paul Facchetti entretien avec Daniel Abadie, March 26 1981," in *Jackson Pollock* (Paris: Musee National d'Art Moderne, Centre Georges Pompidou, 1982), 297. ■ 30 Robert Rosenblum, "Varieties of Impressionism," 7. ■ 31 Steinberg, "Month in Review," 47–48. ■ 32 Knoedler's announcement card for its exhibition of Monet's *Nymphéas*, October 8–27, 1956, in the Knoedler Archives. I am grateful to Edye Weissler, Knoedler's archivist and librarian, for access to this information. The quotation is from Georges Clemenceau, *Claude Monet, the Waterlilies* [orig Paris: Plon, 1928], trans. George Boas (Garden City, New York: Doubleday, Doran & Company, Inc., 1930), 17–18. ■ 33 Hess, "Monet: Tithonus at Giverny," 42, 53. ■ 34 Kramer, "Month in Review," *Arts* 31 (November 1956): 52–53 ■ 35 William Seitz, "Introduction," *Hans Hofmann* (New York: The Museum of Modern Art, 1963), 7, 8, 46; Hans Hofmann, "The Search for the Real in the Visual Arts" in *Search for the Real* [1948], ed. Sara T. Weeks and Bartlett H. Hays, Jr. (Cambridge, Mass.: The M. I. T. Press, 1967), 45. ■ 36 Hofmann in Weeks and Hays, eds., "The Search for the Real," 45; "Monet is not a painter whom Hofmann seems ever to have particularly admired," continued Greenberg, "but only in him do we find any possible precedent for the elisions of light-and-dark contrast that Hofmann dares to make for the sake of pure, singing color." Greenberg in "Hofmann," [from *Hans Hofmann,* Paris: Éditions Georges Fall, 1961], reprinted in Cynthia Goodman, (New York: Whitney Museum of American Art, New York, 1990), 136. ■ 37 Hofmann in Seitz, *Hans Hofmann*, 46, quoted from Hofmann's "Selected Writings on Art," a compilation of his writings, typescript, n. pag. and n.d. in the library of the Museum of Modern Art, some of which were printed in *Search for the Real*. ■ 38 An exhibition of Delaney's yellow paintings, in preparation at the High Museum in Atlanta, Georgia, and scheduled to open in the same month as this exhibition should prove an exception to this tendency. ■ 39 Leeming, conversation with the author, telephone conversation, 30 March, 2001. ■ 40 Delaney sailed to Le Havre on August 28, 1953 (David Leeming, *Beauford Delaney* (New York: Oxford University Press, 1998), 108. ■ 41 Leeming, *Beauford Delaney*, 28–30. Leeming, who knew Delaney, said he mentioned Monet frequently, and that he had spoken to Leeming about his (Delaney's) visit to the Orangerie. Leeming, conversation with the author, telephone conversation, 30 March, 2001. ■ 42 Hess, "Monet: Tithonus at Giverny," 53. ■ 43 Jean Guichard-Meili, review of Delaney, exhibition at the Galerie Lambert in *Arts* (December 16–22, 1964): 27. Translated by Richard Long in "Beauford Delaney: A Retrospective," in *Beauford Delaney: A Retrospective* (New York: The Studio Museum in Harlem, 1978), n. pag. ■ 44 William Rubin and Carolyn Lanchner, *André Masson* (New York: Museum of Modern Art, 1976), 218, entry for July, 1945. ■ 45 William Rubin and Carolyn Lanchner, *André Masson* (New York: Museum of Modern Art, 1976), 183, 185. The first quotation from Masson is drawn from his article, "Monet le fondateur," in *Verve*, p. 68. The second is from a letter to Alfred Barr dated November 1954 in the collection of the Maison de la culture d'Amiens in Amiens, France; the third is from Masson's "Ne pas choisir ses thèmes—être choisi par eux," published in *André Masson: Oeuvres récentes 1968–1970* (Paris: Galerie Louise Leiris, 1970; and the last is from *André Masson, Paintings.* (London: Waddington Galleries, 1972). ■ 46 William Seitz, "Form and Process," in *Mark Tobey* (New York: The Museum of Modern Art, 1962), 21, 84, n. 30. ■ 47 Mark Tobey, quoted in Fred Hofmann, "Mark Tobey's Paintings of New York," *Artforum* 17 (April 1979), 26. ■ 48 William Seitz, *Art in the Age of Aquarius 1955–1970,* ed. Marla Price (Washington: Smithsonian Institution Press, 1992), 14. ■ 49 Eliza E. Rathbone, *Mark Tobey, City Paintings* (Washington: National Gallery of Art, 1984), 101, ■ 50 William Rubin, "Jackson Pollock and the Modern Tradition, Part II," *Artforum* 7 (March 1967): 28. ■ 51 For Pollock and Masson, see William Rubin, "Notes on Masson and Pollock," *Arts Magazine* 34 (November 1959): 38–43; for their *Pasiphaë*'s see also "Pollock as Jungian Illustrator: the Limits of Psychological Criticism," *Art in America* 67 (December 1979): 73–74, and Ellen Landau, *Jackson Pollock* (New York: Harry N. Abrams, Inc., 1989), 124; and for Pollock and Masson at Hayter, see Landau, *Jackson Pollock*, 152. Most writers now, like Landau, think the connection between the two *Pasiphaë*'s, and therefore between Pollock and Masson, was more general, including many examples of Masson's work available to Pollock. See, for instance, Martica Sawin, *Surrealism in Exile and the Beginning of the New York School* (Cambridge: The M. I. T. Press, 1995), 339 and 353. ■ 52 William Rubin, "Jackson Pollock and the Modern Tradition, Part II," 33–34. ■ 53 Ibid., 34. The reference is to Robert Goodnough's "Pollock Paints a Picture," *Art News* 50 (May 1951). ■ 54 Ibid., 34–36. ■ 55 Mark Rothko in Bonnie Clearwater, "Writings by Mark Rothko" (London: The Tate Gallery, 1987), 85. First published in "A Symposium," *Interiors* (10 May 1951). ■ 56 Robert Rosenblum, "Notes on Rothko and Tradition," in *Mark Rothko 1903–1970*, 31. In the same catalogue Michael Compton ably discussed Rothko's approach to the series in his architectural commissions in "Mark Rothko: The Subjects of the Artist," but did not compare it to Monet's series. ■ 57 Jeffrey Weiss, Rothko's Unknown Space," Jeffrey Weiss, *Mark Rothko* (Washington: National Gallery of Art, 1998), 318–322. ■ 58 "A picture lives by companionship, expending and quickening in the eyes of a sympathetic observer. It dies by the same token," wrote Rothko in 1947. Statement in "The Ides of Art: Ten Artists on Their Art and Contemporaneousness," *Tiger's Eye 2* (December 1947): 44. ■ 59 Clyfford Still to a friend, May 1951, reprinted in *Clyfford Still* (San Francisco: Museum of Modern Art, 1976), 119. ■ 60 Rothko to William Seitz, interview 22 January 1952 on deposit at the Archives of American Art; quoted by Clearwater in "Writings by Mark Rothko" in *Mark Rothko 1903–1970*, 73. ■ 61 Clyfford Still in Benjamin J. Townsend, "An Interview with Clyfford Still," *Gallery Notes* 24, Albright-Knox Gallery, Buffalo, New York (Summer 1961), 13. ■ 62 Max Kozloff, "The Problem of Color-Light in Rothko," *Artforum* 4 (September 1965), 39–44; Michael Auping, "Clyfford Still and New York: the Buffalo Project," in *Clyfford Still*, ed. Thomas Kellein (Munich: Prestel-Verlag, 1992), 42. ■ 63 Monet quoted by Paul Tucker, "Revolution in the Garden," 47. ■ 64 Clyfford Still, letter to Betty Parsons, September 26, 1949. Betty Parsons Papers, Smithsonian Institution, Archives of American Art, Washington, D.C., roll no. N68/72. ■ 65 Ben Heller, "Clyfford Still: Dark Hues, Close Values," *Clyfford Still* (N.Y.: Mary Boone Gallery, 1990), n. pag. ■ 66 In a considerably revised version of "American-Type Painting [orig. 1955] Clement Greenberg followed his estimation that "It was maybe a dozen years ago that some of Monet's later paintings began to seem 'possible' to people like myself" that "Clyfford Still emerged as one of the original and important painters of our time—and perhaps more original, if not more important, than any other in his generation," with the observation that "as it turned out, Still, along with Barnett Newman, was an admirer of Monet." *Art and Culture* (Beacon Press, 1961), 221. ■ 67 Still in a letter to Gordon Smith, 1 January 1959, in *Clyfford Still,* ed. John P. O'Neill (New York: The Metropolitan Museum of Art, 1979. ■ 68 Seymour H. Knox, unpublished interview with Michael Auping from a series of three done between September 27 and November 6, 1987. Quoted from Auping, "Clyfford Still and New York," 40. ■ 69 Robert Hobbs, "Confronting the Unknown Within," in Joanne Kuebler and Robert Hobbs, *Richard Pousette-Dart* (Indianapolis: Indianapolis Museum of Art, 1990), 122–130; Richard Pousette-Dart, statement in John I.H. Baur, *Nature in Abstraction: The Relation of Abstract Painting and Sculpture to Nature in Twentieth-Century American Art* (New York: The Macmillan Company, 1958), 79. ■ 70 Evelyn Pousette-Dart, telephone conversation with the author, 27 July 2001. ■ 71 Robert Hobbs, "Confronting the Unknown Within," 130. ■ 72 Thomas Hess, *Barnett Newman* (New York: Walker and Company, 1969), 14. ■ 73 Newman, "The Problem of Subject Matter [c.1944] *Barnett Newman, Selected Writings and Interviews*, 81–82. The essay was published only after Newman's death in Thomas Hess' catalogue, *Barnett Newman* (New York: Museum of Modern Art, 1971), 40. It may also be found in *Barnett Newman, Selected Writings and Interviews*, 82. ■ 74 Barnett Newman, Open Letter to William A. M. Burden, President of the Museum of Modern Art, July 3, 1953. Reprinted in *Barnett Newman, Selected Writings and Interviews,* ed. John P. O'Neill (New York: Alfred A. Knopf, 1990), 38–39. ■ 75 Yve-Alain Bois "Perceiving Newman," in *Barnett Newman, Paintings* (New York: the Pace Gallery, 1988), 5. ■ 76 Newman to Pierre Schneider on Ucello's *The Battle of San Romano* in 1968. "Through the Louvre with Barnett Newman" [*Art News* 68 (Summer 1969)], *Barnett Newman, Selected Writings and Interviews,* ed. John P. O'Neill, 292. ■ 77 Hess, *Barnett Newman,* 1969, 54. Mrs. Annalee Newman, Barnett Newman's widow, has related that her husband went over and approved the Hess' proofs 1969, which suggests that this was the way Newman wanted his relation to Impressionism to be understood. It is notably similar to Rauschenberg's erasure of a de Kooning drawing in 1953 in its implication that in each case, the elder artist presented to the younger a strong case that must be surpassed. ■ 78 Newman to Schneider in *Selected Writings and Interviews*, 293. ■ 79 Marioni's precisely conceived presentation of different layers of pigments in translucent and transparent binders is posited on "the perceptual recognition of the material itself as having content." For him, the context entirely determines viewers' *understanding* of the painting, but the construction of the painting is capable of meeting and radically informing their *perception*. Joseph Marioni, email to the author, 24 September 2001. ■ 80 "Old Master's Modern Heirs," *Life* (December 2, 1957), 94–9. Earlier that year *Life* had presented the work of Helen Frankenthaler, Nell Blaine, Joan Mitchell, Jane Wilson and Grace Hartigan, in similar terms, though not as Monet's heirs. Leja, "The Monet Revival," 106–107, and 293, notes 54 and 55. The term "abstract impressionism" seems to have been first used by Elaine de Kooning in "Subject: What, How or Who?" in *Art News* (April 1955): 62. ■ 81 Finkelstein, "New look: Abstract Impressionism," 66. ■ 82 In Mitchell's case, it is also important to note that she was struck by Willem de Kooning's *Excavation* at the Whitney Museum in 1949, a factor that probably catalyzed her change from impressionism to abstract expressionism. ■ 83 Milton Resnick in *Art U. S. A. Now* 2 (1962), quoted in "Selected Quotations: Milton Resnick," in *Milton Resnick: Selected Large Paintings* (Fort Worth, Texas: Fort Worth Art Center, 1971), n. pag.; The quotation about his paintings is by S. T. in *ARTS* 35 (May/June 1961): 88. ■ 84 J. K. in *Art News* 60 (May 1961): 12. ■ 85 Milton Resnick, telephone statement to Michele Heinreise at Robert Miller Gallery, August 14, 2001. ■ 86 Henry Hopkins, "Introduction" to *Milton Resnick: Selected Large Paintings*, n. pag. ■ 87 Resnick quoted by Nancy Ellison in "The New Work in Roswell" in *Milton Resnick*

(1971), n. pag. ■ 88 "He was not a good colorist," said Mitchell of Monet. Seeing him as a painter of immediate sensation, not of feelings and sensations, Mitchell claimed, "he isn't my favorite painter ... I never much liked Monet." Bernstock, *Joan Mitchell*, 76. ■ 89 Bernstock, *Joan Mitchell*, 76. ■ 90 From Michael Plante, Ch. 7, "Indexing Nationality: The Monet Revival, and American Painting in the French Tradition, Expatriates IV," in the manuscript of his forthcoming book, *Paris's Verdict: American Art in France, 1945–1958*; Gaston Bachelard, "*Les Nymphéas* ou les surprises d'une aube d'été," *Verve* 7, 27–8 (December 1952). ■ 91 Judith E. Bernstock, *Joan Mitchell* (New York: Hudson Hills Press, 1988), 18–19. ■ 92 Barbara Rose, "The Second Generation: Academy and Breakthrough," *Artforum* 4 (September 1965): 58. ■ 93 Thomas B. Hess, *Abstract Painting: Background and American Phase.* (New York: Viking Press, 1959), 100. ■ 94 Paul Schimmel, "The Lost Generation," *Action/Precision: The New Direction in New York, 1955–60* (Newport Beach, Calif.: Newport Harbor Art Museum, 1984), 39. Mitchell bought a house on two acres in Vétheuil, 69 kilometers north of Paris. Bernstock *Joan Mitchell*, 57, 73. ■ 95 Plante, "Indexing Nationality," manuscript. ■ 96 E.C. Goosen, *Ellsworth Kelly* (New York: The Museum of Modern Art, 1973), 35. Kelly did see —and recalled for Trevor Fairbrother—his appreciation of the tension created in Monet's *Rouen Cathedral in Full Sunlight*, 1894 by the way the sky is squeezed to the foreground and edge of the picture. Trevor Fairbrother, *Ellsworth Kelly, Seven Paintings (1952–55/1987)* (Boston: Museum of Fine Arts, 1987), n. pag. ■ 97 Nathalie Brunet, "Chronology, 1943–1954," in *Ellsworth Kelly, The Years in France, 1948–1954* (Washington, D.C.: The National Gallery of Art, 1992), 178. ■ 98 Brunet, "Chronology," 192–93; quoted from an interview with Ellsworth Kelly by Paul Taylor in *Interview* 21, no. 6 (June 1991), 102. ■ 99 Ibid., 193. ■ 100 Kelly quoted by John Coplans, *Ellsworth Kelly* (New York: Harry N. Abrams, Inc., 1971), 28–30. ■ 101 Yve-Alain Bois, "Ellsworth Kelly in France: Anti-Composition in Its Many Guises," *Ellsworth Kelly, The Years in France, 1948–1954* (Washington: The National Gallery of Art, 1992), 14, 19, 34, n. 35. There is a ready-made aspect to a few of Kelly's work, such as the 25 squares of store-bought dyed cotton, stretched onto wooden panels that comprise *Red Yellow Blue White*, 1952. See Bois, 27–29 for more about this and the pictorial ■ 102 Bois, "Kelly in France," 27–29. ■ 103 Linda Nochlin, "Kelly: Making Abstraction Anew," *Art In America* 3 (March 1997): 71. ■ 104 Nochlin, "Kelly: Making Abstraction Anew," 75–76. ■ 105 See Franz Meyer, "Sam Francis in Europe" in *Sam Francis: Paintings 1947–1972*, ed. Robert T. Buck, Jr. (Buffalo: Albright-Knox Art Gallery, 1972), 8–9. ■ 106 For Still, Rothko, and San Francisco Bay Area Abstract Expressionism, see Susan Landauer, *The San Francisco School of Abstract Expressionism* (Laguna Beach: Laguna Beach Art Museum, 1996, 15 ff.). See also her *The San Francisco School of Abstract Expressionism* (Berkeley: University of California Press, 1996, 13–26. ■ 107 William C. Agee, "Sam Francis, Color, Structure, and the Modern Tradition," *Sam Francis: Paintings 1947–1990* (Los Angeles: The Museum of Contemporary Art, 1999), 9. Agee quoted Sweeney from *Sam Francis* (Houston & Berkeley: Museum of Fine Arts and University Art Museum, 1967), 21; the estimations of Francis in New York are from Hilton Kramer, "Sam Francis Focus of Whitney Display," *New York Times* (16 December 1972): 27. ■ 108 I.e. Peter Selz, *Sam Francis* (New York: Harry N. Abrams, Inc., 1975), 43. ■ 109 Agee, "Sam Francis," 18, 20, quoting from Sweeney, *Sam Francis*, Sam Francis to Bernhardt Schulze in 1950, 17; for Francis' schooling, see, in the same catalogue, the chronology by Debra Burchett-Lere, 142. ■ 110 Agee, "Sam Francis," 31–2. ■ 111 Selz, *Sam Francis*, 47. Photos of the stages of this transition appear on p 44. ■ 112 In Sweeney, *Sam Francis*, 14. ■ 113 Michael Plante, "Indexing Nationality," manuscript; "Biographie" in *Jean-Paul Riopelle,* organized by Jean-Louis Prat (Montreal: The Montreal Mueum of Fine Arts, 1991). ■ 114 "Biographie" in *Jean-Paul Riopelle,* 195, 196. See also *Jean-Paul Riopelle: Peintures 1946–1977* (Paris: Musée national d'art moderne, Centre Georges Pompidou, 1981): 87. ■ 115 Pierre Schneider in *Jean-Paul Riopelle,* 10. ■ 116 Werner Schmalenbach, excerpted from *Riopelle* (Hanover: Kerstner-Gesellschaft, 1958–1959), 78; translated into English in Prat, *Riopelle*, 81. ■ 117 See William Seitz, "Monet and Abstract Painting," in *Claude Monet: Seasons and Moments* (New York: Museum of Modern Art, 1960), 39, the "weather bureau" observation, by Larry Rivers, is quoted and discussed in Michael Leja in "The Monet Revival," 103–04. ■ 118 There is a regular tradition in the visual arts, more powerful in some eras than others, of privileging the faculty of sight over the other senses. Some ages, the Renaissance, for instance, may have been more "ocularcentric"—more dominated by what vision can tell us about the world—than others. ■ 119 Some, like Martin Jay, would say that the 20th century has denigrated vision (p. 4). On the other hand, W.J.T. Mitchell has argued that recently the 20th century has taken a pictorial turn, in which vision is the major epistemological tool. Others maintain with equal conviction that all the senses are entwined in the production of knowledge. Psychologist James Gibson, sorting this out in the third quarter of the 20th century, arrived at the conclusion that humans have both a "visual world" and a "visual field." In the "visual world," what he calls "depth shapes" are produced through the interaction of all the senses. But we can also detach the sense of sight from its mates, asking it to project the

shapes of three-dimensional objects as if they were flat. A round tabletop, for instance, can be seen as an oval (see James J. Gibson, *Senses Considered as Perceptual Systems* (Boston, 1966); *The Perception of the Visual World*, (Boston, 1950), *The Ecological Approach to Visual Perception* (Boston, 1979). See also John Hell on Gibson in *Perception and Cognition* (Berkeley 1983). We are capable, then, of seeing something that looks flat as representing, or having its origin in, something three-dimensional, and the reverse: seeing something that we know is three-dimensional it representing it as if it were simply a flat shape, as Picasso and Gris did in their tabletop still lives, and Frankenthaler and Ellsworth Kelly do in their brilliantly colored shapes. ■ 120 Clement Greenberg, "The Crisis of the Easel Picture" (April 1948) Clement Greenberg, *The Collected Essays and Criticism*, vol. 2, ed. John O'Brian (Chicago: University of Chicago Press, 1986), 222–224. ■ 121 Clement Greenberg, "The Role of Nature in Modern Painting" (January 1949) *Collected Essays*, vol. 2, 271–272. ■ 122 Clement Greenberg, "On the Role of Nature in Modernist Painting," [1949], repr. in *Art and Culture*, 171. ■ 123 Clement Greenberg on Morris Louis, "Louis and Noland" (May 1960) in *The Collected Essays and Criticism*, vol. 4, ed. John O' Brian (Chicago: University of Chicago Press, 1993), 97. ■ 124 Clement Greenberg, "Modernist Painting" (revised) in *The New Art*, ed. Gregory Battcock (New York: E.P. Dutton, 1966), 66–77. This revised version was originally published in *Art and Literature* (Spring 1965). ■ 125 William Rubin, "Ellsworth Kelly: The Big Form," *Art News* 62 (November 1963): 35. ■ 126 Kay Larson, "In the Blink of an Eye," *New York* (October 20, 1986), 88. ■ 127 Joseph Masheck, review of Gene Davis, *Artforum* 10 (February 1972), 85. ■ 128 Michael Fried *Three American Painters* (Cambridge: Fogg Art Museum of Harvard University, 1965), 24. ■ 129 Rosalind E. Krauss, "Jules Olitski," *Jules Olitski Recent Paintings* (Philadelphia: Institute of Contemporary Art, University of Pennsylvania, 1968), n. pag., and Michael Fried, "Jules Olitsky's New Paintings," *Artforum* 4 (November 1965): 39. ■ 130 Kermit Chapma, "Olitski: Nothing but Color," *Art News* 66 (May 1967); 37. A relevant reference for the history Monet and his followers in color structure faced may be found in Jacqueline Lichtenstein, *The Eloquence of Color, Rhetoric and Painting in the French Classic Age* (Berkeley: University of California Press, 1989). ■ 131 Marcia Tucker, "Foreword and Acknowledgments," *The Structure of Color* (New York: Whitney Museum of American Art, 1971), 5. ■ 132 Harold Rosenberg, "Dogma and Talent," *The New Yorker* (October 15, 1973): 113–115. ■ 133 Robert Hughes, "Color in the Mist," *Time* (July 16, 1973), 57. ■ 134 Rosenberg, "Dogma and Talent," 116–18. ■ 135 Jules Castagnary, "L'exposition du boulevard des Capucines: Les Impressionistes," *Le Siècle* (April 29, 1874), quoted and translated by Richard Shiff in "The End of Impressionism: a Study in Theories of Artistic Expression," *Art Quarterly,* n.s. 1 (Autumn 1978): 338; see also 374, n. 8. ■ 136 Shiff, "The End of Impressionism," 354. ■ 137 To distinguish themselves from the Impressionists, the Symbolists characterized Impressionist art as materialistic. Significantly, they excluded Monet and Cézanne from this criticism, recognizing, Shiff believed, a "sympathetic subjectivity." Shiff, "The End of Impressionism," 368. ■ 138 Shiff, "The End of Impressionism," 355, 359, 360. Shiff here quotes Zola, "Le Naturalisme au Salon," (1880) from Émile Zola, *Mon Salon, Manet, Écrits sur l'art*, Antoinette Ehrhard (Paris, 1970). ■ 139 Robert Herbert "Method and Meaning in Monet," *Art in America* 67 (September 1979), 90–108. ■ 140 See Herbert's comments about the difference between his approach and those of Clark, Shiff, and others in his "Impressionism, Originality and Laissez-Faire" in *Radical History Review* 38 (1987): 14–15, nn. 2–4, 10. ■ 141 Robert Herbert, "Method and Meaning in Monet," 92. ■ 142 Robert Herbert, Ibid., 97–101. ■ 143 Robert Herbert, Ibid., 103. ■ 144 One of the most monumental testimonies to its continuing vivacity was the 1988 exhibition and catalogue, *La Couleur Seule, l'experience du monochrome* in Lyon, prepared by Maurice Besset (Lyon: Ville du Lyon in collaboration with the Museés de France et le Centre National des Arts Plastiques, 1988). ■ 145 As Eliasson's installation demonstrates, Monet's questions are lately most profitably plumbed in a number of media, as is also suggested by the videos of Lucier and Rist. ■ 146 These painters included Marcia Hafif, Olivier Mosset, Phil Sims, Jerry Zeniuk, Robert Ryman, and Doug Sanderson. Thomas Krens, "Introduction and Acknowledgments," *Radical Painting* (Williamstown, Mass.: Williams College of Art), n. pag. ■ 147 Lily Wei, "Essay," *Radical Painting*, 12. ■ 148 Marioni quoted in Wei, "Essay," *Radical Painting*, 15. ■ 149 Marioni statement in *Radical Painting*, 31. ■ 150 Bridget Riley in Roald Nasgaard's "Pleasures of Sight and States of Being, Radical Abstract Painting Since 1990," in *Pleasures of Sight and States of Being, Radical Abstract Painting Since 1990* (Tallahassee, Fla.: Florida State University Museum of Fine Arts, 2001), quoted from John Spurling, "In My Own Way, Yes. The Paintings and Writings of Bridget Riley," *Modern Painters* (Autumn 1999), 36, on p. 4 in Nasgaard. ■ 151 Joseph Marioni, "Socrates and the Alligator: Whose Problem Are You Trying to Solve?" *Abstract Painting between Analysis and Synthesis* (Vienna: Galerie Nächst St. Stephan, Rosemarie Schwarzwälder, 1992), 71, Quoted in Nasgaard, "Pleasures of Sight," 4. ■ 152 Nasgaard, "Pleasures of Sight," 21. ■ 153 Byron Kim, telephone conversation with the author, 18 May 2001. ■ 154 Lily Wei in *Here and Now* curated by Monika Szewczyki (Bialystok: Sacheta National Gallery, prepared by the Arsenal Gallery in Bialystok, 2001).

Hajo Düchting

Color and Technique: Monet and His Influence on Abstract Painting

Monet's Painting—Nature into Art

Apart from studies on individual works or artists, there has been little scholarly research on Monet's technique or the techniques of the Impressionists.[1]

Up to 1890 Monet used not only white primed canvases but also beige, gray and reddish-brown ones. For his late paintings, however, particularly the *Nymphéas* (the paintings of waterlilies in the lily pond, hereafter referred to as the *Waterlilies*) he used white canvases exclusively. Some were fine and mechanically woven, others had a pronounced texture, that is, a coarser weave.[2]

The studies for the *Waterlilies* were made both outdoors and in the artist's newly built studio from sketches assembled in 'model books.' Preliminary drawings, such as those Monet had made for individual paintings until 1890, were completely dispensed with. In the first step of the painting procedure, the motif was sketched with broad gestural brushstrokes in thin paint on the primed, uniformly white canvas. This *ébauche* (first draft) was a completely free and, above all, very colorful layout of the composition, which was not made to harmonize with the given reality of the motif (local color) until the second step. This quasi *informel* (formless) layout can still be seen on some unfinished ("non fini") canvases (*cachets d'atelier*) (ill. p. 142).[3]

Before completing the *ébauche*, Monet broadly hatched in the textures, partly by not filling in outlines of forms. These hatches vary in direction, form, size and color intensity depending on what is (still) their representational reference. They also counteract the dissolution of the forms, something that Monet criticized as a shortcoming in Turner's pictures (despite his interest in them).[4] In twenty to thirty working sessions Monet then applied several layers of color in thick, dry oil paint, previously freed from oil (rarely wet-on-wet). These flecks of paint only partly overlap, so that underlying and neighbouring areas of color remain visible. The aim is to obtain a rough, vibrating surface that appears to be constantly changing (vibrating) through varying reflections of the light. In some paintings this impression is heightened by the use of highly textured canvases and broad old paintbrushes (ill. left).[5]

Claude Monet, Nymphéas, 1920 Waterlilies
Oil on canvas, 100 × 300 cm.
Paris, Musée Marmottan-Monet

Detail from: **Le Bassin aux nymphéas, le soir**, 1920
The Waterlily Pond in the Evening (Diptych,
part 1). Oil on canvas, 200 × 300 cm.
Zurich, Kunsthaus Zurich

Besides the brushwork, it is above all the colors that are responsible for the optical vibrations. Monet's palette (ill. right) is limited to six colors (white, cadmium yellow, red cinnabar, carmine red, cobalt blue, emerald green).[6] In the *Waterlilies* it excludes the gray values used to show depth and chiaroscuro that were important pictorial devices in traditional landscape painting. Instead, Monet employed the values of hues, as Delacroix had demonstrated, so that a picture is built up of hues with approximately the same values. He not only used light-dark, warm-cold and complementary color contrasts but also color modelling from yellow-orange to red through violet-blue to green. The brushstroke's representational descriptive function dissolved increasingly into a purely painterly one.

The question continues to arise as to what extent Monet was involved in the contemporary discourse on new color theories. An interview in 1888 shows that Monet approached color mainly from the point of view of the intensity of contrasts and that he took the laws of complementary colors into account in doing so.[7] These laws had been researched scientifically in France in Michel-Eugène Chevreul's monumental book, *De la loi du contraste simultané...*, Paris 1839 (*On the Law of Simultaneous Contrast and its Application in Pictures*; Chevreul's color wheel, ill. middle right), though they had already been explained by Charles Blanc using the example of Delacroix. Delacroix's pioneering role was underscored in the 1880s by Théodore Duret, who saw "peinture claire et colorée" realized in his murals in Saint-Sulpice.[8] While at the beginning of his career Monet worked in the *peinture claire* tradition of Corot and especially of Boudin, he sought from the late 1970s on to combine *peinture claire* with *peinture colorée* as derived from Delacroix.[9] Monet most likely got his information on the effects of color contrasts straight from Delacroix's diaries, which were among his favorite reading. On the other hand, Monet never used the 'divided color' technique that he so admired in Constable's paintings of fields and that was later systematized by Seurat (in the *pointillage* technique).[10]

The first coloristic innovation of Impressionism was to ban the color black, particularly from shaded areas, by introducing colored shadows in the complementary color of the object casting the shadow. Art criticism panned this as "violet mania."[11]

Contrasting any color creates the same physiological conditions, for the changing complementary stimuli thus induced produce both an intensification of the color contrast and an optical vibration. Monet (as did the other Impressionists) learned early on about the application of such contrasts, especially the complementary ones (red-green, violet-yellow, blue-orange), and made much use of them in his paintings from the 1970s on (e.g. the red-green complementary contrast in *Regatta in Argenteuil*, ill. p. 145).

Monet's shift to an expressive and subjective choice of color with an emphasis on color contrasts was recognized by Signac in 1894 as a fundamental event representing his modernity.[12]

Contrasts of this kind are also common in his *Waterlilies*, but they are embedded by very refined color modelling from warm to cold (and light to dark) in the context of color that avoids strong accents in favor of a softly flowing, harmonious overall atmosphere.

Monet's juxtaposition of separate, unmixed, contrasting brushstrokes that are only partly intended to depict reality contributes substantially to the vibration of the

Monet's palette. Paris, Musée d'Orsay

Chevreul color circle

paint surface. The hues extend through all varieties of color modelling from yellow-orange to red and violet-blue to green as well as the complete range of complementary contrasts. The laws of color (simultaneous contrasts, complementary contrasts, color modelling, etc.) and the lively brushwork create movement that goes far beyond that of the figurative subject and brings about a close interaction between the picture and the viewer. First of all, this color, largely detached from the motif and yet referring to it, evokes a host of moods and sensations controlled by Monet with the help of certain color concepts. While Monet rejected or did not apply a systematic color theory, it could nevertheless be said as regards these late works that they are about color, although by that time the first abstract painting focusing on color had already been painted (by Kandinsky and Delaunay). Unlike non-figurative, abstract painting, Monet's work was still concerned with evoking atmosphere, ultimately inspired by the experience of the natural landscape, though conveyed by a rather free play of color (abiding by its laws) and an exaggerated gestural brushstroke.

The coloristic system produces the appearance of nature's intrinsic elemental character. The viewer is free to refer his experience of elemental, natural appearances back to familiar perceptions or to plunge right into the coloristic system, in a meditative and contemplative self-awareness (and thus to become aware of his own 'inner nature'). This turning towards the elemental (of nature) broke the ground for the elemental character of color, which was then built on in the 1950s, e.g. by Art Informel and Abstract Expressionism, and continues to be further developed by the exponents of 'painterly art' to this day.

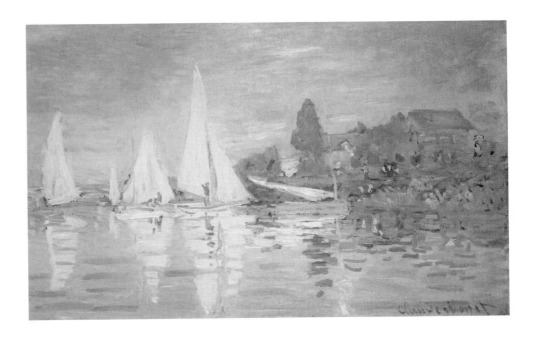

Claude Monet, Régates à Argenteuil, 1872
Regatta in Argenteuil
Oil on canvas, 48 × 75 cm.
Paris, Musée d'Orsay

Monet in America

At the end of the 1940s a completely independent kind of painting arose in the USA. Abstract Expressionism (New York School or American-Type Painting), as it was called, represented an entirely abstract concept of art and excluded all traditional historic pictorial forms. In barely a decade it attained prominence both in America and in Europe. When the Monet revival began at the end of the 1950s, the artists of Abstract Expressionism, such as Jackson Pollock, Mark Rothko, Clyfford Still, Ad Reinhardt, Mark Tobey, et al, were already in the mature phase of their style, which they had developed from a wide variety of sources. The discovery of Monet's late *Waterlilies*, however, gave these painters a powerful new incentive and confirmed their focus on pure, spiritual abstraction.[13]

While Pollock was familiar with 'classical' Impressionism, he may have known the *Waterlilies* from reproductions (probably through the intermediary of Masson). Nevertheless, it was precisely Monet's Impressionism that was an interesting point of departure for Pollock. The impressionist brushwork technique (impasto) inspired Pollock to paint with a very dense, closed texture ("autonomous, homogenous crust of paint" in Meyer Shapiro's words).[14] He had already used this technique in his early paintings, such as *Shimmering Substance*, 1946 (ill. p. 147). The paints overlapping in long curving strokes create a dense texture, whose glowing white intensity recalls a hot summer afternoon. The reference to Monet's Giverny landscapes, e.g. *Pont Japonais*, seems to appear both in the technical handling of the paint and the landscape association.

In Pollock's most important paintings the drip technique is so thickly applied that it is comparable to the molecular structure of Monet's late impressionist paintings. This shows very clearly in *Lavender Mist, Number 1*, 1950 (ill. p. 123), where the drippings leave behind a dense vibrating network of paint traces. Moreover, Pollock's motivation was similar to that of the mature Monet: both painters wanted to depict the flow, rhythm and movement of modern life, which Pollock tried to describe with the term 'accidentality.'

Pollock's all-over, the even distribution of paint drippings in picture format, can be traced back to the non-hierarchical, chromatic method of composition used by Monet in his late works.[15]

As in some of Monet's *Waterlilies*, Pollock's color structure is based essentially on light-dark tonalities, i.e. individual hues are surrounded by other achromatic hues (brown, black, white, silver-aluminium) and thus make a homogenous impression instead of emphasizing strong color contrasts. Pollock does not use saturated hues but light, broken tints in many nuances. One hue (such as green in *Full Fathom Five*, 1947) is dominant, while the other colors are held back.

In the 1950s the influence of the late Monet on the Abstract Expressionists was traced back mainly to similarities in the all-over composition and the style of "colored incrustation" (Rubin). To Greenberg the late Monet was the painter who had shown painting a new direction away from figurative reproduction to pure color structures.[16]

Barnett Newman is the only American artist to comment on Monet and Impressionism in his writings. His paintings, however, show the least affinity to Monet's late work

Jackson Pollock, Shimmering Substance, 1946
Oil on canvas, 76.3 × 61.6 cm.
New York, Museum of Modern Art

(apart from their oversized format, which was important to Newman for enhancing the effect of the 'sublime').[17]

By referring back to Impressionism (particularly to Monet) Newman not only indicated that he saw himself as a reformer of art but also showed what importance color had for him.

"In the mid-1940s when I began to move towards what occupies me today, I discovered that emptiness cannot be overcome by building up patterns, manipulating space or creating new organisms. A canvas filled with rhetorical brushstrokes may seem full but this fullness could turn out to be energy running off into emptiness, just as a sparkling wall of color can be full of colors without really having color. My canvases are full, but not because they are saturated with colors but because color creates fullness. Their fullness is what occupies me. It is interesting to me to notice how difficult it is for people to take the intense heat and blaze of my color. If my paintings were empty they could take them with ease. I have always worked with color without regard for existing rules concerning intensity, value, or non-value. Also, I have never manipulated colors— I have tried to create color." [18]

For Newman, colors are a neutral "inert material" to begin with. Only during the painting process itself does color become an essential element that evokes a sense of grandeur (the sublime) in a picture. In his remarks on color, Newman rejects all historically based rules and value-judgments. No matter what color he chooses, it does not become the carrier of the artist's emotions until the moment he uses it on the

canvas. Color serves as a neutral medium, so to speak, to pick up the artist's emotional impulses and to make the painting into a transcendental event that the viewer is able to empathize with.

Mark Rothko, the second major Color Field painter of the New York School, also used color as his only pictorial device in order to experience its inner (spiritual) quality. The sensual experience of color that you feel when contemplating Rothko's paintings depends on a very complex, intricate treatment of color (as material) and its application on the primed surface (picture plane) (ill. pp. 125, 287).[19]

By 1950 Rothko had developed his working procedure with a sequence of steps that he more or less maintained from then on. On the untreated, unprimed canvas he spread glue (or egg emulsion) died with pigments. Rothko then made this primer durable with thin washes of oil paint, whereby he usually extended the color over the edges of the stretched canvas. As he did not frame his pictures, this gave the impression of a unified panel. Onto the primer he then applied patches of color in a special mixture of oil and egg-based emulsion. Some of these patches were diluted with turpentine and were so thin that the particles of pigment separated almost completely from the mixture, remaining barely attached to the surface. In this way he made the incoming light penetrate the layers of paint

so that it was reflected by the individual particles of pigment and enveloped the picture plane in an aura of color and light.[20]

While his paintings usually had the same vertically aligned rectangular format, the colors were used in a wide variety of ways. To an unusual series of colors that were both contrasting and closely related, Rothko added light and darkness, transparency and opacity, high or low saturation, smooth or gestural textures, warm and cold contrasts, hard and soft edges, and above all countless nuances by superimposing layers of color.

As opposed to the Bauhaus teachings circulating at the time (Klee's and Kandinsky's, as taught, e.g. in Hans Hofmann's classes) Rothko made his color evolve through contrast and assimilation: "Either the fields in the painting are expansive and press outwards in all directions or they contract and drift into the depth in all directions. Everything I want to say can be found between these two poles." [21]

Rothko knew how to manipulate colors so that with every color he could go in both directions. Pure complementary contrasts are, however, rare in Rothko's work. His unusual color nuances also demonstrate that he was very familiar with the history of color in painting (from Pompeian painting through illuminated manuscripts to Matisse).

The kinship between Monet's late work and that of the Abstract Expressionists was also picked up with increased verve by some younger painters. Between 1952 and

Sam Francis, Baseler Wandbild, 1956–1958
Basel Mural
Basel, Kunsthalle

Willem de Kooning, Rosy Fingered Dawn at Louse Point, 1963
Oil on canvas, 203.5 × 178.5 cm.
Amsterdam, Stedelijk Museum

1955 references to late Impressionism turn up in several paintings by New York artists (Guston, Joan Mitchell, Sam Francis, Miriam Shapiro, Wolf Kahn, Hyde Solomon, etc.). These painters, soon grouped together as being "Abstract Impressionist,"[22] demonstrated their affiliation to Monet and his *Waterlilies* most clearly.[23]

Sam Francis, living in Paris in the 50s, was inspired by Monet's *Waterlilies* to organise pictorial space with loosely connected blobs of color. The introduction of intense hues, mainly the triad of primary colors, blue, yellow and red, which Francis assembles with strong contrasts, sometimes overlapping and running down in colored streaks because of the liquid application of paint, also harks back to the impression made by the *Waterlilies*.[24]

The influence of Monet reached a first apogee in his three large-sized murals for the stairwell of the Kunsthalle in Basel (opened in 1958, see p. 148). Sam Francis carries the tradition of *décoration* of his predecessors Monet and Bonnard forward in these works. In the year that his Basel triptych was completed, Francis and other Art Informel artists were invited to a "Hommage à Monet" organized by Pierre Restany. In the preface to the catalogue Restany summed up again the basic elements in Monet's 'waterlilies' that were exemplary for a group called the "nuagistes" at the time. Frédéric Benrath, one of the members, is also represented in the present exhibition (ill. p. 181).

The paintings of Francis' last years of production, with gesturally-brushed or splattered-on paint, refer back to the beginnings of Action Painting (*Taiaisha*, 1986), yet they also pick up stylistic features (color textures) from Monet's *Waterlilies* again.[25]

Her living in Vétheuil from 1968 on, not far from Monet's garden in Giverny, was enough to make Joan Mitchell's painting an especially interesting example of the affinity between Monet and the gestural painting of the New York School.

After moving out there her palette became brighter, with hues high in value, the references to the landscape became clear, and the colorful impasto thicker. But it is particularly in her late work that the gestural brushstrokes densify into chromatically refined compositions. Violent whacks of the brush interweave like seaweed drifting in water; the white canvas remains partly exposed, thus making the overlapping traces of the brush breathe and vibrate (e.g. *Chord X*, 1987, ill. p. 249). The conglomerations of trickles and drips of paint seem to float in the air like a colorful phantasmagoria, yet without obliterating the references to natural scenery of prime importance in Mitchell's oeuvre.[26]

Closely related to Mitchell's works and yet created in a completely different spirit are the pictures by de Kooning painted in the mid-1950s, a series of abstract landscapes in an extremely dynamic, gestural style. From 1960 on, de Kooning used lighter tones and he crowded yellow, white and pink layers together into a compressed pictorial structure. The dynamism of the gestures going in all directions makes the picture appear

energy. *Rosy Fingered Dawn at Louse Point*, 1963 (ill. p. 149) is an amalgam of a sequence of expansive overlapping gestures made with the brush, partly transparent or else with heavy impasto, that involved the use of his whole body and the help of large, heavy, bristly brushes. Such paintings not only discharge the vehement energy of gestural painting but also reveal an impressionist experience of nature evolving from direct experience.[27]

Milton Resnick, who lived in Paris from 1946 to 1949, was much less famous. Back in New York from the 1950s on, Resnick developed a gestural and abstract style of painting influenced by de Kooning and Hofmann that recalls the tradition of French painting in its lightened palette and its intense hues high in value. In his large-sized pictures of the 1960s, Resnick transformed his experience of the impressionistic texture of paint into flowing, shimmering veils of color. As though wafted by an invisible breeze, they drift out in all directions, filling the entire pictorial space with closely placed colorful contrasts (*F. L. W.*, 1960, ill. p. 272). Unlike the other Colorfield painters in New York (Rothko, Newman), Resnick filled his color fields with associations to land-scape, flowering, and naturally growing elements. His paintings represent some of the most powerful examples of Abstract Impressionism in the reception of Monet's late work.[28]

The immediate proximity to artists and works of French Impressionism also inspired other American artists staying in Paris after the war. One of the best known is Ellsworth Kelly, whose years in France (1948–1954) were fundamentally important for the development of his style. Kelly owed the principle of monochromy, or of non-hierarchical composition, as well as the 'overwhelming' format of his paintings (which led to 'shaped canvases' later) not only to his studies of Cubist pictorial structure (collages). He was also influenced by the experience of Monet, which he assimilated in 1952 afte visiting Giverny in his *Tableau vert*, 1952 (ill. p. 217). Its two-dimensional surface modelled in shades of green is still indebted to the chromatic depth of the *Waterlilies*.

Winfred Gaul, Kalahari, 1983, painting in three phases. Acrylic on canvas, 200 × 340 cm. Property of the artist

Raimund Girke, Große Konstruktion, 1993/94
Oil on canvas, 200 × 240 cm.
Property of the artist

In the grids and color panels to follow, color is used according to a random principle in highly saturated autonomous hues, which —according to Kelly—also owed its basic inspiration to the way Monet's *Waterlilies* are about color.[29]

Elemental Painting

Along with the analytical, deliberately fundamental or elemental painting of the 1960s and 1970s, the painterly style is now being rediscovered all over Europe as being of value. Thus painters are once again addressing Monet's (late) work. One of them is Winfred Gaul, who, after an informal phase, explored the techniques of painting in experimental series that owe their basic inspiration to Monet's series (e. g. *Kalahari*, a painting in three phases, 1983, ill. p. 150).[30]

Raimund Girke's paintings were often shown in a similar context as well, although his approach is considerably more strict and systematic, seeking intensity and variety in reduction instead of in the elaboration of pictorial means. After informal beginnings and dark shades Girke arrived at a more compact pictorial structure in the second half of the 1950s with a 'serial' script written with a brush, followed by an increased preference for the color white (*Strukturen*, 1959, ill. p. 199). Alternating meditative, tranquil pictorial structures and lively gestural ones, Girke's oeuvre passed through a succession of both series and mutations that culminated in expressive dynamics in the 1990s. Unlike the paintings of the 1950s and 1960s, these works do not have a grid structuring the movements of the paintbrush. Turbulent gestures create a painterly kind of tension in the structures of color accompanied by cool blue hues. By illustrating the painting process he reveals reflections on painting that define the picture plane, space, and—above all—light (emanating from color) as the constants of painting. Once again, the analysis of Monet's color spaces had served as inspiration (*Große Konstruktion*, 1993/94, ill. above).[31]

In the 1960s and 1970s, Gotthard Graubner made the physical compression of color into the main idea behind his art. In his "Farbraumkörper" (color-space bodies) dating from the early 1970s on, he brought the spatial quality and the corporeality of color into a mutually conditional relationship. The spatial energies of the movements of color saturating the 'color body' in many layers are transposed into real space by the three-dimensional expansion of the "Farbkissen" ('color cushions'). This twofold connection to space is picked up by the revolving color energies that are 'calmed down' by numerous superimposed layers. The luminosity of the color organism is also bound to the materiality of the color, like free-floating light from color that reveals color's twofold basis: sensual presence and spiritual transcendence. Of course the idea of the painting as an organism and the technical process of layering paint both have a long tradition that goes back to Alberti. Yet Graubner, too, has repeatedly pointed out the importance of Monet for the development of his pictorial language (see Statement p. 206).[32]

For Jerry Zeniuk, who went from being associated with the 'Radical Painting' group to a very independent, autonomous kind of color painting, "painting is a universal

language, ... a unique visual form of expression."[33] Color is his exclusive medium. His paintings are full of friction, with harsh color contrasts often clashing head-on or spreading out onto the exposed white of the canvas. Zeniuk stakes all on the power of color, which he propels through striking warm-cold, light-dark contrasts into continually new constellations. Layering and confrontation, cold and warmth, light and darkness produce spatial situations that draw the viewer into the depth of the pictorial space or keep him at a distance. This contradiction between a flat two-dimensional and a spatial three-dimensional experience, between the flatness of the surface of the picture and the depth of the pictorial space is what Zeniuk tries to sound out in his paintings (e.g. *Untitled Number 232*, 2000, ill. p. 305). And this is exactly where Monet's example of the duality of paint texture and spatial depth took effect. In Zeniuk's more recent paintings, also shown in the present exhibition, color has withdrawn to a loosely distributed arrangement of spots, exposing the white or unprimed bare canvas. Nevertheless, it exhibits a flowing, rhythmically structured color-space with a distinct affinity to the color-space in Monet's *Waterlilies*.

Thus Monet's pictorial concept, developed so impressively in his late work, particularly in the *Waterlilies*, is interpreted anew and differently by every generation of painters. The idea they have in common can be called the revival of the painterly element. Even in times of increased competition and over-stimulation from the media, it comprises the heart of any (essential, pure) painting: to become aware of oneself in the process of picture-making as a human being, both a thinking and a sensually responsive being.[34]

1 See especially Robert Schiff, 'Impressionist Criticism and Impressionist Color,' Diss. Yale 1973 and John House, *Monet: Nature into Art*, New Haven and London 1986; for a fundamental study see also Karin Sagner-Düchting, 'Claude Monet: *Nymphéas*. Eine Annäherung,' Diss. Hildesheim/Zurich/New York 1985, pp. 96 ff. on color and technique. For more recent bibliography see: *Art in the Making: Impressionism*, The National Gallery, London 1990. ■ 2 Cf. R. Herbert, 'Methods and Meanings in Monet,' *Art in America* (September 1979) pp. 90 ff. ■ 3 House, *Monet: Nature*, p. 66. ■ 4 Cf., e.g. 'Monet 1918,' in: R. Gimpel, *Journal d'un collectionneur, marchand de tableaux, 1918–1926*, Paris 1963, p. 88. ■ 5 On Monet's brushwork technique see esp. Anthea Callen, *Techniques of Impressionism*, London 1982; *Art in the Making*, pp. 91 ff.; R. Herbert differentiated mainly between "texture strokes," which were broad, and "skip strokes," drawn with a pointy brush lightly across the canvas: 'Methods,' pp. 92 ff.; *Impression: Painting Quickly in France 1860–1890*, exh. cat., National Gallery London, 2000/2001, pp. 104 ff. ■ 6 Letter to Bernheim-Jeune dated 03.06.1905, cited in K. Sagner-Düchting, *Monet in Giverny*, Munich 1994, p. 76. On color see also House, *Monet: Nature*, pp. 109 ff. ■ 7 House, p. 110, no. 17. ■ 8 House, p. 111. ■ 9 House, pp. 110 ff. ■ 10 The amalgamation of a wide variety of theoretical concepts of Chevreul, Charles Blanc, Ogden N. Rood, Humbert de Superville and Charles Henry, among others, led Seurat to assume that he could also achieve an 'optical mixture' in the viewer's eye by using the pointillist technique. A genuine optical mixture, however, can only be ensured with a regular pattern of dots and lines (as in color television). Cf. Winslow Homer, *Seurat and the Science of Painting*, Cambridge, Mass. 1964 and Michael Zimmermann, *Seurat und die kunsttheoretische Debatte seiner Zeit*, Weinheim 1991. ■ 11 D. Bomford, in: *Art in the Making*, p. 87. ■ 12 See K. Sagner-Düchting, *Claude Monet "Nymphéas,"* Munich 1985, p. 102. ■ 13 Cf. also Michael Leja, 'Die Wiederentdeckung Monets und die abstrakte Malerei der New York School,' *Monet im 20. Jh.*, exh. cat. ed. Paul Hayes Tucker, Cologne 1999, pp. 98 ff. ■ 14 Meyer Shapiro, Lectures at Columbia University, 1950–51. ■ 15 See the articles by William Rubin, 'Jackson Pollock and the Modern Tradition,' *Artforum* 5, no. 6 (February 1967), pp. 14–22; no. 7 (March 1967), pp. 28–37; no. 8 (April 1967), pp. 18–31; no. 9 (May 1967), pp. 28–33; cited in Pepe Karmel (ed.), *Jackson Pollock: Interviews, Articles and Reviews*, published in connection with the Jackson Pollock exh. November 1998–February 1999, The Museum of Modern Art, New York 1998, pp. 118 ff. ■ 16 E.g. in the essay by Clement Greenberg 'Der späte Monet' (1957): Idem, *Die Essenz der Moderne: Ausgewählte Essays und Kritiken*, ed. Karlheinz Lüdeking, Berlin 1997, p. 225. ■ 17 B. Newman, "Das Problem des Inhalts," Idem, *Schriften und Interviews 1925–1970*, Bern-Berlin 1996, pp. 94 ff.; and his open letter to William A. M. Burden, President of the Museum of Modern Art, pp. 210 ff. In his posthumously published essay and in this letter Newman emphasized the importance of Monet and of Impressionism for the development of modern art. ■ 18 Cited in Armin Zweite, *Barnett Newman: Bilder – Skulpturen – Graphik, Kunstsammlung Nordrhein-Westfalen Düsseldorf*, Stuttgart 1997, pp. 134–135; cf. B. Newman, *Schriften und Interviews*, p. 247 in a different (inferior) translation. ■ 19 On technique and color in Rothko's work compare Ann Gibson, 'Regression and Color in Abstract Expressionism: Barnett Newman, Mark Rothko and Clyfford Still,' *Arts Magazine* 55, no.7 (1981) pp. 144–153; Roland Bothner, 'Mark Rothkos Modulationen,' *Pantheon* 45 (1987) pp. 173–75; Carol-Mancusi Ungaro, 'Nuances of Surface in the Rothko Chapel Paintings,' *Rothko: The Menil Collection*, exh. cat. Houston 1996, pp. 25–29 and idem, 'Material and Immaterial Surface: The Paintings of Rothko,' *Rothko*, exh. cat. National Gallery of Art, Washington 1998, pp. 283–300; James E. B. Breslin, *Mark Rothko: Eine Biographie*, Klagenfurt 1995; John Gage, 'Rothko: Color as Subject,' *Rothko*, exh. cat. National Gallery of Art, Washington 1998, pp. 147 ff.; *Mark Rothko*, exh. cat. Beyeler Foundation, 2001. ■ 20 Cf. Ernst Strauss, 'Über die Erscheinungsweisen der Farben und des Lichts,' idem, *Über das Licht in der Malerei*, Berlin 1954, pp. 221 ff. ■ 21 Cited in J. E. B. Breslin, *Mark Rothko*, p. 301. ■ 22 Louis Finkelstein, *New Look: Abstract Impressionism*, 1956. ■ 23 "The scorned late work of Monet is now inspiring a whole generation of painters producing completely individual paintings with explosive brushstrokes and brilliant colors": 'Old Master's Modern Heirs,' *Life* (2 December 1957) pp. 98 f. ■ 24 Cf. Claire Staullig, 'La technique picturale de Sam Francis,' *Art Press* 5 (July–August 1973) pp. 12–14; Pontus Hulten, *Sam Francis*, exh. cat. Kunst- und Ausstellungshalle der Bundesrepublik Deutschland, Bonn 1993; H. Düchting, 'Sam Francis-Ordnung im Chaos,' *Künstler: Kritisches Lexikon der Gegenwartskunst*, 27th edn., Munich 1994; William C. Agee, *Sam Francis: Paintings 1947–1990*, exh. cat. The Museum of Contemporary Art, Los Angeles 1990. ■ 25 "I am doing the late Monet in pure form." Sam Francis in conversation with Bernhard Schultze, 1950; cited in *Sam Francis: Les années parisiennes 1950–1961*, exh. cat. Galerie Nationale du Jeu de Paume, Paris 1995, p. 169. ■ 26 See Judith E. Bernstock, *Joan Mitchell*, Herbert F. Johnson Museum of Art, Cornell University, New York 1988; *Joan Mitchell*, exh. cat. Galerie Nationale du Jeu de Paume, Paris 1994. ■ 27 "I drive over to Louse Point, that's a nice beach on Long Island Sound, where the water is calm. There is no oceanfront. I plunge into reflections. The water reflects, but loose myself in reflections on the water." Carole Agus, 'De Kooning,' *Newsday* (5 September 1976) part II, p. 3; cited in Harry F. Gaugh, *Willem de Kooning*, Munich/Lucerne 1984, p. 73. ■ 28 See *Milton Resnick: Paintings 1945–1985*, with an essay by Linda L. Cathcart, exh. cat. Contemporary Arts Museum, Houston, Texas 1985; *Milton Resnick: Paintings 1957–1960, from the collection of Howard and Barbara Wise*, exh. cat. Robert Miller Gallery, New York 1988; *Milton Resnick: Monuments*, exh. cat. Robert Miller Gallery, New York 1997. ■ 29 *Ellsworth Kelly: Die Jahre in Frankreich 1948–1954*, exh. cat. Westfälisches Landesmuseum für Kunst und Kulturgeschichte, Münster 1992; Diane Waldman (ed.), *Ellsworth Kelly*, exh. cat. Haus der Kunst, Munich 1997/1998. ■ 30 "Genau genommen begann mein Dialog mit Claude Monet in jenem Augenblick, als ich in der Orangerie vor seiner 'grande décoration' stand, überwältigt von der Pracht der Farben und den Dimensionen dieser einzigartigen Installation: Malerei als Malerei und sonst nichts." ("To be precise, my dialogue with Monet began the moment I stood in front of his 'grande décoration' in the Orangerie, overwhelmed by the splendor of the colors and the dimensions of this unique installation: painting is painting and nothing else.") W. Gaul, 'Dialog mit Monet,' unpublished script; see also Lothar Romain, *Winfred Gaul: Der Maler*, Munich 1999, p. 15. ■ 31 Cf. Gottfried Boehm, 'Weisses Licht,' *Künstler: Kritisches Lexikon der Gegenwartskunst*, 9th edn., Munich 1990; Dietmar Elger (ed.), *Raimund Girke: Malerei*, Sprengel Museum Hannover etc., 1995/96, Stuttgart 1995. ■ 32 See *Gotthard Graubner*, exh. cat. Hamburger Kunsthalle, Hamburg 1975/76; *Gotthard Graubner*, exh. cat. Kunstmuseum, Düsseldorf 1983; *G. Graubner: Die Bildlichkeit der Farbe; Neue Malereien (1982–84); Farbraumkörper und Papierarbeiten*, exh. cat. Galerie m Bochum 1984; *G. Graubner*, exh. cat. Galerie Alter Meister, Dresden 2000. ■ 33 Wilhelm Warning, 'Jerry Zeniuk—Malerei im Spannungsfeld der Gegensätze,' *Künstler: Kritisches Lexikon der Gegenwartskunst*, 47th edn., Munich 1999, pp. 7–8; *Jerry Zeniuk: Oil and Water*, exh. cat., ed. Dieter Schwarz and Ulrich Wilmes, Städtische Galerie im Lenbachhaus, Munich 1999. ■ 34 On the concept of essential painting see Matthias Bleyl, *Essentielle Malerei in Deutschland—Wege zur Kunst nach 1945*, Nürnberg 1988; on current color painting and its various relationships to the history of color and to Monet: Michael Fehr (ed.), *Die Farbe hat mich: Positionen zur nicht-gegenständlichen Malerei*, Essen 2000.

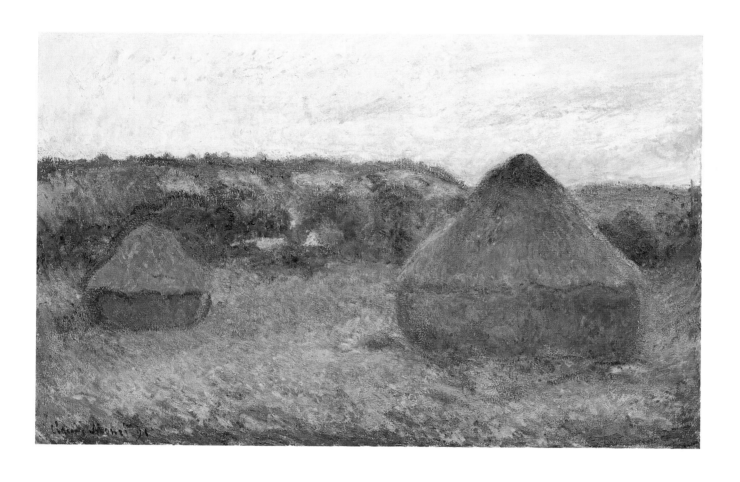

Gottfried Boehm

"Work" and "Series:"
Problems in Modern Conceptions of Pictorial Structure Since Monet

One of the more thought-provoking and vexing phenomena in modern art is the way this art has consistently put itself under attack. The results of this ongoing self-reflexive scrutiny and revision of foundations manifest themselves everywhere, no subject matter or material—whether natural, shaped, or invented—is immune to being viewed as an artifact or to being turned into a picture. To illustrate this in detail is hardly necessary. Surrealism, Dada, happenings, Fluxus, object art, abstract art, pop art, Duchamp, Beuys —all, in their different ways, have shifted art's boundaries. Such art-historical considerations aside, who has not, at one time or other, failed to recognize an intended work of art? We mention this as a reminder of the well-known fact that art's borderline, the line between art and everything else, between art and reality, has become moveable and open to revision.

How the concepts "work" and "series" relate to each other belongs in this overall context. Unspectacular though the question may seem at first, and far from fundamental, it nevertheless harbors its own subversive design on art, conceivably on art's secret heart, namely on the category of a work. For, if the heterogeneous phenomena of traditional art have a common denominator, some defining, binding characteristic, then surely it is this: that art is always a work—a work of art. Everyday usage swiftly equates the two, despite which it is still far from clear what is meant by "a work." Let us proceed tentatively and note that, as an artistic "creation" shifts in a serial direction, a crucial aspect of the work, namely its uniqueness, is affected. That only one such work exists is part of the traditional work's distinction. A picture similar to the *Mona Lisa* is liable to be deemed a surrogate. Can even the *Mona Lisa* exist as a series? We know this is possible—by Andy Warhol, if not by Leonardo. Question answered.

This still provides little real insight into what a "work" is. However, uniqueness belongs to the traditional idea of it, going hand in hand as it does with a work's irreducible individuality. Are uniqueness and non-replaceability the same? Let us, for the present, note that a study may be more important, as a work, than a finished picture, that, en route to an artistic goal actually reached by the artist, artistic creations having their own integrity may come into being, endued with teleology,[1] yet stages on a journey.

Let us sketch a provisional concept of series, as we have done for work. Unlike the latter, we find that, no matter how the members of a series are related, they are never

Claude Monet, Deux Meules, déclin du jour, automne, 1890/91
Two Haystacks, Dusk, Autumn
Oil on canvas, 65 × 100 cm. Chicago, Art Institute of Chicago, Mr. And Mrs. Lewis Larned Coburn Memorial Collection

stages towards a goal. Retaining the notion of a goal generates the paradox that every picture in a series is, in principle, equally distant from it, that is to say, there is no progressive approach, no progressive completion. Applied to Monet, the first picture in the *Rouen Cathedral* or the *Poplars on the Epte* series is a member of a set involving sequence—the first picture is followed by the second, this by the third, and so on— but no progressive approach to *the* cathedral or *the* poplars. No attained or unattained "target picture" (or paradigm) lurks behind the pictures. At most, one might say that all the members of a series taken together go to constituting some such essence. I repeat, this is only a first approximation. However, it does allow certain questions to be posed more clearly. For example: Are all twenty cathedral pictures, or all eleven popular pictures, "works," i.e. has a miraculous proliferation of works occurred? And, if not, how do individual pictures, in internal structure and serial relations, differ from the old concept of a work? Clearly, what a "picture" is at any given time—what elements comprise it, what unifies it—has a history.

Let us sketch a chapter or two of this history briefly. If we take Monet as its starting point, then for good reasons; hopefully, these reasons will become more cogent as we go along. Yet, even in the case of Monet, a certain pre-history is discernible, in pictures that also exerted a direct influence on him: the Japanese woodblock print series of Hokusai or Hiroshige, for instance the *36 Views of Mount Fuji* (1830–32). Going further back in European history, the question arises whether an early form of series painting might not be detected in the *capriccio*, in Guardi's *vedute ideate*, for example. Or is this a question of variations on a theme?[2] In the reverse direction, from Monet to the present, we are on much firmer ground. Here, a growing tendency to paint in series makes itself felt, a tendency we might sum up in the phrase *From picture series to serial painting*. The distinction will concern us later. Of course, not all painting manifests this tendency, only one—albeit very important—division, a division composed chiefly of artists whose work either abstracts or is abstract.

The key figure of the first phase was evidently Kandinsky. Not that he explicitly painted in series—the work-groups entitled *Impression* or *Improvisation* from his Munich period still need to be examined in this light—but that he and his circle illustrate the historical development nicely. It was they who disseminated Monet's discoveries. This is more plausible than it may sound at first when one recalls Kandinsky's famous Monet experience, an episode Kandinsky himself wrote about. On first seeing a picture in Monet's *Haystacks* series in Moscow 1895, Kandinsky was not only struck by its originality of style—he did not recognize its subject to begin with—it also showed him what painting really was or could be. That this initiation was effected via one of Monet's *series* paintings is no coincidence.[3] When Kandinsky left Russia, he took his French discovery with him, first of all to Munich. After 1911, Jawlensky, who was on friendly terms with Kandinsky, painted his first series. It was Jawlensky who, in the 1930s, was to produce one of the most significant contributions to series painting ever in, amongst other projects, his *Meditations* series, which comprised several hundred paintings. Finally, in The Blue Rider almanac of 1912, Kandinsky met up with Schoenberg, who introduced the first serial conceptions in music.[4]

Simultaneously, Mondrian was creating his first picture series (e.g. *Sea* and *Ocean and Pier*). They paved the way for his abstract painting in the 1920s, which

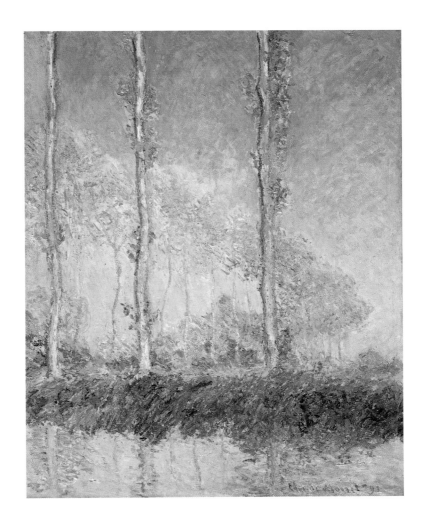

might be termed an ongoing series, or serial painting in the strict sense. For now the rules underlying all his pictures are specifiable, right up until the 1940s. Based on these pre-established rules holding for every picture, his serial sequences arose. Mondrian imparted his insights to the de Stijl movement (e. g. to van Doesburg), as Kandinsky did his to the Bauhaus, of which he was a member. Here they were adopted by the young Josef Albers in particular (beginning with his *Treble Clef* works). Emigrating, Albers took them to America, himself creating, from around 1950 until 1976 when he died, what is probably the largest picture series to date, namely his *Homage to the Square*. Containing over a thousand members, it too was based on pre-established rules.

The second phase of serial painting, loosely related to Albers, does not stem historically from him alone. It is particularly pronounced in American art in the work of such painters as Ad Reinhardt, Frank Stella, Kenneth Noland, Morris Louis, and, although differently, Andy Warhol. Of course, the development of series painting—now a hundred years old—has produced other names and historical directions. However, listing them here would not further us in the issues we now return to, namely: What induced Monet to switch from solo pictures to large-scale series? And: How does a picture "in a series" differ from a picture as "a work"?

I shall introduce three propositions, as theses, and discuss each in turn in relation to Monet and later serial painters. Art historians are far from having solved all the problems concerning series; acceptance of this fact is perhaps a necessary first step.[5]

The first thesis states: It is in virtue of an inner structure of a picture that a work modifies its individuality, i.e. its specific character as a "work," and becomes a member in a series.

What is this inner structure? The pictures in the *Haystacks* series can, of course, still be viewed in the context of landscape painting. The minute one does so, however, significant differences spring to mind. The division of the pictorial space into two, or three, horizontal zones or transverse fields, with the picture open at its sides, is certainly met with in earlier landscape painting. Monet, however, is not interested in creating space by distinguishing pictorial planes in a non-reversible sequence of fore, middle, and background. Instead, his pictures elaborate an interrelatedness of zones by adamantly refusing to differentiate with regard to three-dimensional, centered pictorial space. Monet does create spatiality, but it is better understood as a function of color, as for instance when a violet shadow, indicating proximity, corresponds to a cool blue-violet off in the distance. Speaking more generally, Monet structures his pictures by means of an optics of latent unsharpness. For what we see far more readily than we distinguish haystack and meadow as objects is how both merge in a field of coarsely granular paint strokes. Or we might say that objectual differentiability gives way to a—pre-objectual— continuum of paint strokes, no less important thematically than what they represent. Of course, a traditional landscape is also an arrangement of paint on the picture sur- face, only here it helps the viewer differentiate things and their compositional relations. Monet, one might say, operates with a dual optics: that of the motif, and that of the continuum of paint strokes. But motif and continuum are not distinct. The optics is not dual because one sees "objects" on the one hand, and unsharp areas on the other. It is dual because, while everything appears unsharply, certain parts generate recognizable objects and others have no representational function. Monet loosens the tie between picture and external reality. His optics of unsharpness does not discard the motif out- right, but henceforth it is more an occasion than a goal. By foregrounding material qualities (the continuum of amorphous paint strokes), the picture takes on the character of an appearance. This is clearly what Monet meant by the term "impression" which he used as a title for one of his pictures—whereupon critics sought to censure the entire development, calling it "impressionism."

Let us examine briefly the term "appearance" to which the pictures have led us. It issued from the all-embracing optics of unsharpness dominating the picture. This unsharpness is undiminished by our mobilizing, say, our knowledge of what a haystack looks like "in reality." The picture itself undermines all attempts at dis- tinguishing how things appear from what, apart from these appearances, they might "really" be.

This intensification, or absolutization, of reality-as-appearance is connected with a further characteristic of Monet's painting, a temporal quality. The unsharpness we have noted affects not only things and their spatial relations. It also precludes our gleaning specific temporal information and indicators from a picture. With Hobbema, for instance, we can distinguish various temporal moments in a picture, as well as subordinate ones

within the pictorial space. Monet's continuum of paint strokes, however, is a temporal irritant that embraces every part of the picture, and its effect is everywhere the same: the viewer relates paint strokes arbitrarily and, as a result, the entire picture appears under the aspect of instantaneity. Time, particularized in the motions of bodies and things, no longer figures. Instead, the entire picture is temporally imbued and itself appears as time. Instantaneity describes an isolated impression and, strictly speaking, has no past or future. What "immortalizes" itself in such painting is the *nunc stans*, the stationary moment.[6]

We have outlined certain changes in pictorial structure for Monet. Let us summarize briefly with regard to the distinction between "work" and "series." Monet's pictures are not self-contained creations with a compositional, perspectival, or any other center. They are constellations rather than compositions. They direct pictorial energy back into a picture's virtual center far less than they ensure a certain pictorial openness: pictorial space and time remain unspecific. This helps us grasp the precise nature of Monet's assault on traditional concepts of picture and "work." His pictures are no longer structured upon the analogy of an organism where head, body, and limbs combine in one life. Expressly or otherwise, the traditional concept of a work was informed by this notion of a living organism.[7] It presupposed a closed, centered structure, and a definite hierarchy of parts. "Pictorial body" is one of the terms art historians have coined to express this. In the words of Fritz Baumgart, referring to this new conception of pictorial structure dating from the Renaissance: "Pictures understood in this sense are unique, irreducible living beings whose members have grown organically … A world exists within the picture frame that relates to nothing beyond itself. The "pictorial body" … is, like the human body, a unique, living organism …"[8]

Monet dismantled this pictorial body, and with it the traditional, closed work-structure based on uniqueness. In their place he put new principles, amongst others an ultimately abstract instantaneity that bars a picture from ever becoming an "individual." Such instantaneity is abstract because it precludes all inferences to past or future. It is the "whirring second" (Paul Celan). It can, however, correspond to a definite light situation Monet perceived and then addressed in a painting. A crucial upshot of this is the following. Once an artistic problem can no longer be posed and potentially solved in terms of organic pictorial structure, it is no longer confined to being a one-off, goal-directed attempt. It must, or at least it can, be repeated. The next picture tackles the same problem, expressing it in a new way. Similarly the third, fourth, and subsequent pictures. Substance, in the individual work, is replaced by structure in the series, the members of the series being linked by repetition.

Now for our second thesis. It needs less explanation, and states: Serially organized painting conceives of reality as a formless process, an infinite becoming.

The thesis is derivable from the pictures. But it may also be seen as a cause or reason why Monet felt compelled to make such far-reaching changes in his conception of pictorial structure. A brief word concerning each of these aspects.

Via diverse considerations our examination of the *Haystacks* led us to the conclusion that Monet, by means of a continuum of paint strokes, detail-like pictorial content, and instantaneity, interpreted nature as an open process. His eschewal of traditional composition, of hierarchization, and of the pictorial body ensure that our experience vis-à-vis

one of his pictures remains incomplete, and essentially so. It does indeed begin and
end, but it never shapes up to full specificity.

Monet never thought of himself as an abstract painter. Close as he seems to have
come to abstraction, especially in his late works, he never went the whole way. He loosens
the tie to reality, but never cuts it entirely. Evidently he loosens them because, in his in-
tensive, lifelong study of nature, pursued chiefly in out-of-doors painting, he discovered
something essential that needed expression, something that hitherto had gone all but
unnoticed, namely that nature is chaotic and is involved in a permanent process of be-
coming and change. Ultimately, one can form no idea of the beginning and end of the
process. Instead of depicting nature quantitatively, according to its limits and shape,
Monet chose a new path, that of intensity. One moment suffices, a "cross-section through
nature" in the space of a second has a better chance of capturing nature's essential
flux than any compositional stylization combining before and after in a transitory unity,
a "fertile moment" (Lessing). That nature reveals itself as appearance—this, at bottom,
is Monet's profoundest insight. In it he recognizes that, aside from appearances, nature
simply has no essence. Monet undoubtedly believed this. In his important monograph on
the artist, Georges Clemenceau, "Le Tigre," records this pronouncement: "A maximum
of appearances in intimate relation to unknown realities: that is what I'm striving for.
When one is in rapport with appearances [i.e. *not* things, author's note], then one cannot
be far from reality, or at least from as much as we can know of it ..."[9]

Summarizing with regard to our present concerns: Only where reality ("nature")
itself is viewed as formless and radically changing is a pictorial style called for that
embodies a deep recognition of this. Such painting will not attempt to comprehend the
reality—it could only misconstrue it—instead, it reflects it, in a picture sequence, so
that the flux is re-enacted.

Our third, and last, thesis concerns what binds a series together. It states: Picture
series follow the rule of iteration. This, in conclusion, will enable us to distinguish between
painting in series and serial painting, historically speaking, the difference between Monet
and Mondrian, or between Jawlensky and Albers, i.e. between serial artists whose works
abstract, and those whose works are abstract.

Our last considerations suggest, in effect, that a series develops from a common
theme, for instance from haystacks and cathedrals for Monet, or from landscapes and
heads for Jawlensky. This alone, of course, does not adequately distinguish the phenom-
enon from a traditional painter's variations on a theme, Goya's *Desastres de la Guerra*,
say, or Guardi's *vedute ideate*. Variations have no direct contact to each other, and are
related only insofar as they share a theme. When we speak of iteration, however, we refer
quite specifically to what unites members of a series. What exactly is this unifying rule?
If, instead of iteration, we say repetition, it becomes clearer. In each individual picture,
a structure (not just a theme) must be present, one that can be repeated in the next pic-
ture. We have already described the structure for Monet. It consists, generally speaking,
in his optics of unsharpness, that is to say, in his eschewal of form and in his creating
a continuum of abstract paint strokes. No matter how individual haystacks may differ,
they all follow this rule. Monet, of course, over and above this, still worked with a motif.
Without it, the rule would apply to his entire oeuvre. This also explains why, in his case,
as with all abstracting as against abstract painters, we can speak of painting in series,

but not serial painting. That Monet's series compose totalities, each series' members forming an ulterior unity, arises from this. This unity, cautiously put, seems for Monet to consist in his having viewed haystacks, cathedrals and waterlilies, in a certain sense, as prisms of a light whose waxing and waning (traceable in the"stations" the paintings represent) illustrate the cosmos of nature *quâ* process. They exhibit "deeds of light" on canvas, and mirror the spectral refraction of the sun's course. Light is energy; only the highest alteration would Monet call "enduring."[10]

Iteration—to summarize this point—is not just a link between pictures, rather it establishes a pictorial rule for all pictures. Monet, as we have seen, still relates his rule to a motif (as also Jawlensky, amongst others). Mondrian, Albers, and later series painters, on the other hand, elevated their pictorial rules to absolutes.

We have already noted how Mondrian's motif-less painting follows its own pre-established rules to the exclusion of all else. His entire mature oeuvre, from around 1925–40, can be seen as the grandiose outcome of an iteration based on the following three rules:

1. Right angles only are allowed;
2. Only the primary colors, plus black and white, may be used;
3. Symmetry is not allowed.

Of course, the rules only concern the iteration, they cannot help interpret Mondrian's pictures. One's experience of the paintings and the deliberations the painter embarked from are not the same. Josef Albers' series *Homage to the Square* also follows definite rules. They lay down the pictures' geometrical chassis, but they leave colors and their interrelations undetermined. Again, what a viewer experiences in the pictures, or what makes up their semantic structure, is not involved here.

A further notable fact must be mentioned. Of Mondrian, Albers, Stella, Louis, Reinhardt and others we can say that their painting, basically, consists in the serial elaboration of one (or a fraction more than one) picture type. It is, at bottom, "one picture painting." Its diversity stems from the flexibility of the conceptions underlying the pictures, and their susceptibility to interpretation. What amounts to a radical reversal of the old conception of a work has taken place. If, formerly, it was a question of manifesting in

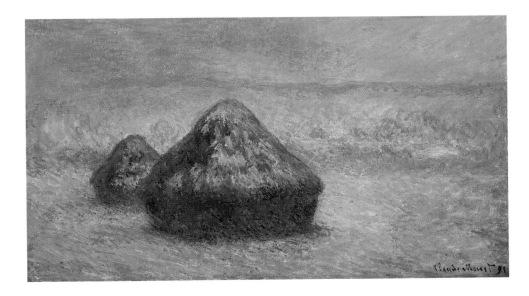

Claude Monet, Meules, effet de neige, soleil couchant, 1890/91 Haystacks, snow effect, sunset
Oil on canvas, 65 × 100 cm. Chicago, Art Institute of Chicago, Potter Palmer Collection

a multiplicity of individual works, each of which bore the stamp of uniqueness, the ordered wealth of a world saturated with norms and ideals, the above artists now seek to articulate an order-less, infinitely chaotic reality in a single picture spread over an open series.

This one-picture conception of painting jettisoned all the divisions traditional painting took from the empirical world and developed in the genres of landscape, portraiture, history painting, and so on. No longer does a painter paint an individuated work, a portrait, a fable, this or that motif or theme. He simply paints, sequentially, pictures. The series the pictures compose has for its part become open, losing the last vestiges of unity among its members. While we can still view Monet's series as wholes, in terms of his conception of nature, or Jawlensky's late series, his *Meditations*, as a paradigmatic mirror of human experience between life and death, the sum of all *Homage to the Square* pictures—of all serial pictures—is no longer itself a form, a sort of super- or meta-work. The principle of a series has been radicalized. Henceforth it has no definable beginning or definite end. And while the individual pictures are countable, their order is unimportant. The number of members in a series is open as well now, and can remain indefinite. No matter how many there are, all exist on an equal footing. We began by referring to art's attack upon itself as a determining factor in modern art. In the problem of series, we can observe how art, nevertheless, survives the demise of the "work," in the sense of uniqueness, as long as it adheres unswervingly to the irreducibility of its experiences.

1 See *Das Kunstwerk*, ed. Willi Oelmüller, in the series *Kolloquium Kunst und Philosophie* 3, Paderborn, 1983, *passim*; and in the same volume, the present author's "Werk als Prozess," pp. 326ff. ■ 2 See Lucrezia Hartmann, *Capriccio. Bild und Begriff*, PhD thesis, Zurich, 1973. ■ 3 On Kandinsky's discovery of Monet, see W.C. Seitz, "Monet and Abstract Painting," in *College Art Journal*, 1956, p. 34; also Jean Louis Faure, "Les sources impressionistes de l'abstraction moderne," in *Bulletin de la Faculté des Lettres de Strasbourg*, 1968, p. 741. ■ 4 K. Lankheit (ed.), *Der Almanach des Blaue Reiters*, Munich, 1979 (4th edition). ■ 5 See J. Coplan, *Serial Imagery*, Pasadena, 1986 ■ 6 See Gottfried Boehm, "Strom ohne Ufer. Anmerkungen zu Claude Monets Seerosen," in: *Nymphéas. Impression—Vision*, exh. cat., Basel, 1986, pp. 117–127 ■ 7 Not only in Quintilian's rhetoric (as in classical rhetoric generally), but also from the time of Alberti's treatise on painting, is the traditional concept of a work discussed on the analogy of an organism. It is *the* place where ideas of measure and the human body converge. See Gottfried Boehm, *Bildnis und Individuum*, Munich, 1985, p. 79. ■ 8 Fritz Baumgart, "Zur geschichtlichen und soziologischen Bedeutung des Tafelbildes," in *Deutsche Vierteljahresschrift und Geistesgeschichte*, Vol. 13, No. 13, 1935, p. 381. ■ 9 Georges Clemenceau, *Claude Monet*, Freiburg, n.d. (ca. 1929) ■ 10 Emil Maurer, "Letzte Konsequenzen des Impressionismus. Zu Monets Spätwerk" (1975), in *15 Aufsätze zur Geschichte der Malerei*, Basel, 1982, pp. 188f.

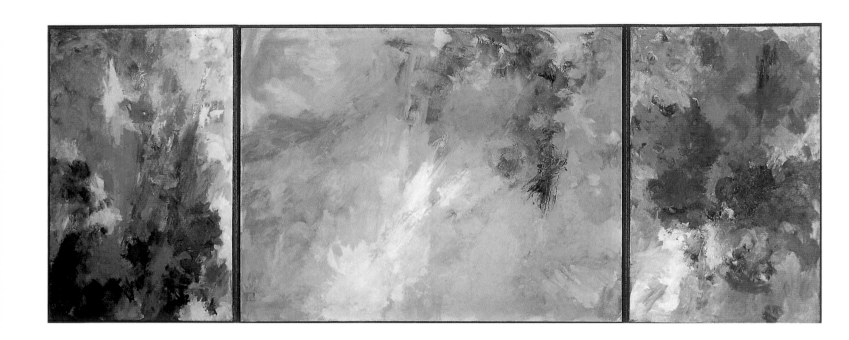

Claudia Posca

Monet and German Art Informel in the 1950s

*In all of these works, a difficult and dearly paid-for orientation becomes
visible not in other things, but in itself.* (Julien Alward, 1957)

An adventure of "special visual pleasure,"[1] a "logical derealization of nature,"[2] and
a "synthesis of sensations that draw both on memory and precise observation,"[3] are
some of the descriptions applied to Monet's late work, from the *Waterlily* canvases to
those done in Giverny. These are attempts to put a mystery into words—the way Monet
captures reflections of sky and trees in water, dissolving images of the Japanese Bridge,
rose trellises, weeping willows, wistarias. This liquid landscape of "optical sensations"[4]
is presented as a microcosm of finely articulated, closely packed "vibrating" brush-
strokes that daringly expunge discreet objects and plasticity. With the result that
Monet's vision detaches "visible nature from its familiar moorings" by means of
"'nonformal' passages that considerably delay, and in part prevent, an objective
reading."[5]

This finding opens a field of phenomenological experience whose coordinates
mark the issue of Monet's meaning as a model for non-objective painting, all the way
down to L'Art Informel. The story began with what was viewed as an epoch-making
phenomenon—the compelling "modernity" of Monet's style and its combination of
naturalism and construction.[6] Its significance was recognized as early as 1952, by
Fritz Novotny,[7] as it was that same year by the French painter André Masson. Writing
in the journal *Verve* under the programmatic title "Monet le fondateur," Masson declared
the *Waterlily* canvases in the Orangerie to be "the Sixtine Chapel of Impressionism" and
described their style as "un des grandes tournants de la peinture, une commotion."[8]

As obvious in hindsight as this realization of the late Monet's genuinely "modern"
vision may be, and despite countless references to the major influence of his dissolution
of form on modern art down to 1950s European Art Informel, very little attention has
been paid to the reception of Monet by German artists working in this gestural, abstract or
nonformal vein.[9] The transatlantic discussion, focussing on the New York School and 1950s
Action Painting, is advanced by comparison, as Michael Leja noted in the catalogue to
the 1998 Boston exhibition "Monet in the 20th Century."[10]

In tracing the reception (or rejection) of Monet among German abstract artists,
Novotny's approach deserves emphasis, because it represented an early indication of an
"abstract" view of Monet in the German-speaking area in the 1950s. Yet recognizing the
artist's dependence on the natural model, Novotny did not describe Monet's abstraction

Heinz Kreutz, Sonnengesang, triptych,
1957/58. Hymn of the sun
Oil on canvas, with hinged wings, central panel
130 × 162 cm, wings each 130 × 80 cm.
Berlin, Private collection

as being absolute.[11] By comparison to the "Monet revival" announced by William Rubin in his famous 1967 article "Jackson Pollock and the Modern Tradition,"[12] William Seitz's preceding article "Monet and Abstract Painting" in the *College Art Journal* in 1956,[13] Franz Meyer's 1986 description of the far-reaching American reception of Monet in the 1950s by artists from Pollock to Newman to Rothko,[14] and the already mentioned essay by Michael Leja on "The Rediscovery of Monet and the Abstract Painting of the New York School,"[15] Novotny's position (at least at the current, fledgling stage of L'Art Informel research) appears singular and capable of promising ramification. Support could be found in another German-language publication, also of 1952 and likewise strongly emphasizing the abstract aspect of Monet's *Waterlilies*. In this essay, Karl Hermann Usener declared that "the landscape painting becomes a color harmony," and "the merely registering vision of Impressionism proves ever more clearly to be a projecting vision."[16]

At this point it is still an open question whether the American "Monet revival" of the 1950s was paralleled by a broad, historically based interest in Monet on the part of German Informel artists, from K. O. Götz through Bernard Schultze and Gerhard Hoehme down to Otto Greis and many others. After his death in 1926, and despite the opening of the Monet Museum in the Orangerie the following year, Monet long disappeared from sight[17] "against the background of Constructivist-oriented art."[18] The process was exacerbated in 1927 by derogatory critiques whose authors compared Monet's "Grand Wall Panels" in the Orangerie to "stage sets" or, worse, to "wallpaper,"[19] declared them "a short-lived entertainment art … at which one looks without seeing it, registers without thinking, and forgets without regret."[20] The art historian Lionello Venturi even went so far as to call the *Waterlilies* a great artistic error.[21]

Any prospective history of Monet reception on the part of German gestural abstractionists would likely be tacitly based on the model of a progressive development of art from objectivity (traditionalism) to abstraction (modernism), with a strong focus on the non-objective, form-negating tendencies in Monet's late work, regardless of its motivation by and continual recourse to the natural model. Yet the purpose behind viewing Monet as abstract is quite clear. It is a matter of answering the question whether, on the basis of his evident "modernity," Monet, like Cézanne and Picasso, contributed to what Karl Jaspers called the "sharp jolt in Western philosophizing" and thus might, like them, prove to have been another forefather of modernity.[22]

This raises the question whether, and which, artists down to the present day have explicitly concerned themselves with Monet's painting and drawn sustenance from it for their own aesthetic. This was demonstrably the case for representatives of the New York School from Joan Mitchell to Sam Francis, down to the Canadian artist Jean-Paul Riopelle, who dedicated an entire painting sequence to Monet under the title *Nymphéas*.

In the context of a recently reawakened interest in gestural, open painting,[23] the late Monet has not surprisingly been seen through "nonformal" spectacles and the *Waterlilies* considered a stimulus of Art Informel. Back in 1980, Manfred de la Motte, a connoisseur and critic of the German brand of this style, already shed critical light on such invocations of form-negating spirits and ancestors, especially as regards Monet and his *Cathedrals* and *Waterlilies*.[24]

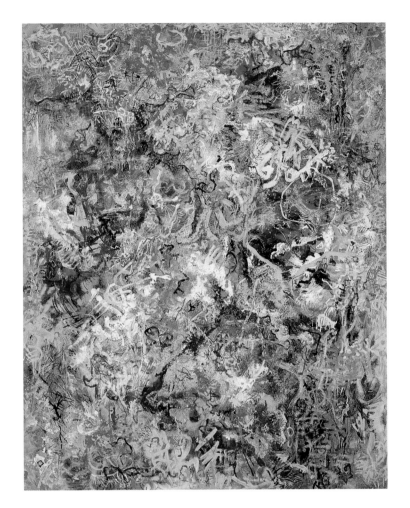

The problem involved in assuming a linear, if phenomenologically convincing, Monet reception on the part of German Art Informel is a problem of detail. Postwar gestural abstraction in Germany was not a uniform style but an immensely heterogeneous movement composed of "lone wolves,"[25] who can hardly be expected to have developed a binding nonformal visual language in the footsteps of Monet. Accordingly, the detection of a logical continuation of Monet in the emergence of Art Informel would have to be predicated on an ideal historical construct based on visual comparisons, in the absence of historical facts—at least as long as relevant documents such as critiques, letters, artists' statements, etc., have not been presented on a broad basis. Until this has happened, we will not know whether there was indeed a Monet reception of the kind described among German artists working in the Informel vein in the 1950s.

In view of the "historicity of understanding,"[26] we should be wary of losing sight of the "radically new character of L'Informel painting" and the fact that it represented a radical break with all previous art.[27] In addition, the question of Monet's influence on German Informel—which must be asked individually for each artist involved—might profitably be pursued by a three-pronged approach. As Franz Meyer remarked in 1986, by reference to William Rubin's 1968 essay in *Artforum,* the "investigation [can] be conducted on three levels, namely that of the Impressionist pictorial form in general, that of the pictorial form of the

Nymphéas in particular, and that of actual inspiration by Monet."[28]

The still unwritten history of the reception of Monet on German Informel art will certainly not be one-dimensional but highly complex and involved, especially in light of André Malraux's "Imaginary Museum" and its plethora of individually tinged versions. In this imaginary show, reformulations of a radically non-objective art created in the late 1940s and 1950s under the impression of war (both in Europe and America) were directly juxtaposed with Monet's paintings—suggesting the presence of abundant similarities between his tendency to formal dissolution and the gestural approach of Art Informel.

Monet may appear to have anticipated this style despite the fact that he never abandoned links with nature and reality.[29] The unfocused, liquid imagery of the late works indeed seems to parallel that radical dissolution of form, between emergence and disappearance, that was so characteristic of Art Informel. Note has been taken of the way Monet's paint application is divorced from the local color of objects to become autonomous, and engender a comprehensive "esthetic of open form" (Sagner-Düchting[30]). The late works have been said to include a conception of the art work as a representation of its own exhibition space (Krauss[31]), or to represent an image-generating, explicit challenge to the viewer's eye "to complete the image" (Boehm[32]) while concomitantly conveying a new understanding of nature which interprets "the landscape as an image of a world in flux" (Boehm[33]). Monet's late works are said to represent a "logical aesthetic

Bernhard Schultze, Penthesilea, 1954
Oil on hardboard, 139 × 105 cm.
Private collection

derealization of nature" (Usener[34]). This also applies to the serial working method of the *Cathedrals, Haystacks* and *Waterlilies,* whose temporalized painting "under the impression of the momentary" (Boehm[35]) and "oceanic image form" as a "metaphor for nature and reality" (Boehm[36]) witness, in the wake of Roger Marx, to the "modernity" of Monet and thus stand to disposition as possible points of departure for nonformalistic painting.

Since Novotny and Usener, various authors have continued to argue this influence, if usually without bolstering their phenomenological findings, obtained on the basis of visual evidence, with detailed and secure historical proofs. "Monet's experiences fully resurge in L'Art Informel, Tachisme, Abstract Expressionism, Action Painting, Abstraction Lyrique,"[37] was how Emil Maurer described the consequences of Impressionism in 1982. As examples, Maurer named Monet's *Nymphéas* and *Haystacks,* saying that one could isolate "square-meter-sized excerpts" from them which "could be read in a Tachiste or Informel way."[38]

Similar arguments were advanced in 1956 by Marcel Brion. In his *History of Abstract Art,* Brion stated that the logical further development of Impressionism could really have led to "nothing else but complete abstraction...." Because "in Impressionism in the last quarter of the 19th century, a non-objective tendency already became apparent which, although not conscious of itself, is easily recognizable in paintings such as the *Cathedrals* of Monet."[39]

The same thrust is found in Jean Selz's *L'Impressionisme,* first published in 1972 in French in Paris. "When one traces the further development of the liberation of color achieved a century ago," writes Selz, "one must admit that Tachisme represents its logical consequence in abstract painting."[40] This was confirmed by Werner Hofmann in his *Grundlagen der modernen Kunst,* 1978: "The remark made by a contemporary artist that the Impressionists shot paint from pistols onto the canvas—alluding to the extremely sketchy temporalization and accentuation of the act of painting—indicates that the Tachisme of our own period has advanced farther along this path."[41] Susanne Henle, in her 1978 dissertation, points out that "under the impression of gesturally-determined American painting ... Monet [was] seen as an initiator of nonformal painting."[42] In contrast, Sagner-Düchting argues that Monet became a model for modern art due to the significance of his "idea of an open space-time continuum" which combines "individual images with the concept of the series." This, together with his "aesthetic of open form," puts Monet "among the pioneers of key visual conceptions of modernity.... The history of the effect of the *Waterlilies* and Monet's late works could easily be traced down to color abstractions of the present day.... In this sense, too, Monet's *Waterlily* canvases anticipated central efforts of abstract color painting since L'Art Informel."[43]

Further Monet receptions that emphasize the "fleeting" and "abstract" character of his late art could be added. However, this would only point up the problematic nature of purely phenomenological arguments based on form-dissolving similarities between Monet and subsequent styles, because the finding of "Informel-like passages" in the late Monet, based on a perception that was certainly essentially shaped by 1950s Art Informel itself, is only one side of the coin.

On the other side, unprejudiced by this, remains the question of the function of Monet's paintings as a model for German Informel. In addressing this issue, we basically enter an unwritten chapter of art history. Any approach to what might have constituted a

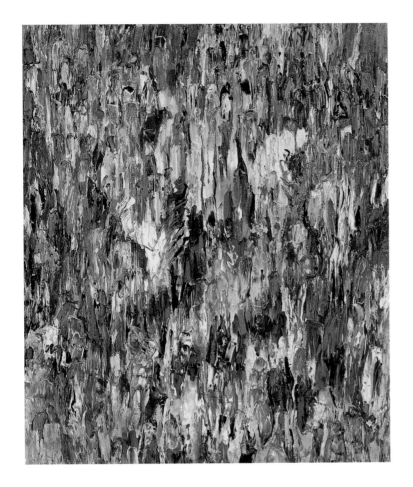

Monet reception on the part of German artists of the period would have to begin with an inquiry into the extent to which those who spent extended periods in Paris, such as the Quadriga group,[44] to which K.O. Götz belonged, or Hoehme, Schultze or Gaul (to name only a few by way of example), recorded or even registered the Monet revival in question. Was Monet's art discussed in artists' and critics' circles in the artistic melting pot of Paris? Was Monet interesting for artists working in gestural abstraction, was his work a topic of discussion among them, not to mention an aesthetic model? Were there Monet exhibitions in Paris or in Germany which might establish a "Monet revival" as a fact for German Informel? If so, did these presentations exert an effect so strong as to make Monet's painting a trigger for gestural abstraction?

Investigators in fact list very few and widely scattered exhibitions in Europe and America. The prime ones were the Impressionist exhibition shown at the Basel Kunsthalle in 1949, which included a dozen of the late *Waterlily* and floral paintings, and five of the large-format panneaux; the 1956 presentations devoted to the *Waterlilies* at galleries Katia Granoff, Paris, and M. Knoedler & Cie, New York; and finally the Monet retrospectives shown at the Royal Scottish Academy, Edinburgh, the Tate Gallery, London, and the St. Louis and Minneapolis museums in the U.S.[45]

As the brevity of this list implies, research into Art Informel and its sources still faces many open questions. K.O. Götz, who saw the *Nymphéas* in the 1950s and was impressed by Monet's paintings,[46] was recently asked in an interview about the resonance of the Monet exhibitions just mentioned. His reply: "We didn't notice any of that in Paris. And I was really in the midst of the fray."[47] Nevertheless, Monet represents "a rock" for Götz. "A lot of artists are impressed by him, and all of them have said something about Monet at some point. Still, I haven't been influenced by Monet. I've just admired him."[48]

Götz went to see the *Waterlilies* with Riopelle.[49] When asked, Götz said he could "definitely" imagine calling Monet one of the fathers of Art Informel. "Only the late Monet, however," he added. "These are almost nonformal paintings. The bridge is hardly recognizable any more.... You have to consider what a strong personality Monet must have been. Because non-objective art had been there since 1910. How early on Kandinsky worked non-objectively, and also Kupka, Larionoff! All of this had already come to pass—non-objective art, abstract art, geometric art. By this time, Picasso had already begun painting neoclassical women and beautiful heads. In contrast, Monet clung persistently to what I am tempted to call his Informel vision—because you can hardly recognize the bridge, but only suspect it's there. And he achieved this 'flickering' effect using three, four, or sometimes even only two colors, which he interlocked with each other by means of little sausage-shaped strokes."[50]

Gerhard Hoehme, during a visit to the 1986 Monet exhibition in Basel, told Willi Kemp of his desire to see his own paintings hung among Monet's *Waterlilies:* "Maybe

Gerhard Hoehme, Netim, 1958/59
Oil on canvas, 160 × 130 cm. Private collection, Long term loan to the Museum am Ostwall, Dortmund

toward the end of the exhibition, for one evening, when the Monet exhibition is over but not yet entirely removed, I can manage to hang my pictures between Monet's. An old wish of mine!"[51]

If Hoehme's vision can be inferred to reflect admiration of Monet's art, a corresponding attitude can be found in statements by Winfred Gaul, who despite his later turn away from L'Art Informel because "the revolt [had become] a style,"[52] still must be counted historically as belonging to the movement.[53] In his 1987 book *Picasso und die Beatles*, Gaul notes, with reference to Monet, that he had "an especially intimate relationship to this great artist.... Alongside Matisse, he was one of the most decisive inspirations for what painting can be. I discovered his *Waterlily* paintings for myself and admired them at a time when artists and art history had forgotten him, namely during my first stay in Paris."[54]

What does this "inspiration" mentioned by Gaul—assuming it will be supplemented by further, as yet undiscovered artists' statements regarding Monet—mean for the history of his reception by Art Informel and its oscillation between visual evidence and factual historicity? Can a direct path be traced from Monet's virgules, or slashes, to the gestural brushstrokes of Informel? Did artists working in this vein follow this path without reservations? Was Monet truly their aesthetic mentor as regards formal dissolution and gesture? Or might it not rather be the case that the "rebels against form," despite their admiring rambles through Monet's Orangerie, each developed his own, individual version of the form-divorced image on his own, individual basis? And that by so doing, on the level of self-discovered devices of gestural painting, they opened the eyes of art history for a "modern" perception of Monet?

Heinz Kreutz, pan bläst abends die flöte, 1956
pan blowing the flute, evening
Oil on canvas, 75.5 × 95.5 cm.
Frankfurt/Main, Historisches Museum

1 Gottfried Boehm, "Jenseits des Impressionismus," in: *Nymphéas. Impression—Vision* (exh. cat.), Kunsthalle, Basel, 1986, p. 118. ■ 2 Karl-Hermann Usener, "Claude Monets Seerosen-Wandbilder in der Orangerie," in: *Wallraf-Richartz-Jahrbuch,* vol. XIV, Cologne, 1952, p. 224. ■ 3 Karin Sagner-Düchting, *Monet in Giverny,* Munich and New York, 1994, p. 78. ■ 4 Fritz Novotny, *Die grossen französischen Impressionisten—Ihre Vorläufer und ihre Nachfolge,* Vienna, 1952, p. 6. ■ 5 Gottfried Boehm, "Mnemosyne—Zur Kategorie des erinnernden Sehens," in: Gottfried Boehm, Karlheinz Stierle and Gundolf Winter (eds.), *Modernität und Tradition, Festschrift für Max Imdahl,* Munich, 1985, p. 48. An impression of these "non-formal passages" is conveyed by the book *Monet im 20. Jahrhundert* (ed. by Paul Hayes Tucker, George T. M. Shackelford and Mary Anne Stevens, Cologne, 1999), which contains numerous reproductions of details from Monet's works. This catalogue was first published in 1998, in connection with the Monet exhibition at the Boston Museum of Fine Arts, which in 1999 travelled to the Royal Academy of Arts in London. ■ 6 Regarding modernity, see Karin Sagner-Düchting, *Claude Monet: Nymphéas,* Hildesheim, Zurich and New York, 1985. ■ 7 Novotny, *Die grossen französischen Impressionisten,* op. cit., p. 23 ff. The poles of tension in Impressionism between naturalism and construction have also been described by Fritz Schmalenbach: "The painting of Impressionism deobjectifies the object, thins it out, but the face of things remains naturalistic, and that to the highest degree; every dab in the painting is derived from the natural model, could not have emerged without it" (Schmalenbach, "Impressionismus—Versuch einer Systematisierung," in the same author's *Studien über Malerei und Malereigeschichte,* Berlin, 1972, p. 26). ■ 8 André Masson, "Monet le fondateur," *Verve,* vol. 7, nos. 27 and 28, 1952. Quoted in Franz Meyer, "Das 'Monet revival' der fünfziger Jahre," in: *Nymphéas. Impression—Vision* (exh. cat.), Basel, 1986, p. 146. "One might dream of a Monet who begins to paint on large canvases, on clear and shimmering surfaces, the quintessential domain of Veronese, Tiepolo. Do not dream any longer; look at his greatest work, the *Nymphéas.* Despite their monumentality, they lack the characteristic traits of Venetian or Flemish wall decorations. In terms of intellectual disposition, it would seem to me, Monet was a marvellous easel painter who decided to entrust his vision to a surface large—and impressive—enough to encompass the entire world. A cosmic vision, I should say, if this term had not been watered down in recent years and applied indiscriminately to everything.... An abandoned abode in the heart of Paris, a consecrated abode for the unattainable. One of the culminations of French genius" (Masson, "Monet le fondateur," op. cit., p. 68. Quoted in Romy Golan, "Ein ozeanisches Gefühl: Monets grosse Wandtafeln und Wandgemälde in Frankreich 1927–1952," in: *Monet im 20. Jahrhundert,* op. cit., p. 97). ■ 9 Understandably, in the present essay I can do no more than attempt to sketch a history of Monet reception within L'Art Informel, extensive research on which still remains to be done. A promising example is the Dortmund research project "Informelle Kunst," instituted in 1998 by the Museum am Ostwall in conjunction with a foundation, the Stiftergesellschaft zur Förderung der Sammlungen des Museums am Ostwall. The project's first publication was *Informel—Der Anfang nach dem Ende,* vol. I, Dortmund, 1999. ■ 10 Michael Leja, "Die Wiederentdeckung Monets und die abstrakte Malerei der New York School," in: *Monet im 20. Jahrhundert,* op. cit., pp. 98–108. ■ 11 For instance, in another passage of his book *Die grossen Französischen Impressionisten* (op. cit., p. 17), Fritz Novotny emphasizes the naturalistic recourse of Impressionism to nature and actual things: "Where the plastic, individual configuration is reduced to a complex of paint flecks ... thus diminishing and altering the intrinsic value of individual things, the naturalistic overall effect could nonetheless remain unprejudiced as long as all of these basically very violent alterations in detailed appearances still stood in the service of a representation of light and atmosphere. Ultimately, in the final phase of pure Impressionism, this was the essential manner of referring back to reality as seen." ■ 12 William Rubin, "Jackson Pollock and the Modern Tradition—Part II," *Artforum,* March 1967. ■ 13 William Seitz, "Monet and Abstract Painting," *College Art Journal,* XVI, fall 1956. ■ 14 Franz Meyer, "Das 'Monet revival' der fünfziger Jahre," in: *Nymphéas. Impression—Vision* (exh. cat.), Basel, 1986, pp. 145–160. ■ 15 See Michael Leja, "Die Widerentdeckung Monets ...," op. cit., pp. 98–108. ■ 16 Karl Hermann Usener, "Claude Monets Seerosen-Wandbilder in der Orangerie," op. cit., p. 224. ■ 17 "In 1931, four years after Monet's death, 128 works were shown in a comprehensive retrospective at the Orangerie. This was the only exhibition in a French museum between the world wars, and the artist—as Paul Jamot, senior curator of the Louvre, pointed out in the catalogue introduction—still had a hard time of it" (Romy Golan, "Ein ozeanisches Gefühl: Monets grosse Wandtafeln und Wandgemälde in Frankreich 1927–1952," in: *Monet im 20. Jahrhundert,* op. cit., p. 92). ■ 18 Sagner-Düchting, *Monet in Giverny,* op. cit., p. 100. ■ 19 Jacques-Emil Blanche, "En me promenant aux Tuileries," *L'Art vivant,* September 1927, p. 695 ff. Quoted in Paul Hayes Tucker, "Die Revolution im Garten—Monet im 20. Jahrhundert," in: *Monet im 20. Jahrhundert,* op. cit., p. 83. ■ 20 Eugenio d'Ors, *La Vie de Goya,* Paris, 1928. Quoted in Tucker, ibid., p. 83. ■ 21 Lionello Venturi, quoted in Tucker, ibid., p. 83. ■ 22 On Monet as a patriarch of modernism,

see Gottfried Boehm, "Jenseits des Impressionismus," in: *Nymphéas. Impression—Vision,* op. cit., p. 117; and Franz Meyer, "Das 'Monet revival' der fünfziger Jahre," op. cit., pp. 145–160. In contrast to Boehm and Meyer, Max Imdahl answered the question as to the "padres" of modernism in favor of Cézanne, since in view of Cézanne's paintings one could speak "veritably of the executive character of the coloration as a system-generating process," whereas "in Monet's paintings the paint particles (as flecks or virgules) infuse life into a traditional, objective, perspective pictorial structure or act apart from such a structure, which exists independently of them and most certainly does not emerge from them" (Max Imdahl, "Cézannes Malerei als Systembildung und das Unliterarische," in: Imdahl, *Zur Kunst der Moderne—Gesammelte Schriften,* vol. I [ed. by Angeli Janhsen-Vukicevic, Frankfurt am Main, 1996. p. 277). ■ 23 The current interest in L'Art Informel was reflected, for example, in the 1997 exhibition "Kunst des Informel—Malerei und Skulptur nach 1952," Museum am Ostwall, Dortmund, and the 1998 "Brennpunkt Informel—Quellen, Strömungen, Reaktionen," Heidelberger Kunstverein, Heidelberg. In 1999, the Museum am Ostwall in Dortmund published the results of a year-long research project conducted in collaboration with the Stiftergesellschaft zur Förderung der Sammlungen des Museums am Ostwall: *Informel—Der Anfang nach dem Ende.* Regarding further exhibition projects, see Jörg Restorff, "Kleckern und Klotzen—Informel: Kunst von gestern?" *Kunstzeitung,* no. 25, September 1998. ■ 24 Manfred de la Motte, "Materialien zum deutschen Informel," in: *Informel—Götz, Schultze, Hoehme,* Museum am Ostwall, Dortmund, 1980, p. 17. ■ 25 One should by no means imagine L'Art Informel as a cohesive art movement, as it might well appear to be from this distance in time. "It was more," as Winfried Gaul recalls, "a network of sympathies, friendships, convictions and aesthetic ideas that often strongly diverged but that, for all their different interpretations, had one thing in common: the impetus of the new, fresh, unjaded" (Gaul in conversation with Claudia Posca, in: *Informel—Der Anfang nach dem Ende,* op. cit., p. 254). As early as 1958, Heinz R. Fuchs mounted a L'Art Informel exhibition at Kunsthalle Mannheim under the open-ended title "Eine neue Richtung in der Malerei" (A New Direction in Painting). Various designations for this new direction were listed on the title page of the catalogue, from Abstract Expressionism, Tachisme, Lyrical Abstraction and L'Art Informel, through Experimental Painting, Structures and Element Color, down to Art Autre, Couleur vivante and Meditative Coloration. See Claudia Posca, "Zwischen 1952 und 1959," ibid., pp. 46–65. ■ 26 Hans-Georg Gadamer, "Geschichtlichkeit des Verstehens," in: Gadamer, *Wahrheit und Methode—Grundzüge einer philosophischen Hermeneutik,* Tübingen, 1986, esp. p. 275. ■ 27 Rolf Wedewer, "Informel," in: *Kunst des Westens—Deutsche Kunst 1945–1960* (exh. cat.), Kunsthalle Recklinghausen, Cologne, 1986, p. 86. In his book *Kunst in der BRD 1945–1990* (Hamburg, 1995, p. 154 ff.), to which Wedewer refers, Martin Damus writes: "Yet with L'Art Informel, something new appeared. It was not a further development, not a ramification, nor did it stand in connection with German Expressionism.... This was no continuation of the art of modernity. The caesura marked by this art around the middle of the century was deeper than the artistic 'revolutions' around the turn of the century.... The radical break of L'Art Informel with all previous art is only suggested by the statement that now, after the object had been banned, the resistance of form had been overcome.... What was radically new about this art was its unfinishedness, its refusal of definitive form." ■ 28 Franz Meyer, "Das 'Monet revival' der fünfziger Jahre," op. cit., pp. 145–160. ■ 29 Monet himself continually pointed out the dependency and orientation of his painting to natural appearances: "At Giverny, in the water proof, Monet explained the aims of his final period to his philosophically-minded friend Clemenceau: 'I am simply expending my efforts upon a maximum of appearances in close correlation with unknown realities. When one is on the plane of concordant appearances one cannot be far from reality, or at least from what we can know of it.... Your error is to wish to reduce the world to your measure, whereas, by enlarging your knowledge of things, you will find your knowledge of self enlarged'" (Monet, quoted in William Seitz, "Monet and Abstract Painting," *College Art Journal* [New York], fall 1956, p. 45). Max Imdahl likewise emphasizes this link to nature: "In his painting Monet accepts an undoubtedly given, preconceptual visual natural appearance external to his painting procedure—metaphorically speaking, Monet paints 'experiences' of nature; whereas for Cézanne, the preconceptual visual appearance of nature is an inducement for painterly, system-building operations—metaphorically speaking (with Rilke), Cézanne paints 'experiences' in face of nature. This, precisely, marks a watershed in the approach of painting to nature" (Imdahl, "Cézannes Malerei als Systembildung und das Unliterarische," op. cit., p. 277). This is confirmed, if indirectly, by Clement Greenberg, who in 1956 wrote that Monet's own taste was not at the height of his art. The fact that he was not in a position to recognize or accept "abstractness"—the quality of the medium per se—as a principle was beside the point: it was present and clearly recognizable in the late works (Greenberg, "The Later Monet," *Art News Annual,* 1957 [December 1956], pp. 132, 148; quoted in Leja, "Die Wiederentdeckung Monets ...," in: *Monet im 20. Jahrhundert,* op. cit., p. 100). ■ 30 Sagner-Düchting, *Monet in Giverny,* op. cit., p. 65. See also, by the same

author, *Claude Monet: Nymphéas—Eine Annäherung,* Hildesheim, Zurich and New York, pp. 19–21. ■ 31 Rosalind Krauss, "Photography's Discursive Spaces," *Art Journal,* 42 (winter 1982); quoted in Romy Golan, "Ein ozeanisches Gefühl ...," in: *Monet im 20. Jahrhundert,* op.cit., p. 86 ff. ■ 32 Gottfried Boehm, "Jenseits des Impressionismus," in: *Nymphéas. Impression—Vision,* op.cit., p. 119. ■ 33 Boehm, ibid., p. 121. ■ 34 Karl Hermann Usener, "Claude Monets Seerosen-Wandbilder in der Orangerie," in: *Wallraff-Richartz-Jahrbuch,* vol. XVI, Cologne, 1952, p. 224. ■ 35 Boehm, "Jenseits des Impressionismus," op.cit., p. 120. ■ 36 Boehm, ibid., p. 126. ■ 37 Emil Maurer, "Letzte Konsequenzen des Impressionismus—Zu Monets Spätwerk," in: Maurer, *15 Aufsätze zur Geschichte der Malerei,* Basel, 1982, p. 193. ■ 38 Maurer, ibid., p. 193. ■ 39 Marcel Brion, *Geschichte der abstrakten Kunst,* Cologne, 1961, pp. 79 and 187. ■ 40 Jean Selz, *Lexikon des Impressionismus,* Cologne, 1977, p. 16. ■ 41 Werner Hofmann, *Grundlagen der modernen Kunst,* Stuttgart, 1978, p. 230. ■ 42 Susanne Henle, *Claude Monet—Zur Entwicklung und geschichtlichen Bedeutung seiner Bildform* (PhD diss.), Bochum, 1978, p. 123 ff. ■ 43 Sagner-Düchting, *Monet in Giverny,* op.cit., p. 65 ff. ■ 44 Unlike the loose-knit "Gruppe 53," a group of L'Art Informel painters founded by Gerhard Hoehme and Peter Brüning in 1953 in Düsseldorf, the Frankfurt group "Quadriga" formed in a more accidental way, on the occasion of an exhibition titled "Neu-Expressionisten," shown in 1952 on the private premises of the Frankfurt collector Klaus Franck. The artist-poet René Hinds held a night lecture in which he described the exhibiting artists K.O. Götz, Otto Greis, Heinz Kreutz and Bernard Schultze as a "quadriga". As Götz later recalled, "In fact Quadriga was not a group. Quadriga was purely coincidental. As was the fact that Kreutz, Greis, Schultze and I were there. We showed there one after the other, and then each went his own way. By 1954 the thing was over" (Götz in conversation with Claudia Posca, in: *Informel—Der Anfang nach dem Ende,* op.cit., p. 241). On the Quadriga group, see Ursula Geiger, *Die Maler der Quadriga, Otto Greis, K.O. Götz, Bernard Schulze, Heinz Kreutz und ihre Sonderstellung im Infomel,* Nuremberg, 1990. ■ 45 This information is taken from the text by Christian Geelhaar, "Claude Monets Nymphéas in Basel: 1949 und 1986," in: *Nymphéas. Impression—Vision,* op.cit., p. 9. ■ 46 "How often I walked through the side entrance of the Orangerie in Paris to look at Monet's *Nymphéas.* Here there were no forms any more, no figure-ground problem, no front and back. Everything interlocked and formed a weave, nothing obtruded itself" (K.O. Götz in conversation with Georg Bussmann, in: *Quadriga 1952–1972—Karl Otto Götz, Otto Greis, Heinz Kreutz, Bernard Schultze* [exh. cat.], Frankfurter Kunstverein, Frankfurt, September 1972; reprinted in Manfred de la Motte [ed.], *K.O. Götz,* Bonn, 1978, pp. 41–44). ■ 47 K.O. Götz in conversation with Claudia Posca, Niederbreitbach-Wolfenacker, July 1, 2001, unpublished. ■ 48 Götz, ibid. ■ 49 About his viewing of the *Nymphéas* with Riopelle, Götz wrote: "For Riopelle, not Picasso was the most significant artist who pointed to the future but the late Monet. Riopelle went with me to the Musée de l'Orangerie to Monet's *Nymphéas* and explained to me which passages seemed so important to him. It was not the waterlily pictures on the round walls, but the painting at the head of one of the rooms.... Riopelle alleged that the nonformal principle was already anticipated here" (K.O. Götz, *Erinnerungen II 1945–1959,* Aachen, 1994, p. 94 ff.). ■ 50 K.O. Götz in conversation with Claudia Posca, Niederbreitbach-Wolfenacker, July 1, 2001, unpublished. ■ 51 Gerhard Hoehme, quoted in Willi Kemp, "Begegnung mit Gerhard Hoehme," in Kemp (ed.), *Begegnung mit Gerhard Hoehme,* Düsseldorf, 1992, p. 36. In a conversation with the present author in July 2001, Margarete Hoehme confirmed that her husband was concerned primarily with flickering and lightness in painting, and that this aspect of Monet's painting interested him as well. Yet there could be no question of an intensive involvement with Monet's painting or discussions of it on Hoehme's part. ■ 52 Winfred Gaul, "Das deutsche Informel—ein Rückblick," *Das Kunstwerk* (Baden-Baden), no. 5/XXXVI, November 1983; reprinted in Gaul, *Picasso und die Beatles—Erinnerungen, Aufsätze, Kommentare zur Kunst nach '45,* Verlag bei Quensen, Lamspringe, 1987, pp. 70–78. ■ 53 See Claudia Posca, "'Blanc Angélique'—Aufbruch zur Analytischen Malerei," *Informel—Der Anfang nach dem Ende,* vol. I, Dortmund, 1999, pp. 183–192. ■ 54 Gaul, "Unzeitgemäße Gedanken zum 'Zeitgeist'," in Gaul, *Picasso und die Beatles,* op.cit., pp. 70–78. See also, by the same author, "Besuch in Giverny," op.cit., pp. 200–202.

Jean Bazaine

Frédéric Benrath

Beauford Delaney

Sam Francis

Bernard Frize

Raimund Girke

K. O. Götz

Gotthard Graubner

Hans Hofmann

Ellsworth Kelly

Byron Kim

Per Kirkeby

Willem de Kooning

Morris Louis

Joseph Marioni

André Masson

Joan Mitchell

Barnett Newman

Kenneth Noland

Jules Olitski

Jackson Pollock

Richard Pousette-Dart

Milton Resnick

Gerhard Richter

Jean-Paul Riopelle

Mark Rothko

Clyfford Still

Mark Tobey

Andy Warhol

Jerry Zeniuk

Jean Bazaine

1904	Born in Paris
1922	Studied (sculpture) at the Ecole des Beaux-Arts and Académie Julian, Paris
1922–25	Studied (art history and philosophy) at the Sorbonne, Paris
1924–	Free-lance painter; copied works in the Louvre, painted studies from the motif and in the natural landscape
1937	First stained glass window
1941	Organized the "Jeunes peintres de la tradition française" exhibition at Galerie Braun, Paris
1952	Traveled to the U.S.

174

1964	Grand Prix National des Arts
1976	Founded the Association pour la défense des vitraux en France (for the preservation of stained glass windows)
1980	Commandeur des Arts et des Lettres
1984–88	Stained glass windows of Saint-Dié Cathedral; mosaics for Palais du Luxembourg and an ensemble for the Cluny-La Sorbonne underground station, Paris
2001	Died in Paris

Bazaine's painting is a persistent exploration of nature, continually reiterated in the process of painting — not of nature in the sense of external material appearances but of the creatively apperceived essence of nature, its secret structure. Evolving from the gestural process, the handwriting of his painting is a pulsating, vibrating structure of spots tracing the energetical impulse of being in the world. Bazaine distanced himself from the mainstream of Informel, which he accused of being a "spontaneity hoax." Not the kinetic externalization of subjective energies is what matters but understanding, finding meaning through painting. To Bazaine the tissue of painting stands for "that secret tissue that runs through all things." The structure of the painting becomes analogous to the enduring structure of being, in which nature is recognizable by its signs: "The elemental thing that we are dimly striving towards is, like the earth itself, a conglomeration of countless layers of living things. True sensibility exists where the painter discovers that the movements of the trees and the surface of the water are related to each other. This is where, after the world has thus gradually contracted and become condensed, he sees the great essential signs emerge from the midst of infinite appearances. They are his own truth and the truth of the universe at the same time." (Bazaine, *Notes sur la peinture d'aujourd'hui*, Frankfurt/Main 1953, p. 46).

It is not only the essence of nature that reveals itself to him in the structure of color. In his 'handwriting' the painter penetrates nature's layers down to a last layer of meaning emerging as a creative vision from behind the appearances. Bazaine's pictorial idiom developed between 1942 and 1947 in coming to terms with Cubism and the *peinture pure* of Robert Delaunay. He transformed the grid structures derived from Cubism through underlying colored forms into swinging vibrating movements producing a dynamic sweeping turbulence of interactive colors and shapes.

He received numerous commissions for monumental works, mostly with religious subject matter, including stained glass windows, mosaics and tapestries.

The most important metamorphosis in Bazaine's work occurred in the 1950s, when the abstract colored forms become more dynamic, blended and loosely ordered. The dividing structural framework was gone and a wavy movement permeated the picture, the parts with colored forms drifted through the composition in an undulating motion. One fundamental inspiration for this new pictorial structure came from the *Waterlilies* by Monet, which Bazaine's thorough reading of Marcel Proust disclosed to him. Works such as *Dernière neige à Rochetaillée*, 1959, immediately suggest Monet's delicate colored textures and his homogeneous pictorial spaces sustained by associations to natural phenomena. Bazaine now abandoned his rhythmical pictorial frameworks entirely. His feathery brushstroke became the sole carrier of the pictorial structure as well as the agent conveying different groups of motifs.

Lit.: J. Bazaine, *Notes sur la peinture d'aujourd'hui*, Paris 1948; Jean Tardieu et al., *Bazaine*, Paris 1975; Pierre Cabanne, *Jean Bazaine*, Paris 1990.

Qu'est-ce que l'art abstrait? C'est, nous dit-on, le rejet absolu "de l'imitation, la reproduction et même la déformation de formes provenant de la nature". C'est se refuser à faire entrer le monde extérieur dans son jeu et s'efforcer de bâtir, en marge de toute influence "extérieure" le drame des lignes et des couleurs. C'est ce qu'en langage actuel on appelle le "non-figuratif."

Cette tentation de faire surgir de soi, informes pour le monde, bouleversants, les signes mêmes, les cicatrices de ses plus secrets mouvements intérieurs, c'est la raison d'être du peintre depuis que la peinture existe. Mais il ne peut que la peinture existe. Mais il ne peut s'agir de rejeter des formes (mais des combinaisons de formes) provenant de la nature, puisque les formes du tableau si peu figuratives soient-elles, il faut bien même passant à travers nous, sortant de nous, qu'elles viennent de quelque part.

Jean Bazaine, *Notes sur la peinture d'aujourd'hui*, Paris 1948. pp. 40–41

Jean Bazaine, Dernière neige à Rochetaillée, 1959
Oil on canvas, 97 × 130 cm. Zurich, Dr. Peter Nathan

Frédéric Benrath (Gérard Philippe)

1930	Born in Chatou
1946–48	École des Beaux-Arts, Toulon
1949	École des Beaux-Arts, Paris
1950	Traveled to Scandinavia
1963–64	Ford Foundation scholarship in Berlin
1969–	Lecturer in the history of art at the École d'Architecture in Versailles
	Lives in Paris

In the 1950s, Benrath was ranked with the lyrical abstract painters of the École de Paris. Following contact with Wols, he began to take an interest in German landscape painting of the Romantic period. From 1956, his style was pared down to expansive, breathing colored surfaces in which the all-over of Art Informel gave way to a centered compositional structure. In *Les Correspondances* (1955, owned by the artist), a red surface is enveloped by surging blue tones below and yellow tracts towards the top. The color movement is reinforced by whirls scratched into the wet paint with the handle of the brush. Other pictures from this time such as *La Traversé des Apparences* (1961, Musée de Grenoble) manifest bright lightning-like irruptions of color in great sweeps of dark color areas, like an emanation of light in darkness, a Romantic motif that Benrath (whose pseudonym is incidentally derived from Schloss Benrath, a baroque house near Düsseldorf) associates with German idealistic literature and philosophy, as many of the picture titles in the following years indicate.

These pictures attracted the attention of art critic Julien Alvard, who in 1953 invited him to take part in a group exhibition called 'D'une nature sans limites à une peinture sans bornes' (From boundless nature to unbounded art). In consequence, Benrath progressed to becoming a notable artist of the 'Nuagistes' group, in company with artists such as René Duvillier, Pierre Grazinai, René Laubiés, Marcelle Loubchansky and Nasser Assar. This short-lived painting school rejected both geometric abstraction and the gesticulatory abstraction of Art Informel, orienting itself instead to the color spaces of Turner and Monet's waterlilies. Its adherents expanded Art Informel, with which it was associated both in terms of development and historically, by introducing greater transparency and especially spatial depth in the picture. As a result of the atmospheric fragmentation of the surface effect, their works included the four elements and elemental cosmic rhythms in their frame of reference.

Benrath's encounter with Monet's waterlily pictures, which he first went to see at the Orangerie at the prompting of gallery owner Katia Granoff in 1951, made a deep impression on him. In the dominance of color turbulences (over objective contour), luminosity and transparency of the layers of color, and indeed the dramatic chiaroscuro motion, Benrath perceived the foundations of a future objectless but emotionally intense painting. In the following years, he steadily moved away from gesticulatory whirls enigmatically shrouded in clouds of color, which mostly open up the deeply dark color areas in the center of the picture into garish streaks of light. From the end of the 1970s, the graphic element disappeared completely from his pictures, to make way for an 'unbounded' extension of diffuse mists of color, limited only by an insertion in a different color at the upper edge, as a sort of horizon. The clouds of color in the depth of the picture undulating between light and dark shades give rise to associations with cosmic myths of origin, landscapes by Caspar David Friedrich and Goethe's theory of color, for whom color arises in the struggle between darkness and light—but they also recall Monet's fluid color spaces once again.

Lit.: *Le Nuagisme*, même, exh. cat. Musée des Beaux Arts, Lyons 1973, Geneviève Bonnefoi, *Frédéric Benrath*, Ginals 1985; Jean-Noel Vuarnet, *Frédéric Benrath. Deus sive Natura*, Paris 1993 (detailed bibliography and exh. list).

I owe my own discovery of the Waterlilies in 1951 to Katia Granoff, whom I used to visit every day at her gallery in the Quai Conti at that time. It was at her suggestion I went to see Monet's huge works in the rotunda of the Orangerie.

My astonishment, and I must say my consternation as well when I saw these immense canvases, was enormous, and in the hours I spent looking at them my conviction grew that there, on the basis of these wide open spaces, a future for painting lay concealed that I hoped to explore.

Contrary to the famous joke by the great painter who said the weather was always fine in Impressionism, Monet's emblematic painting *Impression, Sunrise* has nothing of the sunny work about it, either as regards the emotion it conveys or in its structure. With the dissolution of its structure and fragmentation of its various components, which clearly show that the painter wanted to break with some of the artistic notions of the 19th century, the work serves as a manifesto.

After the series of cathedrals and haystacks, among other things, in the great and final phase of the waterlilies the founder of Impressionism set about a strategy of draining his subject dry, which means that the time for depicting was over. The time of the tyranny of history, mythology, objects and even self-representation was forgotten.

That's more of a revolution than evolution, because although the waterlilies remain a 'subject', Monet goes beyond just representing them. Whereas some avantgarde painters after Cézanne moved the tables, as it were, so as to show several facets of things simultaneously, Monet goes about his business of dissolving forms, which also destabilizes our perception. This dissolution is not complete disintegration, and though the painter is confronted with natural elements, it is principally with the most complex, inexhaustible and most dangerous of them for painting, namely light. It is not of course the time-controlled light as in the cathedral series, nor is it a modulating light. It is a consuming light. Although the concept of time continues in force, it is the suspended time of motionless waters in the ponds at Giverny.

Monet's waterlilies are not the waterlilies of Giverny. These immense paintings have left the realm of representation and now belong to the sphere of the most absolute and least discursive style of painting. Almost carved into the block of physical and sensory impressions, these giant canvases question the whole concept of depth again by creating a space of their own. The splendid coloration is charged with tension by the most extreme violence. Looking at the waterlilies means looking in the eye of the typhoon, and some pictures look so densely encoiled against the strange compressed background that looking at them almost strangles one. How can one help thinking of some of Pollock's pictures, who seems to have these in mind? Since my first encounters with the waterlilies almost a half-century ago I have followed the principle that governs this style—not to paint in the same way, but because I thought that understanding a painterly world would help me to find my own parameters.

To resist any temptation to return to self-contained art (i.e. structure) and open the work to all freedoms of color, Monet bid farewell to drawing, which I found extraordinarily seductive. Just as I was also attracted by what this painting, made up of fractures, transcended matter and fluid light, contained in terms of darkness, shadowiness and latency. In this tragic and at the same time so splendid sphere with its dazzling luminosity—the ambivalence of sensibility in Monet's style contained the core of the most important components of modern art—a way opened up that can be discovered anew again and again. Entering the Monet rooms at the Orangerie, which is not unlike a crypt, is always an overwhelming moment for me, similar to when one crosses the threshold of Rothko's ecumenical chapel in Houston. These are places that offer body and soul alike a miraculous opportunity to go far beyond just seeing, to be filled with living motion, to be moved and shaken.

Frédéric Benrath, Paris, 2000.

Frédéric Benrath, Les correspondances, 1955
Oil on canvas, 195 × 130 cm. Property of the artist

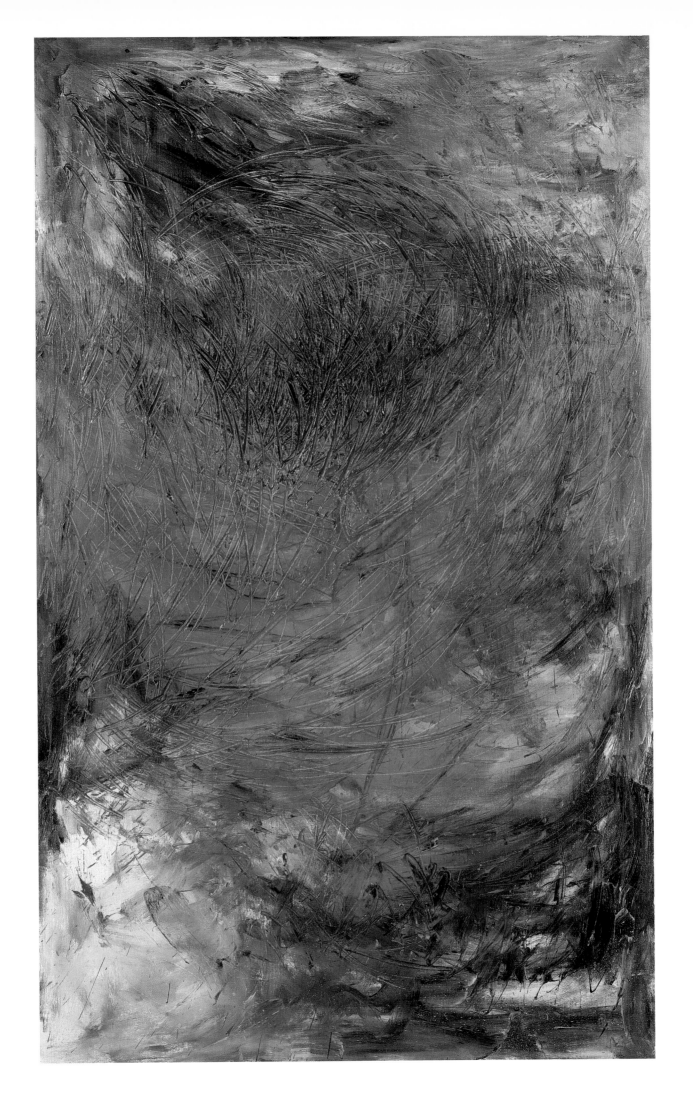

Beauford Delaney

1901	Born in Knoxville, Tennessee
1925	Moved to Boston; Boston Art School
1926	Discovery of Monet's late works at a museum exhibition in Boston
1929	Moved to New York; influence of Alfred Stieglitz, John Marin and Arthur Dove
1951	Scholarship to Yaddo artists' colony in Saratoga Springs, New York
1953	Moved to Paris
1960	One-man show at the Paul Facchetti Gallery, Paris
1964	One-man show at the Lambert Gallery, Paris
1975	One-man show at the Darthea Speyer Gallery, Paris
1979	Died in Paris

"When we stand in front of a picture by Delaney, my friends, we stand in the light," said James Baldwin, one of the artist's oldest friends, in 1973. He was talking not just about the painting quality of the pictures, which seem to have been painted with a light-filled brush, but also metaphorically. For Delaney, light had the power to illuminate and to heal and thus dispel the shadows of night that accompanied him all his life.

Besides his conventional portraits, Delaney sought to reproduce the dynamics of 'inner light' in his abstract works, thus adding his name to the list of light-obsessed artists of Impressionism and Fauvism that he had so admired as a student at Boston Art School. Top of the pantheon for Delaney was Claude Monet, whose Giverney landscapes and haystacks he had seen first-hand at an exhibition in Boston in 1926. He was fascinated by atmospheric light that dissolved everything tangible into nebulous shapes.

Although after his move to New York in 1926 Delaney became a member of black artists' associations (Harlem Artists' Guild and Cloyd Boykin's Primitive African Arts Center), he continued to pursue his modernist studies. During the Great Depression he had nevertheless to paint in a more commercially attractive objective style in order to survive, and exhibited with other black colleagues —painters and jazz musicians such as W.C. Handy, Palmer Hyden and Ellis Wilson—in numerous exhibitions. He helped the distinguished painter Charles (Spinky) Alston with his famous WPA mural in Harlem Hospital. Only in his sketchbooks could Delaney devote himself to his abstract pictorial work. In these, reference to his nervous problems, the 'other voices' that had plagued him since childhood, occurs again and again, and he sought to combat them with his abstract painting. Guided by Stuart Davis, Delaney devoted himself at the Art Students League to his studies of modern European art, discovering Cézanne, Van Gogh and Gauguin, Picasso and Braque, and Fauvistes Vlaminck, Derain and Matisse. These influences became evident in his paintings of the 1950s with their pronounced geometricization and bold coloration (*Washington Square*, 1951, privately owned). An important sponsor was the photographer Alfred Stieglitz, who focused attention on the early American avant-garde (John Marin, Stuart Davies, Arthur G. Dove, Max Weber, Georgia O'Keeffe) in his Gallery 291. Of these artists, Delaney was again interested chiefly in the abstract qualities of light and color developed by Marin and Dove. To be closer to his European models, in 1953 Delaney decided to spend a month in Paris. The month lasted 26 years, a period associated with all the high points and low points of an artist's career. Delaney painted his best abstract pictures in Paris, which in their fullness of light and movement follow straight on from Monet's example, but also have their place in the École de Paris, as his three great one-man shows in Paris demonstrate. Especially his large pictures of the 1960s such as *Untitled* (1961, privately owned) manifest an exclusive con-centration on color, in Delaney's case mostly a bright, radiant yellow as a symbol of light, which, applied in vibrant, gesticulatory brushstrokes, creates a dense, subtle texture reminiscent of Monet's waterlily pictures. Despite his steadily deteriorating mental condition, Delaney turned out in these years some splendid pictures in the tradition of Pollock and De Kooning in their gesticulatory abstrac-tion, but nonetheless indebted to Abstract Impressionism in their fine, differentiated coloration.

Lit.: David Leeming, *Amazing Grace, A Life of Beauford Delaney*, New York/Oxford 1998; *Beauford Delaney. Liquid Light: Paris Abstractons 1954–1970*, exh. cat. Michael Rosenfeld Galley, New York 1999.

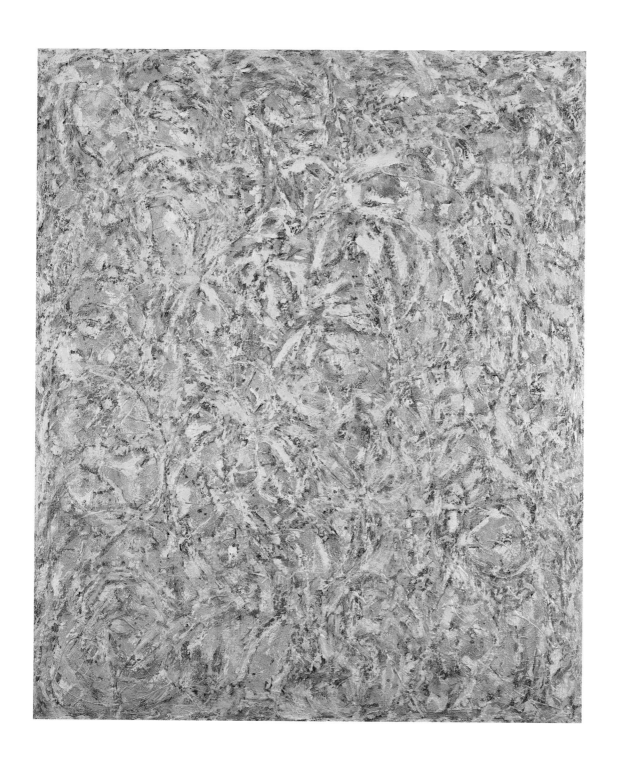

Beauford Delaney, Untitled, 1960
Oil on canvas, 91.45 × 70.45 cm. New York, Courtesy of Rosenfeld Gallery

Beauford Delaney, Untitled, Paris, 1963
Oil on canvas, 99.7 × 81.3 cm. New York, Courtesy of Rosenfeld Gallery

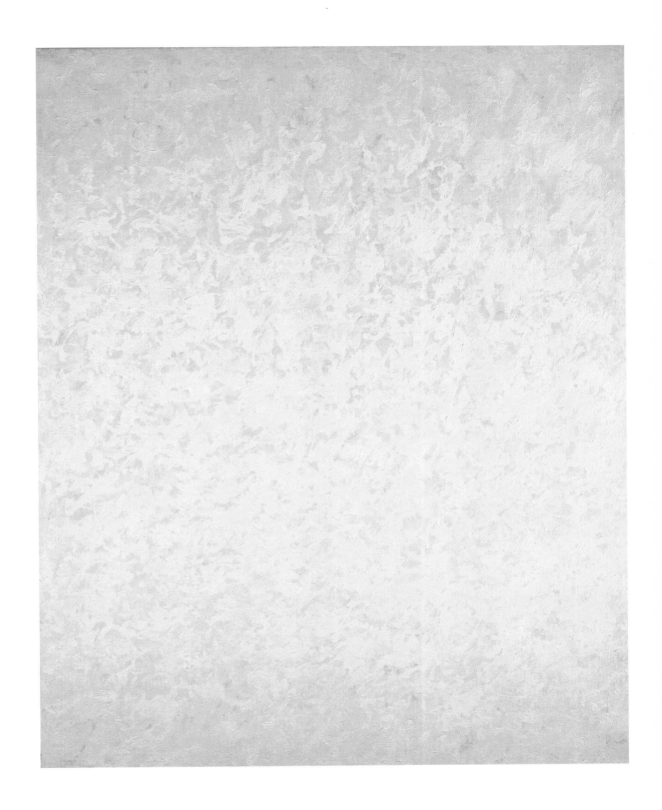

... the painting of Beauford Delaney will surprise some viewers. His abstractions relate by their virtuosity of touch and color to those of Sam Francis and of other abstractionist disciples of the technique of Monet's *Nymphéas*.

Edouard Rodti, 'Figuratif et abstrait', in: *Jeune Afrique*, Paris, 1973, Paris. Trans. by Richard Long in: exh. cat. *Beauford Delaney, A Retrospective*, New York 1978.

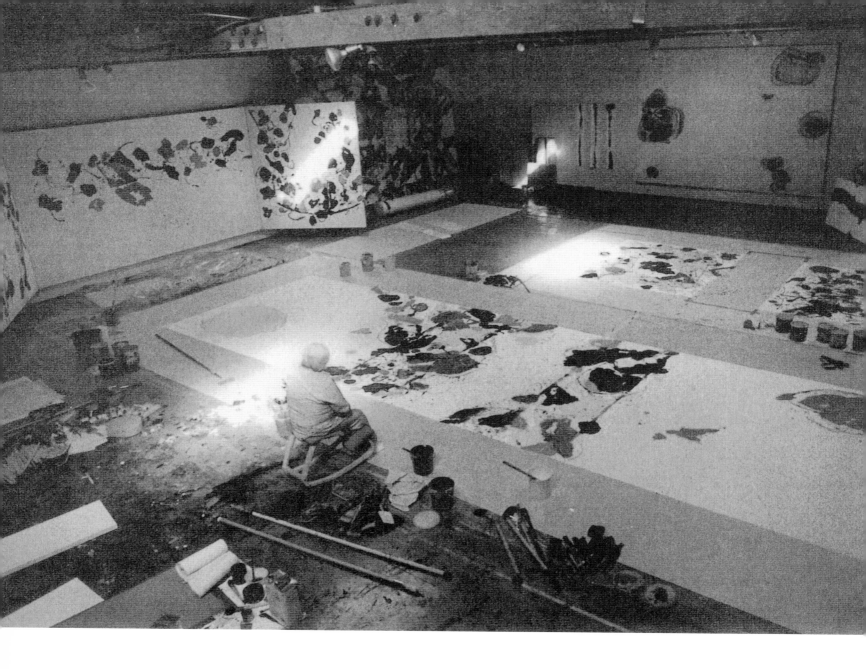

Sam Francis

1923	Born in San Mateo, California
1941–43	Studied botany, medicine and psychology at Berkeley, University of California
1943–45	Military service in the US Army. Sustained a severe spinal injury during a crash landing, involving lengthy hospitalization. From 1945, turned to painting
1948–50	MA in fine arts and art history at Berkeley, University of California
1950–57	Lived in Paris; decisively influenced by Monet and Art Informel
1955	First major museum exhibition at the Kunsthalle in Bern
1958	Large triptych for the stairwell in the Kunsthalle, Basel
1962	Settled in Santa Monica, California
1964	Visited Japan. First pottery works
1977	Commission for two pictures for the new concert hall in the Louisiana Museum of Modern Art, Humlebæk; first grid/network pictures
1984	Founding of Lapis Press

1986	Founding of Sam Francis Medical Research Center for research into environmentally conditioned and infectious diseases
1992	Major retrospective in Bonn
1994	Died in Santa Monica

The early monochrome works by Francis developed in Paris were not part of Art Informel but were nonetheless shown together with the latter in exhibitions in Paris, London and Bern. With his picture *The Big Red* (1953, MoMA, New York), Francis took up the American tradition of painting patches of color, but also using the 'suggestive color' of European painting leading from Monet via Pierre Bonnard to Paul Gauguin and Henri Matisse.

From Monet, Francis learned important ideas about organizing pictorial space from loosely connected spots of color, which open up an anti-illusionist sense of depth as a loose textural weave. Another consequence of the Monet influence is the introduction of intense color values, especially in the blue/yellow/red configuration, which can be used for intense contrasts, but in being dripped on the canvas they also overlap and run down in color streaks. This cloud-like structure, which runs together to make islands of color, shows the white ground below, so that the impression of a moving, radiant color organism arises, of which only one part—though a strongly charged one—is visible. The inspiration of Monet reached its peak in 1958 (*Untitled*, 1958) with the three large murals for the stairwell at the Kunsthalle in Basel. In the same year, Francis was invited along with other *informel* artists to a 'Hommage à Monet' organized by Pierre Restany. In the foreword to the catalogue, Restany summed up once more the major features of Monet's waterlily paintings that had been such a source of inspiration to the Nuagiste group at the time.

In the mid–1960s, Francis began to develop a new style in which the patches of color are displaced more and more to the margins of the outsize pictures. In still other pictures, broad rivers of color overflow the surface in several intersecting directions, developing great intensity at the intersections. In parallel to this, Francis was already developing a different style, monopolizing the surface of the canvas for expressive gesticulatory trajections (*Big Red II*, 1979, Louisiana MoMA, Humlebæk). The pictures of the last creative decade are paeans of joy in life, which in their (apparently) carefree use of paint applied gesticulatorily or sprayed on establish a link with early days of action painting. The pure energy of color finds expression in them, color as a resource, as a subject and as the essence of a picture (*Untitled*, 1990). These exudations of fluid color also hark back to Monet's waterlily pictures in their use of dense textures as a stylistic resource.

Lit.: *Sam Francis*, exh. cat. Bonn, Stuttgart 1993 (with detailed bibliography); *Sam Francis 1923–1994*, exh. cat. Galerie Proarta, Zurich 1994; Ingrid Mössinger (ed.), *Sam Francis. The Shadow of Colors*, exh. cat. Kunstverein Ludwigsburg etc., Kilchberg/Zurich 1995; *Sam Francis. Les années parisiennes 1950–1961*, exh. cat. Galerie nationale Jeu de Paume, Paris 1995; *Sam Francis. Paintings 1947–1990*, exh. cat. Museum of Contemporary Art, Los Angeles 1999 (exhibition Houston, Malmö, Madrid, Rome); *Sam Francis. Bilder 1953–1992*, exh. cat. Galerie Proarta, Zurich 1999/2000.

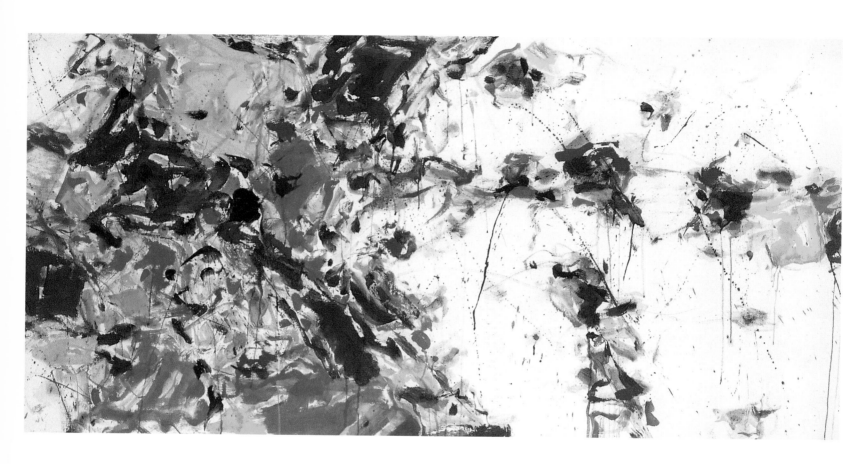

Sam Francis, Untitled (SF 58–262), 1958

Acrylic on paper, 92.5 × 183 cm. Zurich, Galerie Proarta

Sam Francis, Untitled (SF 90–63 PRS), 1990

Acrylic on paper, 103 × 185 cm. Zurich, Galerie Proarta

I'm doing pure late Monets.

Sam Francis when asked about his own work, August 1967, in: exh. cat. *Sam Francis*, Museum of Fine Arts and University Art Museum, Houston and Berkeley, 1967.

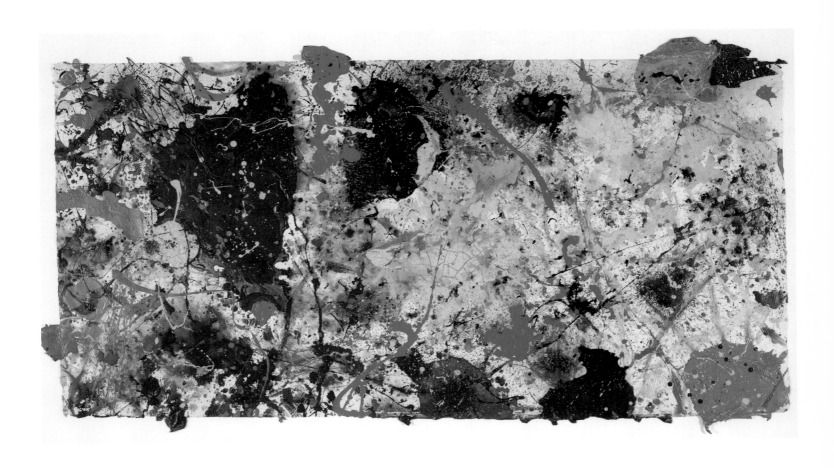

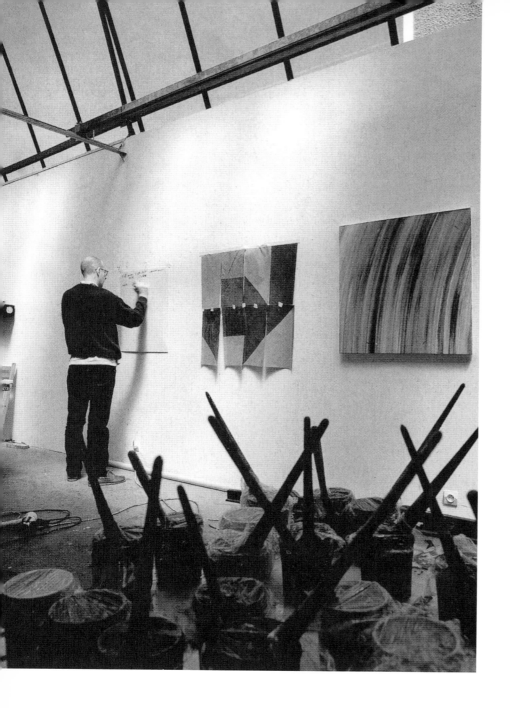

Bernard Frize

1954	Born in Saint-Mandé near Paris
1979	First one-man show at the Galerie Lucien Durand, Paris
1999/	
2000	Retrospective at the Museum Moderner Kunst Stiftung Ludwig, Vienna etc.
	Lives and works in Paris

Frize's painting creed was already evident in the first series painted in 1976: strokes painted with a fine Schlepper covered the canvases in a regular sequence (all-over) without leaving a distinguishable hand or visible subject. Frize is interested in reconnoitering painting, producing pictures (linked with reflections on the concept of pictures in the post-modern period) and exploring the

materials that can be used in producing them. He is constantly developing new series and experiments demonstrating how painting can be done with a variety of tools and instruments and processes. Frize explores the position of painting with regard to the manual production of pictures and discovering the processes this requires or could employ. However, with his knowledge of the history of painting, he doesn't merely reproduce painting techniques and surface effects (naively) but subjects processes of making pictures to a critical examination on a methodical test bed. This also applies to the *Suite Segond* series produced in 1980, where Frize applied bits of dried skin of industrial gloss paint to the canvas, thus subverting every standard rule of painting and every artistic intervention. Painting seems to function here as a ready-made and spring up fully armed without the painter's assistance. But the selection of paint skins, like the seemingly almost alchemic process of forming folds, fraying and overlapping the paint skins on the canvas reveals the interest of the artist in the crafted production of painting and its sensory effect on the viewer. Particularly the last aspect takes Frize close to radical painting, but he maintains a clear distance from its dogmatic theory. For Frize, there is no preconceived theory and no regulation of the painting process to be complied with time and again. Like Polke, he is always on the lookout for new painting materials and ways of applying them, in order to come up with an image of painting that is perforce abstract but nonetheless full of sensory connections. Whereas in early series such as *Natures Mortes* Frize depicted the unbridgeable gulf between picture and image, more recent series show a mixed process (resin, ink, acrylic) of patterns and efflorescences of confusing beauty, suggestive of seascapes or landscapes, marble or Chinese ink paintings etc, depending on the viewer's background and emotional state.

The paintings of the *Othon (BDGE)* series apply a simple painting process using a roller to the production of paintings in which four colors are rolled on top of each other in different order, thus producing a new picture. The picture patterns that arise quite accidentally give rise to multiple levels of natural landscape associations and thus call the viewer's power of imagination to account. The *Othon* paintings were created using a device consisting of seven paint rollers, with which Frize could cover the entire canvas in one sweep.

The many series by Frize, which reject any continuous stylistic development and instead rely on the volatile principle of chance, reveal a fundamental quest in Frize's artistic activity, i. e. to hone the viewer's awareness of the process of perception and bring out the thematic nature of painting as a visualization of sensory processes.

Lit.: *Bernard Frize. Size matters*, exh. cat. Carré d'Art, Musée d'art contemporain de Nîmes/Museum moderner Kunst Stiftung Ludwig, Vienna etc., 1999/2000.

Several years ago, Keichi Tahara invited us to Monet's garden at Giverny. A famous make of camera had commissioned him to do illustrations for using a new model. He took pictures of us sometimes surrounded by blurred vegetation, or else we were the background and the flowers were sharp. Keichi was taking the photos to explain what you have to do with the camera, and we would have some nice souvenirs. I remember being surprised by the visit. I didn't expect to reconsider his paintings starting with their real-life referent.

No doubt Monet would not have found anything in these images. Yet even here instantaneous photography was not out of place.

Everyone knows how Giverny was organized to offer a spectacle of nature that was renewed during the seasons, always ready to provide subject matter and stimulate inspiration. Can one help thinking that this device, this machine for producing nature and subject matter was also an essential part of a complex strategy that involved his position of being an artist in his day. Yet the series (the stacks of grain, the cathedrals...) form a sucession of paintings like chain links. New possibilities constantly appear which have to be utilized. Organic automatism quivers at first from the shock of the color and my reflexes involve me—despite myself—in an unconscious operation that occupies the daily run of my life. That's the beast that turns its millstone,' he wrote.

Giverny systematizes the organization of an effective device where Monet benefits from a re-primed position every day. The constant and the changeable elements of the garden remain exterior to him, inexhaustible. The system ensures the desire to work. Every picture provides him with a new approach. Need becomes production and series.

This program will be revealed to have an effect on his position as a painter as much as on the circumstances of his painting. Little by little, these scenes are de-naturized while gestures are liberated from forms. Monet uses an infinite range of colors as figures cease to be rendered precisely any more. The object of his work has shifted: the impression, the passing minute engenders an organic coherence without fixed form.

Much later, American Abstract Expressionist painters were to see encouragement for their work in it. They would retain the recording of a subjective awareness. The connection with the world that Monet and the Impressionists had set up would offer a framework to allow painting to occupy the ordinary daily world and its determinations.

The paintings of the "Othon" series were made with a roller the size of the canvas and four fresh colours were applyed successively. Each painting shows the mixture of the coats of paint which were applied in a different order.

Bernard Frize, Paris, August 20, 2001

Bernard Frize, Othon D, 1994

Acrylic and resin on canvas, 125 × 92 cm. Vienna, Courtesy Galerie nächst St. Stephan

Bernard Frize, Othon B, 1994

Acrylic and resin on canvas, 125 × 92 cm.

Vienna, Courtesy Galerie nächst St. Stephan

Bernard Frize, Othon E, 1994
Acrylic and resin on canvas, 125 × 92 cm.
Vienna, Courtesy Galerie nächst St. Stephan

Bernard Frize, Othon G, 1994
Acrylic and resin on canvas, 125 × 92 cm.
Vienna, Courtesy Galerie nächst St. Stephan

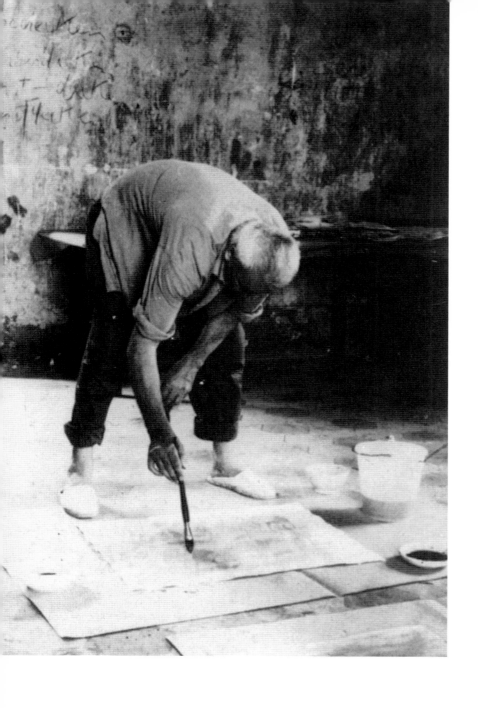

Raimund Girke

1930	Born in Heinzendorf
1952–56	Studied at the Staatliche Kunstakademie, Düsseldorf
1959	Awarded City of Wolfsburg prize for painting
1966–71	Reader at the arts and crafts college of Hanover
1971–	Chair at the Hochschule der Künste, Berlin
	Lives and works in Cologne and Berlin

Girke's work, an examination of the theme of the non-color white, has been shown in various contexts since the 1970s that chiefly stressed painting as a process and a reflection of the resources employed. Terms such as 'analytical', 'planned' or 'fundamental' painting were used (e. g. 'Planned Painting' at the Münsterland Kunstverein 1974, or 'Fundamental Painting' at Amsterdam's Stedelijk Museum in 1975), although Girke more readily identifies with 'fundamental' than the other terms:

"The word 'fundamental' suits the process of painting I do. I prime my pictures in a rhythm that suits me and that manifests a connection with the rhythms that follow. Nothing may be added to any part of the picture without it relating to something else, even if it is covered over later ... So it is a question of approach and, intellectually, about a style that goes back to original principles, though it can become quite complex and lead to total freedom." (Girke, in: *artium Kunstkalender* 2000, p. 162)

As a student at the Düsseldorf academy, Girke was initially influenced by Art Informel painting. However, his picture composition is put together in blocks, without the gesticulatory spontaneity of Informel. The dark, earthy tones were increasingly overlaid by linear layers of white colors that lend the picture composition a firm, consistent structure (*Schwingungen*, 1959, owned by the artist). By the Pop Art and Fluxus periods Girke had already established a position wholly his own on the German painting scene, with his white paint fields and white structures, whose delicate transparency of minimal gray or white gradations radiate a meditative calm.

From 1971, Girke extended the severely reduced white-gray tonality to include color values in differentiated brown and blue tones, in association with a free brush style. Parallel to the pictures of the *Gray Changing* series (e.g. *Gray Changing II*, 1973, owned by the artist), he did numerous paper works in gray modulations in which he produced subtle nuances of color by means of very thin layers of watercolor paints. From the early 1980s, the brush technique took on a still greater individuality. The contrast of a dark ground overlaid with white brushstrokes gives rise to a dynamic fluctuation, which nonetheless hangs together as a rhythmic whole. Accents of ochre, brown and blue activate the gray values dormant in the white and unfold a living, breathing coloration in the visual process (*Schreiben*, 1985, Saarland Museum, Saarbrücken). During this period, the paper works in the media of drawing, graphics, water colors and gouache assumed particular importance. In the pictures of the 1990s the painting spectrum grew still further. Along with the calm works, pictures emerged with an expressive dynamism that are notable for hard chiaroscuro contrasts (*Farbstrom*, 1991, Ströher Collection, Darmstadt). In contrast with the works of the 1950s, the brushwork is not articulated on a linear scanning pattern but flows freely over the whole surface of the picture. The sweeping, dynamic gestures lend the cool blues of the color structure a painterly tension. For Girke, white is not just a carrier for painting processes (as with Robert Ryman) but a basic metaphor for painting as such that is indispensable for the creation of depth, space and above all light. The self-examination of the artist is also evident in the reflection of painting, and is at the same time an examination of the world.

Lit.: *Raimund Girke. Arbeiten* (Works) *1953–1989*, exh. cat. Kunstverein Ludwigshafen, Mainz 1989; Dietmar Elger (text), *Raimund Girke. Arbeiten auf Papier* (Works on Paper), exh. cat. Museum am Ostwall, Dortmund etc., 1987/88; Dietmar Elger (ed.), *Raimund Girke. Malerei—Retrospektive* (Retrospective of Paintings), exh. cat. Sprengel Museum, Hanover etc., Stuttgart 1996.

Monet

... a sea of color, of light, of light-saturated color; color that dominates everything, conditions everything, is set in motion, endlessly modulated motion without a beginning or end. Movement, breathing, pulsating, incessant and infinite, pressing into space and over the edge of the picture; movement that is close to the rhythm of writing, that is the direct precipitation of the painter's excitement (speaking, writing, painting) and yet calm, relaxed and meditative, reminiscent of Zen.

Monet exposes himself to his senses, but above all to his eyes. The world is experienced via the intelligent eye, seeing and realising are indissolubly one.

In the late, great waterlily pictures—apparently paradoxically—rapid cognition is followed by lengthy, repeated work on one and the same subject, a persistent working at 'painting'; the painter is located entirely in the process of painting; there is no end, no final solution. An aesthetic of completeness is abandoned in favour of a stance in which changing and developing—the processing, reductive, fragmentary elements—are what matters.

Magnificent, luxuriant coloration and exaggerated, pulsating motion are transferred via condensation and reduction into pure painting, casting off impressions of nature. Sensory perception and spiritual exploration achieve a subtle, dynamic balance.

Cologne, July 30, 2001

Raimund Girke, Structures, 1959
Synthetic resin on canvas, 125.5 × 181 cm. Cologne, Property of the artist

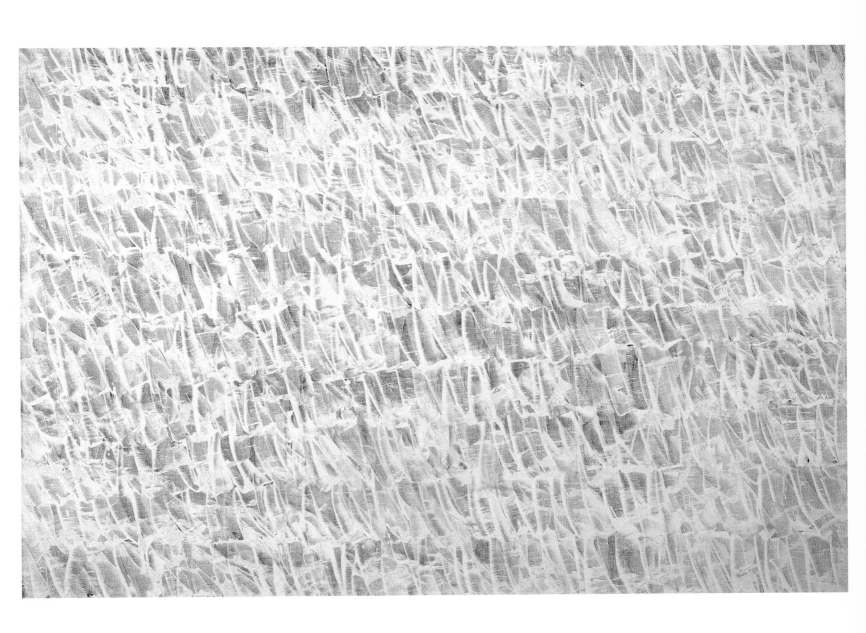

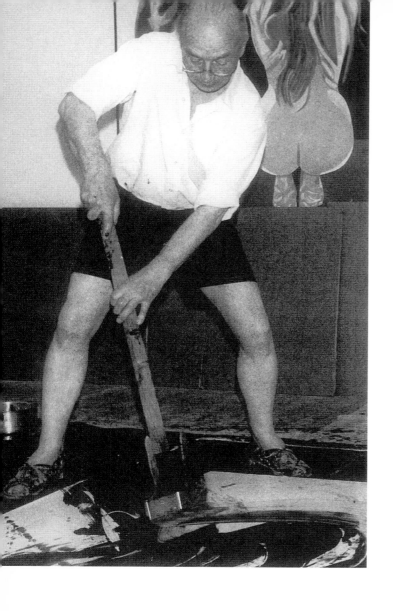

K. O. Götz

1914	Born in Aachen
1932	Studied at the Higher Weaving College, also attending the arts and crafts college in Aachen
1933	First abstract paintings
1935–45	Banned from painting and exhibiting; continued to paint in secret
1936–	Experimented with abstract films, photopainting and photograms
1936–38	Military service with the Luftwaffe
1939–45	Military service; did abstract tempera paintings in his spare time in Dresden
1948–53	Publication of *META* magazine; member of the COBRA group
1950–59	Frankfurt and Paris
1952	Quadriga exhibition at the Franck gallery in Frankfurt (with Otto Greis, Heinz Kreutz and Bernhard Schultze); first Informel works

1955	Took part in the 'Peintures et sculptures non-figuratives en Allemagne d'aujourd'hui', Cercle Volney, Paris
1957	Took part in the 'couleur vivante' (Städtisches Museum, Wiesbaden) and 'Eine neue Richtung in der Malerei' (Städtische Kunsthalle, Mannheim) exhibitions
1958–59	Took part in the 29th Biennale in Venice and documenta 2 in Kassel
1959–79	Appointed to chair at Staatl. Kunstakademie, Düsseldorf
	Lives and works in Niederbreitbach-Wolfenacker (Westerwald)

Götz was already doing abstract work in 1933 that made use of painting materials and picture surfaces as areas of experimentation, e.g. spray pictures using templates. At the same time, he experimented with abstract films, photo paintings and photograms. From 1944 Götz worked on the *Fakturenfibel*, a compilation of abstract forms that were visibly derived from reality. Of great importance for his later work are the *Monotypien* (from 1946), in which he drew in a rapid gesticulatory style on a glass plate with turps-thinned printer's ink and the gesticulatory drawing was then pulled on paper. Götz also used a razor blade to push the paint around, anticipating his later doctor blade technique.

The 1950s brought Götz decisive encounters and contacts with the Parisian art scene, notably Hans Hartung, Georges Mathieu, Jean Fautrier, Wols and Sam Francis, but also André Breton and the Surrealists. With his poetic work, Götz is among the most important German Surrealist poets. Prompted by the automatism of Surrealism, Götz looked for a way of subjecting the act of painting on canvas to speed and chance. From 1952, he explored the use of a doctor blade, which allowed him to spread thinned paint over the picture in a lightning movement. As a result of the intervention of the doctor blade, a negative occasionally arises in the positive of the color trace, the light facture of which combines with the background. In a subsequent step, positive and negative are combined with a dry brush (*Picture of 12.12.1952*, 1952, K.O. Götz and Rissa Stiftung, Wolfenacker). Of course, this action painting process is preceded by outlines and sketches which are developed over years and are indispensable for Götz's concept of art.

"After the preceding meditation about a simple pictorial idea—the utmost enhancement of subjective expression by the speed of the painting process, in order to burst the barriers of one's own subjective concept thereby … in the search for poetic expression in the picture." (Götz, in: *Dokumente zum deutschen Informel*, ed. Manfred de la Motte, Galerie Hennemann 1976, p. 144.)

The speed of the painting process inevitably involves the dissolution of the classic design principle (picture composition) and the destruction of the conventional basic pattern relationships. This 'passage' technique Götz saw ready-formed in Monet's waterlilies in the Orangerie, which he often went to see during his time in Paris.

"What I admired in Monet's waterlilies was that there were no longer any forms, no problems of pattern or ground, no behind and in front. Everything interlocked and formed a mesh, nothing stood out." (K.O. Götz, quoted from exh. cat. Galerie Hennemann, Bonn 1978, p. 42)

In Götz's idea of a picture, neither individual forms nor individual colors exist. Everything exists only in the profound dovetailing with its neighbours, a spatial slurring that opens up an imaginary picture space. Götz has stuck to this technique and this pictorial philosophy to this day, and has created an oeuvre with an inexhaustible repertory of expressive possibilities.

Lit.: K.O. Götz, *Erinnerungen*, 4 vols., Aachen 1993–1999; Horst Zimmermann (ed.), *Karl Otto Götz. Malerei 1935–1993*, exh. cat. Staatliche Kunstsammlungen, Dresden 1994; Wolfgang Zemter (ed.), *K.O. Götz. Die Monotypien*, Bönen 1996; Tayfun Belgin (ed.), *Kunst des Informel. Malerei und Skulptur nach 1952*, Museum am Ostwall, Dortmund, Cologne 1997; *Brennpunkt Informel. Quellen-Strömungen-Reaktionen*, Cologne 1998; Claudia Posca, *Von der Zähmungen des Gestus*, in: *Informel. Der Anfang nach dem Ende*, ed. by Museum am Ostwall, Dortmund 1999, p. 151ff.

Monet's genius lies in the fact that he allowed himself to be swept along by the force of his own artistic development and continually expanded the innovative elements in his painting until, ultimately, the object in his work disappeared completely. This was also at a time in which Symbolism, Cubism and abstract art were becoming established movements. In his late works, Monet was greatly inspired by nature (Japanese Bridge or colored fog). He developed characteristics in his style which were indicative of the Informalist painters of the 1940s and '50s. The Informalists, however, did not draw upon nature but experimented with a range of materials applied in a manner never adopted before. I admire Monet for his independence and honesty.

K. O. Götz

K. O. Götz, Giverny-Ex. V, 1993

Mixed media on paper and canvas, 200 × 140 cm. Property of the artist

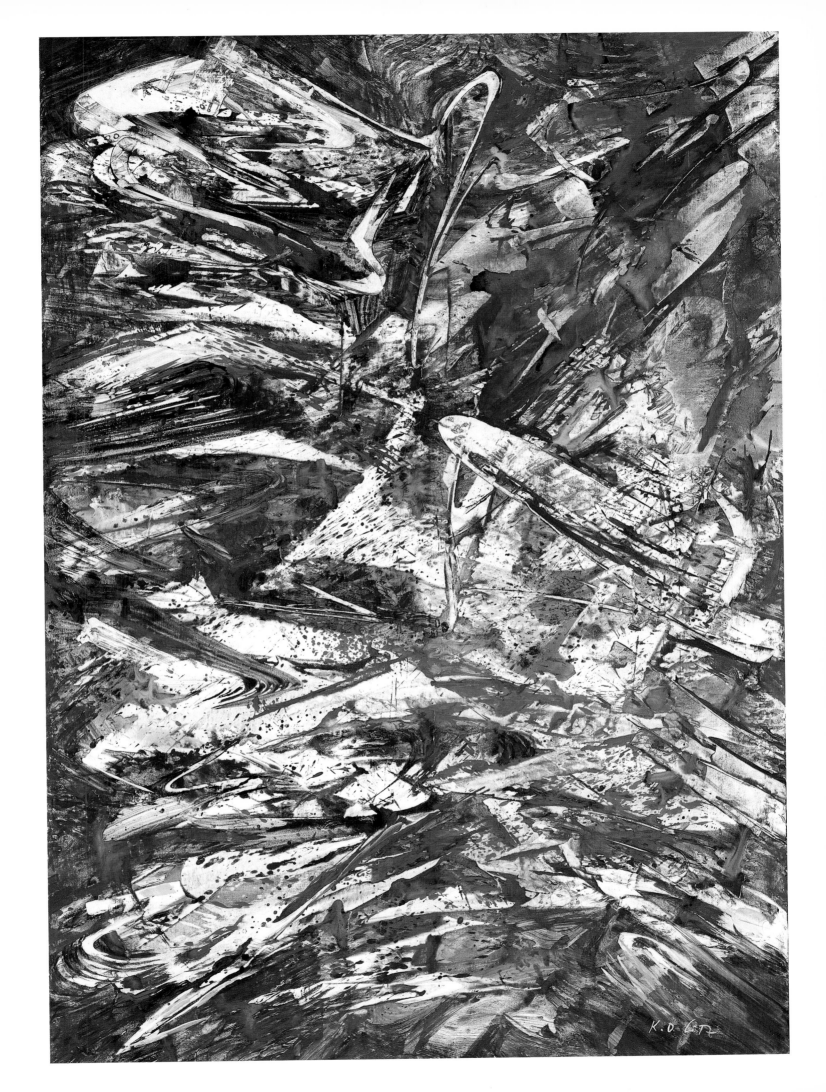

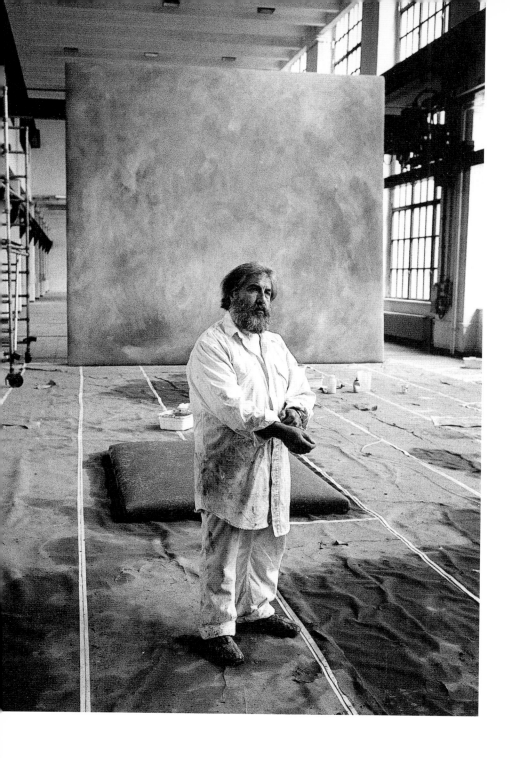

Gotthard Graubner

1930 Born in Erlbach (Vogtland)

1947–48 Studied at the Hochschule der Bildenden Künste, West Berlin

1948–49 Studied at the Staatliche Kunstakademie, Dresden

1954 Left the German Democratic Republic

1962– Cushion pictures

1965 Appointed to Hochschule der Bildenden Künste, Hamburg (professor from 1969)

1968–71 Environments (mist spaces)

1970– Color space bodies

1973 Member of the Akademie der Künste, Berlin

1976–	Chair at the Kunstakademie, Düsseldorf
1982	5th Indian Triennale, New Delhi; Venice Biennale
1996	Member of the Sächsische Akademie der Künste, Dresden
1999	Magnum opus for the Reichstag, Berlin
	Lives in Hombroich near Neuss

Graubner discovered what he wanted to do while he was still a student: explore and expound color as an autonomous pictorial resource. Proceeding in logical steps and successive work phases, Graubner opened up new ways to color in pictures that impressively illustrate their independent existence, autonomous laws, the process of their creation and their effects. Graubner describes the development of his painting with three concepts: it goes from the flat 'color spaces' (watercolors, sponge gouaches, blotting sheets) via the 'color bodies' (*Cushion pictures*, 1964–65; *Trampoline pictures*, 1970) to the 'color-space bodies' (from 1970), in which the paint soaks through 'bodies' (synthetic wadding) draped on the canvas in numerous layers until a breathing organism develops, made of finely changing values ranging from color to non-color, that can be experienced both as a visual atmospheric manifestation or a haptic 'visual body'. With its numerous modulations of bright and dark, warm and cold nuances, stronger and weaker intensities in fluid transparency and increasing density, color acquires its own floating three-dimensionality. This color space is nonetheless always bound to the three-dimensional volume of the material base. Just as breath and breathing condition each other, color is neither at one with the base material nor liberated from it. Color functions as the specific energy potential of the pictorial organism.

Although Graubner presents liberated color, he is not an adherent of the 'pure' color creed, i.e. absolute colorfulness such as is manifest in pioneering works of abstraction by Kandinsky, Delaunay and Mondrian. With a profound knowledge of the history of painting, he prefers to follow Titian's advice to 'dirty' the paint and adopt his painting technique of using many layers of varnish. Only then do the depths of the colors begin to unfold. For Graubner too, colors are the 'deeds and sorrows of light'. They never issue forth radiant and pure. They always have something of shadow in them from which differentiated color space is created. The colors in the 'color space bodies' can unfold their full potential only through the manifold refraction of the colors, the fluid transistor-like transitions between light and dark, cold and warm. Only then does that strange light-filled suspension of color tones arise that opens up space and light in the material of the pictorial body.

"The action of the color is the decisive element. Only one color area is addressed at a time. The communication between cold and warm values causes tension and interaction. Color spreads over the surface as if of its own accord. The consistency of the color determines the movement, the path that the color follows in its unconscious course. Pile-ups occur. The color space moves in the vortex of the accretions of pigment. The surface breathes." (Graubner, 1963, in: exh. cat. Kunsthalle, Hamburg, 1975/76, p. 75)

On the other hand, Graubner's pictures draw life from the appearance of natural processes and associations with elemental experiences of nature such as the artist has sketched and recreated time and again on his numerous travels. Nature is meant in the wider sense here when the change of the material substance (color pigment) is described in a cerebral color space, recalling the transmutation of the alchemist's processes. This impression of the elemental, self-reproductive and constantly changing is a feature especially of the more recent color space bodies (from the mid-1980s) in which a new, livelier gesticulation pulls together what are now very intense, even optically provocative color tonalities into vortices and flows.

Lit.: *Gotthard Graubner*, exh. cat. Kunsthalle, Hamburg 1975–76; *Gotthard Graubner. Farbräume—Farbraumkörper-Arbeiten auf Papier*, exh. cat. Kunsthalle, Düsseldorf 1978; *Gotthard Graubner—Radierungen. Unikate aus den Jahren 1969–1995*, exh. cat. Münsterland Kunstverein, Münster 1999; *Gotthard Graubner*, exh. cat. Galerie Alter Meister, Dresden 2000; *Gotthard Graubner, Arbeiten auf Papier*, exh. cat. Städtische Kunsthalle, Karlsruhe 2001.

Without intending to undermine Monet's importance as an Impressionist painter, it was his late work that fascinated me in particular.

In his late work, he did not try to depict light but to let it be seen through his art itself. Color was no longer a copy but exuded its own light, its own life.

Gotthard Graubner, 2001

Gotthard Graubner, Mystical Engagement, 1986

Acrylic and oil on canvas over synthetic on canvas, 300 × 250 × 15 cm. Property of the artist

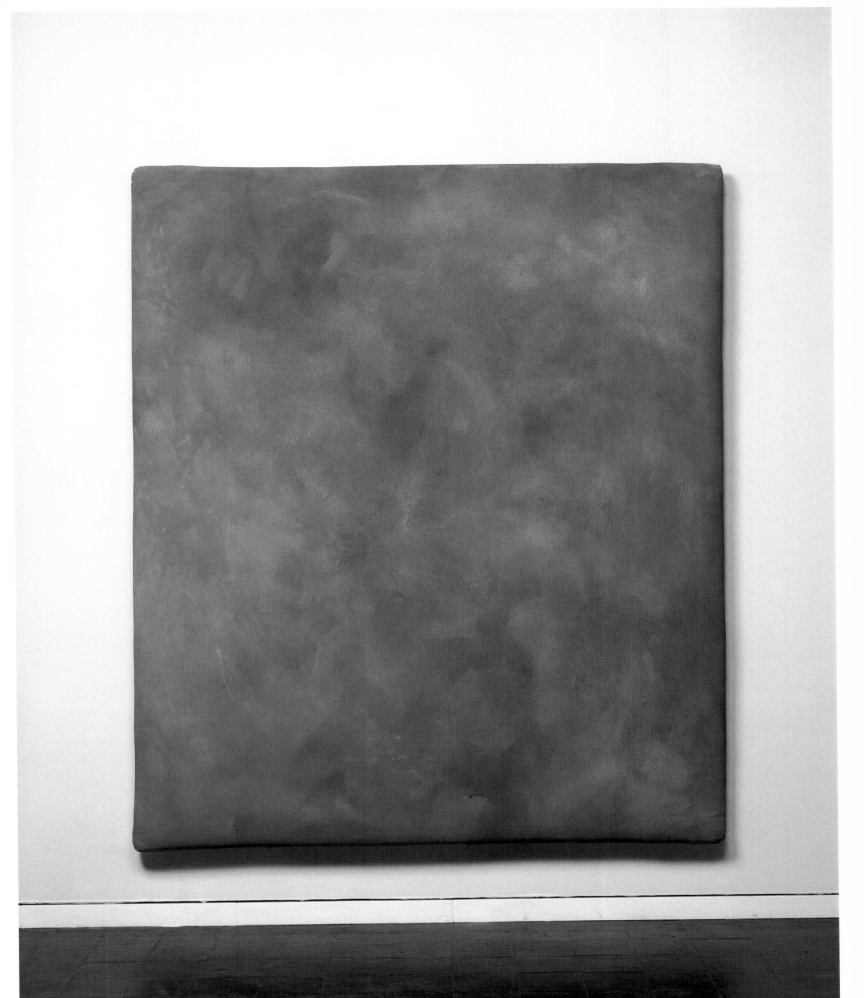

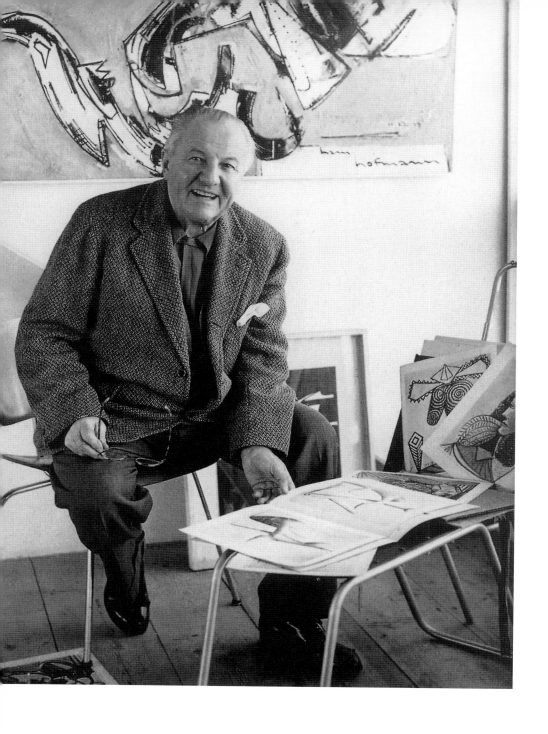

Hans Hofmann

1880	Born in Weissenburg
1898	Moritz Heymann's art school in Munich
1904–14	Visited Paris; attended École de la Grande Chaumière and the Académie Colarosi; became acquainted with Matisse, Picasso, Braque, Sonia and Robert Delaunay
1910	First one-man show at Paul Cassirer in Berlin
1914	Returned to Munich
1915–32	Set up his own art school in Munich
1932	Emigrated to New York; taught at the Art Students' League
1933	Opening of Hofmann School of Fine Arts in New York
1941	Obtained American citizenship

1944	First one-man show at Peggy Guggenheim's Art of This Century Gallery in New York
1957	Retrospective at the Whitney Museum of American Art (touring exhibition)
1958	Closed his school; returned to his own work; mosaic for the facade of the New York School of Printing
1963	Retrospective at the Museum of Modern Art, New York
1966	Died in New York

Hans Hofmann was among the most important art communicators and teachers of art for a whole generation of American artists, and himself played a part in the creation of Abstract Expressionism. He was represented at documenta 2 in Kassel, where the style was present in force, along with Arshile Gorky, Jackson Pollock, Willem de Kooning, Philip Guston, Franz Kline, Robert Motherwell and Barnett Newman. In 1960, Hofmann, together with Philip Guston, Franz Kline and Theodore Roszak, were the American representatives at the 30th Biennale in Venice. These landmarks alone show how important Hofmann was as a teacher and artist in bringing European art to America and also for the development of an independent American tradition. His lectures about picture composition were legendary, especially the 'push-and-pull' principle that Hofmann presented in such exemplary manner in his own abstract works, demonstrating the tension between gesticulatorily generated picture-depth and surface-stressing geometric color elements. His former pupils, including Lee Krasner, Clement Greenberg, Milton Resnick, Jasper Johns, Helen Frankenthaler, Frank Stella and the like, readily acknowledged the influence of Hofmann's art historical discursions. He passed on the knowledge and experience of Cubism and Fauvism he had gained in Paris, especially the artistic philosophy about the pure resources of painting developed by Delaunay and Matisse. At the heart of this was color, which was to acquire ever increasing importance in Hofmann's own work.

Attendance at a summer school at Berkeley University in 1930 through the good offices of a former pupil, Worth Ryder, enabled Hofmann to establish links with America. In 1932, he was very glad to make use of these to settle for good in New York, where he opened a new school in 1934. How far American art is indebted to Hofmann is best expressed in the writings of the influential art critic Clement Greenberg, who himself attended courses under Hofmann and became the intellectual 'accoucheur' of Abstract Expressionism. Even before the actual Monet Revival of the 1950s, American painters were able to acquire a sound familiarity with the techniques and strategies that later flourished not only in America but also in Europe, in the predominance of color, gesture and abstraction. During this demanding teaching activity, Hofmann's own painting had of necessity to remain in the background, but it returned to the fore all the more powerfully after Hofmann gave up the school. His work ranges from gesticulatory painting à la Pollock, whom he had got to known via Lee Krasner, to the geometrical abstraction of Mondrian and Malevich, and ultimately to the blending of these two stylistic principles, as in *The Conjurer* of 1959.

Lit.: William C. Seitz, *Hans Hofmann*, exh. cat. Museum of Modern Art, New York 1963; Walter Darby Bannard, *Hans Hofmann, A Retrospective Exhibition*, exh. cat. Museum of Fine Arts, Houston 1976; Cynthia Goodman, *Hans Hofmann*, New York 1986; C Goodman, *Hans Hofmann*, exh. cat. Whitney Museum of American Art, New York, Munich 1990; *Hans Hofmann, Wunder des Rhythmus und Schönheit des Raums*, exh. cat. Städtische Galerie im Lenbachhaus, Munich 1997.

... a bridge from Delaunay and Matisse to Monet's late work ...

Clement Greenberg, *Hans Hofmann*, Paris 1961.

Hans Hofmann, The Conjurer, 1959
Oil on canvas, 150.5 × 114 cm. Munich, Städtische Galerie im Lenbachhaus

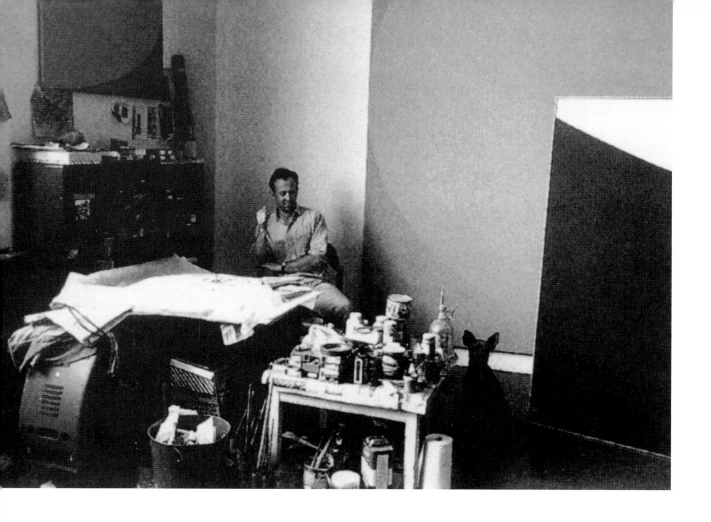

Ellsworth Kelly

1923	Born in Newburgh, NY
1941/42	Studies design at the Pratt Institute in Brooklyn
1944	Fights in Normandy invasion
1946–48	Studies at the School of the Museum of Fine Arts, Boston; subsequently at the Ecole des Beaux-Arts, Paris
1950/51	Lecturer at the American School, Paris; first abstract paintings
1954	Moves back to New York
1964–92	Participates in documenta 3, 4, 6 and 9 in Kassel
1969	Murals for UNESCO in Paris
1974	Wins Painting Award of the Art Institute of Chicago
1980	Wood and metal sculptures
1998	Retrospectives in New York, Los Angeles and Munich
	Lives in Spencertown, NY

As early as his years in Paris, Kelly was working on abstract paintings with planar geometric elements spread across several panels and limited to plain primary colors (*Colors for a Large Wall*, 1951, The Museum of Modern Art, New York). The colors, showing intrinsic values and applied completely evenly, cover the whole canvas so homogeneously that it is only with modular serialization and the reference to the wall that a unified picture comes about. The discovery of the late works of Monet (in May 1952) meant a new freedom of painterly expression for Kelly. It is reflected in his choice of over-sized formats and in his taking up monochromy and the concept of the series (interviews in June 1991 and April 2000).

Subsequently, from 1954 on when he was back in the USA, Kelly's pictorial concept became more and more liberated from European examples of geometric and neo-plastic abstraction (Arp, Mondrian, Vantangerloo). Closely connecting the sign of the color to the surface of the picture led to a new unity of form and ground, a "post-Cubist space" (Clement Greenberg). Kelly's pictures usually consist of one or more precisely outlined forms in strong bright colors. The term 'Hard Edge Painting' was coined for this style. During the 1960s Kelly often used angular formats and combined separate monochrome panels to form installations covering entire walls. His ideas on new pictorial and spatial concepts transforming the two-dimensional painting into a three-dimensional pictorial object made Kelly an internationally acclaimed artist during this period.

Besides paintings he also produced graphic art, collages, relief sculptures and sculptures in wood and metal, alternating geometric with organic forms and restrained with bright colors (*Diagonal with Curve IX*, 1979). All of his abstract geometrical objects have an incisive mathematically calculated form that stands out silhouette-like in space. Pictures and sculptures or reliefs are for Kelly variants of equal value with which to express complex formal relationships. For instance, the overall form of the *Houston Triptych* (1986) he created for the grounds of the Museum of Fine Arts cannot be grasped at once but only takes shape in a step-by-step perceptual process.

A recent expression of this concept was his temporary installation of the *Yellow Curve* in 1990 in a portico in Frankfurt a. M. *Yellow Curve*'s clearly defined, eccentric form of a segment of a circle enters into a close relationship with the architecture, its monochrome yellow shape referring to the existing spatial conditions. Hence the work can be seen both as painting and sculpture in space.

Lit.: *Ellsworth Kelly, Gemälde und Skulpturen 1966–1979*, exh. cat., Staatliche Kunsthalle, Baden-Baden 1980; *Ellsworth Kelly: Die Jahre in Frankreich 1948–1954*, exh. cat., Westfälisches Landesmuseum für Kunst und Kulturgeschichte Münster, Munich 1992; Anthony d'Offay and Matthew Marks (eds), *Spencertown: Recent Paintings by Ellsworth Kelly*, New York 1994; Diane Waldman (ed.), *Ellsworth Kelly: A Retrospective*, exh. cat., Solomon R. Guggenheim Museum, New York etc., New York 1996 (Haus der Kunst, Munich 1997/98); *Ellsworth Kelly: The Early Drawings 1948–1955*, exh. cat., Harvard University Art Museum, Cambridge, etc. 1999/2000 (Städt. Galerie im Lenbachhaus, Munich 2000).

My first contact with Monet's late work was a painting of waterlilies (*Nymphéas*) in May 1952 in the Kunsthalle in Zurich. Although I had been living in Paris since 1948, I had never visited the Orangerie Museum in which are exhibited Monet's large murals of the *Nymphéas* (his gift to France after the end of World War I) which were installed after his death in 1926.

Returning from Zurich to Paris, I found a book on Monet by his close friend, Georges Clemenceau, the Prime Minister of France, in which I learned that Monet had lived and worked in Giverny and died there in 1926. My knowledge of Monet's work ended with the Haystacks, and I knew nothing of his work after 1900.

In August of 1952 I wrote to Monet's stepson, Jean Pierre Hoschedé, in Giverny who invited me to make a visit. A friend and I took a train to Vernon, then walked several miles along a dirt road where we found the property. Entering the main house, in the entry room there were early early landscapes and a painting of the English Parliament. I said "These are 19th Century; what was done after 1900?" Hoschedé said, "Come, I'll show you." He took us out to the gardens and the large glass studio which Clemenceau had helped Monet build in 1917. I remember there were a couple of broken glass panes, some pigeons flying around, and a lot of leaves on the floor. At that time the French art world didn't appreciate Monet's late work.

And there they all were. There must have been fifteen enormous paintings, twenty feet long. I was very impressed. I had never seen paintings like this: overall compositions of thickly applied oil paint representing water with lilies, with no skyline. I felt that these works were beautiful, impersonal statements.

In 1951, I had begun to make paintings made up of joined panels, with each color on its own canvas, with only color and form as the content. I wanted to make visually engaging, impresonal works. Seeing the *Nymphéas* affirmed what I was doing.

The day following the trip to Giverny, I painted *Tableau vert*, my first monochrome. I had already made works with many color panels, but to make one color on a canvas was a challenge.

Monet's last paintings had a great influence on me, and even though my work doesn't look like his, I feel I want the spririt to be the same.

Ellsworth Kelly, 12/08/2001

Ellsworth Kelly, Waterlily series, 1968
Pencil on paper, 61 × 48.3 cm. Property of the artist

Ellsworth Kelly, City Island, 1958
Oil on canvas, 184 × 152 cm. Private collection, USA

Ellsworth Kelly, Tableau vert, 1952
Oil on canvas, 74.3 × 99.7 cm. Property of the artist

Byron Kim

1961	Born in La Jolla, CA
1986	Skowhegan School of Painting and Sculpture
1983	B.A.,Yale University
1998	*Wall Drawings*, Whitney Museum of American Art at Philipp Morris, New York
2001	New Paintings (*The Sky is Blue*), solo exhibition at the Max Protetch Gallery, New York
	Lives and works in New York

Kim's point of departure as an artist is the Abstract Expressionist tradition, whose principles also apply to his own painting: intensive, monochrome color fields, absolute two-dimensionality and negation of compositional hierarchy. Abstract painting does not interest Kim for formal reasons alone but as a means to express the sublime, the universal and the eternal. This search for a timeless, absolute, aesthetic beauty is apparent even in his earliest works. In a project called *Synecdoche* (a figure of speech that means a part standing for the whole), which Kim exhibited in 1992 at the Max Protetch Gallery, he arranged 200 monochrome panels painted in shades ranging from beige to brown on the walls of the gallery. Apparently a mere study of shades, the panels actually reproduced the skin colors of his friends, relatives and models, precisely observed and accurately painted. This and other works such as *Yellow Abstract Painting*, a yellow enamel picture inscribed "Mongol," associated Kim briefly with 'Gender Art' artists, who visualise socio-cultural problems such as gender, identity, race, and body awareness. However, Kim's works always have a special poetry and a high aesthetic standard. They are thus considerably closer to the spiritual tendency of abstract painting than to more recent fashionable trends. The same applies to *Emmett at Twelve Months*, 1994, which shows the colors of tiny anatomical details of the artist's son at the age of one divided up in fields arranged like a puzzle. Other works depict the predominant colors of places where the artist stayed for a certain period of time. The tradition of monochrome painting also occupied Kim in a series of technically brilliant oil paintings entitled *Gray-Green* (1996) displaying a wealth of nuances among blue and gray-green tones. Kim collected antique Chinese dishes of the Koyro Dynasty with a celadon glaze in wonderful nuances that served as models for his paintings.

In his recent works the concept of monochromy is expanded to allow a greater openness and breadth of associations. Kim's large murals bring him back closer to Abstract Expressionism again and, in their allusions to landscape, to the *Waterlilies* of Monet. The installation shown in the present exhibition, however, departs from the framework of painting. With the constantly changing leaves of the irises it brings a both poetic and conceptual note into play.

Lit.: Francesco Bonami, 'Byron Kim,' *Flash Art* 26 (October 1993), pp. 122 ff.; Jutta Schenk-Sorge, 'Byron Kim,' *Kunstforum* 4 (1993) pp. 399 ff.; Susan Krane, *Tampering (Artists and Abstraction Today)*, exh. cat., High Museum of Art, Atlanta 1996; 'Byron Kim: Grey-Green,' exh. cat. Hirshhorn Museum and Sculpture Garden, Washington, D.C., 1996; *Byron Kim*, exh. cat., Max Protetch Gallery, New York, 2001.

Recently I took the 'F' train from home in Brooklyn to MoMA to see its great waterlily triptych. Amidst the throng of tourists, I found it hard to distinguish myself as a viewer. I hadn't thought about Monet in a long time, yet I had the arrogance to think that I had come to see something that others couldn't see. No insights came to me. I think that Monet would have told me to forget myself and just look. But I have trouble putting aside what I know. I am often stuck with who I think I am. European romanticism and Zen Buddhism teach us about the paradox of distinguishing (enlightening) onself in order to reveal to oneself that there is no distingushing oneself. When will I realize that I am just another tourist?

Monet once told the American painter Lila Cabot: "When you go out to paint, try to forget what objects you have before you, a tree, a house, a field or whatever ... Remember that every leaf on the tree is as important as the features of your model."

If Monet were our contemprary, he would not be making Impressionist paintings, or even Post Impressionist paintings. He would help us to see in a new way. In this spirit I offer you (and Claude Monet) a flower, or a part of a flower. I would offer you the whole flower, but I am afraid you would misunderstand, that you would think I was giving you a thing. Instead, what I want to give you is an iris petal, a stroke of blue-violet, one of Monet's signature strokes, an opportunity to see.

Byron Kim, 2001

Byron Kim, White Painting #5 (After Melvin), 2001

Oil on canvas, 228.6 × 233 cm. New York, Courtesy the artist and Max Protetch Gallery

Byron Kim, Grunion Run, 2001

Oil on canvas, 228.6 × 233 cm. New York, Courtesy the artist and Max Protetch Gallery

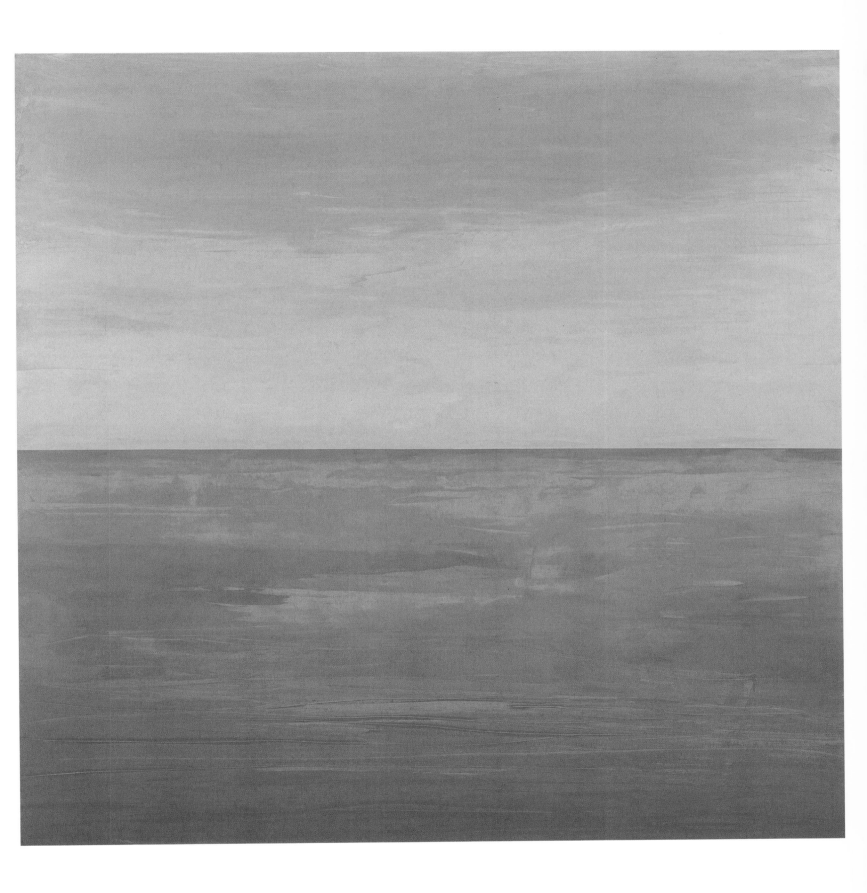

Per Kirkeby

1938	Born in Copenhagen
1957	Studied natural sciences at the University of Copenhagen
1962	Attended the Experimental Art School in Copenhagen to study painting, graphic art and 8-mm film
1965	Grant to study at the State Art Foundation; published his first book of poetry
1966–67	Performances with Joseph Beuys, Nam June Paik, and others
1974	First exhibition at the Michael Werner Gallery, Cologne
1979	Solo exhibition at the Kunsthalle Bern and the Aarhus Art Museum
1982	Documenta 7 in Kassel; member of the Danish Academy of Literature
1983	First bronze sculptures
1988	Professor at the Staedel School in Frankfurt/Main
1992	Documenta 9 in Kassel
	Lives in Copenhagen, on Laesø Island and in Frankfurt/Main

Kirkeby is not only a painter but also a sculptor, who sets up his well-known brick sculptures mainly in public spaces. In addition, he does a lot of drawing and has created a large body of work in a wide variety of print techniques. But Kirkeby has also put in appearances as a geologist, filmmaker, essayist, poet, historian, stage set designer, and architect. In other words, he is an artist who has made his mark in almost all areas of creative production. Important inspiration comes from his extensive travels, during which he studies foreign cultures. The complexity of his creativity makes Kirkeby a very unusual figure in the contemporary art scene. Away from spectacular marketable events, he produced a substantial oeuvre over the last forty years. In addition, there are numerous publications by the artist dealing in poetic or pseudo-scientific form with numerous aspects of his work, which taps many resources.

Kirkeby has explored—also in writing—Monet's *Waterlilies*. In fact, the appearance of his new paintings undeniably suggests abstracted landscape impressions. Rudiments of perspective draw the viewer into the picture; the viewer can make out landscape structures that sometimes recall botanical forms. On second glance, however, these impressions become tangled up in ruptures in the composition, they go astray or are lost in completely abstract-looking color and formal relationships.

While Kirkeby's pictorial reflections are concerned with nature in the broadest sense, with landscape and vegetation, figure and atmosphere, they are primarily transformations of perceptual processes, that is, their subject is the correlation of the eye and the hand while painting. Of primary importance is not the painting process itself, as often seems the case with his virtuoso Informel structures, but the complicated interplay of perception, experience, and transformation. Its subject is the ambivalence of formal perception, the sedimentation of landscape impressions and of memories of art historical models (e.g. Monet's *Waterlilies* in the *Wood* series of 1994). It is not a coincidence that Kirkeby's pictures are stratigraphies (or cross-sections) that have absorbed his experience in archaeology and geological field trips and that are layered according to the all-over principle onto different materials (canvas, wood, masonite, blackboards).

Lit.: Klaus Gallwitz (ed.), *Per Kirkeby, Gemälde, Arbeiten auf Papier, Skulpturen, 1977–1990*, exh. cat. Städtische Galerie im Städelschen Kunstinstitut, Frankfurt/Main 1990; Joachim Gachnang et al (eds.), *Per Kirkeby: Backsteinskulptur und Architektur: Werkverzeichnis*, Cologne 1997; Per Kirkeby, *Handbuch: Texte zur Architektur und Kunst*, Berlin and Bern 1993; *Per Kirkeby: Skulpturen, Terrakotten und Zeichnungen*, exh. cat. Gerhard Marcks House, etc., Oldenburg 1997; Armin Zweite (ed.), *Per Kirkeby: Bild, Zeichnung, Skulptur*, exh. cat. Kunstsammlung Nordrhein-Westfalen, Düsseldorf, Cologne 1998.

A lot can be said on the subject of Monet and modern art. Including obvious trivialities that soon get mired in inexcusable ponderousness. Yet it is these basic, trivial observations that do him justice.

It is a commonplace to say for example that there are similarities between Monet's great waterlily pictures and the great drip paintings of Pollock. That is a fairly rough-and-ready statement, but it contains a hidden truth. It involves, prima facie, only a superficial resemblance. Most people would agree the similarity is superficial, because it is clearly recognizable that Pollock's pictures express panic, while Monet's waterlilies are 'beautiful, wonderful,' etc. Nevertheless, I think that the immediate, superficial resemblance is right, that there is a more profound resemblance, a similarity of spiritual space revealed in these surfaces.

In certain situations and for certain painters, the whole problem of meaning comes back to the question of subject matter. The agony caused by the abandonment of the subject (the subject matter considered as such by the painter and not necessarily what any given public might see as 'subject matter,' even if this is precisely the aspect that establishes a connection in the broadest sense between the painter and the public) is indescribable. That is never 'successful,' of course, but it suffices that it is possible. The agony and the anguish are evident in Monet's surfaces as much as in Pollock's, even if they use different colors.

A painter can live with 'existential consequences,' but they can never constitute his justification. Many painters of the New York School are dead because they believed the opposite. It takes brutality, energy and an ability to work in calculated series—an ability both Pollock and Monet possessed. The cathedral, the poplars by the Epte, in fact Monet's entire output is proof thereof. If this raw energy needs stressing, this is because it is necessary to counter yet again the sentimental conception of the sentimentality of the great water gardens of his final years. The sentimentality involved is the ambiguous one of the river of death, not one of lyrical rapture at the spectacle of nature....

From the point of view of emotions, there is no brutality in the painter Monet who, beside the deathbed of the wife he loved, recorded nuances of the tones of death on her face. With an ominous sensitivity, he allows himself to be almost completely carried away by the profound current of the subject matter. The subject matter that Josephson for example also fell victim to, and this because he had no method to brutalize his knowledge usefully. But it is known that Monet found another solution, another camouflage for the man as a painter. The current of subject matter. The Epte poplars. We would need to see the series brought together, because it is this progression, the current itself that is dangerous. The lyrical solution is all too easy as far as each element is concerned. It is the same current, the same river that carries away the waterlilies and the agonizing faces. A current that recurs in Debussy and Joyce. And those who embark on this splendid current of subject matter are not those who live least dangerously. 'A rower on the river of death,' said Cocteau of Ezra Pound. Even with closed eyes, a ferryman led by his intuition can allow himself to be engulfed by the river.

Per Kirkeby, in: *Ordrupgaardsamlingen, Charlottenlund*, exh. cat. Copenhagen 1979/80, pp. 30–31.

Per Kirkeby, Untitled (Laesø), 1994

Oil on canvas, 200 × 300 cm. Cologne and New York, Courtesy Galerie Michael Werner

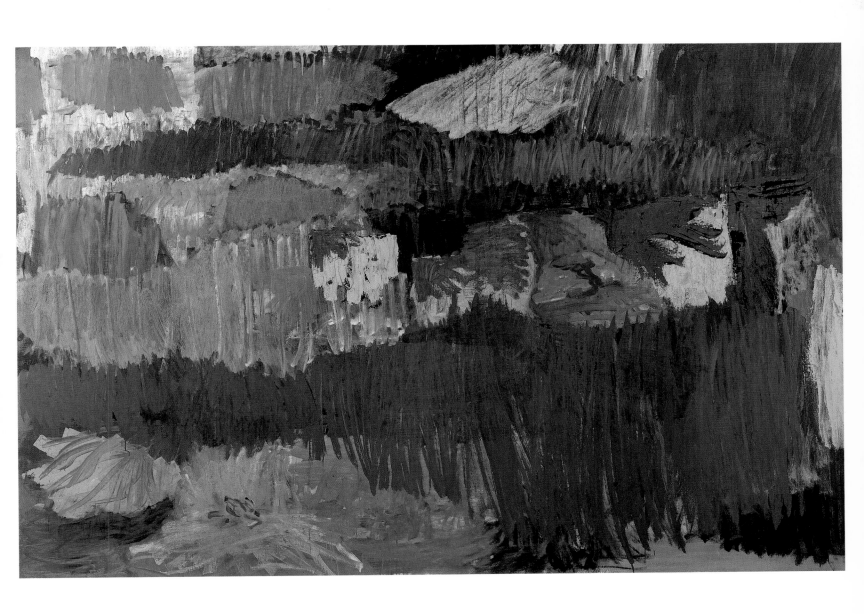

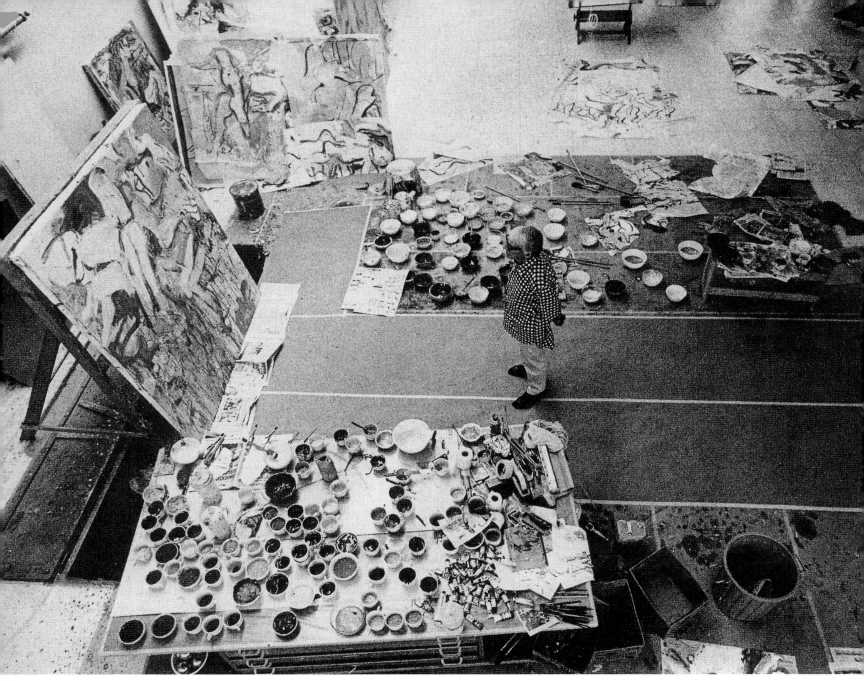

Photo Hans Namuth

Willem de Kooning

1904 Born in Rotterdam
1916–24 Apprenticeship in commercial art and interior decoration; studies at the Rotterdam
 Academy of Art
1926 Emigrates to the U.S.; works as a commercial artist, window dresser, sign painter and
 carpenter
1935/36 Paints murals for the WPA (Works Progress Administration)
1938–44 First series of paintings of women (*Pink Lady*, 1944); makes friends with Jackson
 Pollock; *Abstract and Surrealist Art in America* exhibition
1947–49 Second *Women* series; meets William Baziotes, Adolph Gottlieb, Hans Hofmann and
 Clyfford Still; attends lectures and joins in the activities at the Eighth Street Artists' Club

1950,	
54, 56	Venice Biennale
1956	*Willem de Kooning: Recent Paintings* solo exhibition is his breakthrough as an artist
1957–61	Abstract landscapes
1962	Obtains American citizenship
1969	First bronze sculptures
1983	Two major retrospectives: Stedelijk Museum Amsterdam; Whitney Museum of American Art and Centre Pompidou, Paris
1997	Dies on Long Island

De Kooning's early work was still strongly influenced by European painting, particularly by Surrealism in the Gorky style, as well as by Miró and Picasso. Figurative and abstract studies had equal status in his work without it having a pronounced style. Not until he made the acquaintance of the painters of the New York School, above all Jackson Pollock and Franz Kline, did de Kooning arrive at gestural abstraction. His powerful new style was revealed in his series of paintings of women on the 1950s. In de Kooning's paintings the female body becomes a landscape for the gestation of the 'adventure of painting' in tempests of color in virtuoso density and elemental vehemence, transforming the eternal subject of 'woman' into an exposition on color and space.

His first abstract landscapes are stirred up by an almost physically perceptible passion for painting. Aggressive impetuous brushstrokes shove the paint into the pictorial space and interpenetrate, whereby sudden changes in direction keep breaking up and destroying the structure of the composition (*Easter Monday*, 1956). With these paintings de Kooning had found his creative freedom. Kindled anew by the atmosphere at different times of the day, experiences in the landscape, or his view of New York, it was expressed in a painting process that was constantly re-initiated. In the series he painted the 1960s his palette changed to light, milky tints suggesting light and air. He treated landscape in a new way after moving to Long Island in 1963, where he would walk along the beach or go cycling (*Rosy Fingered Dawn at Louse Point*, 1963). De Kooning's method of painting with light is composed of all the elements of nature that radiate light, particularly the reflecting water of the ocean, the beach, stones, rocks, and clouds. It relates in both choice of colors and texture to European painting modelling with light. The principle of the series arose for de Kooning, as it had for Monet, from the need to treat a certain theme with variations or to try out certain color combinations in succession.

After a new series of paintings of women in the 1960s, de Kooning went back to abstraction. He painted a sequence of extremely frenetic pictures again suggesting natural elements, as also indicated by the titles (e.g. ... *Whose Name Was Writ in Water*, 1975). The comparison with Monet's late work in Giverny is suggested even more strongly by the choice of colors and the texture of the paint. As in Monet's *Waterlilies*, a variety of textures and consistencies of the paint can be seen in de Kooning's late abstract landscapes. De Kooning's were of course painted in the studio and hence are pure abstracts, yet they have absorbed some of the light and the physical appearance of nature nevertheless. In the 1980s de Kooning's style changes once again: the picture plane clears up to light planes threaded with colored ribbons and graphic lines like a final flicker of the gesture of color against the all-extinguishing white.

Lit.: Thomas B. Hess, *Willem de Kooning*, exh. cat., Stedelijk Museum, Amsterdam 1968; *Willem de Kooning: Retrospektive: Zeichnungen, Gemälde, Skulpturen*, exh. cat., Akademie der Künste, Berlin 1984; *Willem de Kooning*, exh. cat., Hirshhorn Museum, Washington 1993/94; *Willem de Kooning: Die späten Gemälde, Die 80er Jahre*, exh. cat., Kunstmuseum, Bonn 1996; Gabriele Uelsberg, ed., Willem de Kooning, *Über die Kunst: Gesammelte Schriften*, Bielefeld 1998.

I had already started working here (in Louse Point) earlier, and I wanted to get the feeling of light again when painting ... I wanted a connection with nature. Not to get natures scenes to paint but a feeling for light that appealed to me a lot, particularly here. I've always been very interested in water ... When I came here, I even went so far as to produce a sand paint—a large pot with sand paint. As if I'd taken sand and mixed it. And the gray-green grass, the marram grass and the sea were mostly steel gray in all shades. When light falls on the sea, a sort of gray light lies on the water ... It got so far that I was able to paint in the atmosphere I wanted to be in. It was like the reflection of light. I reflected about the reflections on the water.

Purely by chance, I'm an eclectic painter: I only have to open a book with reproductions in it and I always find a painting I could be influenced by ...

Willem de Kooning in conversation with Harold Rosenberg, in: *Art News*, vol. 71, no. 5, September 1972, pp. 54–59

Willem de Kooning, Rosy Fingered Dawn at Louse Point, 1963
Oil on canvas, 203.5 × 178.5 cm. Amsterdam, Stedelijk Museum

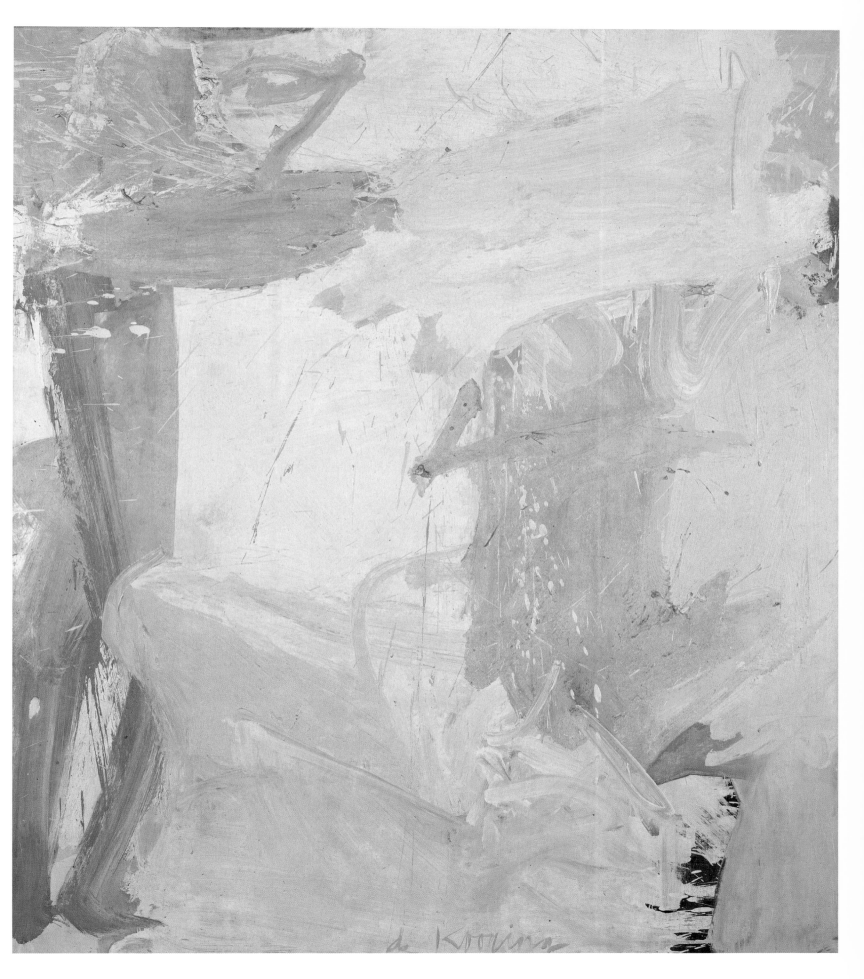

Morris Louis (Morris Louis Bernstein)

1912 Born in Baltimore
1928–33 Studies at the Maryland Institute of Fine and Applied Arts
1936–40 Works for the WPA (Works Progress Administration)
1954 Starts the *Veils* series
1957 First solo exhibition at the Martha Jackson Gallery, New York
1959 Solo exhibition at French & Company (*Veils*)
1962 Dies in New York

Living in New York from 1936–40, Louis was friends with David Alfaro Siqueiros, Jack Tworkov
and Arshile Gorky and took part in various workshops on experimental techniques. His first paint-
ings were in the style of Jackson Pollock and Robert Motherwell. His pleasure in experimenting
with color led him to use the first acrylic paints available on the market in 1948. These so-called
Magna paints developed by Leonard Boccour still had to be thinned with turpentine. In 1952 Louis
moved to Washington D.C., where he taught at the Workshop Center and met Kenneth Noland.
He joined Noland on a trip to New York to look at art. They met the influential art critic Clement
Greenberg and saw works by Franz Kline and Jackson Pollock. But what impressed the two young
artists most was the work of Helen Frankenthaler, who had first used the 'soak-stain' technique in
her picture *Mountains and Sea* (1952, National Gallery of Art, Washington). This involved pouring
thinned paint (and letting it run freely) on raw canvas, i.e., unprimed (or manufacturer pre-sized)
light beige canvas.

"The revelation he received became an Impressionist revelation," was how Greenberg described the impact on Louis of the work of Pollock and Frankenthaler. It was also, Greenberg said, "a revulsion against Cubism." In effect, Frankenthaler showed Louis a way back to Impressionism through Pollock, a way that required him to discard those Cubist aspects of Pollock's style that coexisted with the Impressionist ones. Alternatively, whereas Pollock's interpretation of Cubism had retuned him to Impressionism, Louis's interpretation of Pollock, made possible by Frankenthaler's interpretation, returned him to Impressionism more completely. Either way, the "bridge between Pollock and what was possible," provided by Frankenthaler led to the past as well as to the future (Cf. Elderfield, exh. cat., *Morris Louis*, The Museum of Modern Art, New York and Boston 1986, p. 27).

After returning to Washington, Louis and Noland experimented extensively with the new technique. From this semi-automatic process of spilling and superimposing Magna paints thinned with turpentine and from the dynamics of the running paint, also aided by tilting and turning the canvas (still stretched on the wedged stretcher in the first works), Morris Louis developed dense multi-colored color fields, the so-called *Veils*, starting in 1954. He executed them in different forms (e.g. flowers from 1959 on) and colors, from very light, transparent blends to heavy, dark curtains of broken complementary colors (e.g. *Russet*, 1958, Museum of Modern Art, New York).

After his first—disappointing—solo exhibition in 1957 at the Martha Jackson Gallery, Louis destroyed all work done after 1955 and went back to the early *Veil* forms. Subsequently, in the series of *Unfurleds* he started in 1959/60 he created a dramatic tension through the contrast between the empty white canvas and the highly saturated rivulets of color running down on the sides. The empty central zone emphasizes the complementary colors along the sides and functions as an energy field for the effects of simultaneous contrasts. His last works at the beginning of the 1960s, the *Stripes* series (e.g. *Twined Columns*, 1960), concentrate even more on the properties of colors, their luminosity, intensity and brilliance, and less on the technical process of pouring paint and letting it run. The even bands of paint form columnar shapes on the beige canvas and show pure perceptual fields where multifarious interactions occur among the colors. Just before the outbreak of his fatal illness Louis was still experimenting with striped structures in horizontal and diagonal positions.

Unlike Noland and other painters of so-called 'Post-Painterly Abstraction' (Greenberg) Louis was mainly concerned with contrasts between the paint and the canvas (exposed vs covered), inner and outer form, center and periphery, as well as contrasts between colors. Louis was one of the most consequential painters in this school to pursue the representation of color as a purely optical phenomenon.

Lit.: *Morris Louis: The Veil Cycle*, exh. cat., Walker Art Center, Minneapolis etc. 1977; Kenworth Moffet, *Morris Louis in the Museum of Fine Arts, Boston*, exh. cat., Museum of Fine Arts, Boston 1979; D. Upright (ed.), *Morris Louis: The Complete Paintings; A Catalogue Raisonné*, New York 1985.

Myself as affected by paintings

I believe I spoke to David [Smith] about a related point of difference
between myself as affected by paintings and most other painters I've
known: I don't care a great deal about the positive accomplishments
in their work or my own since that leads to the end. I look at paintings
from the negative side, what is left out is useful only as that leads
to the next try and to the next. In this sense the positive accomplish-
ments of Pollock or anyone else has little meaining for me and I
acknowledge a debt to bad, but not indifferent paintings and to
students who so ineptly paint an invention of what they feel what
little they know. The art experience in these often surpass Picasso
and the muscular painters. I doubt that this backing-in approach is
new either for, with all this, painting sems to establish some bond
with art; historically it also becomes engulfed.

Morris Louis in a letter to Clement Greenberg of June 1, 1954, Archives of American
Art, Smithonian Institution, reprinted in: Dean Swanson, exh. cat., *Morris Louis: The
Veil Cycle*, Minneapolis, Walker Art Center, 1977, p. 32.

Morris Louis, Twined Columns II, 1960

Acrylic resin on canvas, 260.4 × 335.6 cm. Private collection, USA

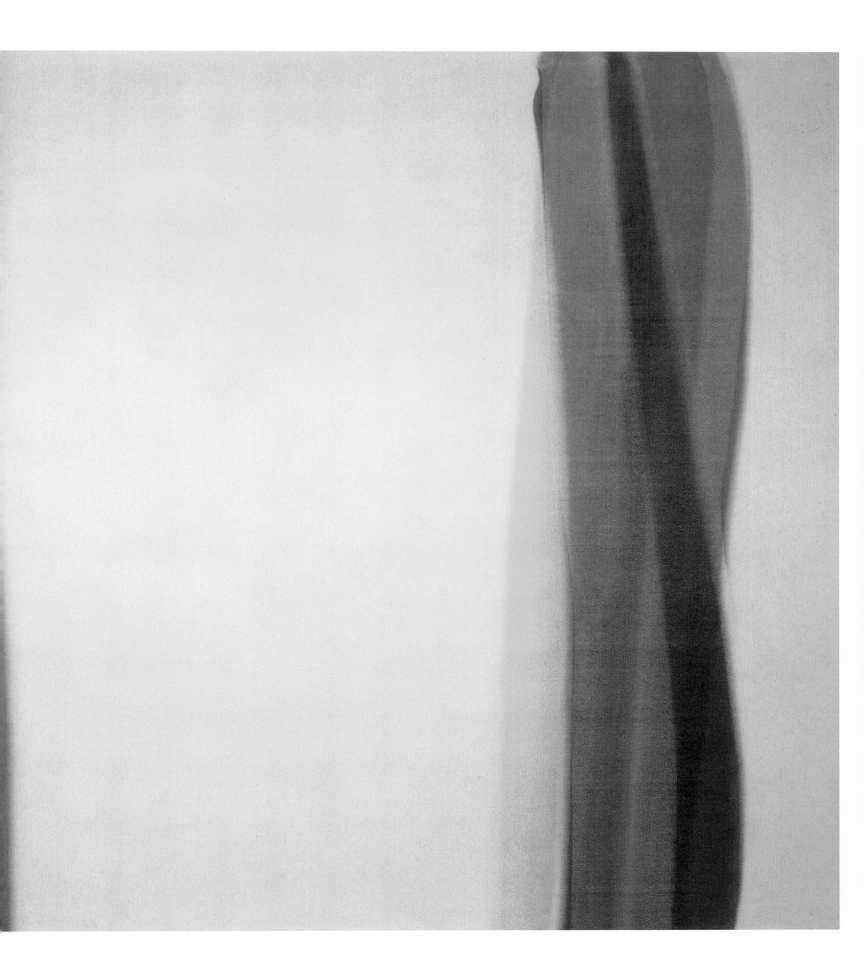

Joseph Marioni

1943	Born in Cincinnati, Ohio
1962–66	Cincinnati Art Academy
1966–70	San Francisco Art Institute
1972	Moves to New York
1998	Retrospective at the Rose Art Museum, Brandeis University, Waltham, MA
	Lives in New York

Joseph Marioni came to prominence in the mid-1980s in the context of the debate on Radical Painting theory, which was led mainly by himself. His manifesto-like text written jointly with Günter Umberg (*Outside the Cartouche: Zur Frage des Betrachters in der Radikalen Malerei*, Munich 1986) tried to set down the concepts of Radical Painting or rather to establish the fundamental principles of the 'radical' perception required of the monochrome paintings that Marioni is still producing today. The exclusivity demanded by this text, the absolute restriction of the picture to an object beyond all traditional methods of interpreting and perceiving pictures, reads more like a compulsive kind of self-restraint today. Its dogmatic narrowness caused some members of the group to break away again quickly (see Jerry Zeniuk). Marioni's works at least are sustained by a considerable painterly sensuality that relates to the tradition of color modelling from the Impressionists and Monet to Matisse and the Fauves down to Robert Ryman and Brice Marden, to name two styles that were decisive impulses for Marioni.

From Ryman he learned about the physical handling and significance of painting on canvas. This concerns the size, the choice of canvas, stretching the canvas on the wedged stretcher, priming it and passing inspection on it. The selection of the painting equipment (paintbrush, roller, etc.) and paints that follows is especially important because of the focus on color as the sole pictorial means. The extremely careful production of the painting is one of the basic tenets of Radical Painting. Marden, on the other hand, showed Marioni how to treat paint as something precious, to handle the paint in a painterly way, transforming it in the process of painting into a new space for sensual and spiritual experience.

Marioni stakes everything on the 'presence of color,' whereby it is only the sensual impression of the layers of acrylic paint applied with the roller that counts. Linguistic references of any kind to color or to Marioni's painting are not allowed. The painting process itself is made transparent by the simple act of using a roller and letting the paint run so that the viewer can trace the development as well as the manual and material production of a painting. The abolition of controlled intervention in the flow of paint, which differentiates him from painters such as Pollock or Morris Louis, emphasizes the autonomous presence of color as the sole means of expression in the sense of 'pure painting.' Marioni's paintings, despite the restraint when it comes to what is called the artist's hand, are full of powerfully expressive movement and radiate an almost Mediterranean warmth and sensual delight, connecting him to Monet even in this emotive respect.

Lit.: *Joseph Marioni: Painter*, exh. cat., Städt. Museum Abteiberg, Mönchengladbach 1994; *Joseph Marioni: Private Icons*, exh. cat., Staatl. Kunsthalle, Baden-Baden 1995; *Joseph Marioni: Paintings 1977–1994*, exh. cat., Wiener Secession, Vienna 1996; *Joseph Marioni: Paintings 1970–1998, A Survey*, exh. cat., Rose Art Museum, Brandeis University, Waltham, MA 1998.

Claude Monet is the first great Structuralist of 20th-century painting. By this I mean he is the first painter to make major statements as to how the paintings are structured rather than how they are composed. Here I refer specifically to the late great Waterlilies. There followed Mondrian, Newman, Pollock and a few others. To understand the distinction between structure and composition we need only think about the great classic line paintings of Jackson Pollock and ask ourselves this question—do we judge these paintings by how they are composed or by how they are structured? Monet's paintings are structured in the same way as Pollock's except that Monet does it with color. The visual *gestalt* of their paintings forms a whole unit in which all the parts are interdependent.

If you have ever sat on a couch looking at a glass coffee table you can see three fields of view; one is the stuff on the table, a book, ashtray, coffee cup; you see the things under the table, legs, carpet, a dog; and you see the reflection in the surface of the glass of things above the table, window, walls, ceiling fixture. These three different layers of visual composition are there by random selection and while they may provide a visual moment of aesthetic experience it does not have aesthetic value. If you have ever played three-dimensional chess you can understand the problem. The fields of view must structurally work as a whole image—all of the parts must form a *gestalt*, i. e. it must visually function as something greater than the sum of its parts. The visual *gestalt* of a painting has a spacial dimension that is filled with light and Monet structures the space with color. In some sense Pollock was building the three-dimensional chess board; Monet is playing the game.

Monet presents to our eyes a shimmering surface of water, like a sheet of glass, the surface of the water reflects the things above, sky, clouds, a tree; there are the waterlilies on the water and things under the surface. Monet's great contribution to the history of painting is not in a discussion about the meaning of waterlilies—he is presenting a structure of light that is enormously complex and yet works in our vision as an image. The random things in the composition of the pond are merely pawns in the visual game. The value of his painting lies within the structural breadth of color as a single image—the image is light. The difficulty of intellectually grasping the significance of this is evidenced by the fact that at the end of the 20th century there was little to no discourse on the issue of light in painting. Light is life, it allows us to grow, it is our metaphor of understanding and yet the Modernist discourse on painting has failed to see the light.

The disciplined practice of High Modernist painting presents to our eyes the material structure of light. The irreducible essence of painting is the articulation of color on a flat plane. The painting's *gestalt* is the seeing of light. The age of industrialization, with the invention of the electric light and the machine as its metaphor, has done enormous damage to our vision of painting. Monet is a god in an age of intellectual heathens.

Joseph Marioni

Joseph Marioni, Yellow Painting, 2001
Acrylic on canvas, 212 × 210 cm. Zurich, Property of the artist, Courtesy Galerie Mark Müller

André Masson

1896	Born in Balagny-sur-Mer
1907	Accepted at the Académie des Beaux-Arts in Brussels
1912–13	Registers at the Ecole Nationale Supérieure des Beaux-Arts to study with Raphael Collins
1920	Moves to the studio at 45, rue Blomet that becomes the meeting-place of the Surrealist avant-garde
1924	Kahnweiler mounts Masson's first solo exhibition at the Galerie Simon; André Breton buys his painting, *Les Quatre Eléménts*; joins the Surrealist group
1929	Breaks with André Breton and the Surrealists; 2nd Surrealist Manifesto
1933	Theater design for the ballett "Les Présages;" makes friends with Georges Bataille, whose journal, *Minotaure*, he works on

1941	Escapes via Martinique to New York; settles in New Preston, CT; retrospective at the Museum of Baltimore; influence on Jackson Pollock
1945	Returns to France; lives first in La Sablonnière near Poitiers and from 1947 in Le Tholonet near Aix-en-Provence
1964	Retrospective at the Akademie der Künste, Berlin and Stedelijk Museum, Amsterdam
1976/77	Retrospective at the Museum of Modern Art, New York; drawings retrospective at the Musée d'Art Moderne de la Ville de Paris
1987	Dies in Paris

Masson is probably one of the most experimental Surrealists of his generation. His famous studio at 45, rue Blomet was the meeting-place for painters, including Juan Miró and Jean Dubuffet, and writers, such as Armand Salacrou and Georges Limbour, searching for new artistic possibilities. Limbour introduced Masson to the Surrealist group headed by Breton, who at first supported him but then shut him out of the group because of a disagreement. Nevertheless, Masson's acquaintance with Breton was extremely stimulating and inspired him to create his first automatist drawings and paintings. During this period he discovered the importance of agitation for his creative production; it became the driving force of his painting and guarantor of his revolutionary intentions. In his works the dionysian (affective) element alternates in predominance with the contemplative (spiritual) pole of his being, which felt drawn to Hinduism and Tantrism. The dionysian spirit was acknowledged in an automatism that Masson, like no other Surrealist, took to the limits of its potential.

From 1926 on he painted Surrealist works exhibiting automatist or semi-automatist painting techniques and dealing with subjects related to violence and death.

"The most important thing was to demonstrate in an affective way the profundity that one had inside: the phantasms, the desires, everything that came from inner realm" (Masson, *Vagabond du Surréalisme*, Paris 1975, p. 29).

The subject of Masson's works is thus not the physical world, but the relationships of things to each other and to people. Hence his major theme in the 1930s is metamorphosis, the transformation and blending of things and of the sexes in order to show the elemental force that animates and moves everything (*Germination*, 1942, private collection, Paris).

After his emigration to the USA his new social and artistic environment and his experience of the fertile countryside supplanted the horrors of war (and the dogmas of Surrealism).

In 1942 Masson published *Mythologie de l'Etre*, one of his first books featuring both text and illustrations. That same year he visited the Metropolitan Museum of Art in New York and saw some of the late works of Monet, which impressed him deeply (e.g. *La Manneporte*, 1883, which joined the Metropolitan's collection in 1950). He recognized the modernity of the late work of Monet, whose pictures had only been regarded with scorn by the Surrealists (as being too naturalistic). Back in Paris, this impression became even stronger when he saw several paintings of waterlilies at the Tériade Gallery. He intensified it by viewing the *Waterlilies* decoration in the Orangerie ("the Sistine Chapel of Impressionism"). The article he wrote as a result ('Monet, le fondateur' *Verve* [1950]) heralded, at least in France, the re-discovery of Monet. Masson thus became a mediator in Monet's role for modernity in the painting of the post-war era. The French Art Informel movement, in particular, is unthinkable without the reference to Monet's late work.

Lit.: Caroline Lanchner and William Rubin, *André Masson*, exh. cat., Museum of Modern Art, New York 1976; André Masson, *Gesammelte Schriften 1*, eds Axel Matthes and Helmut Klewan, Munich 1990; Beate Reifenscheid (ed.), *André Masson: Rebell des Surrealismus*, exh. cat., Ludwig Museum im Deutschherrenhaus, Koblenz 1998.

You can't really be a painter without loving Monet. He was the first artist who was capable of unsettling me ... Monet taught me to understand what a revolution in painting can be. Only with Monet does painting take a turn ... he dispels the very notion of form that has dominated us for millennia. He bestows absolute poetry on color. I don't connect the idea of color either with Van Gogh or Cézanne ..., but with the lustre of Monet's paintings, with the intoxication I always get from looking at them. If there's a colorist alive today, he owes it to Monet, whether he knows it or not.

The death of Monet in 1926 didn't really affect me ... it was only after I broke with Surrealism in 1931 that color became important in my life again. From then on, Monet really grabbed my attention. In 1950, I'd seen pictures by Monet at Teriade's that had never been exhibited. The great *Waterlilies* from the last part of his life that had remained in Giverny ... and I was convinced then that the disfavor that had overtaken Monet's pictures, in France at least, was quite unjustified. After all, wasn't he the founder of Impressionism, i.e. the whole of contemporary painting?

People will no doubt object that I don't paint like Monet. That is true, but I'll say it again—I think of him when I'm thinking about what color's for. In Monet's paintings there's no void. The space is full ... There isn't an inch of space that doesn't vibrate from the way the color is applied. It's a very personal style, the beginning of gestural painting. You could analyze the different kinds of paint applications—as a comma, twisted brushstroke, hatching, in the form of dots or relief. It's a system of signs.

Apart from the Surrealists and Dada, Monet paved the way for a whole century of painting.

There's a place you have to visit to rediscover Monet. That's Giverny. You have to take a look at the pool he made there by a diverting a branch of the Epte and planting waterlilies. It's the crazy story of a genius mad about beauty.

... The Japanese bridge overgrown with glycinias is a real Monet. I get very poetic when it's about Monet. You have to be—otherwise, if you try to get to the bottom of him any other way, you don't get to the heart of his genius.

All in all, you can say that painting was invented or re-invented by Monet. There's a revolution there ... Monet's a turning point.

André Masson on Claude Monet, *Interview with André Masson*, 1975 (recorded by Alice Rewald), in: *André Masson: Collected Works*, 1990, pp. 277–284.

André Masson, Le printemps s'avance, 1957
Oil on canvas, 172 × 55 cm. Paris, Private collection

Joan Mitchell

1926	Born in Chicago
1944–47	Studied at the School of the Art Institute, Chicago
1948–49	trip to France; works in Paris and Le Lavandou
1950	Moved back to New York; meets Franz Kline and Willem de Kooning
1955	Summer in Paris; met Jean-Paul Riopelle (her companion until 1979)
1959	Moved to Paris; studio in rue Frémicourt
1968	Moved to Vétheuil
1972	First museum exhibition at the Everson Museum of Art, Syracuse, NY
1974	Retrospective at the Whitney Museum of Art, New York
1988	Retrospectives in Ithaca, NY, San Francisco, Buffalo, NY and La Jolla, CA
1992	Died in Vétheuil

Through her acquaintance with Franz Kline and Willem de Kooning, Joan Mitchell was received into the Abstract Expressionist group early on. Her works were shown at major New York galleries in the 1950s (*Ninth Street Show*, 1951; *Artists of the New York School: Second Generation*, 1957, both at the Jewish Museum, New York). Her early paintings with their different gestural spots, sprinkles and hatches are actually related more closely to lyrical abstraction. In 1959 she moved to Paris where she met Jean-Paul Riopelle, who played an important role as a catalyst in her work and life by being a link between the early *Art informel* (Wols) and 'tachist' abstraction of the 1950s. Moving to Vétheuil in 1967/68 brought her even closer to the source of these art movements, so close that she denied any direct reference to Claude Monet in her interviews (even though her rooms were lavishly decorated with reproductions of Monet's works). Nevertheless, paintings such as *La Grande Vallée* series (1983) reveal at first glance how much Mitchell let herself be inspired by Monet's late works (especially the *Waterlilies*). Broad gestural brushwork fills the pictorial space with dense layers of shades of blue over refined nuances of red, yellow and pink and, on the edges, different greens.

The blues have a particularly wide range of tints and shades, changing from light blue tints to medium shades to very dark blue-black shades. The reference to landscape is clear from the choice of colors alone, but the gestural brushstroke suggests both vegetation and water as well. The broad, saturated, colored textures and the highly refined application of gestural brushstrokes and brushwork techniques immediately recall Monet's *Waterlilies*. Her working in series (*Tineuls*, *Champs*, *Trees*, *Tournesols*) in the 1980s can also be seen as dependence on her (secretly) revered model.

In her pictures of the late 1980s the handling of the brush becomes even freer and more frenzied, the colors overlap and intersect with whirling slaps of the brush, nevertheless emanating a peculiar poetry. The *Chords* series (e.g. *B. Chord X*, 1987, Galerie Alice Pauli, Lausanne), with crowded conglomerations of impulsive emanations of color towards the center of the picture, again reveal Mitchell's origins in the gestural abstraction of the New York School. However, Mitchell had also regarded these pictures with synaesthesia in mind, as the titles suggest. She had seen things synaesthetically from early childhood; for instance, she associated letters with certain colors (less with music). One of her few statements should be understood from this standpoint: "My painting is not an allegory, not a story; it is more of a poem." A visual poem, one might add, that transforms the joy of life, exact powers of observation and, above all, deep emotionality into virtuoso gestures of color.

Lit.: Judith E. Bernstock, *Joan Mitchell*, exh. cat., Herbert E. Johnson Museum of Art, Cornell University, New York 1988; *Joan Mitchell*, exh. cat., Galerie Nationale du Jeu de Paume, Paris 1994; Klaus Kertess, *Joan Mitchell*, New York 1997

I knew Joan Mitchell from 1979, when I lived in her house, till she died in 1992. I can tell you therefore, in what she said to me over the years, her admiration for Claude Monet never waned, even if she didn't want to be specifically bracketed with his painting.

Joan Mitchell liked the *Waterlilies* and she went to Giverny several times. Her painting very quickly showed extreme originality, resolutely independent, flamboyant, handling large and small-scale works with the same genius.

A key word with Joan Mitchell was 'feeling'.

There were works centered on Lime Trees, Fields, Trees, Sunflowers, the Grand Canyon and other 'Ss', but Joan Mitchell often rejected the word 'series' when people said it in her hearing.

Joan Mitchell was very impressed in her childhood by the picture treasures of the Art Institute of Chicago— very soon she wanted to come to France, to see Europe, and 'set foot in the land of Mozart'.

Letter from Gisèle Barreau, Vétheuil, to Karin Sagner-Düchting, October 16, 2000

Joan Mitchell, La Grande Vallée IV, 1983
Oil on canvas, 260 × 200 cm. H. Lebrun Collection

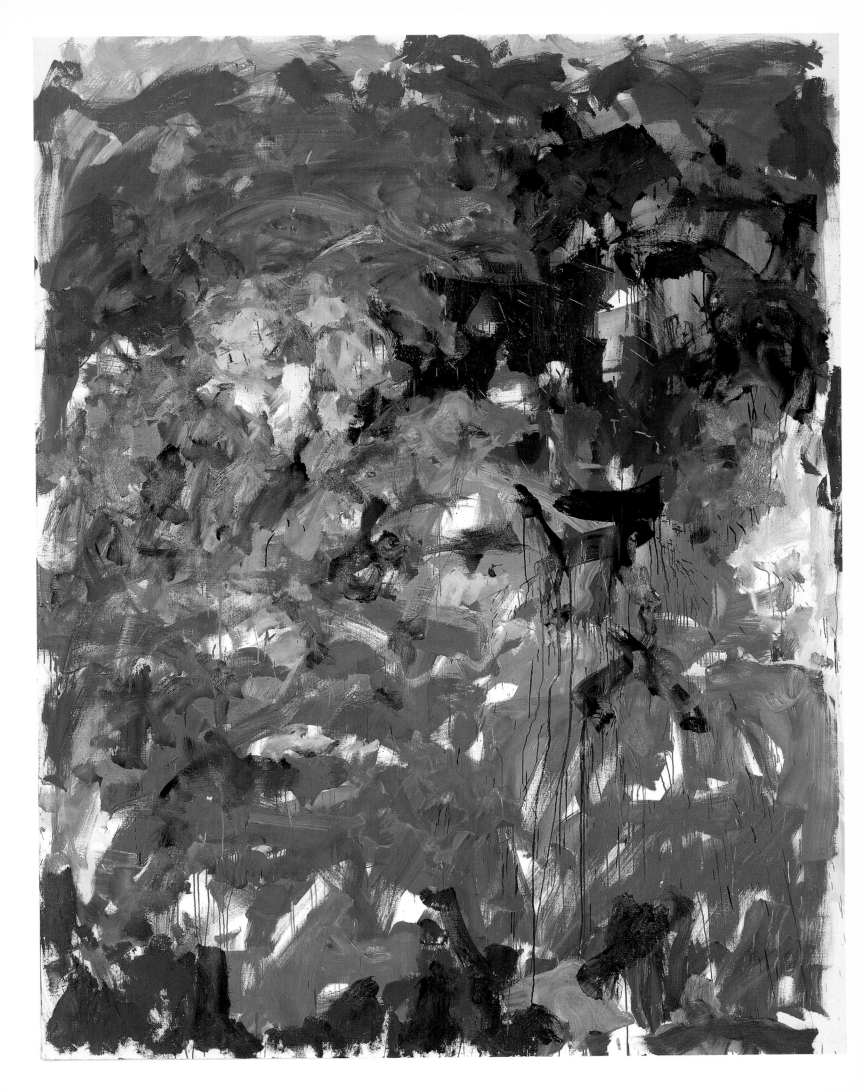

Joan Mitchell, Chord X, 1987

Oil on canvas, 260 × 200 cm. Lausanne, Galerie Alice Pauli

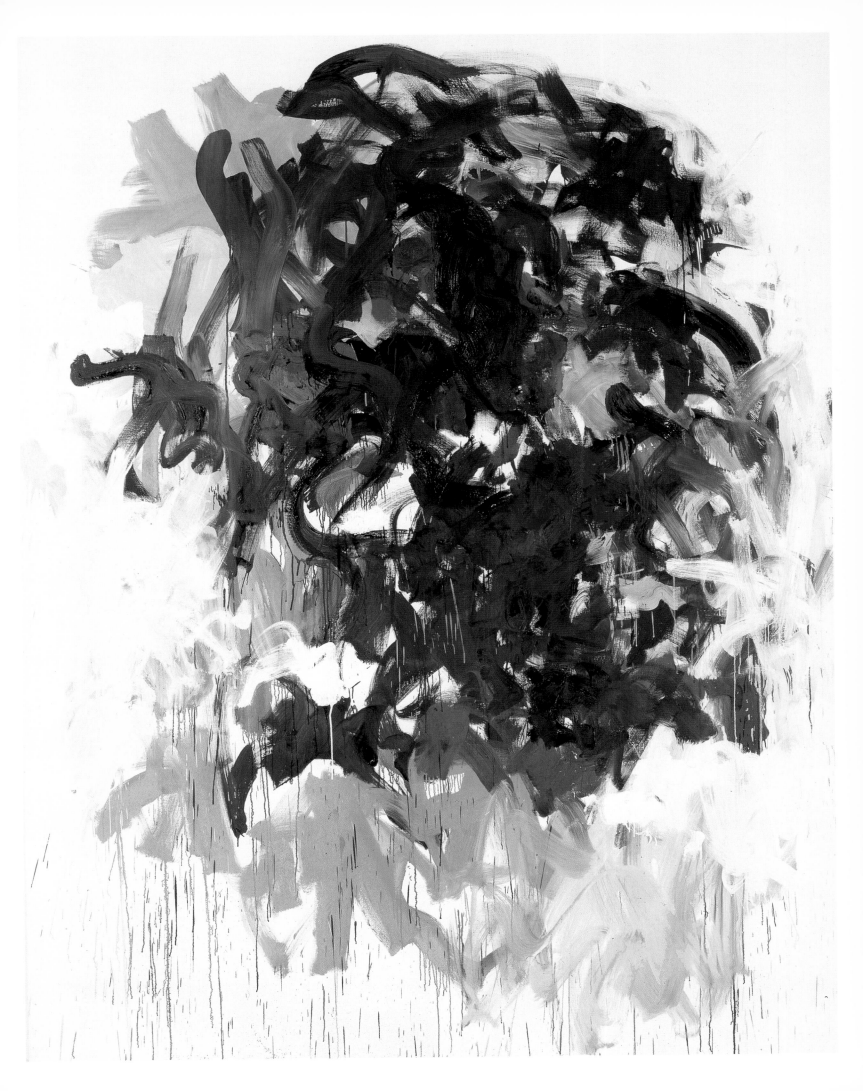

Barnett Newman

1905	Born in New York
1922	Took courses at the New York Art Students League and studied at City College of New York, specializing in philosophy
1931	Taught art (until 1939) at New York high schools
1943–47	Met Hans Hofmann, Clyfford Still and Jackson Pollock
1948	Rejected vegetal formal idiom; *Onement I* is the first abstract Color Field painting with a 'zip' (stripe); essay: 'The Sublime is now'

1950–51	One-man shows at Betty Parsons Gallery
1958	One-man show at Bennington College, Vermont; participated in the exhibition 'The New American Painting' at the Museum of Modern Art, New York
1962–	Taught at American universities and lectured
1964	*Stations of the Cross* in the Guggenheim Museum, New York *Who's afraid of Red, Yellow and Blue* (1966–70)
1969	Exhibition of lithographs (1963/64) at the Basel Kunstmuseum
1970	Awarded a prize by Brandeis University, Waltham, Massachusetts, for his life's work. Died in New York

In 1940 Newman destroyed much of his early work and stopped painting for a year. He wrote theoretical essays on art which helped to make him the spokesman of the young American avant-garde. Inspired by studies in the New York Botanical Gardens and the Museum of Natural History, he worked on small drawings of biomorphic forms in 1944. Like numerous other American painters, he became fascinated by Surrealist imagery and techniques. His own abstract pictures were often based on myths. In 1948 Newman founded 'The Subjects of the Artist,' a school for painting, with William Baziotes, Robert Motherwell and Mark Rothko. That same year he found his mature style in *Onement I* (1948, Museum of Modern Art, New York), in which a vertical, light red stripe bisects a dark red field. Newman's first one-man shows at Betty Parsons' New York gallery (1950 and 1951) show his potential for diversity in painting. Typical of his work are monochrome surfaces painted without traces of brushwork and bisected or subdivided by one or more stripes, which Newman called 'zips' (literally zip or zipper). These elements are constantly varied, either in respect of composition or the properties of the colored stripes, canvas size, format or palette. Compositions either remain entirely symmetrical or the 'zips' are shifted to the edges (*Vir Heroicus Sublimis*, 1950/51, The Museum of Modern Art, New York).

Rejecting the European tradition of abstract painting as being too factual, Newman developed a philosophy of art centered on his concept of the 'Sublime', which he wanted to explore and present in experiential terms through his own pictorial devices (outsized formats, monochrome, a palette distinguished by intensity of hue, shifting focal elements off-center, deploying colored stripes as an emanation). Experiencing the 'Sublime' entailed experiencing unfettered freedom. In his painting, Newman sought to liberate spectators from the prescribed boundaries of rationally directed experience, thus raising consciousness. The glowing color surfaces, as saturated in hue as medieval stained-glass windows, are intended, when viewed in extreme close-up so that the picture cannot be fitted into its architectural context, as decoration, to trigger off transcendental experiences. Color space connotes nothing of the reality outside the picture; it is both concrete and spiritual like color itself in its materiality and spiritual emanations. The vertical lines cannot be perceived in entirety when viewed close-up; they appear like fractured boundaries between the various experiential spaces, devices deployed for enhancing and contrasting in the continuum of color surfaces. Newman's purism in his choice of painterly devices reveals consummate mastery of technical skills. The paintings in large formats are built up from paint applied in layer after layer to achieve precisely calculated color effects through subtle underpainting. The line of the 'zips' and their relationship to the whole has been established with equal precision to produce just the right 'acceleration' of seeing. He did the fourteen paintings comprising his most important work, *The Stations of the Cross* (1958–1966), after a serious illness. They sum up Newman's conviction that it was indeed possible to convey spiritual messages through abstract painting.

Lit.: Thomas B. Hess, *Barnett Newman*, exh. cat. The Museum of Modern Art, New York 1971; Harold Rosenberg, *Barnett Newman*, New York 1978 (Reprint 1994); Brenda Richardson, *Barnett Newman. The complete Drawings 1944–1969*, exh. cat. Baltimore Museum of Art, 1979; John P.O. Neill (ed.), *Barnett Newman. Schriften und Interviews 1925–1970* (trans. Tarcisius Schelbert), Bern and Berlin 1996; Armin Zweite (ed.), *Barnett Newman. Bilder, Skulpturen, Graphik*, exh. cat. Kunstsammlung Nordrhein-Westfalen Düsseldorf, Stuttgart 1997.

... Impressionism gave art an unmistakably different appearance ... And, just for that reason, modern art begins with the Impressionists since, for the first time in the history of art, a group of artists turned its attention exclusively to solving a technical problem in painting—namely that of color ... They liberated the artist's palette from its prison ... Monet created a new color aesthetics ...

Cf. Barnett Newman, *The Problem of Content, 1944–1945*, in: Barnett Newman, *Schriften und Interviews*, Bern/Berlin 1996, pp. 94–97.

Barnett Newman, Tertia, 1964
Oil on canvas, 196 × 88 cm. Stockholm, Moderna Museet

Kenneth Noland

1924 Born in Asheville, North Carolina
1946–48 Studied at Black Mountain College in North Carolina
1948/49 Studied in Paris under Ossip Zadkine
1949–51 Taught at the Institute of Contemporary Art, Washington D.C.
1951–60 Taught at Catholic University, Washington D.C.
1952–56 Taught at the Washington Workshop Center of the Arts
1977 Member of the American Academy and the Institute of Art and Letters
1985 Milton Avery Professor of the Arts, Bard College, Annandale-on-Hudson, New York
1986/87 Artist-in-Residence in Computer Video Arts at the Pratt Institute in New York
1992 documenta 9 in Kassel
 Lives in Vermont

Inspired by 'stain painting' (soaking an unprimed canvas with diluted paint to ensure that the color and the ground are integral with each other), a technique Morris Louis and Noland had learned from Helen Frankenthaler, Noland developed what he called *Circle Paintings* in the late 1950s. Pure color of intense hue was applied, often in the free, gestural manner, in concentric circles of varying widths. Thus structuring a painting through the use of both contrasting and flat color retains overtones of Josef Albers' 'Homage to the Square' series; Noland had studied under Albers at Black Mountain College. However, Noland's use of the staining technique made his work very different to both Albers' and the Abstract Expressionists'. Free, gestural application of paint subverts the geometric system while the 'cool', impersonal procedure of 'staining' has cancelled the expressive signature. In the *Circle Paintings* Noland found the essential elements of his approach to color painting: the circular segments demonstrate intense color values at their purest and most simple; composition results solely from the arrangement of colored rings on the color field without any hieratic intent. Since the colored rings are related to each other without tension, Noland has managed to focus perception entirely on the emanation of color.

Unlike Rothko and Newman, Noland was not concerned with creating an irrational, transcendental color space. What he was primarily interested in was spreading color energies. He experimented with all sorts of formats and shapes, including elliptical and angular ones (chevrons) and even diamond-shaped pictures: square canvases balanced on one corner. He also tried out a great many different painting techniques.

By the late 1960s Noland was also working with elongated horizontal formats, on which he painted stripes of varying width and color tonality. By handling his stripes and the 'canals' of different color between them, Noland aimed at provocation in visual terms to activate perception. Noland saw the stripe paintings as the maximum in concentration of color hitherto achieved.

His subtle modulation of color, based on assimilation and contrast as well as the landscape or atmospheric quality conveyed by these stripe paintings also link Noland with Monet's waterlily paintings.

In the 1970s Noland returned to his shaped canvases, cutting irregular polyhedrons from canvases filled with asymmetrical color fields. The 1980s 'chevrons' represented his rediscovery of the material properties of color. With them he returned to the classical technique of priming canvases and handling paint texturally with a palette knife. During those years he also made sculptural objects of painted canvas and perspex as well as architecturally related work for the Weisner Building at the Massachusetts Institute of Technology in Cambridge, Massachussets.

Lit.: Kenworth Moffet, *Kenneth Noland*, New York 1977; Karen Wilkin, *Kenneth Noland*, New York 1990; W.C. Agee (ed.), *Kenneth Noland. The Circle Paintings 1956–1963*, exh. cat. Museum of Fine Arts, Houston, Texas 1993.

Looking on Monet

I went to Paris in 1948 and stayed there a year, until 1949. I saw the Jeu de Paume; but we had a hard time getting to see the Orangerie. It was only erratically open, but I finally did get to see it. I actually got to see a lot of Monet—not something that was easy in the U.S., though when I was seventeen, I did go to the National Gallery in Washington, D.C. with my father, to see the Impressionist paintings there. I was struck by what happened in them, especially a Monet cathedral painting, when I walked back from it, then up to it again. There was a transitional level in the color—a scale that worked differently from far back than in play close up—that is, the *matière* of color.

There is something else about the action of color in Monet that I've been able to get into words only recently. Paintings that are good—or great—tend to float. They lose the function all-over. It's basically frontal. Too much value change makes it angle in and out of space and seperates part from part. The majority of Monets I've seen are horizontal.

It seems the difference between horizontal and vertical is that we see verticals as things. We see horizontal things as fields. Horizontal things have more of a sense of floating. You don't get that from a vertical painting. I suppose that's why color painting, from the Impressionists on, tended to be horizontal. Actually, it's been my experience that all great paintings also seem to float.

Kenneth Noland, Telephone conversation with Ann Gibson, September 13, 2001.

Kenneth Noland, Brunswick, 1969
Acrylic on canvas, 194.4 × 257.8 cm. Private collection, USA

Jules Olitski

1922 Born in Snowsk, Russia
1924 Emigrated to the U.S.
1939–42 Studied at the National Academy of Design and the Art Students League in New York; American citizen since 1942
1942–45 Served in the armed forces
1949–51 Studied in Paris at the Académie de la Grande Chaumière and studied sculpture under Ossip Zadkine
1952–55 Trained as an art teacher at New York University
1956/57 Taught in New York and at Bennington College in Vermont
1968 documenta 4 in Kassel
1973, 77 One-man shows at the Museum of Fine Arts, Boston
 Lives in New York

Although Olitski's early work, with its emphasis on material, still reveals the influence of Fautrier, Dubuffet and de Staël, his encounter with Helen Frankenthaler made him change direction after 1959. Using light colored, diluted paint and biomorphic forms, he moved to 'stain painting'; this work was shown in 1964 by the Bern Kunsthalle in a retrospective entitled 'Signals.' Olitski became increasingly preoccupied with the problem of color. From 1964 he worked on color field paintings in large formats and also developed what he called 'spray paintings.' These were vast canvases on which color was handled in an 'Impressionist' manner, applied with a spray gun so that no sharp edges were formed and gradual transitions in color modulation could occur. Olitski quickened and accentuated the fluid modulation of color by using strong contrasts at the edges of his canvases, thus charging the picture surface with intrinsic tensions conducted through color alone. The painting shown here, *Compelled* (1965), is remarkable for extremely delicate, blurred gradations of misty diffracted color fanning out to be 'cushioned' by an intense green on the left-hand edge of the picture and intensified in value as they shade into red. This new approach to color differs from that endorsed by other leading exponents of Post-Painterly Abstraction. The ambivalence of absolute flatness combined with the opening up of color and light spaces in visual terms places these Olitski paintings close to the textural handling of floating color revealed in Monet's waterlily paintings. Although his earliest 'Spray Paintings' were still dominated by complementary colors and stark contrasts, Olitski was not long in discovering that the strength of this technique lay in softly modulating the light and shade values of one dominant color tone and this led to a tendency towards monochrome effects. By the late 1960s Olitski's conception of painting had shifted from the primacy of pure color to textural handling of paint and the surfaces to which it was applied. Monochrome mists of color hovering towards grays increasingly came to emphasize the tactile and material qualities of the picture surface. In the 1970s this tendency was reinforced by the use of thixotropic gels in his paints and other painting aids. He began to build up his pictures in the manner of the Old Masters, using impasto, glazes and varnishes to underscore the material qualities of painting. This approach to handling the medium, featuring alternating crusty, waxy and pastose surfaces and fine textures created by spraying, opens up depths in the picture space. The multiple layering of shades of color creates the 'edges' which function as a sort of 'drawing' within the color spaces to anchor compositions and are a distinguishing feature of Olitski's work.

Lit.: Kenworth Moffet, *Jules Olitski*, New York, 1981; H. Geldzahler (ed.), *Jules Olitski*, exh. cat. Salander-O'Reilly Galleries, New York 1990; K. Wilkin and S. Long (eds.), *The Prints of Jules Olitski. A Catalogue Raisonné 1954–1989*, New York 1989.

When I look at Monet I am always struck by the immediacy of its surface: its radiance, its aliveness. The late paintings are especially celebrated; they look to our eyes as if they were painted yesterday, but I find his work, even early in his career, just as beautiful, just as alive.

The Impressionists theorized much about colors and structure. My hunch is that when Monet put his brush to canvas he was not guided by theories, but rather was giving his intuitive sense free rein and was, as Cézanne might have said, expressing his sensation in the face of nature.

Jules Olitski to James Yohe, Ameringer-Howard, 2001.

Jules Olitski, Compelled, ca. 1965
Acrylic on canvas, 204.5 × 334 cm. Private collection, USA

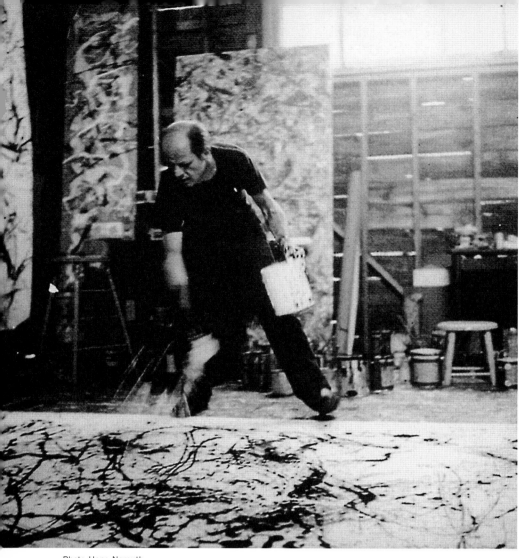

Photo Hans Namuth

Jackson Pollock

1912	Born in Cody, Wyoming
1928	Manual Arts High School, Los Angeles
1930	Studied at the New York Art Students League under Thomas Hart Benton
1935–42	Worked for the WPA (Works Progress Administration)
1936	Assistant at David Alfaro Siqueiros' workshop
1943	First one-man show in 'Art of this Century'
1947–50	The first drip paintings
1950	Hans Namuth's film on Pollock's work and his approach to painting
1951/52	'Pourings' with a tendency to figuration
1955/56	Long phase of depression
1956	Killed in a car crash

The name Pollock is shrouded in the myth of the lone pioneer of Abstract Expressionism whose meteoric rise to fame and equally rapid decline (brought on, it was thought, by excessive drinking and advanced monomania) marked him as a fallen angel. Even as a boy Pollock lived a restless life while his family moved from one farm to another. Nor did he last long at any of the art schools he attended except for a brief interlude at the Manual Arts High School in Los Angeles. There he was initiated by 'Schwanny' (his teacher, F. J. de St. Vrain Schwankowsky), into the mysteries of Thomas Wilfred's 'Light Art' with color and music as well as the theosophical doctrines preached by Krishnamurti. At the Art Students League he again found one inspiring teacher, Thomas Hart Benton, an exponent of American Regionalism, and Pollock painted in his manner for a while. The formative influence on his development was, however, the work of the Mexican muralist David Alfaro Siqueiros, whose assistant he was for a time before working as a mural painter under the auspices of the WPA program (Works Progress Administration). Under such diverse influences, Pollock's work evolved from a saturnine and grotesque personal interpretation of Benton's Regionalism into the more abstract vehement Expressionism of the early 1940s. Pollock's vigorous rhythms derived from Bentham as well as Albert Pinkham Ryder, El Greco and Rubens. His emotional iconic idiom and his original approach to handling color (his technique came to be based on the use of commercial enamels and metallic paint applied with a spray gun) recall the Mexican muralists Siqueiros, José Clemente Orozco and Diego Rivera. Further sources he drew on included such pioneering European Moderns as Picasso, Paul Klee and Joan Miró. Works like *Pasiphaë* (ca. 1943) were acclaimed early on by astute critics like Clement Greenberg and the art dealer and collector Peggy Guggenheim, who organized Pollock's first show. After moving to Long Island, Pollock began to experiment with drip paintings: paint was trickled or poured in intricate, exuberantly gestural loops and tracks on to canvases spread out on the floor. The dense tangle of layered spatters, lines and strokes developed into a gestural fabric of painting which relied less on purity and autonomy of color than on the drive and energy of the gesture with which it was flung on. The picture field was turned into an 'arena' (Greenberg), a place for experimenting with the release of pure energy. A film made by Hans Namuth (1950) shows the artist at work 'dripping' a painting. With the grace of a dancer Pollock moves about the surface he is painting to drip, spray and spatter paint on it with unorthodox painting utensils (brush handles) to weave color into an indissolubly tangled skein of textures. Greenberg pointed out in his writings how important Impressionism and Monet had been to Pollock, and recognized the affinity of Pollock's densely worked textures with the late Monet even before the Monet revival took place.

His drip paintings made Pollock unquestionably the most celebrated American artist of the 20th century. However, his life was marred by personal crises, with heavy drinking accompanied by bouts of psychotherapy. In his late work he returned tentatively to figuration yet these paintings rarely achieved the intensity of the drip paintings.

Lit.: Francis V. O'Connor / Eugene V. Thaw (eds.), *Jackson Pollock. A Catalogue Raisonné of paintings, drawings and other works*, 4 vols. New Haven and London 1978; *Jackson Pollock*, exh. cat. Musée Nationale d'Art Moderne, Paris 1982. Ellen G. Landau, *Jackson Pollock*, New York 1989; *Siqueiros/Pollock—Pollock/Siqueiros*, exh. cat. Kunsthalle Düsseldorf, 1995; *Jackson Pollock*, exh. cat. Tate Gallery, London 1999; *Jackson Pollock*, exh. cat. Kunstsammlung Nordrhein-Westfalen, Düsseldorf 1999; Pepe Karmel (ed.), *Jackson Pollock. Interviews, Articles and Reviews*, The Museum of Modern Art, New York 1999.

The late Monet has his hand out directly to Jackson Pollock, as the waterlily paintings are no longer impressions—they are truly starting to be expressionistic in the full blind sense of expressionism as we understand it.

And that leads straight on to many other artists but the biggest of course is Pollock. I asked Pollock: "Do you paint nature?" And he said: "I am nature." I think, really, Pollock was his own nature, that's what he was saying; he probably thought that nature was *his* nature, but I actually think that Claude Monet *is* nature. If anybody has the right to be called nature, its Monet.

Sean Scully, 2001

Jackson Pollock, Untitled, ca. 1949
Fabric collage, paper, cardboard, enamel and aluminum paint on Pavatex,
78.5 × 47.5 cm. Riehen/Basel, Fondation Beyeler

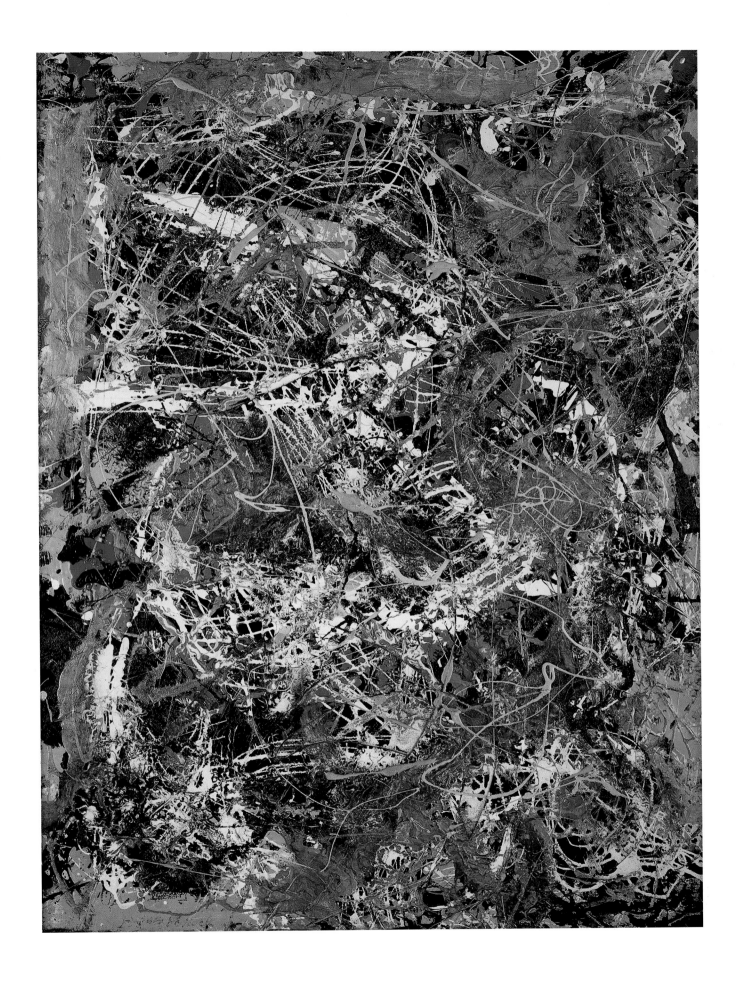

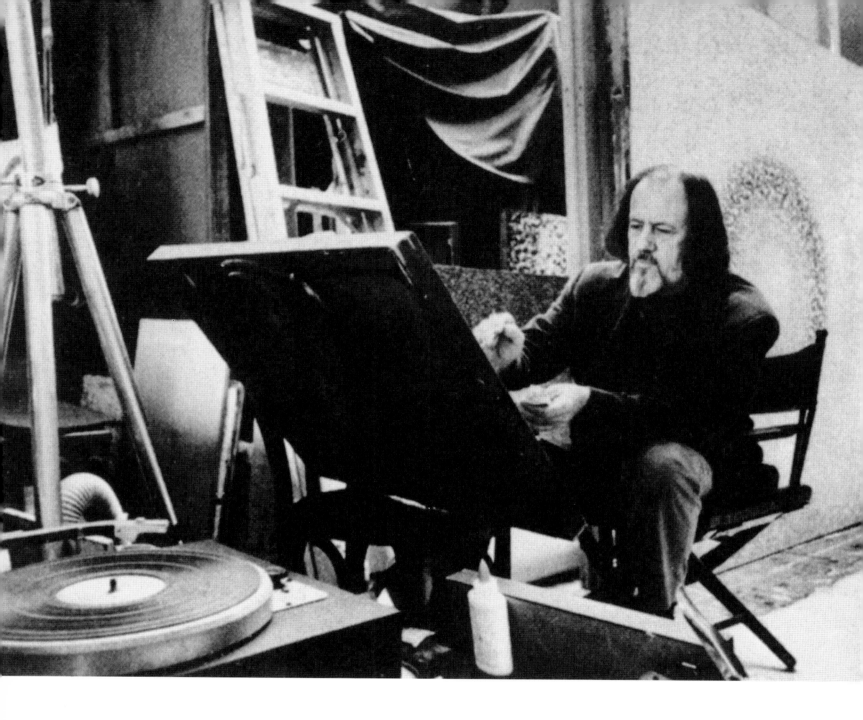

Richard Pousette-Dart

1916	Born in Saint Paul, Minnesota
1924	Began to paint under his father's supervision
1936	Enrolled at Bard College, Annandale-on-Hudson, New York state, but left by the end of the year to learn painting and sculpture on his own
1936/37	First biomorphic bronze sculpture; assistant to Paul Manship; move to Manhattan
1939	Stopped working for Lynn Morgan's photo studio to concentrate on painting
1941	First one-man show at the Artist's Gallery in New York
1944	'Salon for Young Artists' in Peggy Guggenheim's Art of this Century, the first public appearance of American Abstract Expressionism
1947	One-man show at the Art of this Century gallery

1948	Under contract to the Betty Parsons Gallery; participated in lectures and discussions with artists at the 'Subjects of the Artists' School
1959–61	Taught at the New School of Social Research in New York
1969/70	Retrospective at the Museum of Modern Art, New York (traveling exhibition)
1971	Traveled in Europe (Paris, Chartres, Rome, Florence, London)
1980–92	Taught at the Art Students League, New York
1992	Died in Suffern, New York

Self-taught, Richard Pousette-Dart developed into a subtle and sophisticated painter, whose work is an expression of his deeply mystical philosophy and life-long quest for spiritual truth. After figurative beginnings, Pousette-Dart joined the inner circle at the fledgling New York school ('Subjects of the Artists'), where he participated in discussions and gave lectures in the group round Rothko and Baziotes and took part in the three-day conference in Studio 53 (organized by Robert Motherwell, Alfred Barr and Richard Lippold), from which American Abstract Expressionism would emerge. Pousette-Dart's ideas and interests, however, led him in quite a different direction. His wide-ranging intellectual preoccupations led him to the obscure sources of the Cabbala and mysticism, whose universal teachings he tried to translate into ritualized forms (circles, ellipses, star-shapes). They either emerge from beneath thick layers of paint or disappear beneath them (*Symphony Nr.1, The Transcendental*, 1942). By 1959 these forms and figurations were covering the entire picture surface. His forms consist in dots of subtly modulated color which, as if subjected to strong radiation, seem to dissolve. In developing this technique, Pousette-Dart had only to draw on the works of Cézanne, Monet and Seurat which were available to him for study in New York museums. The richness and complexity of Pousette-Dart's paintings and drawings are due in large part to his idea that (spiritual) depth might only be attained by the application of layer after layer of paint. The innumerable layers encrusting the entire picture field link up with the late Monet, whom Pousette-Dart so greatly admired and represent for him layers of experiential knowledge: 'Art transcends, transforms nature, creates a nature/beyond nature, a supra nature, a thing in itself/its own nature, answering the deep need of man's/imaginative and aesthetic being.' (quoted in Robert Hobbs/Joanne Kuebler (eds.), Richard Pousette-Dart, exh. cat. Indianapolis Museum of Art, 1990, p. 130).

However, in quest of depth and light, the artist had to subvert the surface. He did this by layering innumerable points and dots in which spiritual symbols appear only to vanish once again in wave after wave of color, as exemplified by *Hieroglyph (White Garden)*, 1971.

Pousette-Dart experienced his paintings as a variegated, transparent opaque mirror ... with a lot of noise and a very quiet spot inside him where stillness moved by being motionless and every problem which had ever existed was solved ... the summation of nature, as real as any weed, tree, animal, person or flower (to paraphrase Notebook B–156).

His paintings are the quest for light and spiritual truth, which he defined as light dammed up in darkness and darkness filled with light (paraphrased from Notebook B–156), evoking the harmony of opposites which Pousette-Dart, following the mystics (including Goethe) sought to express in painterly terms.

Lit.: Robert Hobbs/Joanne Kuebler (eds.), *Richard Pousette-Dart*, exh. cat. Indianapolis Museum of Art, 1990; *The Living Edge. Richard Pousette-Dart (1916–1922), Arbeiten auf Papier*, exh. cat. Schirn Kunsthalle, Frankfurt a. M., 2001.

Richard Pousette-Dart had long been interested in Monet's painting … Especially from the 1960s and 70s onward, Pousette-Dart's work moved from large heavy impasto to an Impressionism or Pointillism. He became increasingly involved with light, both physical and cosmic, and pursued ever more intently his philosophy and meditation. The brushstrokes of Monet and Pousette-Dart were short, almost quick and on a point, as if they were trying to capture that always elusive light and color in one breath.

Evelyn Pousette-Dart, 2001.

Richard Pousette-Dart, Hieroglyph White Garden, 1971
Oil on canvas, 180 × 180 cm. New York, The Estate of Richard Pousette-Dart
and American Contemporary Art Gallery

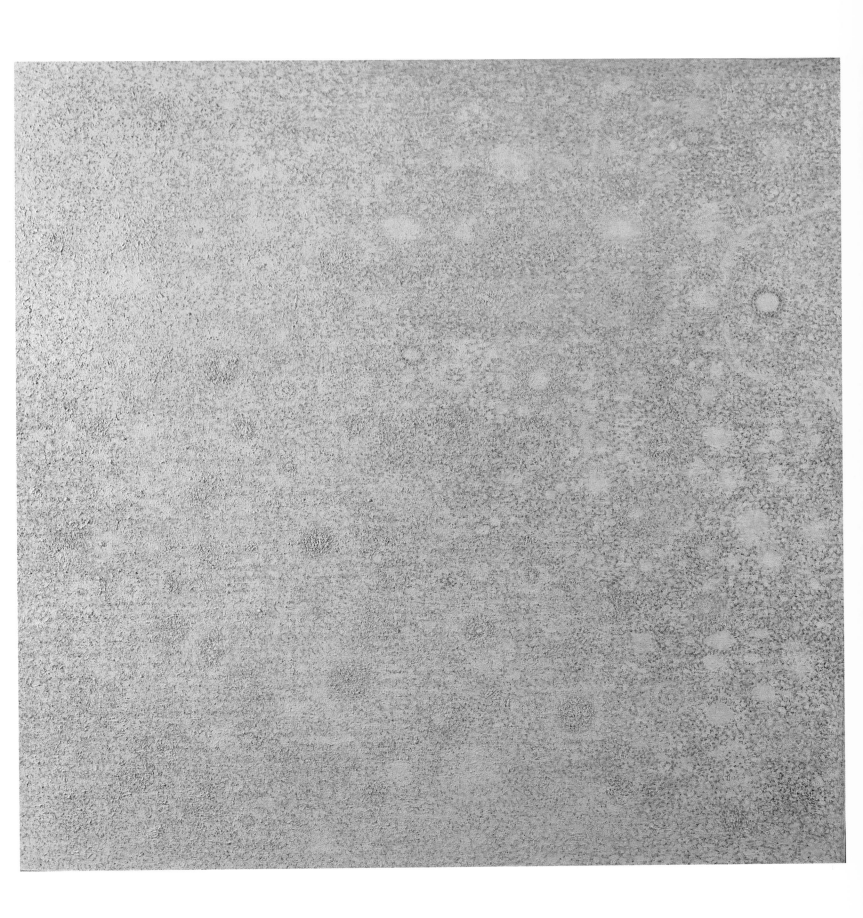

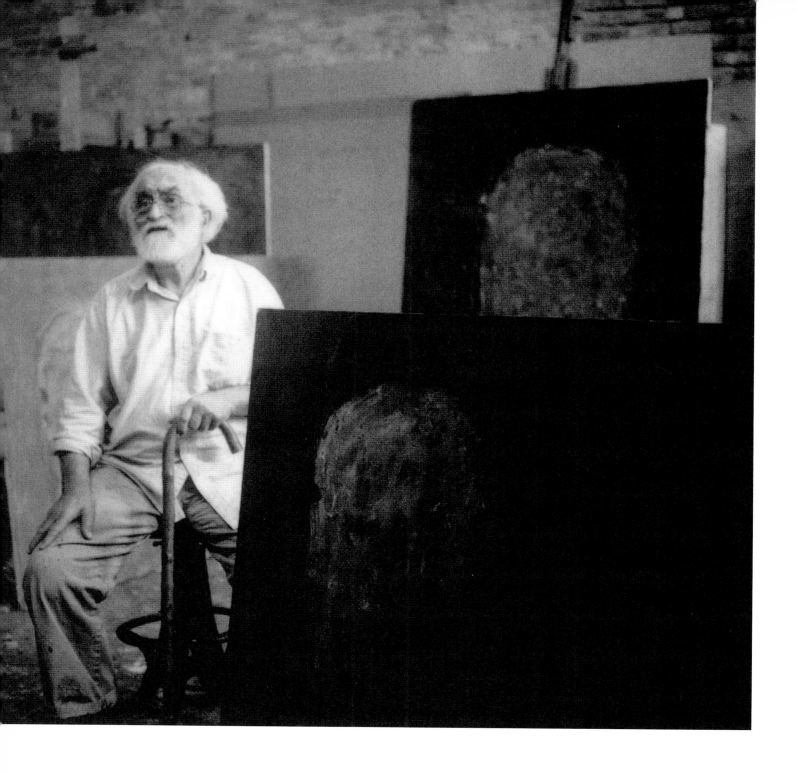

Milton Resnick (Rachmiel Resnick)

1917	Born in Brtaslav, Ukraine
1922	Emigrated with his family to the U.S. (Brooklyn, New York); assumed the name 'Milton'
1929–32	Studied technical drawing at the Hebrew Technical Institute in New York
1932/33	Pratt Institute of Art, Brooklyn, New York
1933–37	Studied at the American Artists' School
1938/39	Worked for the WPA (Works Progress Administration); friends with Willem de Kooning
1940–45	Served with the U.S. Army in Europe
1946–48	Stayed in Paris, where Wols was his neighbor; began abstract painting

1948–51	Returned to New York; took part in discussions and exhibitions at the '8th Street Club'
1954	Taught at the Pratt Institute
1971	Retrospective at the Fort Worth Art Museum, Texas
1976	Bought a derelict synagogue at 87 Elridge St. New York, where he still lives and works
1985	Retrospective at the Museum of Contemporary Art in Houston, Texas
	Lives in New York

Undoubtedly one of the most 'painterly' Abstract Expressionists, Milton Resnick has always rejected the term as too literary for his taste. To Resnick painting means continually working on a picture with paint as one's material. He experienced paint as a storm and saw himself as a 'straw in the wind.' And again 'Paint is as much a thing of life, precious and important to me. I wait upon it as servant rather than master … It is a heavy wave that wrecks my will. It spreads on canvas, in air and carelessly climbs into myself.' (Resnick, statement made in 1985, quoted in: *Milton Resnick. Paintings 1945–85*, exh. cat. Contemporary Arts Museum, Houston, Texas, p. 73). Spanning nearly six decades, Resnick's work continues to astonish with new approaches and variations on what a sensitive painter can develop from processing the material properties of paint. It begins with the early abstract pieces of the 1940s, which still show the influence of Gorky and de Kooning in echoes of the Surrealist preference for biomorphic forms and goes on through the dense, vehement pictures of the 1950s to the fluid currents of color that were his 1960s and 1970s signature, arriving ultimately at the wall-like, densely textured work of the 1980s and 1990s (*Monuments*).

An early 1920s emigrant to the U.S., Resnick became acquainted with the pioneering European Moderns (Cézanne, Monet, Léger) while studying art. He was also inspired by the work of outsiders like Chaim Soutine, notable for its volcanic eruptions of color. During a stay in Paris in the late 1940s, the young artist came into contact with both classical and modern masterpieces. Back in New York, Resnick joined the group of artists soon to be known as the New York School although he tended to withdraw from their debates on the development Modern art should take in America, preferring to remain in his little studio (below de Kooning's). For all his reticence, Resnick played an important role in the genesis of American Abstract Expressionism and was invited to participate in numerous group exhibitions surveying the work of artists belonging to this movement. Unlike the Color-Field painters, Resnick always emphasized the importance of paint as a medium for his handling of color. He was not only interested in gradations of color (blues, for instance). He has always been preoccupied with the physical properties of paint as the raw material coming out of the tube to produce color (for instance, ultramarine as oil paint). From this 'primordial stuff' Resnick achieved some of the finest work done by the New York School (e. g. *Genie*, 1959, Whitney Museum of American Art, New York), remarkable for shimmering color and sweeping gestures which reveal obvious affinities with Monet. Resnick himself did not realize how close his own work, which he was showing at the Howard Wise Gallery in 1961 in New York, was to the consummate mastery of the waterlilies until the great Monet exhibition mounted at the same time by the Museum of Modern Art. The Resnick paintings of the 1960s are in fact closest to the late Monet in handling of color and brushwork as well as composition. By the mid-1960s, however, Resnick had switched to working with tiny, pulsing daubs and dots of colors, all of the same tonality, recalling Tobey's work, albeit with the emphasis on color. In Resnick's later work, compositions and textures continue to darken and condense into cloudy masses of surging color.

Lit.: *Milton Resnick. Paintings 1945–1985*, exh. cat. Contemporary Arts Museum, Houston, Texas; *Milton Resnick. Paintings 1957–1960 from the collection of Hoard and Barbara Wise*, exh. cat. Robert Miller Gallery, New York 1988; *Milton Resnick. Monuments*, exh. cat. Robert Miller Gallery, New York 1997 (with extensive bibliography and list of exhibitions).

My earliest influence was Cézanne. Years later in the early sixties I saw the waterlilies at the MoMA.
I was surprised at how much closer I had come to Monet.

Milton Resnick, 2001

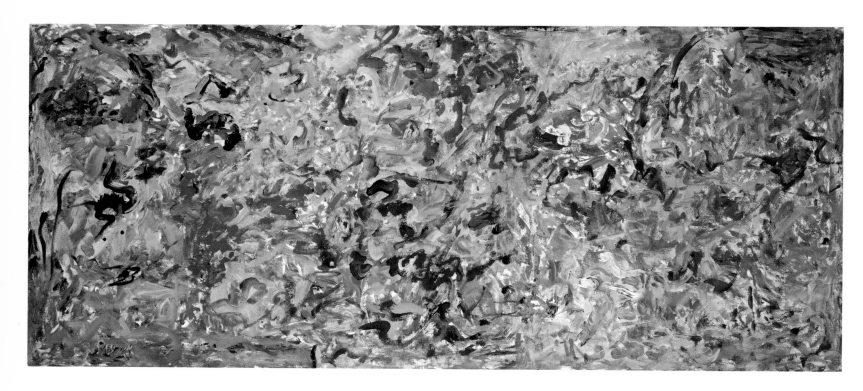

Milton Resnick, F. L. W., 1960
Oil on canvas, 109.2 × 246.4 cm. New York, Betsy Wittenborn Miller and Robert Miller,
Courtesy Robert Miller Gallery

Milton Resnick, Letter, 1960
Oil on canvas, 249.2 × 111.1 cm. New York, Milton Resnick, Courtesy Robert Miller Gallery

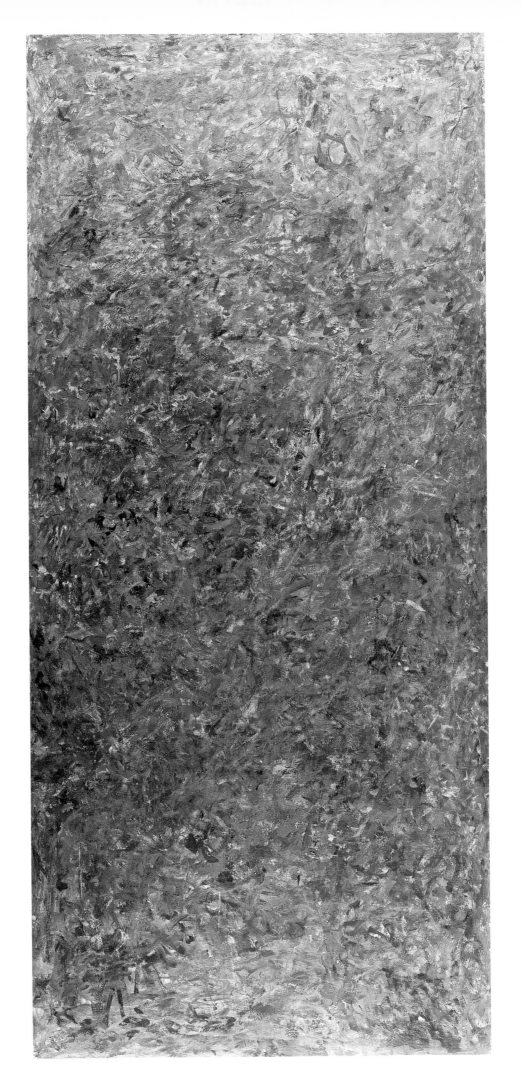

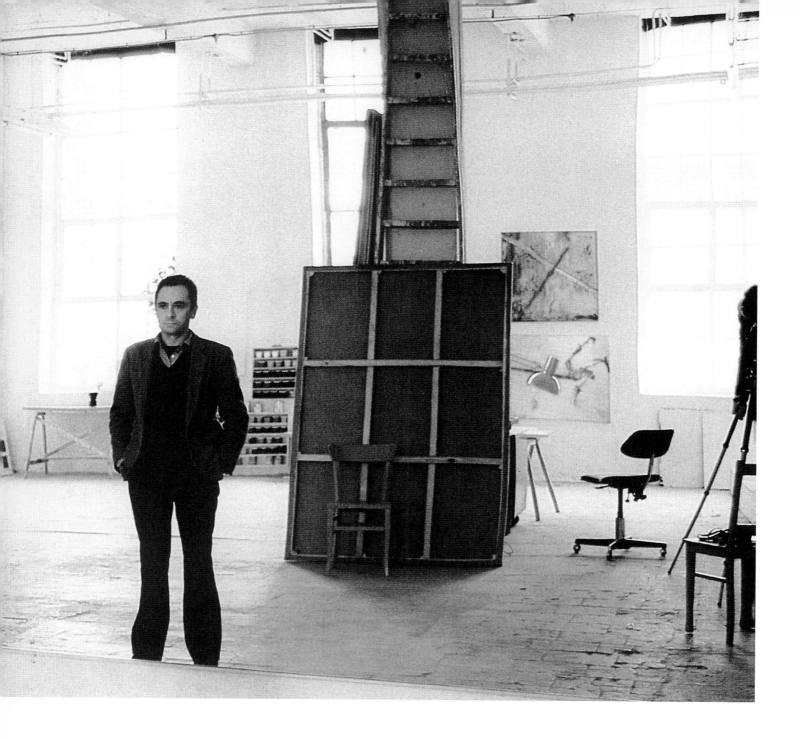

Gerhard Richter

1932	Born in Dresden
1952–57	Studied at the Dresden Art Academy; painting and mural painting
1959	Visited documenta 2 in Kassel; encounter with abstract painting
1961–63	Studied at the Düsseldorf Art Academy under K. O. Götz; *Informel* painting
1962	*Tisch* (*Table*: after a photo), No. 1 in the catalogue he still keeps of his work
1967	Awarded 'Junger Westen' ('Young West') art prize by the city of Recklinghausen; guest lecturer at the Hamburg Hochschule für Bildende Künste
1971–95	Professor at the Düsseldorf Art Academy
1972	Participated in 36th Venice Biennale; documenta 5 in Kassel
1974	'Gray Pictures' in the Städtisches Museum Mönchengladbach

1978	Exhibited 'Abstract Pictures' at the Stedelijk van Abbemuseum in Eindhoven, the Netherlands
1981	Awarded the Arnold Bode Prize, Kassel
1985	Awarded the Oskar Kokoschka Prize, Vienna
1986	Retrospective at the Städtische Kunsthalle Düsseldorf (Berlin, Bern, Vienna)
1991	Retrospective at the Tate Gallery, London
1992	Retrospective at the Musée d'Art Moderne de la Ville de Paris
	Lives in Cologne

Studying under K. O. Götz at the Düsseldorf Art Academy, Richter became familiar with the freedom of *Informel* and painted at first in the *tachiste* manner. Links with the Fluxus movement and American Pop Art made him switch to Realism and paint satirical pictures he classified as 'Capitalist Realism.' During his last year at the Academy, Richter and Konrad Lueg (later Konrad Fischer) staged a 'Demonstration for Capitalist Realism,' where they put themselves on show in a completely furnished room in a Düsseldorf furniture store. By this time Richter was painting from photos gleaned from magazines and books.

From 1962 he began to number his pictures in chronological order. He views the work he has done since then as a discussion of the fundamentals of painting as a medium. Richter painted from pictures found everywhere which he stored in a vast collection he called an Atlas. He either reproduced banal motifs in a realistic manner revealing painterly qualities through his brushwork or dissected them into unintelligibility in the course of painting. The latter approach gave rise to the series entitled 'Vermalungen' ('Mispaintings').

Between 1968–1975 Richter produced 'Gray Paintings', entirely executed in a variety of techniques in grays of varying textures. *Sea-Pieces* (1969–1976), *Cloud Pictures* (1970) and the ever recurrent landscapes (from 1969) definitely rank Richter among the great landscapists along-side Caspar David Friedrich and J. M. W. Turner. The grand finale, for the time being at least, of Richter's dialogue with found photos seems to have been represented by the series of 48 portraits of distinguished artists and academics he showed at the 1972 Biennale.

In 1966 Richter embarked on his first 'color panels.' He based these on the standard sheets with swatches of paint samples of the type issued by paint companies. In addition, he produced the 'mispainted' series *Red-Blue-Yellow* in 1972. Here Richter has randomly distributed the resulting subtractive gray values across the picture surface. In 1976 Richter began to lay down compositions of brilliant hue, at first on small canvases executed in the Informel manner, demonstratively featuring Götz's squeegee technique 'presented' with stunning virtuosity. Classified generically as 'abstract pictures,' these are becoming larger in format, representing Richter's hitherto most comprehensive and diverse body of work dealing with 'painting as painting' (*Abstract Painting No. 525 "Prague"*, 1983). However, these works are not limited to demonstrating the possibilities of painting techniques. To Richter they also represent a societal model as a metaphor for social conditions in which 'what is most diverse and contradictory' is united 'with the greatest possible freedom in a vital and vigorous manner'.

Richter is still working on the abstract pictures, interrupting this long-term project with bouts of superrealistic representational painting (the *RAF* series, the *Mother and Child* series, *Candle Motifs*).

Lit.: Ulrich Look / Denys Zacharopoulos, *Gerhard Richter*, Munich 1985; Jürgen Harten (ed.), *Gerhard Richter, Bilder / Paintings 1962–1985*, exh. cat. Städtische Kunsthalle Düsseldorf and elsewhere, Cologne 1986; Hans-Ulrich Obrist (ed.), *Gerhard Richter. Text. Schriften und Interviews*, Frankfurt a. M. and Leipzig 1993; Gerhard Richter, exh. cat. Kunst- und Ausstellungshalle der Bundsrepublik Deutschland Bonn, Stuttgart 1993 (2nd ed. 1996); Hans-Ulrich Obrist (ed.), *Gerhard Richter. 100 Bilder*, Stuttgart 1996.

I think there's part of him that does follow Monet: the part about seeing.

Byron Kim

Gerhard Richter, Abstract Painting No. 525 "Prague", 1983
Oil on canvas, 248 × 250 cm. Munich, Loaned by the Herzog Franz von Bayern
Collection to the Bayerische Staatsgemäldesammlungen

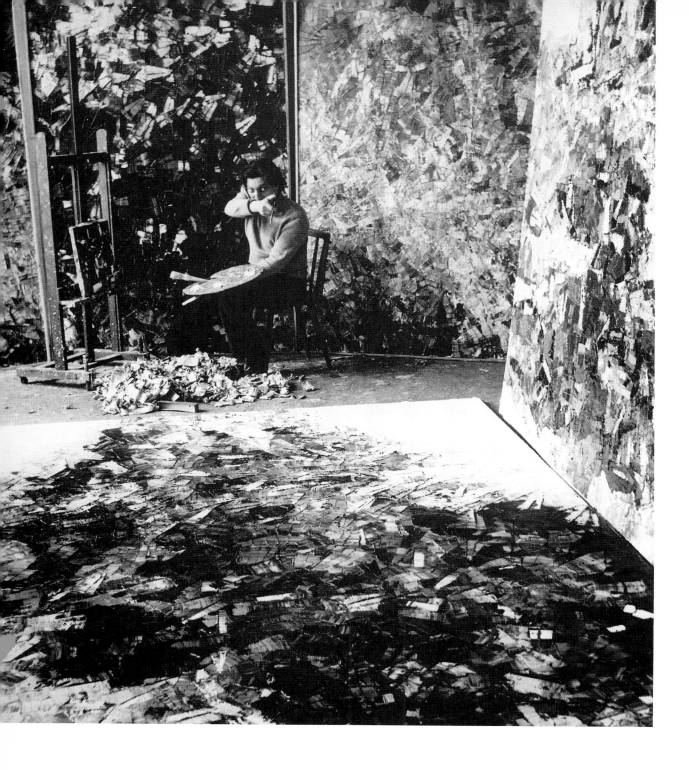

Jean-Paul Riopelle

1923	Born in Montréal
1943–45	Took courses at the Académie des Beaux-Arts in Montréal; graduated from the École du Meuble, where he studied under Paul-Émile Borduas; first serious attempts at painting
1945/46	Influenced by Surrealism; early member of the 'École automatiste'
1946	Participated in international Surrealist exhibitions in New York and Paris; traveled in Europe and met André Breton; moved to Paris
1947	Contacts with Patrick Waldberg, Pierre Soulages, Georges Mathieu, Wols et al.; Friendship with Sam Francis, whose first show at the Galerie du Dragon he organized

1949	First one-man show at the Galerie Nina Dausset, Paris
1954–	Exhibited regularly at the Gallery Pierre Matisse, New York
1958	First sculpture
1967	Retrospective at the Musée du Québec
1972	One-man show at the Musée national d'art moderne, Paris
1981	Retrospective at the Musée national d'art moderne, Paris
	Lives in Montréal

André Breton's writings led Riopelle to begin to paint in a style inspired by Automatism. As a logical next step, Riopelle moved to Paris 1947, where he sought contact with the early Surrealist circles and Breton and, more importantly, the founders of Informel, including Georges Mathieu, Wols, Hans Hartung and Camille Bryen. Riopelle was finally and truly 'consecrated' in the brotherhood of artists by being accepted at the fabled exhibition 'Véhémences confrontées' mounted by Galerie du Dragon in 1949 and uniting important representatives of Abstract Expressionism (Pollock, Rothko, Mathieu, Francis, Tobey, Bryen, Hartung). During this period Riopelle began to develop the style of painting which would be memorably his own: using his whole body, he applied paint in the gestural manner to the entire canvas (all-over painting) until the canvas was covered with a densely textured encrustation of color. He would usually finish this off by adding a few accentuating touches of white paint to what were otherwise emphatically colorful canvases. He painted increasingly with the palette knife and by the 1950s Riopelle was constructing entire picture surfaces (e.g. *Cuivre nocturne*, 1953, Pierre Matisse Gallery, New York).

On a trip to the U.S. in 1955, he met the leading exponents of gestural Abstract Expressionism: Jackson Pollock and Franz Kline. He particularly admired Kline and became friends with him. The Abstract avant-garde of the New York School, however, had little influence on Riopelle's work, which developed consistently from then on. Of paramount importance to his work, on the other hand, was his discovery of the late Monet, especially the large waterlily paintings donated by the Impressionist to the Paris Orangerie.

K. O. Götz recalls Riopelle's enthusiastic response to the waterlily paintings: "For Riopelle, the most important painter showing the way forward was not Picasso but the late Monet. Riopelle went with me [K. O. Götz in 1951] to the Musée de l'Orangerie to see Monet's waterlilies and explained to me which parts seemed so important to him. It was not the yellow waterlilies on the round walls but the picture at the head of a room. Here, water, shrubs and reflection of the shrubs in the water were woven into a single structure; there was no front and no back, everything was presented on a single level, on the surface. Even above and below had become unimportant. You could have turned the picture upside down without changing its painterly meaning. Riopelle said the Informel principle had already been anticipated here." (K. O. Götz, *Erinnerungen/Memoirs 1945–1959*, Aachen/Aix-la-Chapelle 1995, pp. 94/95).

Riopelle's insights into the formal problems posed by Monet's work were distilled into some of his own pictures, for instance, very evidently so in *Robe of Stars*, the series *Nymphéas* and *Hommage à Robert le Diabolique*. The center of this painting is taken up by a large, grayish white surface sending out sparkling outliers all the way to the edges and corners of the picture, which are accentuated by reds and yellows.

Thus, by rhythmicizing the picture surface, Riopelle has placed the direct relationship with nature, which was so essential to Monet, at a painterly remove, linking it within a new design uniting gestural abstraction with rich chroma to create works of great lyricism.

Lit.: *Jean-Paul Riopelle. Rétrospective*, exh. cat. Musée national d'art moderne, Paris 1981; *Jean-Paul Riopelle, 'D'hier et d'aujourd'hui'*, exh. cat. Fondation Maeght, Vence 1990; *Jean-Paul Riopelle. Catalogue raisonné 1939–1953*, Vol.1, ed. Yseult Riopelle, Paris 1999.

My idea is not abstraction but much more how I get there via a free gesture (an autonomous brushstroke) ... to understand what nature is, and so not to start from deconstructing nature but go in the direction of reconstructing the world ...

You know, if one had the opportunity to visit Giverny, the place where Monet painted his waterlilies, you would see that it is only the size of a small pond. That is incredible; these huge, outsize pictures came out of a really small pond ...

Jean-Dominique Rey, "Monet toujours vivant. Reflexions sur les Nymphéas," in: *Galerie Jardin des Arts* 1974, no. 139, p. 86.

Jean-Paul Riopelle, Hommage à Robert le Diabolique, 1953
Oil on canvas, 200 × 282 cm. New York, Acquavella Galleries

Jean-Paul Riopelle, Peinture 1950, 1950

Oil on canvas, 84 × 100 cm. London, Gimpel Fils

Jean-Paul Riopelle, Robe of Stars, 1952

Oil on canvas, 200 × 150 cm. Cologne, Museum Ludwig

Mark Rothko (Marcus Rothkowitz)

1903 Born in Dvinsk, Russia
1913 Emigrated with his family to Portland, Oregon
1921–23 Studied at Yale University in New Haven, Connecticut

1925–29	Studied under Max Weber at the Art Students League in New York
1935	Founded the group of artists known as 'The Ten'; showed his work at the Galerie Bonaparte in Paris and elsewhere
1938	Became an American citizen
1940–	Signed his work as 'Rothko'
1943	Manifesto of 'Mythological Painting'
1945	First showed work at Peggy Guggenheim's Gallery 'Art of this Century'
1948	Founded his own painting school: 'The Subjects of the Artist'
1951–54	Taught at Hunter College in New York (1957 Tulane University in New Orleans)
1961	Retrospective at the Museum of Modern Art, New York
1970	Committed suicide at his New York studio

During the 1930s Rothko's figurative paintings of scenes were derivative, leaning towards Max Weber and John Marin. Rothko had his first one-man shows at the Portland Museum and the New York Contemporary Arts Gallery. In 1935, together with eight other artists (Adolph Gottlieb and Ilya Bolotowsky et al.) he founded the group of artists who would become famous as 'The Ten.' Preoccupation with Surrealism led him to change his style: biomorphic forms and mythic symbols began to surface in his work. To justify his shift to this new style, Rothko published, together with Gottlieb, a statement in the New York Times in 1943, in which they proclaimed that art should deal with 'tragic and timeless themes' and this statement became the manifesto of 'mythological paint-ing.' Drawing on ancient mythology as his source of timeless symbols, Rothko began to abbreviate them to calligraphic signs. In the mid–1940s he abandoned this calligraphic approach, which was obviously linked with Surrealist automatism, for hazy color fields.

From 1949/50 what is generally regarded as the classic Rothko began to emerge: large rectangular color fields with hazily blurred contours which seem to hover over a ground of a different color. According to Rothko, the lack of a perceivable structure in such paintings blotted out memory and liberated recollection. Colors breathe in wide, open spaces without definable boundaries and shapes. The resolution of tensions and tacit sublimity distinguishing such paintings is attained by color contrasts which, together with simplicity of form, are attuned to experiential meditation. Rothko's religious background in Judaism is not inconsistent with the co-existence of mystical connotations and a conscious reversion to the tradition of the 'Sublime' in European art and letters (see Barnett Newman) manifestly informing his work. Rothko viewed his paintings as living organisms and color as something profoundly human and sensual but also as the gateway to experiencing the transcendental. Rooted in the colorist tradition, he felt closer to Monet than to Cézanne. His technique of making color spaces hover over the ground is reminiscent of the 'inner spaces of surfaces' in Monet's waterlily paintings.

Rothko joined the group round Peggy Guggenheim and was not long in becoming a leading exponent of the Abstract Expressionism which was developing as the New York School. Together with David Hare, Robert Motherwell, William Baziotes and Barnett Newman, Rothko founded the short-lived art school known as 'The Subjects of the Artist' in 1948, which was best known for lecture evenings. From 1950 Rothko's work was shown at the Betty Parsons Gallery and then at the Sidney Janis Gallery. As time went on, he said less and less about his paintings yet the influence his work exerted on American Color-Field painting grew increasingly evident. Commissions for large murals (1958 Seagram Building, New York; 1961 Harvard University, Cambridge; 1964 a non-denominational chapel in Houston, Texas) did nothing to assuage the uncompromising quality standards he applied to his work. For all his reservations about it, the chapel in Houston is numbered among his masterpieces.

Lit.: *Mark Rothko 1903–1970*, exh. cat. Walraff-Richartz-Museum, Cologne 1988; James E. B. Breslin, *Mark Rothko. Eine Biographie*, Klagenfurt 1995; *Mark Rothko, The Menil Collection*, Houston 1996; *Mark Rothko*, exh. cat. National Gallery of Art, Washington 1998; *Mark Rothko*, exh. cat. Fondation Beyeler, Basel 2001.

The reactions [of the viewers] … say unanimously my work has the power to convey a new way of looking. This message becomes visible through a new structural language they have never experienced before. In my pictures you find an unspoiled, conscious, elemental humanity. Even the pictures of Monet have something of this, which is why I prefer Monet to Cézanne…. Despite the general view that Cézanne created a new way of looking at things and was the father of modern painting, I prefer Monet. Monet was the greater artist of the two. I don't agree with the current public opinion about the colorists and their art … because color in itself is among the sensory components of art.

Conversation between Rothko and Alfred Jensen on June 17, 1953. Jensen recorded the conversation in letter form. In: James E.B. Breslin, *Mark Rothko: Biography*, Chicago 1993, pp. 381–382.

Mark Rothko, Blue and Grey, 1962
Oil on canvas, 193 × 175 cm. Riehen/Basel, Fondation Beyeler

Photo Hans Namuth

Clyfford Still

1904 Born in Grandin, North Dakota
1905 Moved with his family to Spokane, Washington
1926–27/
1931–32 Studied art at Spokane University, Washington

1933–41	Taught at Washington State College, Pullman
1941	Moved to San Francisco
1943	First one-man show at the San Francisco Museum of Modern Art
1945	Moved to New York; links with Abstract Expressionism
1946	One-man show at Peggy Guggenheim's 'Art of This Century'
1946–50	Taught at the California School of Fine Arts
1952–	Taught at Hunter College and Brooklyn College, New York
1959	Retrospective at the Albright-Knox Art Gallery, Buffalo
1978	Member of the American Academy and Institute of Arts and Letters
1980	Died at New Windsor, Maryland

Clyfford Still was a member of the metaphysical circle within the broader movement of American Abstract Expressionism. Like Barnett Newman and Mark Rothko, he felt he could convey spiritual messages through abstract painting, a stance which made him receptive to the Romantic, mystical movement seeking 'the Spiritual in Art' which had started with Kandinsky.

Recalling the Regionalism of Thomas Hart Benton, Still's earliest pictures focus on life on the prairies (*Row of Grain Elevators*, 1928). A further formative influence on Still, however, was Late Impressionism as practised by Cézanne, van Gogh and Monet. His islands of flickering color can certainly be viewed within the context of the Monet revival as this particular artist's response to Monet's waterlily paintings with their powerfully textured handling of color and vegetal forms teeming throughout the picture space. The suspension of the figure-ground relationship in the late Monet is particularly important as the salient stylistic feature of Still's mature work.

The figurative studies of 1934/35 were followed by a Surrealist phase in the late 1930s and early 1940s in which primitive, mythological and symbolic content was assimilated. Applying paint with the palette knife and the search for light-and-shade effects ultimately led Still to adapt a semi-abstract style distinctively his own, which he intensified from 1944 in larger formats. However, it was not until he linked up with Abstract Expressionism that Still finally attained the stringency that distinguished his mature style. He collaborated on planning the art school known as 'The Subjects of the Artist,' which was founded in 1948 by William Baziotes, Robert Motherwell, Barnett Newman and Mark Rothko, and became friendly with the latter.

Between 1946 and 1950 Still was at the zenith of his powers. Fissured monoliths grow up from the lower edges or descend dramatically down into the picture surface. Frequently a single color is predominant, from a range which plays on the affinities of nocturnal shades for fiery tonalities. Textures are rough and earthy and the mood is aggressive, even forbidding, as if to express Still's rejection of the New York art scene (*1946-L*, 1946, Albright-Knox Art Gallery, Buffalo, New York). Increasingly alienated from this sophisticated art scene, Still left the city in 1961 to settle in rural Maryland. Like Barnett Newman, Clyfford Still admitted Monet's pioneering role and was inspired by the waterlily paintings.

Strong emphasis on the vertical, the 'categorical imperative' informing his canvases (Still), distinguishes the late work in large formats. In some of these Still exploited the radiance of unprimed white canvas. Despite his undisguised contempt for art critics, art dealers and galleries, numerous retrospectives paid homage to Still's work in the artist's later years. The first retrospective was mounted by the Albright-Knox Art Gallery in Buffalo, New York, in 1959. The last during his lifetime was held at the Metropolitan Museum of Art in 1979/80. Not long before he died, Still donated entire groups of paintings to these institutions and to the San Francisco Museum of Modern Art.

Lit.: John P. O'Neill (ed.), *Clyfford Still*, exh. cat. The Metropolitan Museum of Art, New York 1979; *Clyfford Still*, exh. cat. Mary Boone Gallery, New York 1990; Thomas Kellein (ed.), *Clyfford Still (1904–1980)*, exh. cat. Kunsthalle Basel 1992; Justus Jonas-Edel, *Clyfford Stills Bild vom Selbst und vom Absoluten. Studien zur Intention und Entwicklung seiner Malerei*, Ph. Diss., Cologne 1995.

We are no longer willing to illustrate out-of-date myths and create ourselves alibis with contemporary themes. The artist must take complete responsibility for what he creates. His greatness will therefore depend on the profundity of his inward view and the boldness he shows in translating his own vision.

The demands for communication are as presumptuous as they are irrelevant. The viewer generally gets from a work of art what he previously put into it, what his fears, hopes and insights teach him to see. If he can escape these compulsions, which only reflect an image of himself, he may possibly sense something of the inner spiritual content of the work.

Clyfford Still, 1952, in: *15 Americans*, exh. cat. Museum of Modern Art, New York 1952

Clyfford Still, 1951-N, 1951

Oil on canvas, 235 × 175.3 cm. Washington, D.C., National Gallery of Art, Robert and Jane Meyerhoff Collection,

Gift in Honor of the 50th Anniversary of the National Gallery of Art

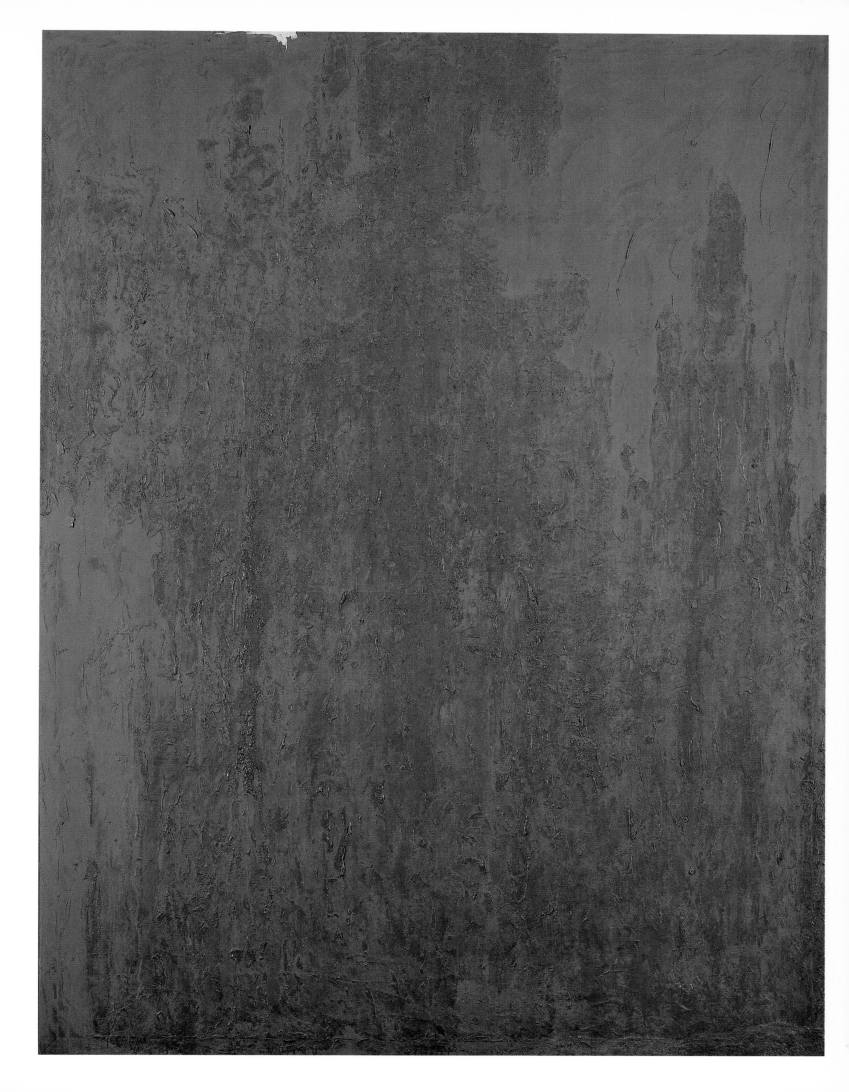

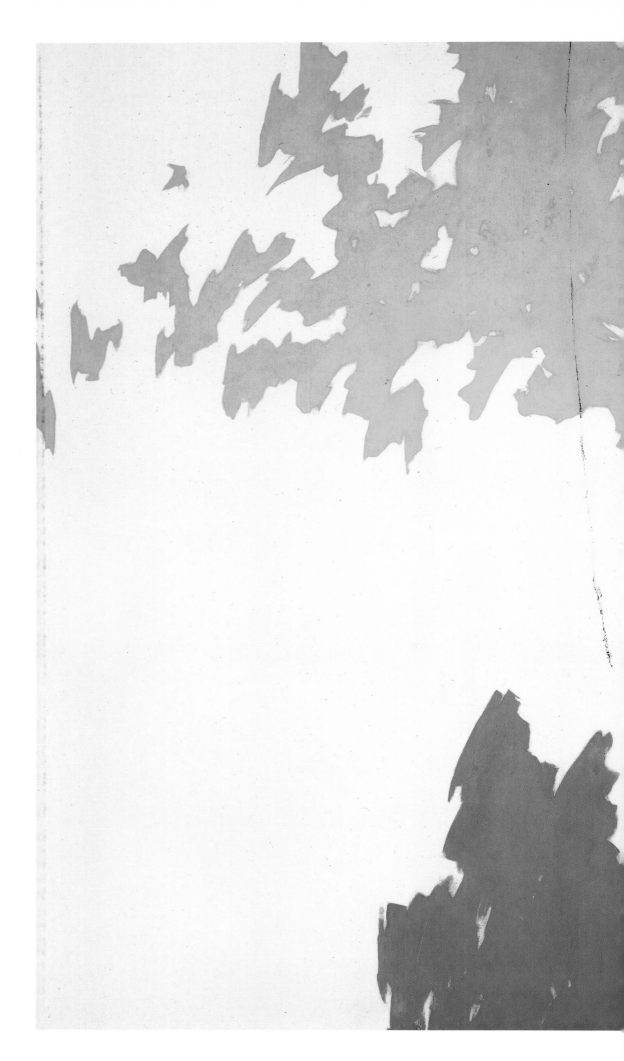

Clyfford Still, Untitled 1959, 1959
Oil on canvas, 284.5 × 392.4 cm.
New York, Marlborough International
Fine Art

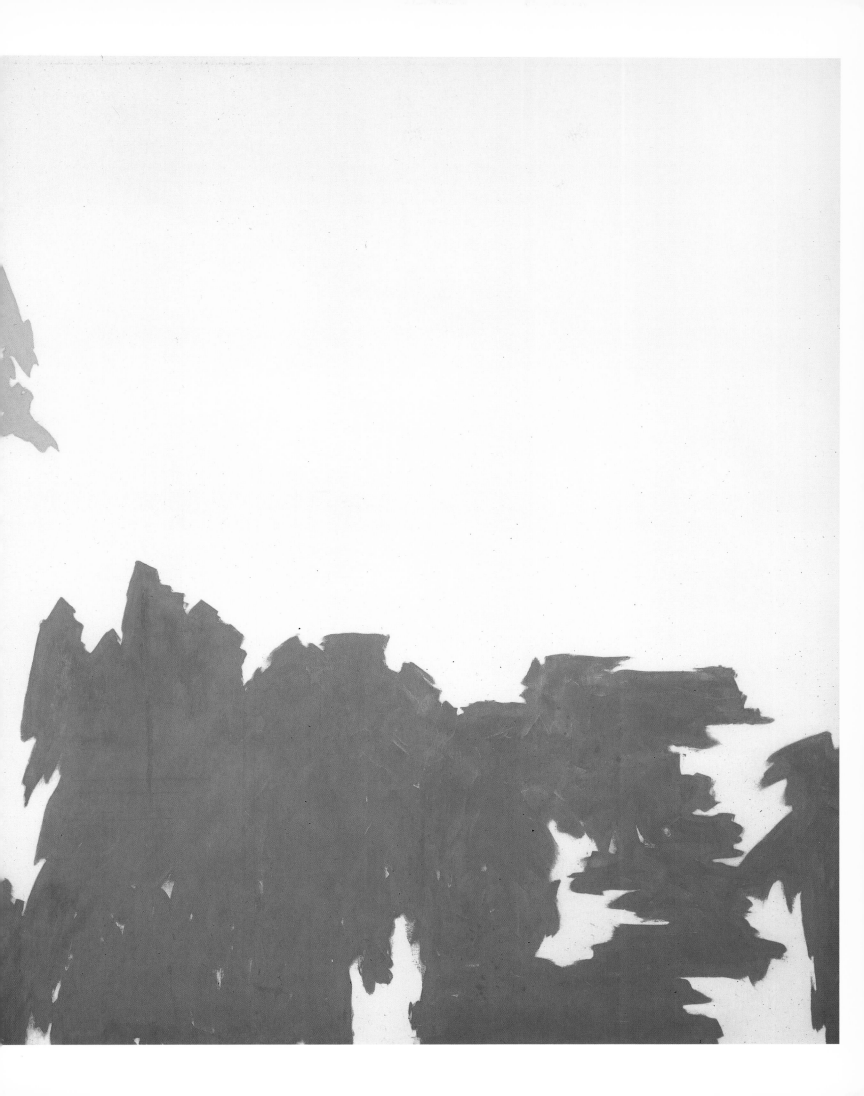

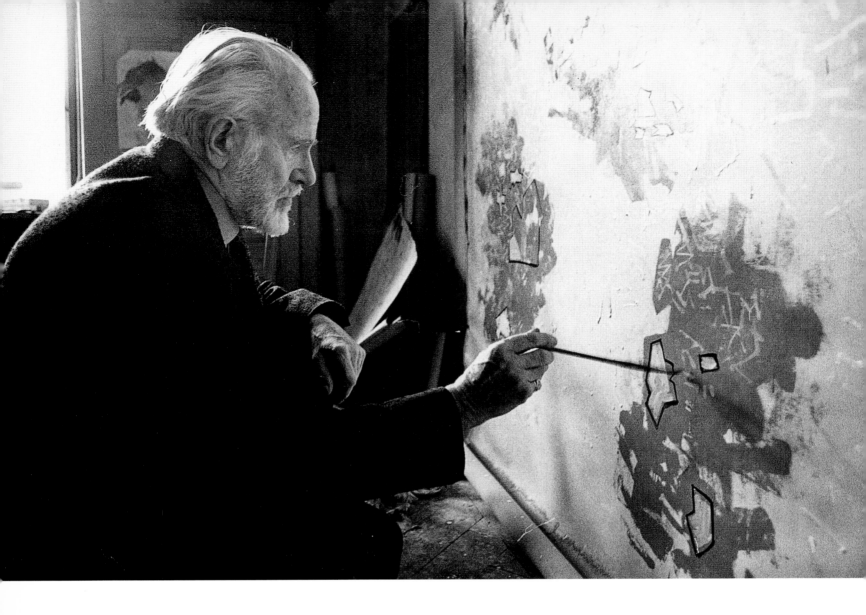

Mark Tobey

1890	Born in Centerville, Wisconsin
1906	Moved with his family to Hammond, Indiana; attended courses in watercolors and drawing at the Chicago Art Institute
1913–17	Shuttled between New York and Chicago; taught himself as an artist
1918	Converted to the Baha'i religion
1922–25	Taught at the Cornish School in Seattle
1934/35	Traveled in China and Japan; first 'White Writings'
1945	One-man show at the Portland Museum of Art, Portland
1954	Began on the 'Meditative Series;' in Paris until 1955
1956	Breakthrough as a free-lance artist; participated in the exhibition of 'American Painting' Tate Gallery in London
1960	Moved to Basel
1962	Retrospective at the Museum of Modern Art in Basel
1976	Died in Basel

The ultimate individualist among the artists known as the New York School, Tobey went his own way from the beginning. It soon led him to East Asian ideas of art and Chinese calligraphy as well as spiritual issues connected with them. As a young man, Tobey was an adherent of Bah'u'llah's doctrine of the unity of all faiths as the source of a higher wisdom. Tobey's inclination towards the universal or cosmic moulded his development as an artist. Surrealist motifs turned, in his hands, into a total experience. In the throbbing life of the big city, the seasonal realities and assemblies of people, Tobey found the idea of an all-embracing and life-enhancing cosmos. His study of East Asian art was what led him to discover his own signature and distinctive iconic vocabulary. European and American tradition, on the other hand, left him largely unmoved—except for Impressionism. His *Broadway* pictures (1935, Museum of Modern Art, New York) represent 'all-over painting' but are very different from Pollock's work. invoking the universal unity of form and movement in an ever abstracter and more intricate tissue of lines, Tobey rendered the universal unity of form and movement in painterly terms while rejecting purely abstract, formal painting. What he was after with his fabric of white lines was the human aspect; he strove to develop a picture space informed 'with electric power, waves, rays, spores, seeds, possibly with sighs, possibly with sounds … and God knows what else' (exh. cat. *M. Tobey*, Fondation Beyeler, Basel 1990/91, p. 13). Tobey's paintings teem with foliate forms recalling vegetation, pointed lines, fleck-like structures, thickets of graphic elements recalling hayricks (*November Grass Rhythms*, 1945), crystalline, splintering line and, throughout, a sweeping, close-knit and overlapping movement which Tobey called 'moving line' (e.g. *Dry Forest*, 1965). The iconic script indissolubly woven into all these forms as their subtext is, however, in-decipherable without reference to nature, which meant so much to Tobey (in this he was like Klee, whom he venerated). The elemental forces of nature, times, places, ways, guided his sight. Tobey also spoke of his admiration for Cézanne and Monet. The late Monet, the object of the Monet re-vival whch had made such an impression on so many other young American painters also played an important role in Tobey's choice of approach to 'all-over painting' as his form of expression. Tobey frequently mentioned the importance of Impressionism to his development. His picture spaces filled with a pulsing web of lines have more in common, at least at first glance, with Monet's 1880s and 1990s textural brushwork than with Jackson Pollock's heavy, gestural strokes. However, what sets Tobey entirely apart from Pollock and other exponents of gestural Abstraction as practised by the New York School is the meditative repose emanating from his 'white writings' which lends his work a quality of radiance and even a presentiment of happiness.

Lit.: M. Bärmann (ed.), *Mark Tobey. Werke 1935–1975*, exh. cat. Museum Folkwang Essen, 1989; *Mark Tobey. Späte Werke*, exh. cat. Stadtmuseum Siegburg 1990; *Mark Tobey. A Centennial Exhibition*, exh. cat. Fondation Beyeler, Basel 1990/91; M. Bärmann (ed.), *Mark Tobey. Retrospektive*, exh. cat. Museo Nacional Centro de Arte Reina Sofia, Madrid 1997.

Ever since I've been trying to make my pictures organic, I sense that there is a reference to nature there ... So I tried for example to experience the sensation of moving grass or waving corn through the medium of painting. To achieve the rhythmic impulse thereof, I had to form the painting from a weave of diverse lines.

Best of all, I like to see in nature what I should like in my picture. If we succeed in finding abstractions in nature, we find the most profound art.

Mark Tobey, in: *Mark Tobey, Werke 1935–75*, exh. cat., Museo d'arte Mendrisio, Museum Folkwang Essen, 1989, p. 113.

Mark Tobey, Oncoming White, 1972
Oil on canvas, 241 × 203 cm. Riehen/Basel, Fondation Beyeler

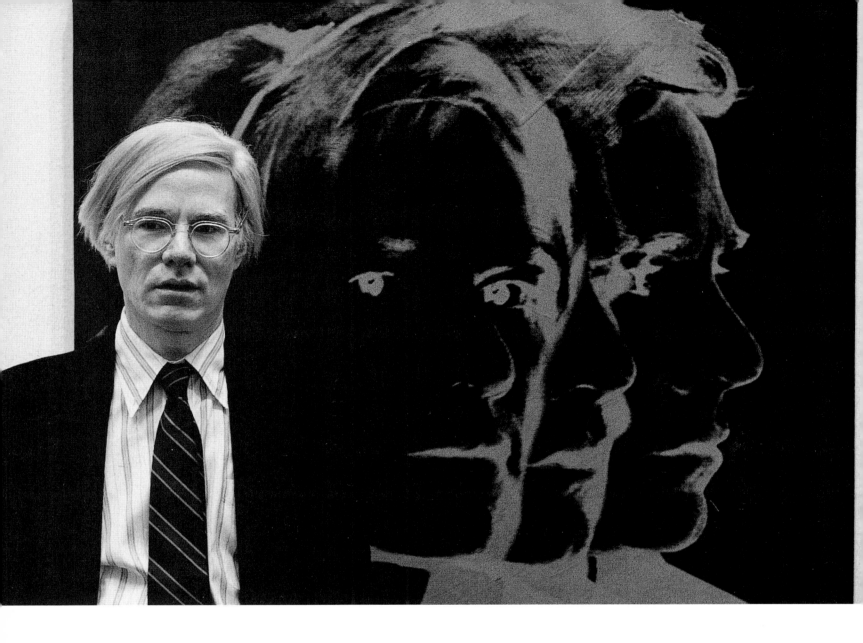

Andy Warhol

1928	Born Andrew Warhola in Pittsburgh, Pennsylvania
1945–49	Studied commercial art at the College of Art, Carnegie Institute of Technology, Pittsburgh
1950–	Moved to New York; worked as a commercial artist, illustrator, shop window decorator
1960–	Early pictures based on comic strips
1962–	Serial pictures and silkscreen prints (*Campbell's Soup Cans, Coca Cola Bottles, Flowers*); Participated in 'The New Realists' exhibition at the Sidney Janis Gallery, New York
1964	Independent Film Award (Films *Sleep, Kiss, Eat,* 1963)
1965	Multimedia events
1968	documenta 4 in Kassel; important museum exhibition at the Moderna Museet, Stockholm; seriously injured when shot by Valerie Solanas, a self-styled women's libber
1987	Died in New York

Andy Warhol was a cult figure, the myth incarnate to the Pop generation. His apotheosis as an enigmatic diva to an awed public, seemingly shy revealed him nonetheless fully aware of his market value, a commodity he repeatedly represented in his strip pictures of the detritus consumer society. Warhol worked in his 'Factory' at trivializing and decoding modern culture. More consistently than any other Pop artist, he elevated Pop Art to a way of life, staging himself as a work of art. He saw through the mechanisms regulating a society in which stars replaced saints. Their lives became legend, their figures enshrined in endless repetition on posters, wrapping paper, in newspapers and the Underground. Icons like Elvis Presley, Liz Taylor and Marilyn Monroe rise above the anonymous masses; stencil-like repetition in Warhol's silkscreen prints and other pictures turns them back into clichés, congealed images of societal yearnings. Artificial creations, stars thus return to the anonymity of the mass culture which generated them. Everything is normed, can be industrially produced, endlessly repeated and used. Feeding on the mass media, Warhol's repertoire was intended for mass production. He turned the myth of the artist, worshipped yet again by the generation of Abstract Expressionists in New York, upside-down, ironically celebrating himself ad absurdum.

Declaring that an artist was someone who produced things which nobody needed but who for some reason thought it was a good idea to give them anyway (A. Warhol, 1968), Warhol was inspired not only by the film industry and the American fast food culture. He also included 'high art' in his production process. The best known example of this is his series of pictures based on Leonardo's 'Last Supper' (Milan), in which he serialized the heads of both the Apostles and Christ, combining them to form large, icon-like panels.

The *Flowers* shown in 1964 at the Leo Gallery in New York (and at Sonnabend in Paris in 1965) owed its existence to Warhol's interest in the late Monet, especially the waterlily paintings, which he had often seen and admired in the Museum of Modern Art. The Leo Castelli installation really does capture an important quality of Monet's late work: apart from serial reproduction, the figure (pattern)-ground relationship which Monet made the subject of his waterlily paintings so that he could subvert it.

His pictures, films and multimedia events made Warhol one of the great sources of inspiration to all the visual arts, not least as the portraitist of late capitalist society. The cool, perhaps even merciless detachment informing these relentless exposés of high society lends Warhol's photo series a quality of clinical objectivity. There was a lot more to his work than that, however, as one realizes when confronted with the last pictures. For all their technical brilliance, or perhaps just because they are the product of so much slick virtuosity, they reveal an overall conception of art in its societal context.

Lit.: David Bourdon, *Andy Warhol*, New York 1989; Kynaston McShine (ed.), *Andy Warhol. A Retrospective*, exh. cat. The Museum of Modern Art, New York; Jacob Baal-Teshuva, *Andy Warhol 1928–1987*, Munich 1993; *Andy Warhol. Sammlung José Mugrabi*, exh. cat. Wilhelm-Hack-Museum, Ludwigshafen on the Rhine 1996.

Most artists repeat themselves all their lives. Isn't life a repetition of the same things happening all the time? I just like doing the same thing over and over again. It's one way of expressing yourself! All of my motifs are always identical but also very different. They change with the luminosity (of the color), with time, and with the atmosphere. Isn't life a series of motifs that change while they go on repeating themselves?

Andy Warhol, Flowers, 1964
Silk screen print on acrylic on primed canvas, 207.6 × 207.6 cm. Riehen/Basel, Fondation Beyeler

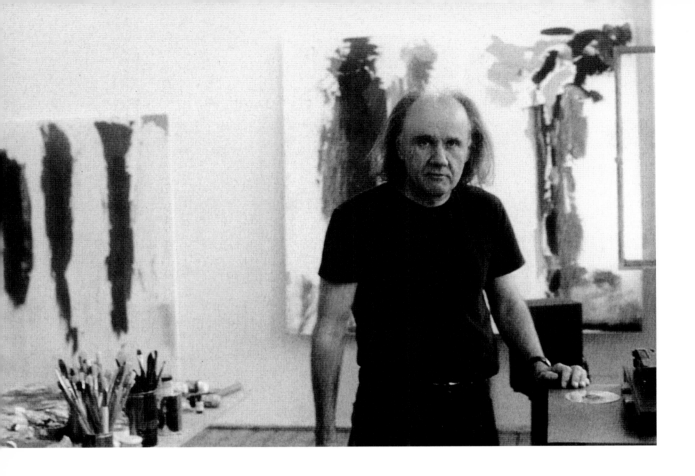

Jerry Zeniuk

1945	Born at Bardowick refugee camp near Lüneburg
1950	Emigrated with his family to the USA; attended school in Boulder, Colorado
1969	Moved to New York
1992–	Professor for painting at the Fine Arts Academy, Munich
1996	Mural for the Munich Local Court
1997	Mural for the new Hypo-Bank Building in Passau
	Lives in Munich and New York

During the 1970s Zeniuk's work was close to monochrome painting. Built up in multiple layers of encaustic, the paintings of that period may look monochrome but are basically in color. They gained Zeniuk admittance to the New York art scene but he became internationally known through exhibitions centered on 'Geplante oder Fundamentale Malerei'. The stringently Conceptual direction taken by exponents of such painting and especially the dogmatic claims, pregnant with theory, made for it by its most voluble apologists did not, however, suit Zeniuk for long. From 1976 he began working solely in oils and dedicated himself to a study of color and form contrasts recalling Paul Cézanne (*Ohne Titel/Untitled, Nummer 108*, 1986, Neue Galerie, Kassel). Another major point of reference was Monet in all his diversity.

His brief participation in the group including Joseph Marioni, Phil Sims, Stephen Rosenthal et al. founded by Marcia Hafif in 1976 culminated in the exhibition 'Radical Painting' organized by Thomas Krens in 1983. The group's adherence to a rigidly dogmatic conception of what painting was all about left Zeniuk feeling constrained rather than inspired. Rejecting the conception of monochrome painting, Zeniuk went through several phases of experimentation to attain a new iconic language of color based on the exuberantly liberating confrontation of brilliant, pure colors.

The painting *Untitled Number 134* (1985, private collection) marks the breakthrough to pure color in the 1980s: the surface is taken up by intense, pure blue, red and yellow, radiating brilliantly from a white ground. The intensity achieved with such color effects is based primarily on the interrelationship between the primary colors, which the painter has juxtaposed and related to each other with vigorous gestural strokes. The surfaces formed from colors are anything but monochrome. Shades vary between light and dark.

The complex fabric of interrelationships between surface, space, form and color developed in the 1990s into a new richness and freedom. For Zeniuk color has come to play a role of ever increasing significance for what is going on in his pictures. He has attained the greatest richness of color in his watercolors. Working in this exacting medium since the early 1990s, Zeniuk has achieved perfect balance between the demands made by color as form and intensity of saturation. Spontaneous handling of color is counterbalanced by the deliberate creative process to form compositions of great density and radiance which definitively rank among this consummate colorist's supreme achievements.

Lit.: Dieter Schwarz/Ulrich Wilmes, *Jerry Zeniuk. Oil and Water*, exh. cat. Kunstmuseum Winterthur and elsewhere, Nürnberg 1999 (with a bibliography and list of exhibitions); Jerry Zeniuk, *Watercolors*, exh. cat. Oldenburger Kunstverein, Oldenburg 2001.

Monet is interesting as an artist and painter for the evolution of his thinking in his work during his lifetime. He began very pictorial and ended very painterly. He went from pictorial time to street time. And his last paintings were understandable only when seen in reality. His work never needs explanation or justification. As an artist I grew up with his waterlillies in the Museum of Modern Art as a painting I came to, to find harmony and stability. It was home base. It was the bridge between art and nature, between color and space, between the 19th and 20th centuries. To this day, every time I see this three-panelled painting I learn or recognize something new. A couple of years ago I made a three-panelled painting in the corner only to realize that paintings, no matter how you bend them, want to be flat. The MoMA waterlilies were for years hung at three angles, until last year, when I saw them hung flat on a wall. To my surprise they were much more satisfying to view and then I learned that this is the way they were meant to be hung. It doesn't matter what is correct, but that one, or I specifically, had a realization of meaning that came from the painting itself. The more years that I paint, the less I want, or am able to verbalize painterly ideas. Now I just look and enjoy Monet. I understand now how he did much of what he did. I no longer look to him for contemporary solutions. Painterly problems or issues are quite different today. But if I am interested in color issues there are few since him who have added to our profound vocabulary of color. The tradition of color painters cannot be separated from the role of color. The best looked for local color, or color and form without atmosphere. One hardly sees color in painting that is not atmospheric or decorative or, worse, flat color. Badly used it is sentimental and romantic in the worst sense. Monet was able to load his surface with color and yet develop an image that is clear, harmonious, and full of tension and drama. He makes it look easy. He makes it look easy.

Jerry Zeniuk, 2001

Jerry Zeniuk, Untitled Number 232, 2000
Oil on canvas, 188 × 233 cm. Private collection

Selected Bibliography

Ruth Berson, *The New Painting: Impressionism 1874–1886: Documentation*, 2 vols., San Francisco 1989

Gottfried Boehm (ed.), *Claude Monet: Nymphéas. Impression – Vision*, exh. cat. Kunstmuseum Basel, 1986

Alfred Boime, *The Academy and French Painting in the Nineteenth Century*, Oxford 1971

David Bomford (et al.), *Art in the Making: Impressionism*, exh. cat. The National Gallery London, 1990

Richard R. Brettell (et al.), *A Day in the Country: Impressionism and the French Landscape*, Los Angeles 1984

Anthea Callen, *The Art of Impressionism. Painting technique and the making of modernity*, New Haven/London 2000

Claude Monet. Exposition Rétrospective, exh. cat. Musée de l'Orangerie, Paris 1931

Georges Clemenceau, *Betrachtungen und Erinnerungen eines Freundes*, Frankfurt am Main 1989

John Coplans, *Serial Imagery*, Los Angeles 1968

John Crary, *Techniques of the Observer: On Vision and Modernity in the Nineteenth Century*, Cambridge, Massachusetts/London 1992

Marc Elder, *A Giverny, chez Claude Monet*, Paris 1924

Francis Francina (et al.), *Modernity and Modernism: French painting in the 19th Century*, New Haven/London 1993

John Gage, *Colour and Culture*, London 1993

Gustave Geffroy, *Claude Monet. Sa vie, son temps, son œuvre*, Paris 1922 (1980)

René Gimpel, *Journal d'un collectionneur, marchand de tableaux*, Paris 1963

Robert Gordon/Andrew Forge, *Monet*, New York 1983

Susanne Henle, *Claude Monet – Zur Entwicklung und geschichtlichen Bedeutung seiner Bildform* (Diss. Bochum 1978)

Robert Herbert, "Method and Meaning in Monet," in: *Art in America* (September 1979)

——, *Impressionism: Art, Leisure and Parisian Society*, New Haven/London 1988

Hommage à Claude Monet, exh. cat. Grand Palais, Paris 1980

Jacques P. Hoschedé, *Claude Monet, ce mal connu*, Geneva 1960

John House, *Monet. Nature into art*, New Haven/London 1986

Joel Isaacson, *Claude Monet. Observation et Reflexion*, Neuchâtel 1978

Stephan Koja, *Claude Monet*, Munich/New York 1996

Martin Krahe, *Serie und System* (Diss.), Essen 1999

Karlheinz Lüdeking (ed.), *Clement Greenberg. Die Essenz der Moderne. Ausgewälhlte Essays und Kritiken*, Berlin 1997

Charles S. Moffet, *The New Painting: Impressionism 1874–1886*, Oxford 1986

Monet & Japan, exh. cat. National Gallery of Australia, Canberra 2001

Monet in the '90s. The Series Paintings, exh. cat. Museum of Fine Arts, Boston 1990

Monet's Years at Giverny: Beyond Impressionism, exh. cat. Metropolitan Museum, New York 1978

Linda Nochlin (ed.), *Impressionism and Post-Impressionism 1874–1904*, Englewood Cliffs, New Jersey 1966

John Rewald/Frances Weitzenhofer, *Aspects of Monet. A Symposium on the Artist's Life and Times*, New York 1984

Denis Rouart/Jean-Dominique Rey, *Monet. Nymphéas ou les miroires du temps*, Paris 1972

Karin Sagner-Düchting, *Claude Monet: Nymphéas. Eine Annäherung* (Diss. Munich 1983), Hildesheim 1985

——, *Claude Monet 1840–1926. Ein Fest für die Augen*, Cologne 1990

——, *Monet in Giverny*, Munich 1994

Grace Seiberling, *Monet's Series* (Diss. Yale Univ. 1976)

W.C. Seitz, *Claude Monet. Seasons and Moments*, exh. cat.
The Museum of Modern Art, New York 1960

Serie – Ordnung und Obsession. Von Claude Monet bis Andy Warhol, exh.
cat. Hamburger Kunsthalle, Ostfildern-Ruit 2001

Robert Shiff, *Cézanne and the End of Impressionism: A Study of the
Theory, Technique and Critical Evaluation of Modern Art*, Chicago 1984

Virginia Spate, *The Colour of Time. Claude Monet*, London 1992

Charles F. Stuckey (ed.), *Claude Monet 1840–1926*, Cologne 1994

——, *Claude Monet 1840–1926*, Chicago 1995

Katharina Sykora, *Das Phänomen des Seriellen in der Kunst. Aspekte
einer künstlerischen Methode von Monet bis zur amerikanischen Pop Art*,
Würzburg 1983

Paul Hayes Tucker, *Claude Monet. Life and Art*, New Haven 1985

——, (ed.), *Monet in the `90s. The Series Paintings*, exh. cat. Museum of
Fine Arts, Boston, New Haven / London 1989

——, (ed.), *Monet im 20. Jahrhundert*, exh. cat. Museum of Fine Arts,
Boston und Royal Academy, London, Cologne 1999

Lionello Venturi, *Les Archives de l'impressionisme*, 2 vols., New York
1968

Oliver Wick, *Nichts und doch etwas. Monet und Rothko.
Farbe und Raum*, Basel 1988

Daniel Wildenstein, *Claude Monet. Biographie et catalogue raisonnée*,
vols. 1-5, Paris 1974–1991

——, *Monet oder der Triumph des Impressionismus*, Cologne 1996

Photo Credits

Prints and transparencies were kindly provided by the institutions and collectors noted in the captions, with the exception of the following:

Courtesy Ameringer-Howard Gallery, New York, p. 208

© The Art Institute of Chicago, pp. 50, 63 bottom, 73 bottom, 76 right, 154, 161

art (Photo: Florian Kleinefenn), p. 190

Christian Baur, Basel, pp. 100/101

Robert Bayer, LAC AG, Basel, pp. 287, 301

Courtesy Frédéric Benrath, p. 178

Olaf Bergmann, p. 203

The Bridgeman Art Library, p. 91 top

Martin Bühler, Öffentliche Kunstsammlung Basel, pp. 85 bottom, 110

Richard Carafelli, pp. 73 top, 123

Cathy Carver, p. 53

Geoffrey Clements, Whitney Museum of American Art, New York, p. 129

© CNAC/MNAM Dist. RMN, pp. 1, 22 left, 70

Denise Colomb, © VG Bild-Kunst, Bonn 2001, p. 278

© The Country Life Picture Library, London, pp. 2-5

Courtesy The Delaney Estate, p. 182

© Denver Art Museum 2001, p. 75

© Durand-Ruel, pp. 16/17, 64/65, 68-70, 104 top

Roland Fischer, München, © VG Bild-Kunst, Bonn 2001, p. 224

Sam Francis Estate, California (Photo: Jerry Sohn), p. 186

Giraudon, Paris, pp. 66, 80/81, 83, 85 top, 86 bottom, 90, 91 top, 92, 93

Courtesy Karl Otto Götz, p. 200

© Bernard Gotfryd, Courtesy of Newsweek, Archiv Kunsthalle Basel, p. 284

Courtesy Gotthard Graubner, p. 204

Bob Grove, p. 39 middle

Foto-Atelier Louis Held, Weimar, p. 36

Hans Hinz/Artothek, p. 97

© Israel Museum, p. 77 left

Courtesy Byron Kim, p. 218

Hans Landshoff (Courtesy Ellsworth Kelly), p. 212

Courtesy Joseph Marioni, New York, p. 236

Courtesy Verlag Matthes und Seitz, p. 240

Franziska Messner-Rast, St. Gallen, p. 196

© Metropolitan Museum of Art, New York, pp. 45 top, 46, 54/55, 94 bottom

Estate of Joan Mitchell (Courtesy Robert Miller Gallery, New York), p. 244

Ugo Mulas, pp. 250, 258

Owen F. Murphy Jr., p. 67

Musée de Metz, p. 174

© Hans Namuth Estate, Courtesy Center for Creative Photography, The University of Arizona, pp. 228, 262, 288

National Gallery, London, pp. 58, 72, 78

© Board of Trustees, National Gallery of Art, Washington, pp. 39 middle, 56 top, 73 top, 291

Fotostudio Ott, p. 65 bottom

© Collection Philippe Piguet, p. 104 bottom

Pinakothek München, p. 277

Estate of Richard Pousette-Dart, p. 266

© Milton Resnick (Courtesy Robert Miller Gallery, New York), p. 270

© Gerhard Richter (Courtesy Verlag Silke Schreiber, Munich), p. 274

Hickey-Robertson, Houston, p. 125

Roger-Viollet, Paris, p. 35, 106

Friedrich Rosenstiel, Cologne, pp. 150, 203

Lynn Rosenthal and Graydon Wood, p. 157

© Jacques Salomon, p. 21

Städtische Galerie im Lenbachhaus, Munich, p. 211

Peter Schibli, Basel, p. 103

Harvey Stein (Courtesy Kenneth Noland), p. 254

© Antoine Terrasse, p. 20 bottom

Collection J.M. Toulgouat, p. 105 right

Wen Hwa Ts'ao, Virginia Museum of Fine Arts, p. 79

© Diane Upright Fine Arts, LLC, p. 232

Malcom Varon, © Metropolitan Museum of Art, New York, p. 117

James Via, p. 63 middle

Rupert Walser (Courtesy Jerry Zeniuk), p. 302

Archives Fondation Wildenstein, Paris, p. 105 left, 107

Worcester Art Museum, p. 77 right

Kurt Wyss, Basel, pp. 294, 298.

Exhibition

Curator:
Dr. Karin Sagner-Düchting

Exhibition consultant:
Prof. Dr. Ann Gibson

Realization:
Dr. Karin Sagner-Düchting
Matthias Kammermeier (Exhibition architecture)
Factory Set Design GmbH, Munich (Exhibition construction)
Wolfgang Hennies (Technical direction)

Administrative support:
Philippine Fischer

Project assistance: Marion von Schabrowsky, Ann Kathrin Bäumler

Conservation consultant:
Florian Schwemmer

Insurance:
Kuhn & Bülow

Public relations:
Alexandra von Reitzenstein

Catalogue

Concept:
Dr. Karin Sagner-Düchting

Cover design:
Sabina Sieghart

© Prestel Verlag, Munich · London · New York, 2001
and Kunsthalle der Hypo-Kulturstiftung

© Prestel Verlag, Munich · London · New York, 2001
© of works illustrated by the artists, their heirs and assigns, except in the
following cases: Jean Bazaine, Frédéric Benrath, Sam Francis, Raimund
Girke, K.O. Götz, Hans Hofmann, Wassily Kandinsky, André Masson,
Barnett Newman, Kenneth Noland, Jules Olitski, Jackson Pollock and
Jean-Paul Riopelle by VG Bild-Kunst, Bonn 2001, Willem de Kooning
by Willem de Kooning Revocable Trust/VG Bild-Kunst, Bonn 2001 and
Mark Rothko by Kate Rothko – Prizel & Christopher Rothko/VG Bild-Kunst,
Bonn 2001

Photo Credits p. 308

Cover: Claude Monet, *Le Bassin aux nymphéas*
(cf. pp. 98/99)
pp. 1–5: The lily pond at Giverny
pp. 14–15: Claude Monet in his Waterlily studio, ca. 1920

Prestel books are available worldwide.
Visit our website www.prestel.com
or contact one of the following
Prestel offices for further information:

Head Office: Mandlstrasse 26 · 80802 Munich
Tel. (089) 381709-0, Fax (089) 381709-35
e-mail: sales@prestel.de
Prestel London: 4 Bloomsbury Place · London WC1A 2QA
Tel. (020) 7323 5004, Fax (020) 7636 8004
e-mail: sales@prestel-uk.co.uk
Prestel New York: 175 Fifth Avenue, Suite 402, New York, NY 10010
Tel. (212) 995 2720, Fax (212) 995 2733
e-mail: sales@prestel-usa.com

Translated from the German by John William Gabriel (Sagner-Düchting,
Posca), Almuth Seebohm (Düchting) and Christopher Jenkin-Jones
(Boehm), with Paul Aston and Joan Clough-Laub

Designed and typeset by Wigel, Munich
Lithography by ReproLine, Munich
Printed by Aumüller Druck KG, Regensburg
Bound by MIB Conzella, Pfarrkirchen

ISBN 3-7913-2615-5

Printed in Germany on acid-free paper